National Treasures of
GEORGIA

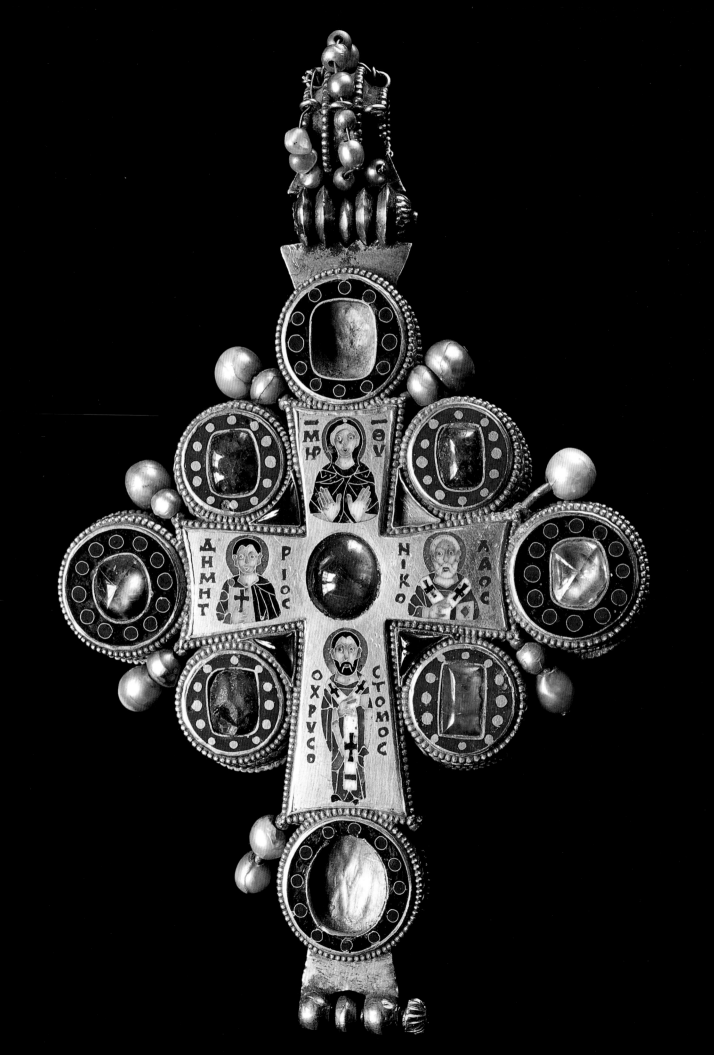

National Treasures of
GEORGIA

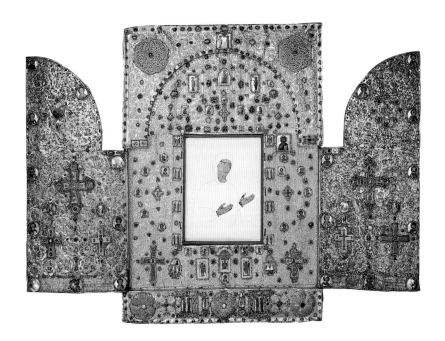

EDITOR
Ori Z. Soltes

PHILIP WILSON PUBLISHERS

THE FOUNDATION FOR INTERNATIONAL ARTS & EDUCATION

First published in 1999 by
Philip Wilson Publishers Limited
143–149 Great Portland Street
London W1N 5FB

Distributed in the USA and
Canada by Antique Collectors' Club,
91 Market Street Industrial Park,
Wappingers' Falls,
New York 12590

ISBN 0 85667 501 6

Edited by Ori Z. Soltes
Designed by Sara Robin

Printed and bound in Italy by
Editoriale Lloyd, Trieste

ILLUSTRATIONS
FRONT COVER Upper part of a chalice
(the Bedia Cup)
BACK COVER Lion figurine
HALF TITLE Psalter (detail)
FRONTISPIECE Pectoral cross
from Martvili
TITLE PAGE The Khakhuli Triptych

PHOTO CREDITS
George Chkhatarashvili
Miriam Kiladze
David Tskhadadze
Laboratory of Monument Fixation

OFFICIAL CARRIER

BRITISH
AIRWAYS

As this catalogue was being printed, the Georgian Government postponed the exhibition. The Foundation for International Arts and Education decided to move ahead with its publication because of the important contribution it makes to the study of applied art.

Contents

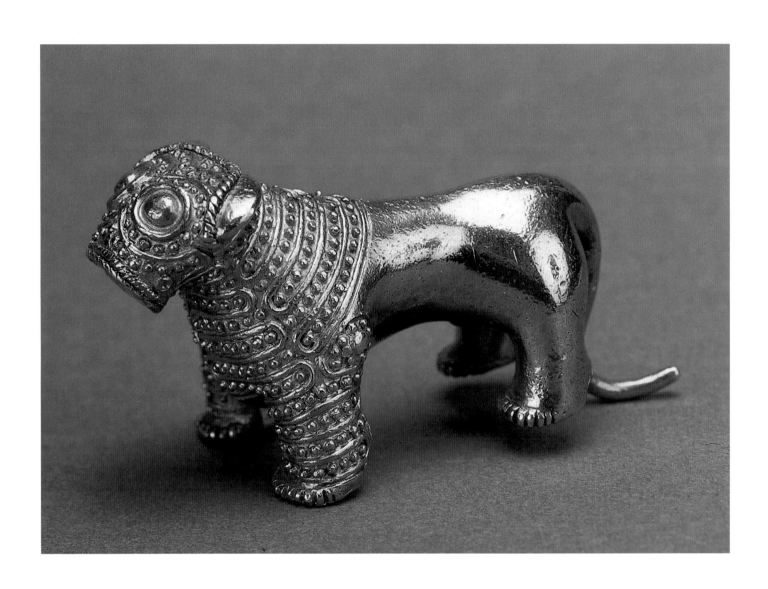

On behalf of the people of Georgia, I am extremely proud that we now have the opportunity to present to the American people the rich treasures of Georgia's culture and history. Americans have access to the very best of the world's culture and I know that it is hard to surprise Americans, but it is my hope and belief that when Americans learn of the glorious and ancient traditions of our nation they will be truly and pleasantly surprised.

The exhibition entitled *The Land of Myth and Fire: The Art and Culture of Ancient and Medieval Georgia* has been assembled with exceptional care by a talented team of American and Georgian specialists. Individual items have been selected from the finest that Georgia has to offer. This glittering display is more extensive and more comprehensive than anything ever seen beyond Georgia's borders.

I felt that this exhibition was such an extraordinary opportunity to present Georgia's culture to America that I appointed a special commission to work closely with the American side in order to ensure the success of this venture. It is my hope that the exhibition will be the focal point for a wide variety of collateral activities – conferences and cultural events, which will allow Americans to become familiar not only with our historic culture and traditions but also with Georgia today.

Our traditions and our culture have supported us for centuries. No aspect of our tradition is more important than our respect for other cultures, for the ability of Georgians to share this small geographic space with other peoples whose traditions differ from those of Georgians. This diversity has enriched the lives of all who share this space. It is therefore with particular pride that I can recognize the fact that parallel to the Georgian National Exhibition, Americans will also have the opportunity to see an exhibition devoted to twenty six centuries of Jewish culture in Georgia. This remarkable relationship and remarkable culture was the centerpiece of a celebration last year in Tbilisi, and I am delighted that we can share it with the American public.

While we are an ancient civilization, celebrating for example the 3000th anniversary of Georgian statehood during this year, we are at the same time a young and emerging democracy. Our relationship with the United States, a young country but an old democracy, is extremely important for us. My hope is that these exhibitions and all of the other activities around them will help Americans to get to know us better and will promote a closer bond of friendship between our two countries and people.

The Foundation for International Arts and Education deserves our gratitude. It originally conceived this dream and has now brought it to reality. We recognize the Foundations affection for Georgian culture, determination in developing the project, and creativity in fashioning such exceptional exhibitions.

On behalf of the Georgian people, we are happy to share with you the treasures of Georgian culture and history.

Eduard Shevardnadze

Foreword

Georgia celebrates its 3000th anniversary as a state in the millennial year 2000. From its very beginnings, the Georgian nation has attached great importance to its art and culture. The earliest works of art in Georgia date from the Aeneolithic Age, but the most important stage in the formation of the Georgian State and the development of Georgian arts began in the fourth century AD, when Christianity was proclaimed to be the state religion. We can observe a continuous process of development in Georgian art since that time.

The monuments of Georgian architecture of the sixth and seventh centuries, characterized by a strict, classic style, clear tectonics, refined proportions, and balanced symmetrical composition, represent some of the best such works of the world of that time. Wall painting, metalworking arts, book illumination, and relief sculpture are among the most prominent achievements of Georgian fine arts of the same period.

The period from the tenth to the twelfth centuries saw a flowering of Georgian culture, which coincided with the last stages of the struggle for the unification of Georgia and the rise of a united country. At the end of the twelfth and the beginning of the thirteenth century, during the reign of Queen Tamar, Georgian poetry reached its apex with Shota Rustaveli's epic poem *The Knight in the Panther's Skin* – a work that stands as a masterpiece of world literature.

Rustaveli, like other great writers, was often ahead of his time. Leaving medieval ideology behind, through his poetry he espoused religious tolerance and the most humanistic of ideas, expressing in his work the spirit and belief that were to become the main features of the European Renaissance. *The Knight in the Panther's Skin* is the most perfect embodiment of the creative genius of the Georgian people and has played an immeasurable role in the centuries-old aspirations of Georgians for kindness and justice. The millennial year 2000 will also mark the 800th anniversary of the creation of *The Knight in the Panther's Skin*.

It is worth noting that the exhibition *The Glory of Byzantium*, held at the Metropolitan Museum in New York in 1997, included several works of Georgian art of the ninth to the thirteenth centuries, as well as Georgian medallions and examples of cloisonné enamels from the museum's collection.

With the re-establishment of independence in the last decade of this century, Georgia has the opportunity to return to the commonwealth of the world's nations, with her centuries-long experience as a crossroads between Europe and Asia, and to take an active part in the new world culture now emerging, which envisions a global community with a common world outlook, shared democratic and humanistic values, and universally held moral principles.

Situated at the junction of Europe and Asia, Georgia has for centuries served as a natural geographic corridor between East and West – a position that has greatly influenced the formation of the state of Georgia, its mentality, culture, and traditions.

Georgia's President, Eduard Shevardnadze, attaches particular importance to culture, seeing it as an ideal medium for presenting the essence of Georgia to the outside world. During the recent turbulent years, when our country was tackling the complex problems of re-establishing its independence and national identity, the President stated: 'The Georgian people must save our culture, and the Georgian people must be saved by our culture.' In this respect the international forum 'Dialog of Cultures Against Intolerance and For Solidarity,' which took place in Tbilisi in July 1995 with the support and participation of President Shevardnadze and UNESCO General Secretary Federico Major, has had considerable resonance.

Georgian culture has gradually become known to the world through the creativity of Georgian theater, cinema, music, painting, and literature. We have paid increasing attention to the protection of our cultural heritage and will continue to do so.

Historically, Georgia is a multinational country, and it has taken considerable interest in the preservation of the cultural and spiritual life of all the peoples living here. The process of reconstruction is always difficult, but no matter how problematic life becomes, art will always remain the main expression of our spiritual needs. Today it is already possible to say that Georgian culture has been saved, and even that culture has saved Georgia. Now the country's main goal is to build a democratic way of life and to take its rightful place within the world democratic community. Once again Georgia will play its time-honored role as the link between East and West, while contributing more and more to world developments.

The presentation of the exhibition is an extremely important event for the people of my country.

Valeri Asatiani
MINISTER OF CULTURE OF GEORGIA

A Few Words from the Foundation

The Foundation for International Arts and Education takes enormous pride in presenting the exhibition to which the book forms the catalogue in the United States. The seeds for this exhibition were planted more than thirty years ago when my wife and I first visited Georgia and saw the splendors of its ancient culture and history. Some years later, when we first discussed the idea with Georgia's first Ambassador to the United States and Canada, The Honorable Tedo Japaridze, we agreed that we were tired of answering the question 'What is Georgia?'. We were convinced that once others saw the country's incredible riches and ancient traditions we should not be faced with that question again. When we began this odyssey in earnest three years ago, few believed that the exhibition was a real possibility, but the friendship and support of our Georgian colleagues constantly buoyed us. Wherever we went, even at the highest governmental levels, Georgians began by thanking us for what we were planning to do for Georgia. But now that dream has become a reality and this catalogue is a testament to the wealth and beauty of Georgian culture and history.

Developing an exhibition as spectacular and as complex as this one requires the work of many devoted people, the support of many organizations, and the cooperation of many museums. We have been blessed in all respects. It took an act of faith to believe that this nascent Foundation could indeed produce such an exhibition. First and foremost, we are all indebted to the distinguished members of the Foundation's Board of Directors, led by Ambassador Arthur Hartman, who have devoted their time and energy to see the Foundation through its birth pains. Secondly, we have had incredible support from our Georgian partners, especially Maka Dvalishvili and her talented staff at the Georgian Art and Culture Center, and Temuraz Khurodze, Prorector of Tbilisi University, who guided the project through the maze of Georgian institutions. The Georgian team putting together the exhibition has had the continuing support of a Presidential Commission, appointed by Georgia's remarkable President Eduard Shevardnadze and chaired by Valeri Asatiani, Minister of Culture. Zaza Shengelia, former Deputy State Minister, has always been available for consultation and support. The Directors of the three main museums – Levan Chilashvili (History), Nodari Loumuri (Art), and Zaza Alexidze (Manuscripts) – assured us that the selection of materials for the exhibition would represent the finest that Georgian culture has to offer; they have made good their pledges. Backward-looking political forces launched a demagogic and often vicious attack on the exhibit's organizers – a thinly veiled campaign against President Shevardnadze and Georgia's engagement with the West. Our Georgian colleagues courageously rallied together to protect not only the exhibition, but, more importantly, Georgia's re-entry into the world's culture, so eloquently described by Minister of Culture Asatiani in his Foreword to this catalogue.

Any project of this scope depends on those who are willing to sponsor it when it is still a gleam in the organizers' eyes. Here, too, we have been extremely fortunate. The Trust for Mutual Understanding provided us with the funds for our first exploratory trips and a series of pilot exchanges of museum specialists. When we were still in the planning stages, Chevron Overseas Petroleum, Inc., Metromedia International Telecommunications, Inc., and CaspianTransCo agreed to be major sponsors of the exhibition. Additional support was supplied by ENRON Corp. The Starr Foundation, and R. J. Reynolds International Tobacco S.A. Their contributions have been invaluable.

Finally, an exhibition needs a home. Gary Vikan, Director of the Walters Art Gallery, Baltimore, signed on early and enthusiastically. His excitement about Georgia gave him the patience to support, cajole, and advise our bunch of enthusiasts. Terry Weisser and Abigail Quandt, conservators from the same gallery, have become celebrities in Georgia because they bring the knowledge, the skill, and, above all, the concern to help Georgians preserve their cultural treasures. Other museums on the itinerary, especially the Fine Arts Museum of Houston and the Mingei International Museum of San Diego, have also provided us with continuing support to make this exhibition a reality.

Every catalogue needs a publisher. Cangy Venables of Philip Wilson Publishers has demonstrated an uncommon combination of determined professionalism and good cheer in seeing us through the production of this catalogue, and flexibility in meeting deadlines.

All of these people helped us along the way, encouraging us, advising us, and supporting us. The final selection of items, the design of the exhibition, and the creation of the catalogue fell to the Foundation's exhibition team, and first and foremost to Ori Z. Soltes, the exhibition's curator and editor of the catalogue. Doug Robinson and Rosemary DeRosa have, as our registrars, patiently brought order out of our chaos, and Meg Craft, as our conservator, has provided that critical link between the lending and host museums in determining how best to treat and protect the wonderful treasures that are being shown.

In conclusion, a few words of heartfelt appreciation to the staff of the Foundation, which has lived this project from the outset: to Heather Parrish-Schmitt who began this journey with us, to Elena Romanova who picked up the baton from her, and to Jessica Tauman who joined us as we rounded the turn. And a special note of thanks to my wife Kathie and son Alec, who worked long and often unrewarding hours to let me live out this dream.

I hope that all who see this exhibition will share our excitement over Georgian culture, and will keep this tangible memento of the experience.

Gregory Guroff

PRESIDENT, FOUNDATION FOR INTERNATIONAL ARTS AND EDUCATION

Introduction

I first encountered the arts of Georgia at an exhibition in Vienna in 1981, organized to coincide with the 16th International Byzantine Congress. Though a Byzantinist, I was unprepared for Georgia's unique interpretation of Orthodoxy. It was totally new to me, and I was thoroughly impressed. Indeed, after nearly two decades, I can still recall the precise location in the gallery where I found the diminutive but monumentally powerful processional cross fragment from the church of Ishkhani (no. 110).

I could hardly have dreamed then that I would eventually play an instrumental role in bringing these treasures for the first time to the United States. Nor could I have guessed what a powerful impact visiting Georgia and working with my Georgian colleagues in developing this project would have on me. I shall never forget my first visit to the treasury of the Georgian State Museum, with its stunning gold tortoise necklace from Vani (no. 56), my initial encounter with the magnificent Lailash Pentateuch (no. 121) at the Institute of Manuscripts, the winding drive up to the Jvari Church on the bluff overlooking the ancient capital of Mtskheta – and, of course, my first experience of Georgia's legendary hospitality, and the art of the *tamada* (toastmaster).

I share a tremendous sense of excitement and pride with Greg Guroff and the Foundation for International Arts and Education, and with all the museum professionals, scholars, and good friends on the Georgian side, who have together made this landmark exhibition possible. For it is the epic story not only of a great artistic heritage, but of a great people.

For a few brief months, treasures of an ancient and proud land will be shared with the world, but forever, a part of me – and, I suspect, of all of those from the Walters Art Gallery who have made the journey with me – shall remain in Georgia. Such is the magic of the Land of Myth and Fire.

Dr Gary Vikan
DIRECTOR, THE WALTERS ART GALLERY, BALTIMORE

Editor's Note

This exhibition and catalogue have undergone a long and often painful birthing process, a successful conclusion to which was made possible through the dedicated attention of many individuals. Greg Guroff has made clear who most of them have been and I add my gratitude to his for their efforts, but this project would have been non-existent without Greg's own efforts from beginning to end. We, the myriad participants in making it all happen, are in part the fortunate figments of his dream of connecting Georgia and its extraordinary cultural history to the wide world at the end of the millennium. The Foundation for International Arts and Education is as successful and important as it is, as a contributor to the growth of the economic and cultural life of Georgia within the larger post-Soviet world, in large part, as well, because of its superb staff, who never miss a beat: Kathie Guroff, Alec Guroff, Elena Romanova and Jessica Tauman. Kathie's contribution to this project has been far beyond what one might term duty or even devotion: her combination of wisdom and tenacity has been a model and a marvel in bringing clarity of detail to the entirety. We all run in vain, trying to keep up with the quality of her editorial and other efforts.

I would also like to thank Margaret Guroff for her splendid editorial assistance. It is, above all, my pleasure to thank Antony Eastmond for the enormous and insightful efforts, combined with deep knowledge, that he brought to bear in the sections of this catalogue which focus on medieval metal- and stonework, enamels and manuscripts. His expertise prevented many a slip into error. Let me add my warm appreciation, as well, to the army of wonderful colleagues whose exploration and explanation of Georgia are shared in this catalogue.

May I also acknowledge the loving support of my wife, Leslie, in shouldering, alone, burdens that should have been shared, in order to make it possible to work so many hours without interruption. To her and our new son, Brahm, whose birth and early growth time have paralleled this project, this catalogue is dedicated.

NOTE: Since Georgian has its own writing system, spellings throughout this catalogue are based on what is currently the consensus among most scholars as to how most effectively to transliterate its sounds.

Ori Z. Soltes
CATALOGUE EDITOR AND EXHIBITION CURATOR

I

INTRODUCTORY

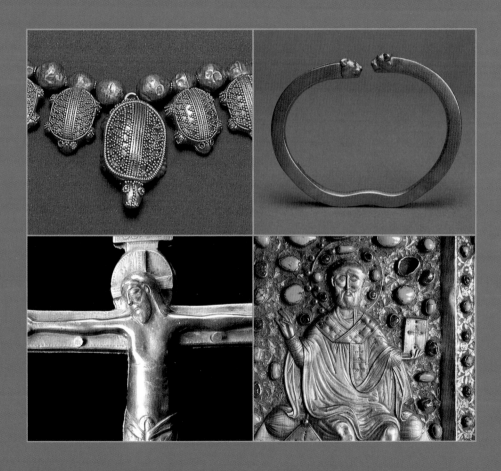

1 The Eternal Crossroads

Ori Z. Soltes

I

For thousands of years, tiny Georgia – about the size of West Virginia – has served as a stopping place for travelers and a prize for conquerors. Yet despite an extraordinary range of outside influences, this Black Sea coast country that even today numbers less than five and a half million people has always maintained a strong sense of itself as a nation. While remaining open to a variety of inputs from Achaemenid, Greek and Roman, Persian and Arabo-Muslim, Seljuk, Ottoman, and Russian culture, Georgia has evolved its own culture and retained its own language, which is unrelated to any major tongue.

Georgia's vast religious literature strikingly reflects an independent national mind. The Georgian Church reveres saints who are celebrated nowhere else in the world (see IV.5). But Georgia's ecclesiastical literature also documents centuries of cordial relations with other Orthodox rites and even with Islam. This same openness is reflected in Georgian secular literature: the national epic poem, *The Knight in the Panther's Skin* (see II.3), is set entirely – and sympathetically – in an Islamic context.

Georgian art and architecture are also revealing. High blind arches rise along walls of churches with wings of equal length, above which soar conical domes: the general structure is shared with Armenia, but the details are not. Basilical churches, similar to those in Byzantium, replace interior colonnades with interior walls, creating triple-naved structures unique to Georgia. Wall paintings and reliefs, icons and enamels, textiles and illuminated manuscripts – all convey a sense both of *Georgianness* and of cultural connection with surrounding peoples. Above all, a continuity of skilled craftsmanship extends from the early Bronze Age to early Modernity.

What, then, is 'Georgia'? And how has it developed over the millennia, tucked away in a corner of the world that has been increasingly isolated in the past few centuries, as the centers of power and interest have shifted steadily westward? We might begin by seeking to understand that layered Georgian sense of being at a constant crossroads throughout the country's history which, in the words of the historian Antony Eastmond, has enabled its people to 'look in many directions from the center'.

The metaphor of a crossroads is a powerful one, symbolizing the infinite pattern of possible meetings between an infinite number of opposed realms. The word can suggest the meeting not only of roads, but of *opposite* worlds. It may also suggest the dynamic tension between horizontal and vertical, day and night, life and death, humanity and divinity.

It is no accident that in many cultures crossroads are marked by protective shrines: lest on the boundary between the safe, the known, the ordered and the unsafe, the unknown, the chaotic a passer-by be torn apart by the oppositions that such antithetical forces set up. Crossroads are points of both creative and destructive potential; as such they can transform reality in the most exhilarating and the most devastating of ways.

Borders are analogues of crossroads, in that they also mark the meeting of opposed realms. Whether or not 'good fences,' in the words of the poet Robert Frost, 'make good neighbors,' they define where one reality ends and another begins – and the best fences may well be those with enough holes in them to allow the dangerous but dynamic interchange that occurs when the content of one sensibility mixes with that of another.

One of the more fascinating crossroads and borders across the range of human experience is the one where history and mythology meet. We speak of these as opposed realms but often forget how intertwined they are. Western thought calls the fifth-century BC historian Herodotus the 'father of history.' Yet his successor among Greek historians, Thucydides, implicitly condemns the master for his lack of historiographic acumen. Herodotus's stories about the origins of peoples and customs are drawn from the local people whom he interviewed in this place or that, and fail to distinguish *mythos* from *historia*. By Thucydides' time the first of these words no longer meant, simply, as it once had, 'a [true] account' (true because who would dare risk the wrath of the gods by making up, for example, the story – the *mythos* – of how the gods were born and in turn created us? Such information can only have come *from* the gods). By the later historian's time *mythos* had come to suggest what it does for us: untrue legend-bound material, opposed to and lacking the accuracy of *historia*.

It is ironic that Thucydides, in his desire to impress us with *his* historiographic acumen, informs us of a method which is hardly falsehood-proof: that he himself witnessed or relied on reliable witnesses for what he describes; that he quoted precisely or *approximately* what was said, or that he put into people's mouths the words he *imagined* they *must have* or *should have* spoken under the circumstances.

In short, everything from speeches by opposing generals to Pericles' famous Funeral Oration should be suspect to us. The imprecision of historiography is inevitable not only for Thucydides, but for an account of, let us say, the Battle of Hastings nearly fifteen centuries later, or the assassination of John F. Kennedy only a generation ago. We weren't *there*, and if we *had* been there, we could surely not absolutely trust our perceptions in the heat of the moment. Eyewitnesses to the same event more often than not offer differing accounts of it, and historians too will offer differing interpretations of events.

History and myth, then, apparent opposites in the thinking that begins, for the Western mind, in the era of Thucydides, are more likely to be intersecting paths. The border between these two territories is a meeting point and a crossroads between sensibilities that overlap each other. And nowhere is this notion more fruitful than across the landscape of the Georgian imagination, the ultimate crossroads between mythic and historical sensibilities.

II

Georgia is a crossroads in an extraordinary range of ways. Geographically and topographically, the country is a meeting point between mountain and sea as the country itself is bifurcated by mountains – the Surami Ridge or Likhi Range – and divided between those mountains that arise (vertically) from its center and the plains that flow out (horizontally) in all directions from that topographical surge. The River Phasis, emptying into the easternmost side of the Black Sea, figures in the mytho-geographic imagination as a meeting point between Asia and Europe, analogous to the Nile and to the Straits of Gibraltar in their joining (or separation) of Africa and Asia, and Europe and Africa, respectively. Indeed Colchis, as the Greeks called it, the western part of Georgia, was believed by many in the time of Herodotus to be connected to Egypt by means of the great river of Ocean that flowed under and around the entire world.

Herodotus himself makes a number of connections between Egypt and Colchis (such as that both locations produce linen – and harbor unicorns!), which share in common the conditions of being highly accomplished cultures on the fringe of the Greek world – *borderlands*, *crossroads* between the familiar and the unfamiliar, the everyday and the exotic. At the same time, the topographic division *within* Georgia has tended to yield a history of political conflict and competition between the parts separated by the Surami Ridge: *Colchis* in the west and *Iberia* in the east – each with different names and overlapping experiences over the course of history.

If the Greeks looked on Colchis and Iberia as two halves of a border reality, the inhabitants of those areas – *Egrisians* and *Kartlians*, in their own language – had a different perspective. They looked out in all directions from the center: west toward the Greek world; south and east toward the Persians; and occasionally north toward the realm across which the Cimmerians and Scythians moved, an area that is now part of Russia. That multilateral viewpoint – the view from the crossroads – would continue through the course of the millennia, down to our own time.

Partially restored Bagrat Cathedral in Kutaisi, early 11th century.

The growth and development of ancient towns and cities in the Colchian-Iberian (*Egrisian-Kartlian* in Georgian) region is in large part traceable to the fact that major trade and transit routes passed through the area – it is a literal crossroads that connects the Greek world to the worlds of the east, from the Black Sea, at Phasis, through the gorges of the Rioni and Mtkvari rivers. Millennia later – the evidence suggests the ninth century AD – a second, more southerly route emerged in the Artanuji–Dmanisi direction, along which new towns arose. Yet again, in the sixteenth century, part of a third international route developed in the Germi-Ardebili region. These three routes all fall within the orbit of the Silk Road. Thus the role of Georgia as an economic crossroads may easily be recognized.

The connection of Georgia to other powers has made it a political and cultural crossroads as well. Its position at the junction of west and east, shielded by the Caucasian mountain range to the north, full of narrow valleys and passes to be controlled and exploited, has provided significant strategic advantages, but has also made it the object of political ambition for diverse groups. The inhabitants have often had to fight to maintain their independence and

national integrity over the centuries. In struggling to preserve that integrity while remaining subject to outside influence from a rich criss-cross of enemies and allies alike, Georgia has managed to preserve its national originality and culture.

A continual center of cultural and military exchange, the region was invaded by and/or subject to the Urarteans, Achaemenid Persians, and Hellenistic Greeks, the Romans and the Parthians, the Sassanian and Byzantine and Seljuk and Ottoman and Tsarist empires – and was ultimately forced into the Soviet Union. Yet regardless of what influences Georgia sustained from such incursions, it maintained its identity with vigor. One might say that Georgian culture never stopped being Georgian, as challenging as it is to define precisely what 'Georgian' means.

III

The very name 'Georgia' is only the latest in a series of names that have been applied to this territory (in its own tongue, the country is called *Sakartvelo*). And the specific geopolitical configuration of the territory has shifted dozens of times through history. Kartli and Egrisi are later Suania and Lazica and then Mingreli and Kakheti. Regional factionalism is as

long-standing a reality as the unifying idea of 'Georgia.' Indeed, political unification was achieved only twice before this century, briefly in the third century BC, and again in the Golden Age of the twelfth and early thirteenth centuries AD. Yet the Georgian language, with its own unique writing system and its own splendid poetry and song, like Georgian gold and silver artifacts, icons, and ecclesiastical textiles, is distinctive. And as Georgia shifted, over the millennia, from being part of the pagan world to being part of Christendom, it became the seat of its own autocephalous church, with its own patriarch, distinct from and equal to the patriarchs in Constantinople (Byzantium), Jerusalem, Antioch, and Alexandria. As we have noted, this church eventually yielded its own array of saints.

Yet Georgia also never lost the capacity to accept others' spiritual views. The split with the Armenian Evangelical Church did not prevent an Armenian church from being built in the heart of Old Tbilisi, a stone's throw from a Georgian Orthodox church. Islam's armies overran and held sway in Tbilisi and other parts of the country for centuries, yet when King David the Builder drove out the Seljuk Muslims in the twelfth century, Islam was not driven away as well. Near those two churches, a mosque still functions, as do others elsewhere throughout the land. Such peaceful coexistence is extraordinary, especially in this general part of the world.

Religion is therefore another area in which Georgia has been a hospitable crossroads over the centuries. Even Jews, rather than being perceived as a *threat* to Christendom, are popularly said to have *brought* Christianity to or *spread* Christianity through Georgia, in the second and third centuries. (This is not altogether surprising, when one considers that the first Christians were simply Jews who believed in the Christhood of Jesus.) The fourth-century Georgian St Nino, who is credited with initiating the final triumph of Christianity in Georgia, is said to have spoken Hebrew with the Jewish inhabitants of Urbnisi, about sixty miles northwest of Mtskheta. In most of Europe the common roots of Judaism and Christianity have more often than not been ignored in favor of murderous hostility. But in Georgia, the consciousness of commonality flows from top to bottom of society and back again. The two faiths intersect in a centuries-long process of influence and counter-influence.

It isn't simply the case that, over the centuries of Christianity's triumph, growth and continued development in Georgia, the process of expansion seems never to have proceeded by oppressing the Jewish minority. (A sixth-century source speaks of a Persian youth who visited a synagogue in Mtskheta, reporting that it was equal in stature to the prayer houses of other religions found there.) But the shared love for Jerusalem is profound. It is reflected in a constancy of pilgrimage by Georgian Christians and Jews alike – yielding more than thirty Georgian monasteries and churches and their marvellous illuminated manuscripts over the centuries on the one hand (see II.2); and nineteenth-century Zionist and non-Zionist educators going back and forth between Georgia and Jerusalem Yeshivot on the other. Both Shota Rustaveli – the national poet of Georgia and author of the twelfth-century epic *The Knight in the Panther's Skin* – and his contemporary (and putative source of inspiration), Queen Tamar, are said to be buried in Jerusalem. And the passion with which the Bagratid royal house, which ruled parts of Georgia for a thousand years, asserts its genealogy from the Israelite kings David and Solomon, is unmatchable – in Europe and Asia, at any rate: one would have to look toward Ethiopia, and the Solomonic ancestry ascribed to its royal house, for a comparable tradition.

The Bagratid claim leads us back to the beginning of this discussion: to Georgia as a crossroads between myth and history, between intellect and imagination. That sensibility illuminates the question of Georgia's beginnings. The interweaving of myth and history attends the shaping of traditions regarding the beginnings of all human cultures of ancient origin. This is no more the case with Georgia than elsewhere, although perhaps the weave is more colorful, the tapestry richer than those of most other cultures. From 1.6-million-years-old *Homo erectus* bones, which offer the possibility that the Eurasian branch of the human race began to stand on its feet in this area, to the Greek notion that that most civilizing element for human enterprise, fire, was wielded here first, Georgia is as overrun with story as it is overwhelmed by breathtaking topography.

Georgia's natural northern boundary – the southern slopes of the Caucasus mountains – is where the early Greeks understood that Zeus had chained the Titan Prometheus, to

punish him for bringing fire to humankind, with the power that fire yields. Given the area's rich ore deposits and the fabulous smelting and metalworking skills of its ancient inhabitants – who five and four and three millennia ago created spectacular jewelry and other objects (see III.2, III.5, III.6) – we can well understand the Greek belief that the giver of fire dwelled in that region. Moreover, Georgia has its own tradition of a Prometheus-like figure, Amirani, who challenged God as Prometheus did Zeus, and was punished for it. The two stories are a crossroads of mythological thinking.

It was to western Georgia – *Colchis* in Greek terms – that Jason and the Argonauts were said to have sailed in pursuit of the Golden Fleece, in the most famous of Greek myths that fasten on this land at the edge of the Greek imagination. And indeed, the River Rioni flows by Poti with pieces of golden ore, which have perhaps been captured for centuries by the local inhabitants, using the fleece of sheep to sieve the water through and trap gold flakes, a process that lends the fleece, before it is combed out, a fantastic sparkle.

Some of the heroes who sailed with Jason are said to have founded Georgian towns that bear their names, such as the northwest coastal city of Dioscurias (now Sukhumi), associated with Castor and Pollux (known as the Dioscuri or 'Twins'). The Amazons are also said to have held sway in the region; a hoard of swords in this exhibition is associated, by tradition, with those warrior maidens. One of their queens fought in the Trojan War as an ally of the Trojans and was slain by Achilles, who fell in love with her at the moment he plunged his sword into her, so impressed was he by her valor. A second Amazon queen, Hippolyta, in a second thread of legend, was carried off by Theseus as his wife, and a third, Thaletris, is said to have visited Alexander the Great as he passed not far from this area, with the intention of bearing a child by him.

This last reference to the Amazons, of course, carries *mythos* out of the age of heroes into the historical period of ordinary people – the fourth century BC (although Alexander is a kind of throwback to heroic charisma even in an everyday age). Perhaps the hoard of swords associated with the Amazons was among those said by the historian Plutarch to have been taken from the dead by the Roman general Pompey's forces, on a battlefield in the Caucasus area

– nearly three centuries after the time of Alexander. Labeling them as swords of the Amazons would have made sense to Pompey. As one who aspired to be the Alexander of his era, he would want it said that he encountered some of the same praeternatural forces as did the Macedonian conqueror – especially out on the border of the Empire, the border and the crossroads between known and unknown realms, between civilization and barbarism, between order and chaos, between *us* and *them*.

On the fringe of the Greek and Roman worlds, both the Colchian and Iberian parts of what we now call Georgia would mediate between these worlds and their 'barbarian' counterparts. Indeed, the Colchian-Iberian role *as* border-land helps account for the association in the classical mind between these places and other border realms, such as Egypt (as already noted) or Spain. It may not be simply coincidence that the far western fringe of the Roman world was called by the same name as the far eastern fringe – *Iberia* – especially as we may understand them both to be connected by the River of Ocean flowing below and around the earth. By the time the Greeks and later the Romans had discovered Georgia, though, that country had already experienced a rich history and culture that can be traced back for millennia, even, it might be said, *beyond* the misty epochs of heroic myth.

IV

Paleontological and archaeological evidence suggests that *Homo erectus* was present in this area over 1.6 million years ago, as we have noted. The evidence further asserts that tribes that might be construed as ethnically ancestral to the Georgians were active in this area during the Paleolithic period (c.100,000–6000 BC). A comparatively mild climate and rich soils at the river basins favored the intensive development of agriculture. Irrigation systems are thought by some Georgian scholars to have been developed here well before they began to evolve in Mesopotamia. The cultivation of the vine and the making of wine may have begun here earlier than anywhere else in the world (see III.3). The Old Stone Age and subsequent periods are indeed all represented in the archaeological record by ample, genetically interrelated material. In short, the record suggests an autochthonous theory – i.e. that the earliest Georgian tribes arose and

evolved within the region, rather than having migrated from elsewhere.

The remains of settlements in several locations are dated to the sixth and fifth millennia BC. Dwellings were apparently made of clay, and agricultural implements, ceramics, and even rudimentary clay sculptures have been discovered, suggesting the initial phases of a rooted economy.

By the early and middle Bronze Ages – the third and second millennia BC – strong tribal unions were formed on Georgian territory (see III.4, III.5). Chieftains were apparently buried together with rich implements, in large mounds. Among these, in sites such as Trialeti (due west of Tbilisi), some wonderful, at times unique, pieces of metalwork have been found. Georgia is rich in ores (gold, silver, and copper), which enabled the very early development of metallurgy. Precious metals and bronze were worked in a refined manner in the third millennium BC and conceivably exported for use to Mesopotamia, Asia Minor, and the North (thus Georgia would have also functioned as a crossroads of metallurgical activity), and late in the second millennium an iron culture began to develop as well. Later still, commentators from around the time of Christ, like Pliny the Elder and Strabo, allude to mining in Transcaucasia. And indeed the brilliant working of metals and stones would continue through successive eras, encompassing medieval icons and even textiles of the seventeenth and eighteenth centuries AD. By the middle of the first millennium, two substantial states had formed, as we have seen: Egrisi in western Georgia and Kartli in eastern Georgia, the entities known to the Greeks as Colchis and Iberia.

By the seventh century BC, Egrisi and Kartli were acting as a crossroads between the Greek world, for which they were part of colonial expansion, and the Achaemenid Medo-Persian Empire. That role would continue under different guises over the centuries that followed, as the Hellenistic world gave way to the Roman Empire, and the Persian Empire, lost to Alexander, was subsequently reborn as the Parthian and Sassanian Empires in turn. That is, as a *border*, both between civilization and barbarism and between civilizations, this twin Egrisian-Kartlian (Colchian-Iberian) realm continued to inspire a rich exchange of history and mythology and of politics, economics, and culture.

The area continued to be noted for its mining, and also for gem production. Pliny tells us in his *Historia Naturalia* (furthering the interweave of history and mythology) that the first finger-ring with a gem was shaped from a fragment of the rock to which Prometheus (Amirani) had been chained. By Strabo's time Colchian linen was apparently no longer the noteworthy commodity it had been at the time of Herodotus. But Strabo informs his readers of another unique feature of Colchis (Egrisi): that it presented all of the necessary materials with which to build ships, from linen and hemp to pitch, wax to timber. The realm to which adventurers like Jason and his crew are said to have sailed could retain its hold on the classical imagination in part because of its singular potential role in making sailing possible. On a more mundane level, as a center of trade, the Colchian coastal city of Dioscurias (which, as we have observed, attributed its beginnings to the famous semi-divine siblings who were part of Jason's crew) was an outstanding example of what the Hellenistic world as a whole was about: synthesis.

As a magnet for produce-exchange, from salt to sheep, Colchis was the ultimate crossroads of traditions and ways of life, coastal and inland, mountain and plains, urban and rural, the masses and the elite; of ideology and theology; and above all, of language. We have noted the uniqueness of the Kartlian (Georgian) language, yet Georgia itself was, throughout antiquity, a center of linguistic exchange. In 77 AD Pliny the Elder quotes the Hellenistic writer Timosthenes as saying that three hundred ethnic groups would find their way down to Dioscurias from the hills to trade – and adds that the Romans, in *their* time, employed a hundred and thirty interpreters to accomplish their business there. This linguistic interchange would continue into the medieval period, when Turkish, Persian, Arabic, and Armenian words would occasionally trickle into the Georgian vocabulary.

V

Thus linguistically, too, Georgia is a fascinating crossroads (see II.1). It stands between the Semitic world on the one hand and the Indo-European on the other, and between these worlds and the Altaic and Touranian (Turkic) worlds as well. It stands in the midst of an array of southwest Caucasian – Kartvelian – languages, but is the only one with its own

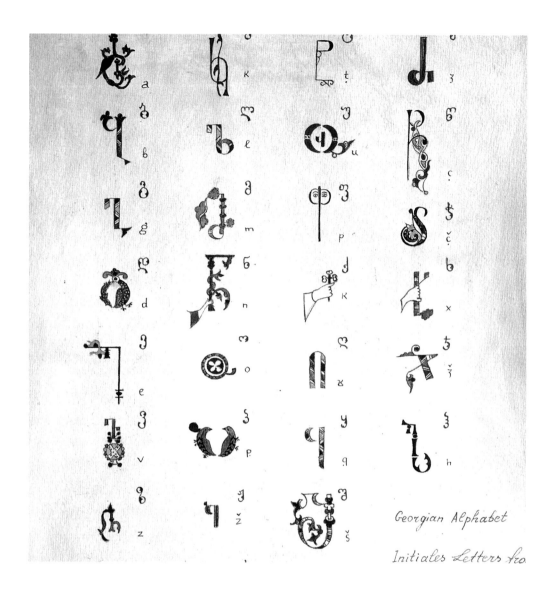

Georgian Alphabet

Initiales Letters fro

Cat. 107 (detail) | Limestone
altar screen panel from
Gveldesi, 8th–9th century AD

writing system. Indeed, the very name 'Georgia' is not part of the language at all; we owe it to the Romans who applied a Latin word for 'farming' to the region, presumably in reference to its rich and well-worked soil.

According to tradition, the Georgian language's unique writing system was developed by the king credited with first unifying the diverse tribes and paired lands into a single state: Parnavazi, a third-century BC ruler. He is said not only to have established a powerful state, but to have laid the foundations for administrative order as well as for centuries of literacy and scholarship. Thus some Georgian literary sources associate him with developing the first Georgian script, although there is no material proof of this. The earliest

unquestionable archaeological evidence for a writing system dates from the fourth century AD, and by the fifth century the written language begins to spread widely. Inscriptions dated to that century can be found on architectural monuments and on ceramics. And perhaps the first Georgian literary work, *The Martyrdom of St Shushanik* (see below and II.1) also dates from this time, as do the first translations into Georgian of several religious texts, including the Bible.

We have already noted that Georgia was a meeting point of both conflict and tolerance with respect to religious diversity. Indeed, the level of tolerance once Christianity has triumphed is remarkable for the medieval world, and

unusual enough even at the end of our own century. We have also noted that Georgia was involved in wide spheres of Christian culture and ideology. Thus a significant volume of Georgian ecclesiastical activity was carried beyond the country's borders (see II.2) to sacred sites in Jerusalem, Syria, Sinai, and Greece.

So, too, new legends and traditions that cross religious lines have continued to emerge. Thus, for instance, the Georgian Jewish community has evolved customs derived from those of its Christian neighbors, such as the inserting of a photograph of the deceased into a 'window' on a gravestone. And the spectacular Hebrew-language Lailash Pentateuch, with its splendid decorations, came gradually, from the twelfth century on, to be perceived not only by Jews but by Christians as having healing powers, as did the so-called 'Breta' Hebrew Bible of a few centuries later. On the other hand, Christian relief stone carving often displays the

geometric and vegetal complexities of Islamic style. But beyond these essentially internal issues, from the post-Roman period to modern times Georgia has been a border not only between political realities but between external religious realms. Thus in the fifth and sixth centuries AD it was a pebble between the millstones of the Christian Byzantine and the Zoroastrian Sassanian empires. There are literary implications: the St Shushanik who was the subject of the country's above-mentioned first known work of literature is immortalized for having preferred martyrdom by clinging to her Christian faith over her husband's choice of conversion to Zoroastrian-ism. There are 'internal' political consequences: conflicts between the eastern and western parts of Georgia (Suania and Lazica, as the further-evolving names became in the Roman and post-Roman era) mirrored the conflict-ridden relationship between the Sassanians and the Byzantines. But by the late seventh and early eighth century, Georgia's eastern

portion (former Iberia/Kartli/Suania) was occupied by the Muslims for the first time.

Subsequently, the western and eastern realms together formed a changing frontier between Christendom and the Islamic world. During the Crusades, King David the Builder is said to have had contact with Baldwin, king of Jerusalem, and two hundred Crusaders are said to have been part of David's forces at the Battle of Didgori, where he inflicted a crushing defeat on the Seljuks in 1121. This boundary–crossroads pattern continued right up to the dawn of the nineteenth century, when Georgia hovered between Russian and Ottoman spheres of religious and political influence.

VI

The fertility of Georgian cultural accomplishment in the midst of a dynamic and dangerous sweep of centuries continues from antiquity right up to the modern era. In the early medieval period that fertility can be seen not only in small objects but in the widespread construction of magnificent architectural monuments all over the countryside (see IV.3), as well as in the growth of towns and impressive fortifications, some of them of major architectural significance.

Politically, the ninth century saw the beginning of the consolidation of the small separate kingdoms and provinces that define regional factionalism in Georgia into larger unions, such as Tao-Klarjeti (currently in Turkey), Abkhazeti (in the northwest, along the coast), and Kakheti-Hereti (to the east) – which led, by the end of the eleventh century, to the formation of a powerful feudal Georgian state. As noted earlier, King David the Builder (1089–1125), of the Bagratid house, played the leading role in the completion of that process, as well as in driving out foreign conquerors and strengthening the reunified monarchy.

United Georgia became a powerful political force that controlled the entirety of Transcaucasia and adjacent regions, the important trade routes passing through it connecting Oriental countries with Byzantium, and tribes north of the Caucasus with Iran and the Near East. Hoards of foreign coins unearthed in Georgian excavations indicate a lively and far-flung medieval trade, which, echoing that feature in antiquity, extended from the sixth and seventh centuries to its peak during the golden age of the unified state in the twelfth and thirteenth centuries.

This lively exchange is visible in the art of these centuries, from icons to ecclesiastical textiles, from superb Sassanian-influenced metalwork to splendid Safavid- and Ottoman-influenced illuminations (see II.3, IV.8). The imaginative ingenuity of the Georgian world is apparent in the center-piece of Georgian literature, the epic poem *The Knight in the Panther's Skin*, the first work of what the Georgians often refer to as the Oriental Renaissance, which coincides with the later part of the twelfth-century Renaissance in Western Europe. The poet champions human aspiration and capacity for fulfillment rather than glorifying God, anticipating the ideology of the Renaissance epoch that was to reach full expression in Europe in the fifteenth and sixteenth centuries (see II.3). Significantly, this text written by a Christian is set in Muslim lands. If the setting is part of the author's desire for exoticism, it is also remarkably sympathetic, particularly given the period and the war-like Georgian relations with Seljuk Islam at that time (to say nothing of the Christian–Muslim struggle in the Crusades).

By then new architectural monuments were punctuating the landscape (see IV.3), and calligraphic texts appeared, often decorated with brilliantly colored miniatures, as well as outstanding gold repoussé objects, enamels, and panel and wall paintings.

VII

As we follow Georgian history forward, we can see it as a crossroads between external influence and national self-assertion even as it is a crossroads between political struggle and cultural accomplishment. By the second half of the fifteenth century, after a hundred years of Tatar-Mongol invasions from the east, as well as internal conflicts, the unified Georgian state once again split into separate kingdoms and principalities. These newly formed political units acted independently: they held diplomatic negotiations, regulated trade relations, appointed administrative bodies, designated their clergy, minted coins, and so on. The decentralization of the state apparently led to the flourishing of a range of cities as administrative centers, setting the stage for the modern era.

Given the presence of fifteenth-century European coins on Georgian excavated sites, it is reasonable to suppose that Georgia conducted trade with European merchants during this period – the heyday of Venetian–Genoese trade competition, which reached into and had an impact along the Black Sea littoral – while participating in the Oriental market-places of Persia, Syria, and the Persian Gulf, which reached *to* Georgia from the south by the Shemakha–Ardebili route and *through* Georgia by way of the northern, Volga–Astrakhan route. The most important trading commodity in Georgia by this time was silk, basically as a raw material – which recalls, textile for textile, the importance of linen as an important trading commodity of ancient Colchis/Egrisi twenty centuries earlier.

We are led back to where we began: to Georgia as the consummate crossroads of culture and history, of history and mythology, of mythology and religion. Georgia as a boundary between the realm of fact and the realm of the imagination, as the synthesis of influences and counter-influences and the ongoing evolution of distinct elements that one might term 'Georgian'. Georgia as a crossroads between its own inclinations toward unity and those toward fragmentation, and as a meeting point between the struggle to repel outsiders and the inclination toward an ethic of hospitality exceeded nowhere on the planet. Georgia, indeed, as an act of mind, creating a singular, recognizable identity out of a mix of diverse parts.

If Georgian history begins with a succession of beginnings – at what time does the transition from paleontology to archaeology to literary reference and the various nominal designations of polity and ethnic identity yield what we would call the 'Georgian' reality? – its culture and its enigmas follow that reality out of the medieval period toward the present day. That question impels us forward to the most difficult phases of the sixteenth and seventeenth centuries, when at times the very existence of Georgia appeared threatened by invasions from the Muslim powers of Ottoman Turkey and Safavid Persia. At that time, Georgian political leaders sought assistance from the outside Christian world. Envoys were sent to various European states seeking assistance. Russia was the only one to respond with more than lip service. Serious diplomatic relations were developed, as the

Tsarist Empire began to assert a generally aggressive interest in the Caucasus overall, establishing a network of garrisoned fortified settlements.

By the Georgievsk Treaty of 1783, Georgia accepted the protection of Russia. But shortly afterwards, calamity struck. In 1795 the Persian Shah Agha Muhammad Khan razed Tbilisi (capital of the eastern kingdom) to the ground. Salvation and disaster met at yet another crossroads when in 1801 the eastern Georgian kingdom was annexed to Russia. In violation of the Georgievsk Treaty, Russian troops were brought in to eliminate that kingdom as an independent entity. Soon other Georgian provinces – from Imereti in the center to Abkhazeti in the far west – were also swallowed by Russia.

In 1817 the Georgian church was also abolished as an autocephalous entity and subordinated to the Russian patriarchate. Until the October Revolution of 1917, Georgia was referred to in Russian imperial documents as 'the (frontier) provinces.' Thus once again the country had become the boundary of a vast imperium, a crossroads between the realm of the Caesars (with which, of course, the word 'Tsar' is cognate) and the *barbari* beyond it. Indeed, Georgia's most specific purpose for the Tsar was to serve as a foothold for the Russian Empire in the Caucasus region and as the center of military action against Turkey and Persia.

Yet the annexation had certain benefits. The strong Russian presence meant an end to the continuous invasions of Georgia by the Persians and the Turks, which had reduced the population to 500,000, as well as to inroads made by Caucasian mountain tribesmen in alliance with those two powers. As on a number of occasions in antiquity and the medieval period, Georgian lands were now consolidated and historical frontiers restored. So, too, through Russia Georgia made renewed contacts with the Western world. By the middle of the century, intellectual life revived. Georgian theaters opened, museums and libraries were founded, and newspapers came into being. Young Georgians sought new educational opportunities in Russian and European universities. These developments intensified in the second half of the century, fueling a Georgian nationalist movement that coincided with the upsurge in revolutionary fervor in Russia itself. The most progressive members of the Georgian

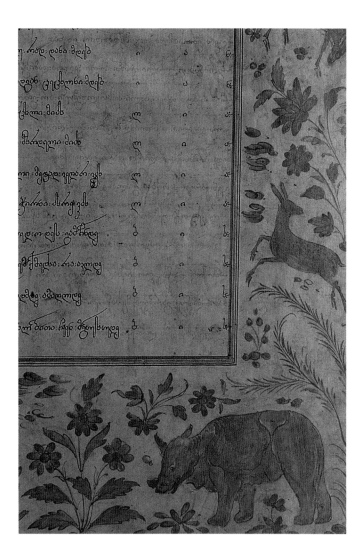

Cat no. 154 (detail) | Manuscript of
The Knight in the Panther's Skin with
Mkhedruli script and diverse flora and
fauna decoration, 1680 AD

intelligentsia began to speak of independence; others hoped merely for greater autonomy within the bounds of the Russian Empire. The most radical Georgians spoke of world revolution, thus helping to form the central body of the Russian Social Democratic Party out of which the Bolshevik Party arose. Indeed, Georgian radicals – including Joseph Stalin and others – were among the leaders of various political factions in Russia.

In the end the Russian Social Democrats ignored Georgia's demands for independence, but after the Tsarist government fell and the Russian army left the Caucasus, on May 26, 1918 Georgia was declared an independent republic by the Mensheviks. This declaration was acknowledged by the RSFSR (the Russian Soviet Republic) in concluding a peace agreement with Georgia on May 7, 1920. As historical forces once more met in Georgia as a crossroads between hope and despair, the Kremlin ultimately could not reconcile itself to the existence of an independent Georgia. Lenin's negotiations with Turkey regarding boundaries coincided with the Bolsheviks' anti-Georgian policy, and so Georgia was deprived of parts of what had long been its historical territory, which were handed over to Turkey; these areas currently remain in Turkey. Ultimately Red Army units invaded and occupied Georgia, depriving the country of its short-lived independence. And so Soviet power was established in Georgia, to last for nearly seventy years.

VIII

On October 28, 1990, in elections in the Supreme Soviet of Georgia, the Communist Party was defeated and its power brought to an end. On April 9, 1991 Georgia was declared an independent republic. History, both ancient and recent, reverberates into this new identity. Georgia is once again a frontier and a crossroads, a hub of new ventures and of new opportunities brought by the investment from a number of directions that has begun to stream into the country.

We note especially how, a century ago, the Black Sea port of Batumi was a stepping-off point in the international oil trade that flourished through pipelines connecting Baku, on the Caspian Sea, to the Black Sea, this role being reminiscent of the kind of role played by Dioscurias over two millennia ago in Black Sea/inland commerce. And today, echoing the enterprise of one hundred years ago, the Transcaucasus gas and oil pipelines are a vaster project still, with a range of foreign and domestic investors involved – a project that will carry Georgia and her neighbors into the next millennium at the head of developments, with political, economic, and military repercussions extending from the Near East to Moscow.

Opportunity and difficulty meet again at the crossroads that is Georgia. There are serious, unresolved issues for the new Republic, such as the future role of Abkhazia as

completely autonomous or not autonomous at all. But Georgians have a serious sense of their long and dramatic history, even as they celebrate the beginning of a new dynamic era. The fondness for celebration – evidenced in the patterns of hospitality for which Georgians are renowned: the groaning board of welcome, the elaborate speeches of the *tamada* (the master of the feast) as food and drink show no sign of ceasing to fill plate and glass, the week-long festivities that are the norm on the occasion of every wedding – continues alongside the seriousness with which energy and ingenuity are directed to the tasks of shaping the future so that it may match the glorious range and variety of past accomplishment.

The essays which follow celebrate that accomplishment – an extraordinary history and culture interwoven with unique customs and traditions. So, too, the physical manifestations of that accomplishment – elaborate and simple objects, unique and everyday – are themselves celebrated, while the issues offered here in introductory form are more fully explored. Indeed, if much of this introduction reflects outsiders' viewpoints, most of what follows presents Georgia from an internal perspective. The essays have been written by Georgian scholars as well as by Western scholars who have studied and lived in Georgia for decades.

In the end, the question of where such an extensive history and culture may be understood to have begun is supplanted by the question of where it will go, now that that history is once again at a takeoff point at the beginning of a new millennium.

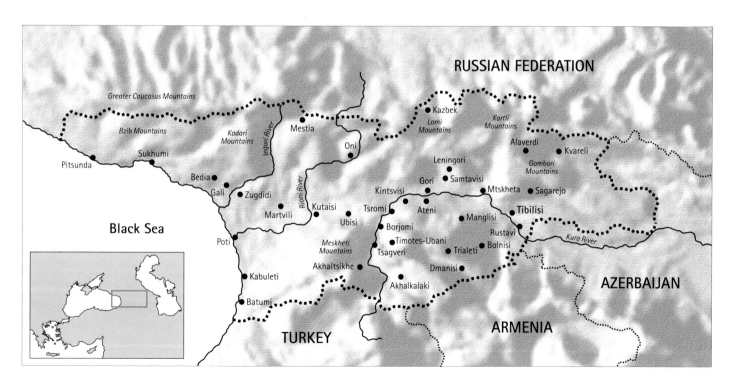

GEORGIA TODAY

2 A Brief History of Georgia

Levan Chilashvili and Nodar Lomouri

I

Georgia occupies the central and western regions of Transcaucasia – that is, the area between the Black Sea and the southern slopes of the Caucasus mountains. Its territory covers some 27,000 square miles (or nearly 70,000 square kilometres), sustaining a population of approximately 5.4 million. Ethnic Georgians comprise nearly seventy per cent of the total population.

Georgia lies at the junction of two continents, Europe and Asia, a geographical position clearly reflected in Georgian civilization, which has been influenced by Western as well as Eastern cultures. A comparatively mild climate, a fertile soil, an abundance of natural resources, and a diversity of flora and fauna created advantageous conditions for the territory to be inhabited from early in human history: the remains of *Homo erectus*, the earliest form of human being, approximately 1.6 million years old, have been found in Georgia. Archaeological excavations have provided evidence of quite extensive inhabitation from the Paleolithic era. By the Bronze Age the local population had achieved an exceptionally high level of development, which is reflected in the rich range of objects dating from all phases of that epoch. The uninterrupted continuity of culture from one period to the next suggests that the ancestry of modern-day Georgians is autochthonous: they have remained where they evolved.

The territory of the Transcaucasus had become inhabited by identifiably proto-Georgian tribes by at least the Neolithic period, in the sixth and fifth millennia BC, if not earlier. By the early second millennium BC – the middle Bronze Age – this general tribal unity had separated into three main tribal groups: the Svans, the Megrels-Chans, and the Karts.

The Svans settled in the mountains of the western Caucasus as well as in the gorges that later became the Abkhazian territory. The Megrels and Chans occupied western Georgia along the southeastern Black Sea coast. The Karts inhabited the eastern part of the Georgian territory and southwest Transcaucasia.

As the Bronze Age yielded to the Iron Age at the end of the second and the beginning of the first millennium BC, these tribal groups began to reshape themselves into strong and widespread unions. Assyrian and Urartean sources refer to the forming of unions of Diaokhi (or Daiaeni) and Kolkha in the southern provinces of the territory inhabited by the three tribal groups just mentioned. These unions already possessed certain administrative characteristics of a state. It would seem to be Kolkha (also called 'Kulka' in some sources, 'Egrisi' in Georgian texts, and 'Colchis' in classical texts) that is mentioned in the earliest versions of legends about Jason and the Argonauts.

II

There is little doubt that the shaping of formal ancient Georgian states took place in the sixth and fifth centuries BC. Colchis (Egrisi), the state of the Megrels and Chans, was created to the west of the Surami mountain range. Colchis extended along the eastern Black Sea coast, from present-day Gagra-Bichvinta to the estuary of the River Chorokhi. This was the area that the ancient Greeks called 'abundant in gold.' Later the state grew to include Svaneti (the area inhabited by the Svans) as well. Colchis minted its own silver coins, called 'Kolkhuri,' from the sixth century BC. During the same period, local urban centers took shape: Kutaisi, the capital, and Suriumi (present-day Vani), which were situated inland;

and Pazisi (present-day Poti) and Dioscurias (near Sukhumi), on the Black Sea coast. From the fifth century BC, Greeks began to settle in these coastal towns or nearby, so that many historians consider them Greek colonies. The influence of Greek culture in any case spread throughout the territory at large from these towns, although local cultural traditions remained dominant.

By contrast, the shaping of a unified state took place east of the Surami range rather later, in the fourth century BC. This was the kingdom of Kartli, called Iberia in classical sources.

In antiquity, these Georgian states enjoyed well-developed economies, with a high level of accomplishment in agriculture as well as in artistic craftsmanship. The Transcaucasian sea-trade route from the Black Sea by way of the Pazisi-Rioni and Kura-Mtkvari rivers – which, according to Greek sources, connected the Hellenistic world with the Near East and India – served as a stimulus for the exceptional prosperity of the many towns in the area.

From the second century BC onward, Georgian states became involved in the complex political events of the Near East, caused by the waning of most of the Hellenistic states and the growth of Roman political influence in Asia Minor (present-day Turkey and northern Iraq). During an extensive period beginning in 63 BC, Colchis found itself under the political control of Rome, and, after the transformation of the remnant eastern Roman Empire into the Byzantine Empire during the fourth, fifth, and sixth centuries AD, it fell under the power of Byzantium. The eastern kingdom of Iberia (Kartli) managed to retain its formal independence and offered active resistance to the Roman Empire as well as to Rome's main rivals, the empires of Parthia and Parthia's successor by the mid-third century AD, Sassanid Persia (modern-day Iran).

The early fourth century AD was an important period in the history of the Georgian states. Around the year 330 (the traditional date is 337), Christianity, which had spread throughout the area since the late first century, was declared the official religion of both Iberia (Kartli) and Colchis (Egrisi). This was a decisive event, with the greatest cultural, ideological and political implications throughout Georgia's subsequent history, in that it orientated the country toward Western civilization.

Cat. 104 | Silver Sassanian-style bowl from Mtskheta, second half of 3rd century AD

However, the fourth and fifth centuries were a difficult period for the east Georgian state of Kartli (Iberia), since it was increasingly dominated by Sassanid Persia. The Caucasian peoples at large attempted to free themselves from Sassanian domination in the late fifth century. In Kartli, King Vakhtang Gorgasali led the struggle for liberation toward the end of the fifth century and achieved significant initial success. However, ultimately he was defeated and killed in the process. It was also during Vakhtang Gorgasali's reign that the Iberian church became autocephalous; an independent eastern Georgian church was headed by its own *catholicos* from that time on, rather than answering to the patriarchs of Byzantium. However, the church in western Georgia remained subject to the Byzantine patriarch in Constantinople.

In the decade of the 520s, Sassanid Persia abolished the kingship in Iberia, absorbing the state as a province. By the end of the same century, Byzantium had also abolished the western Georgian kingdom and divided the country into two political units. The center and southern part – Lazika –

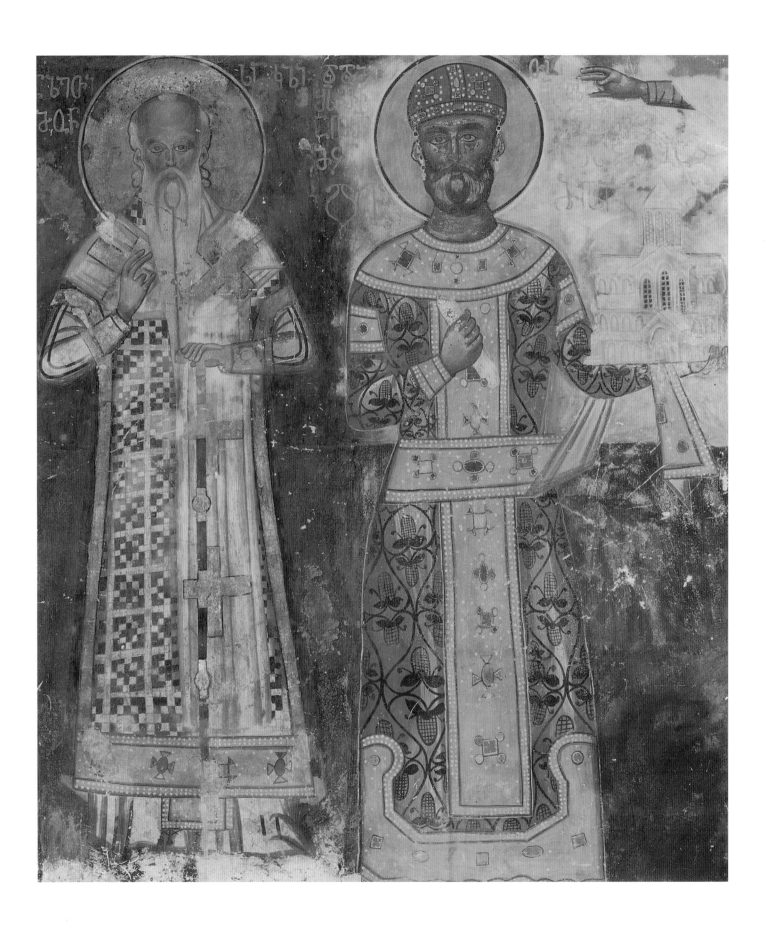

became subject to a military governor named Sittas, appointed by Emperor Justinian, and the north – Kolkheti, where the Abazgs and Apsils (i.e. the Abkhazian and the Adigian tribes) lived along with Georgian tribes – was declared the Abazg Archonate. This region is referred to as the Abkhazian Principality (or Saeristao) in Georgian sources.

Despite harsh political conditions, Georgian culture continued the development that had begun in prior periods. The creation of the Georgian alphabet and of Georgian literature should be mentioned first of all. The early patterns of the Georgian alphabet appear by the fifth century. *The Martyrdom of St Shushanik*, a hagiographic novel that is the earliest known work of Georgian literature, dates from that century (see II.1). So, too, architecture became increasingly sophisticated, and despite Byzantine influence it retains national characteristics and peculiarities (see IV.1, IV.3).

III

In the decades of the 630s and 640s a new political and religious force – the Arab Muslims – appeared on the world scene, arising from the Arabian peninsula. By the middle of the century, having destroyed the Sassanian Empire, they arrived in Transcaucasia, invading the entire area except western Georgia (Kolkheti and Abkhazia/Saeristao). Indeed, the Muslim forces were never able to overcome western Georgia or the most mountainous regions of Kartli (in central Georgia) and Kakheti (the easternmost area).

In the late eighth century, large feudal units and independent principalities were formed on the territory of present-day Georgia – for example, the principalities of Kakheti and Hereti in the eastern part of Iberia (Kartli). In far western Georgia the Abkhazian leader Leo II rose in rebellion against Byzantium. He unified all of Lazika under his banner and declared himself not a Prince of the Abkhazians but the King of the Abkhazians. Thenceforth, the entirety of western Colchis (Egrisi) was referred to as the 'Abkhazian Kingdom.' But the majority of the population was Georgian, as was its political orientation and its culture; the Abkhazian Kingdom (Abkhazeti) was in fact a Georgian state. Thus it was natural that Kutaisi, an ancient Georgian city, became its capital. Moreover, in the ninth century, the church of the Abkhazian Kingdom separated from the patriarchate in Constantinople and subordinated itself to the *catholicos* in Mtskheta – ancient political capital and at the time still spiritual capital of Kartli. Thus the churches of western and eastern Georgia were reunited.

So, too, in the early ninth century yet another independent state was formed in southwestern Georgia: the principality of Tao-Klarjeti (most of which is currently in Turkey). Tao-Klarjeti was headed by the Bagrationi family. Their leader received the title of *Curopalatus*, an honorific indicating political status equivalent to that of Byzantine prince, from the Byzantine emperor. The territory was thus referred to as the 'Georgians' Curopalate.'

In the ninth and tenth centuries, a unification of the diversely governed Georgian lands became more and more desirable. This desire was stimulated by social and economic development in the Abkhazian Kingdom and the various principalities, as well as by the cultural unity among the Georgian regions that was taking shape again during this period (see especially IV.1, IV.2). It was also impelled by the common need to oppose foreign invaders – first the Arabs, then the Seljuk Turks as well as the Byzantines. The move toward unification was initiated by the Tao-Klarjeti principality, mostly through diplomatic means. The process was very gradual, with many failures as well as successes; it resulted in the unification of the largest Georgian regions under the Bagrationi dynasty by the late tenth and early eleventh centuries.

However, the shape of a complete Georgian state was not achieved until the reign of the Bagrationi King David the Builder (1089–1125), perhaps the greatest of Georgian kings. David the Builder carried out internal reforms, laid the foundations for a serious standing army, brought opposing nobles under his strong domination, made the church subordinate to the throne, and drove out the Seljuk Turks with a succession of military victories. Thus he began the process of creating a substantial Transcaucasian state under Georgian leadership.

Detail from wall-paintings on interior of Gelati monastery complex, 1120–30 AD: King David the Builder

During the reign of King David's descendants – Giorgi III (1156–84), Tamar (1184–1213), and Lasha Giorgi (1213–22) – the Georgian state comprised the entire Transcaucasian territory between the Black and Caspian Seas, including Armenian lands as well as Shirvan (present-day Azerbaijan). The remaining Armenian regions, together with the Caucasian mountain tribes (the Chechen-Adigians, Cherkezians, Osetians, Dagestanians, and others) and a number of Turkish regions, were obliged to pay tribute as vassals of the Georgian kings.

The period from the late eleventh to the early thirteenth century is called the 'Golden Age' of Georgian history, during which all areas of the economy achieved their highest level of pre-twentieth-century development and urban life expanded significantly as old cities were rebuilt and new ones founded. Trade, internal as well as external, grew dramatically. During this era Georgia maintained close trade contacts with Arabia, Byzantium, Persia (Iran), Egypt, Russia, and even China, and, moreover, functioned as a Christian frontier in the struggle with the Muslim world during the Crusades.

In addition, the period saw enormous cultural developments – in religious and secular literature, theology and philosophy, architecture, wall-painting, and the manufacture of superb goldwork. Centers of higher learning – for example the Academies of Gelati and Ikalto – were established. A humanistic outlook underlies much of the Georgian literature of that period. This is above all reflected in the epic poem *The Knight in the Panther's Skin* by Shota Rustaveli, which is the greatest monument of Georgian literature of the Golden Age, the crown of medieval culture and the beginning of Renaissance thinking in Georgia (see II.3).

IV

The Golden Age did not last long. In the 1240s the country was invaded from the east by the Mongols. In the late fourteenth century Tamerlane raided it from the same direction. During the following centuries, Georgia was subject to constant invasions by the Seljuk Turks and the Safavid Persians (from modern-day Iran). In the second part of the fifteenth century the united Georgian state was divided into three kingdoms: Kartli in the central west, Kakheti in the east, and Imereti in the west. The former Tao-Klarjeti in the southwest (by then called Samtskhe) was invaded by the Ottoman Turks in the sixteenth century. Georgian kingdoms and principalities fought against one another even as one invasion from the outside was followed by another. Moreover, the country was continuously raided by pillaging mountain tribes from the Caucasus. All these elements combined to yield a decline in the economy and a drastic reduction in the population.

The situation worsened to the point that, by the late eighteenth century, the fragmented Georgian states could no longer survive independently. It was necessary to find a strong ally – a protector. At that time only Russia, a large country with virtually the same religion (and its own ambitions in the Caucasus and Transcaucasus), seemed suited to such a role. In 1783 an agreement was signed with Russia at Georgievsk, a fortress in the northern Caucasus, by King Heraclius II, representing all of Georgia. According to the Georgievsk Agreement (or *Traktat* as it is called in both Georgian and Russian), Russia assumed an obligation to defend Georgia against foreign invaders. However, Georgian royalty remained in charge of the country's internal affairs. But the close Russian contact led, in 1801, to a decree by Tsar Paul I that violated the terms of the Georgievsk Agreement: a large part of Georgian territory (the eastern part) was annexed by Russia. Gradually, one by one, the remaining Georgian kingdoms and principalities became subordinate to Russia. Georgia became part of the Tsarist Russian Empire.

Georgia as an independent state, having struggled for so many centuries to achieve and maintain that independence, no longer existed. But becoming part of Russia had some positive consequences. Most fundamentally, it prevented physical annihilation. Moreover, it again impelled the unification of the Georgian nation. As a result of Russian military successes against Ottoman Turkey, Samtskhe and later Ajara, taken by Turkey in the sixteenth century, were once again joined to Georgia. Further, through Russia Georgia re-established contacts with European countries that had essentially lapsed after the Crusades. By the 1860s, emerging Russian democratic cultural ideas had a positive effect on Georgian culture. Varied cultural traditions revived. Georgian-language theaters, museums, and newspapers were founded. Access to Russian and European universities opened up for young Georgians.

Oil painting by Tsimakuridze, c.1930: King Heraclius II receives Jewish leaders offering their services in the struggle against the Persians (c.1780)

In spite of such positive developments, union with Russia also brought great danger. Georgia became part of the empire's colonial system, which meant active measures to Russify non-Russian peoples. Constant efforts were made to eradicate the Georgian language; Georgian customs and traditions, and everything else Georgian, were systematically banned. The first obvious measure in this direction was the abolition of the autocephalous Georgian church, which was subordinated to the Russian patriarchate in 1817. Religious services were thenceforth conducted in Russian. Moreover, the Russian government sought to involve church officials in measures aimed at the Russification of the people. So, too, Russian officials began intensive attempts to incite other nationalities living in Georgia against Georgians.

V

But the attempts to Russify Georgia backfired. Instead of eradicating the Georgian language and culture, they awakened the region's weakened sense of national identity,

unifying it and saving it from eradication. The national liberation movement became particularly active and successful in the 1860s, simultaneously with cultural democratic ideas when Ilya Chavchavadze (1837–1907) achieved prominence as a leader. A great writer and public figure, Chavchavadze is widely acknowledged by Georgians as the spiritual father of their modern nationalist sensibilities. Thanks to his efforts and those of his colleagues, the nation retained both its national identity and its thirst for freedom; by the time the October socialist revolution took place in Russia in 1917, Georgia was ready to demand independence. Thus on May 26, 1918 the National Council declared Georgia an independent republic, and on May 7, 1920 Soviet Russia recognized Georgian independence. However, in early 1921 the Red Army invaded Georgian territory and took control of the country. Ironically enough, this act was organized by Georgians within the Russian Bolshevik party: Joseph Stalin and Sergo Orjonikidze. On February 25, 1921 Georgia was declared a Soviet republic.

In the early years of Soviet power the Georgian people made several attempts to regain independence, but all of these were drowned in blood. A repressive dictatorship was established in Georgia as it was throughout the Soviet Union. Despite some positive aspects of the arrangement, the country was seriously damaged by collectivization and industrialization – but most of all by constant and numerous reprisals against its early efforts to regain independence. In particular, Stalin's ruthless purge of 1936–8 caused irremediable damage to intellectual discourse, cultural creativity, and progressive nationalist thinking.

About 300,000 Georgians died during World War II. The inner potential of the nation seemed to be broken. However, the invisible struggle went on, nationalist feelings were not completely suppressed, and as soon as favorable conditions were created with the dismantling of the Soviet regime, Georgia gained its independence once again. On April 9, 1991 Georgia was declared an independent republic. Unfortunately, the newly restored republic had to undergo numerous hardships, including shortages of energy and staples as well as damage to the physical infrastructure of its cities. But since the spring of 1992 the country has gradually calmed down and begun to organize its independent life. On August 24, 1995 a new constitution was adopted, and in the same year a new parliament and president were elected. At present Eduard Shevardnadze, an internationally recognized statesman, is president. Georgia is a member of the United Nations, with ambassadorial representation in China, France, Germany, Great Britain, Iran, Israel, Russia, Spain, Turkey, Ukraine, the United States, and other nations around the world.

Georgia Through the Ages: Changing Names and Borders

	West	East
Achaemenid-Roman periods:	Egrisi or Kolkheti (Georgian version of Greek *Colchis*)	Kartli or Iberia*
In classical sources of that era:	Colchis* [or Lazica or Kolkheti]	Iberia*
In later Roman sources:	Colchis* or Lazica [or Egrisi or Kolkheti]	Iberia* or Kartli
In the early Medieval period: (6th–10th centuries)	At the beginning of this period, Egrisi or Lazica; later, Abkhazeti	Kartli Kakheti and Hereti were the eastern parts of Kartli Tao-Klarjeti was Kartli's southwestern part
10th through mid-15th century:	Unified Sakartvelo, which also included Samtskhe in the south**	
Second half of 15th through 19th century:	Imereti	Kartli (central) Kakheti (east) Tao-Klarjeti and Samtskhe (south and southwest, which became part of Turkey)

* This name was used in Greek and Roman sources
** The United Georgia also existed several times during Classical and early Medieval periods
NB: Further detail regarding the historical provinces of medieval Georgia may be found on the maps.

Chronology of Key Events

1.6 million years ago	Settlement of *Homo erectus* in the Caucasus
7th–4th millennium BC	First agricultural settlements in Georgia
4th 3rd millennium BC	Kura Araxian culture (early Bronze Age)
24th–15th century BC	Kurgan (burial mounds) culture
20th–16th century BC	Trialeti culture (middle Bronze Age)
14th–7th century BC	Kolchetian culture (late Bronze Age, early Iron Age)
	Georgian tribes referred to in Assyrian texts as *mushkis*, *tubals* and *kaskis*
13th–8th century BC	Diaochi kingdom (southern Georgia)
11th–8th century BC	Kulchas kingdom (southern Georgia)
8th century BC	Mention of Jason and Medea in Hesiod's *Theogony*: earliest mention of the River Phasis
7th–6th century BC	Expansion of Scythians in the Caucasus
6th–1st century BC	Appearance of kingdom of Egrisi (western Georgia, called 'Colchis' by the Greeks)
	Greek and Achaemenid Persian influence
401–400 BC	Mention of Georgian tribes in *Anabasis* by the Greek author Xenophon
Early 3rd century BC	Founding of kingdom of Kartli (eastern Georgia, called 'Iberia' by the Greeks and Romans) by Parnavaz
	Putative creation of Georgian writing system
Mid-3rd century BC	Apollonios of Rhodes tells story of the Argonauts in his *Argonautica*; they sail to Colchis, under the leadership of Jason, to find the Golden Fleece
65–63 BC	Conquest of Iberia and Colchis by Pompey the Great; the two kingdoms become Roman protectorates
63 BC	Kingdoms of Pontus (northeastern Turkey) and Colchis become Roman provinces; Iberia remains independent under the protection of Rome
131 AD	Description of Colchian towns and fortresses by Arrian (Apsar, Phasis, Dioskurisa, Pitiunt)
298 AD	Nizibin Treaty with Sassanid Persia; Rome prevents the consolidation of Colchis and Iberia
325 AD	Council of Bishops at Nicaea includes the participation of Stratophilos, bishop of Pitiunt (Pitsunda, now called Bishvinta) on the northeastern coast of Abkhazeti
337 AD	Christianity proclaimed the state religion of Iberia
370(?) AD	Sassanid Persia conquers Iberia
	First mention of Tbilisi
433 AD	Foundation of Bir-El-Kut's Georgian Abbey in Palestine
Second half of 5th century AD	Life and reign of King Vakhtang Gorgasali (447–522)
	By this time a Georgian writing system has certainly been developed
	The Martyrdom of St Shushanic written by Jacob Khutsesi
Beginning of 6th century AD	Capital of Iberia transferred from Mtskheta to Tbilisi
523 AD	Persia conquers Iberia and abolishes the kingdom
	Struggle between Persia and Byzantium for the territory of western Georgia
561–? AD	Reign of King Parsman VI
	Georgian church becomes autocephalous
571 AD	General revolt against Sassanid Persia
608–9 AD	Third Council of Duin; schism between Georgian and Armenian churches

622–8 AD	Campaigns of Byzantine emperor Heraclius against Georgia
642–3 AD	First invasion by Muslims
First half of 8th century AD	Establishment of Muslim emirate in Kartli
746 AD	Consolidation of western Georgia by Leo I
813 AD	Ashot I 'the Great' seizes political power in neo-Kartli (southwestern Georgia) for the Bagratid house
950–1001 AD	Reign of David II Kurapalatos; consolidation of Sakartvelo (Georgia)
975–1014 AD	Reign of Bagrat III
1014–27 AD	Reign of George I
1027–72 AD	Reign of Bagrat IV; escalating difficulties with both Byzantines and Seljuks
1072–89 AD	Under George II, tribute paid to the Seljuk Sultan
1089 AD	George II abdicates in favor of his sixteen-year-old son, David IV Agmashenebeli – 'The Builder'
1103 AD	Ruisi-Urbnisi Church Council (strengthening of royal power)
	General reforms in the army
1121 AD (Aug 12)	King David the Builder defeats Islamic coalition in the Battle of Didgori
	End of Muslim domination
1125–54 AD	Reign of Demetre I
1184–1213 AD	Reign of Queen Tamar
1195 AD	Victory of Tamar over Seljuks at Shamkhor
End of 12th century AD	Shota Rustaveli writes his epic poem *The Knight in the Panther's Skin*
1205 AD	Victory of Tamar over Seljuks at Basiani
1210–11 AD	Campaign of Tamar against Persia (Iran)
1226 AD	Conquest of Tbilisi by Horezm Sultan Jalal Ed-Din
1236 AD	Conquest of eastern Georgia by the Mongols
1314–4(?) AD	Reign of George V, 'the Excellent'
	Rebirth of Georgia, reconstruction of its independence and unification
1386–1405 AD	Invasions of Tamerlane
1412–43 AD	Rebirth of unified Georgia during the reign of Alexander I, 'the Great'
1466–84 AD	Disintegration of the Georgian kingdom
1614–16 AD	Destruction of eastern Georgia by Shah Abbas I
1629 AD	First Georgian book printed in Italy
1783 (July 12) AD	Georgievsk Treaty: eastern Georgia (Kartli) becomes a protectorate of Russia
1795 AD	Invasion by Agha Muhammad Khan; Battle of Krtsansi – destruction of Tbilisi
1801 AD (Sept 12)	Manifesto by Tsar Alexander I regarding the abolition of the Kartli-Kakheti kingdom and beginning of its annexation by Russia
1804–11 AD	[Failed] revolt against Russian rule
1817 AD	Subsuming of the Georgian Orthodox church into the Russian Orthodox church
1832 AD	Plot against Russian rule, attempts to restore Georgian monarchy
1852 (May 12) AD	First museum founded in Tbilisi: the Caucasian Museum – first scholarly center in the Caucasus
1870 AD	The first railway line opens in Georgia and Transcaucasia from Tbilisi to Poti
1918 AD (Feb 8)	Founding of Tbilisi University
1918 (May 26)	Declaration of independent Georgia
1921 AD (Feb)	Annexation of independent Republic of Georgia by Bolshevik Russia
	Establishment of Soviet power in Georgia
1941 AD	Foundation of Georgian Academy of Sciences
1990 AD (Oct 28)	Multi-party elections held; defeat of Communist regime in Georgia
1991 AD (April 9)	Restoration of the Republic of Georgia by the Supreme Council of Georgia

II

GEORGIAN LANGUAGE
AND LITERATURE

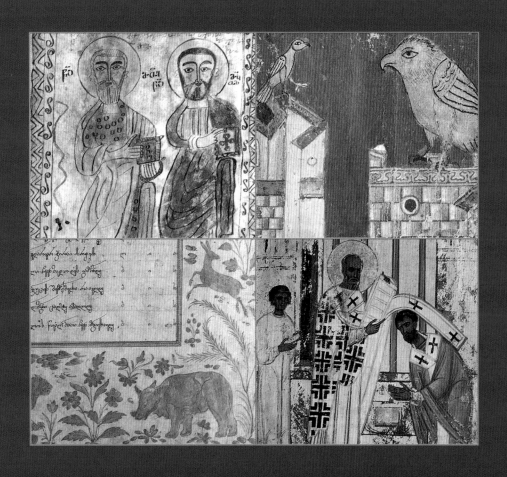

1 The Georgian Linguistic and Literary Heritage

Michel van Esbroeck, SJ

Georgian is not an Indo-European language, nor is it Semitic or Touranian (Turkic). It belongs to the Caucasian language group, which encompasses approximately 80 languages spread to the north and the south of the Caucasus mountains, which extend from the Crimea in southern Ukraine to Baku, Azerbaijan, on the Caspian Sea.

The Caucasian language family includes four distinct linguistic groups. Chechnian, the language of the fiercely nationalist Republic of Chechnya, belongs to the north central group, as do Inguchian and Batish; the northwest (along the northeast Black Sea coast) comprises the Cherkessian group; the east includes the languages of Dagestan, already well-known in antiquity for its approximately forty different languages. Finally there is the southwestern group, in which Georgian is included (the only language among all of these to possess its own script), dating from late antiquity.

Georgian – or Kartlian as its speakers call it – is the language of Kartli, the country's east central region. The language has an ancient literature, much of which is focused on Christian religious subjects. This written tradition begins in the fifth century and continuously reshapes itself right up to the eve of the Communist revolution of 1917. Georgia also offers a tradition of secular literature which begins during the mid-medieval period – in the eleventh century – and is strongly influenced by the neo-Persian language of its neighbors (and more than occasional conquerors) to the southeast. Modern Georgian literature began in the nineteenth century, and presents numerous parallels with western literature. Journals, specialized linguistic institutes, and works of synthesis began to appear in the 1860s in great quantity, focused on history, literature, science, and art.

Georgian religious literature offers all the genres familiar from the literature of the Greek Orthodox church: translations of and commentaries on scripture, homilies taking up the words of the Fathers of the Church, religious offices, lives of the saints, treatises on monasticism, and collections of hymns. The Georgian church has preserved many texts older than the oldest surviving Greek Orthodox works; of particular note are those connected to traditions in Jerusalem from the fifth to the tenth centuries. From the eleventh century onward, the Georgians began to translate the lion's share of what is found in the Greek tradition, most of which is still accessible in Greek and thus makes for interesting comparative study.

Besides such texts, Georgian religious literature contains about thirty historical works written without Greek models, of which the oldest is *The Martyrdom of Saint Shushanik*, from the end of the fifth century. This is the story of an Armenian noblewoman who was married to a governor of the province of Gougarketi, in a region that was an ethnic and religious mix of Armenians and Georgians. The governor (Shushanik's husband) became a Zoroastrian in order to conform to the religious/political conditions promoted by the Persian Shah. Shushanik herself resisted conversion in the name of her Christian faith, which resulted in her complete isolation and ultimate martyrdom around the year 475 (the precise date is disputed).

But the Georgian literary tradition is not only about writing – it is also about rewriting. The *Kartlis Tskhovreba* or *The Life of Georgia* comprises the annals of the country and has appeared in several redactions, which were constantly reworked; properly to interpret its diverse elements, one requires a profound knowledge of Byzantine and Sassanid

Persian politics. The story of the conversion of Georgia by St Nino was reworked at least four times between the fourth and the eighth centuries in the interests of religio-political necessity. In the sixteenth to eighteenth centuries, the genre of religious literature yields increasingly to didactic poetry. Georgian religious traditions were continually rewritten, right up to the pocket editions of *Lives of the Saints of the Georgian Liturgical Year*, published just before 1917. About 15,000 early manuscripts have been preserved: extraordinarily high for a population of some five million Georgian speakers.

Georgian medieval secular literature culminates in the twelfth century with the epic poem by Shota Rustaveli, *The Knight in the Panther's Skin*, the broad cadences and epic sweep reflecting much older poetic traditions. There is no truly comparable work anywhere (see II.3). The *Visramiani*, by Sargis of Tmogvi, tells of the courtly love of Vis and Ramin, a theme adapted from Parthian-era Persian literature (specifically, Nizami's *Loves of Khosrau and Shireen*). Medieval redactions of adventure stories about Amirani, the Georgian equivalent of Prometheus (but in some respects more like Heracles), are credited to Moses Khoneli. The *Shah Nameh* (*The Book of Kings*, the Persian national epic), by the late tenth-/early eleventh-century poet Firdausi, also has an early medieval Georgian equivalent. Finally, *Kalila and Dimnah*, the Arabic version of the Hindu *Pancatatra* (a book of ethical fables), was already translated into Georgian by the eleventh century.

Contemporary prose begins with Ilya Chavchavadze (born in 1837), author of many realist novels and short works. Chavchavadze virtually created the modern Georgian language, founding its first periodical, *Moambus*, as well as its first daily, *Iveria*. Murdered in 1907 at the age of 70, he was canonized as Elias II. A whole school of romance-writers and poets followed him. One of the most celebrated of these is the late nineteenth-century Vazha Pshavela, whose real name was Lucas Razikashvili. Under his real name this poet contributed to the gathering and writing down of ancient Georgian folk-tales, as the Brothers Grimm did in Germany. His subsequent poetic output inspired translation into Russian by Pasternak, author of *Dr Zhivago*. Other writers to be mentioned are the patriotic poet Akaki Tsereteli (1840–1915) and the story-writer Alexander Qazbegi (1848–93),

whose scintillating tales capture the lives of mountain Georgians. The Soviet regime could not destroy Georgian national identity: among the romantic nationalist writers one notes, for example, Mikhail Dzhavakhishvili, whose writing was heavily influenced by Balzac; he perished during the Stalinist purges of 1937.

Systematic study of Georgian literature has been the work of Cornelius Kekelidze, whose writings have been issued in thirteen volumes; he is the author of a four-volume literary history. The broadly focused culturological writings of Ivan Dzhavakhishvili, founder of Tbilisi University, were recently reissued in a twelve-volume edition. The works of Ilya Abuladze, which encompass parallels between Georgian and a number of Near Eastern literatures, are also important. The prolific Helen Metreveli, former director of the Institute of Manuscripts in Tbilisi, has revolutionized the study of the colophons of medieval manuscripts with her work on Georgian documents. Levan Menabde has led research into the far-flung 'Scriptoria Georgiana,' from which so many Georgian manuscripts have emerged in monasteries in a range of places outside Georgia, such as Jerusalem, Black Mountain in Syria, and Mount Athos in Greece (see II.2). In the study of palimpsests, Lamara Khadzaia has produced an exemplary edition of New Testament folios in a manuscript dating from at least the sixth century .

In linguistics, Tamaz Gamkrelidze has examined the affinities between Indo-European languages and Georgian. The Institute of Linguistics in Tbilisi has also produced nearly thirty complete descriptive studies of the many languages of Dagestan. Vakhtang Beridze has carried out extensive research on the many churches, often in ruins, found throughout Georgia, whose style has retained distinctive Georgian attributes through the centuries. The study of frescoes and other kinds of painting has also been vigorously pursued. Gudiashvili's writings on Picasso carry the relationship between word and image into the twentieth century. Finally, Georgian folksongs possess their own characteristic polyphony, which musicologists are still seeking to situate within the framework of world music.

Overall, contemporary Georgian cultural scholarship is part of the continuum of language and literature that has reinvented itself through the centuries since antiquity.

2 Georgian Manuscripts and Cultural and Educational Centers

Lamara Kajaia

The Georgian manuscript tradition has a fifteen-hundred-year history – from the fifth to the nineteenth century – of focus on both ecclesiastical and secular subjects, a focus including all areas of inquiry that were of interest to the medieval mind: textual study, theology, philosophy, philology, linguistics, history, art, astrology, medicine, natural history, law, chemistry, mathematics, geometry, and physics.

The oldest manuscripts have survived in the form of palimpsests, with erased earlier writings that are still faintly legible beneath later works. From the fifth to the eighth centuries, these offer passages from the Old and New Testaments as well as stories of the Apostles, collected liturgical and homiletic works, and apocryphal works such as the *Martyrdom of St Christine, St Kviprian* and *St Justina*, and *Jacob's Protoevangelium*. The study of these texts during the last hundred years has made it apparent that during this early period Georgians were already engaged in very productive cultural and literary activity. Indeed, they not only translated literature from other languages but created original works; these included accounts of the martyrdoms of the Georgian saints Shushanik (written in 476–83), Evstathi Mtskheteli (written in the sixth century), and Abo Tbileli (written in the eighth century).

Manuscripts that have survived from this early period also offer information about the development of the monasteries in which they were created or copied. Thus in the sixth century, thirteen Church Fathers from Syria founded a range of monasteries in Georgia, including Shiomghvime, David Gareji and others (see IV.4, IV.5). These centers eventually produced texts such as *The Life of Grigol Khandzteli*, containing a description of the late eighth-/early ninth-century monastery construction at Tao-Klarjeti in south Georgia,

and *The Life of Seraphion Zarzmeli*, containing a description of the ninth- and tenth-century monastery construction in Samtskhe, just north of Tao-Klarjeti. Conversely, a number of important manuscripts transcribed in monasteries such as Opiza, Shatberdi, Oshki, and Parkhali include descriptions of these monasteries' construction.

Among the important works from Shatberdi is a compendium dating from 973–6 which includes translations of theological works (from Greek) by Gregory of Nyssa, Epiphanios of Cyprus, and Ipolitos Romanos, together with original Georgian works such as *The Life of St Nino* and *The Conversion of Kartli*. Between the years 978 and 988, a monk at Shatberdi named Michael Modrekili produced a masterpiece of Georgian ecclesiastical poetry, a hymnal that includes both original and translated lyrics, accompanied by musical notations. Musical notation has also survived in the collected works of Hirmos and Troparios of Deipara, dating from the late tenth and early eleventh centuries. All these works are important sources for the the study of the history of both Georgian and non-Georgian music.

In the treasury of the Institute of Manuscripts in Tbilisi is a range of ecclesiastical works gathered from monasteries within and outside Georgia, translated into Georgian from other languages by such outstanding authors as Gregory of Nazianzeni, Basil the Great, John Chrysostom, John Sinaites, and Maximus the Confessor. In turn, the copyists themselves became well known for the quality of their work: Eptvime and George Mtatsmindelis, Gregory Oshkeli, Ephrem Mtsire, Arsen Ikaltoeli, and others.

One of the oldest original secular Georgian works at the Institute is an astrological treatise with the Twelve Signs of the Zodiac, written between 1188 and 1210; there is also an

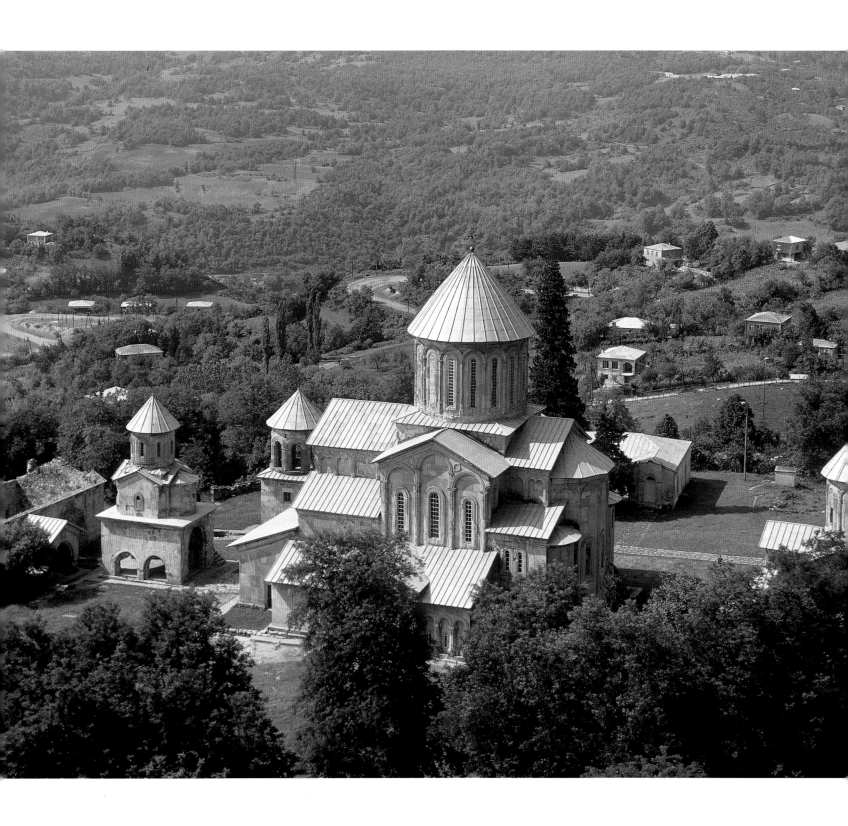

Gelati monastery complex
outside Kutaisi, begun by
David the Builder, 1120–1130 AD

astrological calendar of 1233, executed by a monk named Abuserisdze Tbeli. Numerous philosophical works are preserved at the Institute, including John of Damascus's twelfth-century *A Source of Knowledge* and the thirteenth-century *Dialectics*, translated by Ephrem Mtsire and Arsen Ikaltoeli, both monks at the Georgian monastery complex on Black Mountain, Syria. Arsen Ikaltoeli also translated the late eleventh-/early twelfth-century *Dogmaticon*, and a twelfth-century collection of works by the so-called Pseudo-Dionysius the Areopagite, with commentaries by Maximus the Confessor and Herman of Constantinople, was translated by Ephrem Mtsire. Perhaps the most important historiographical work in the Institute's collections is the com pendium gathered and edited by Leonti Mroveli in the second half of the eleventh century under the title *The Life of Georgia* (see IV.1). Some fifteen separate manuscript copies of this work exist. Also of note are a thirteenth-century copy of the first-century historian Josephus's *Judaean Wars* and

his *Antiquities of the Jews*, translated from Greek, as well as the *Chronograph* of Giorgi Amartol.

Not surprisingly, there are about a hundred manuscripts of Shota Rustaveli's twelfth-century epic *The Knight in the Panther's Skin* (see II.3) in the Institute's collections. There are also numerous manuscripts of other noteworthy medieval Georgian literary works, such as *Amirandarejaniani*, Chakhrukhadze's *Tamariani*, and the *Visramiani* (see II.1).

Important historical documents housed at the Institute include charters such as that granted by Queen Tamar to the Gelati monastery in 1187 and three charters granted to the Shiomghvime monastery: one by King Bagrat IV dated 1058, one by King Giorgi dated 1170, and one by Queen Tamar's vizier (her *mandaturtikhutsesi*) Chiaber, granted with royal approval in 1189.

A number of important Georgian manuscripts are located in museums and libraries elsewhere in Georgia, and abroad in Russia, France, England, Italy, Austria, Germany, Poland,

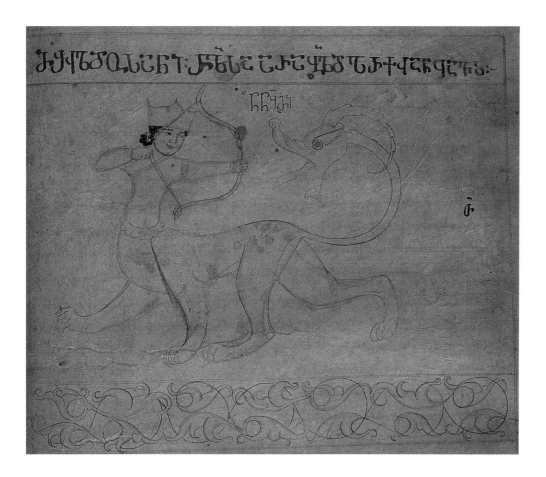

Cat. 126 (detail) | Astrological Treatise, 1188–1210 AD, exhibiting Persian influence

Czechoslovakia, and the United States. This recalls the fact that much of Georgian manuscript production developed outside Georgia – in Palestine and Syria, on Mount Sinai, on Mount Athos in Greece, in Constantinople (now Istanbul), at the Petritsoni Monastery in Bulgaria, and elsewhere (see II.2 and IV.1). The first Georgian monastic colonies abroad began in Palestine, perhaps since the first missionaries to Georgia came directly from there and, given the ongoing devotion to Palestine by Georgians, the first Christian Georgian cultural centers were logically located there.

The earliest foreign site for manuscript production in the Georgian language is considered to be the Sabatsminda monastery in Jerusalem. Among the masterpieces created there, the oldest is an eighth-century work – the *Ladgari* (*Tropologion*) – recopied in the tenth century. It reveals some of the early medieval eastern Orthodox liturgical customs in Jerusalem and is significant in offering a glimpse into early Byzantine literature which is otherwise lost today. An edition of the *Gospels* in Georgian was also prepared at Sabatsminda, as was the first dated collection of Georgian homiletic works (864).

In the second half of the tenth century, the Georgians at Sabatsminda moved to the area of Mount Sinai on the southern Sinai peninsula, taking with them not only the traditions of their monastery, but the manuscripts written and rewritten there as well. In their new home they continued their intensive and extensive literary activity. As the Belgian scholar G. Garitte has observed, this 'collection of Georgian manuscripts sheds light not only on the early history of Georgian writing, but also on the Bible, as well as Greek patristics and Byzantine philology … it carries beyond the limits of Georgian philology.'

A Georgian monastery was also founded on Mount Athos between 980 and 983 by John Mtatsmindeli and Tornike Eristavi. In 979 Tornike led the Georgian army that defeated the rebel leader Bardas Skleros, thereby saving the Byzantine Empire from destruction (see IV.1). Tornike was richly rewarded by the emperor, and he used part of that reward to build the monastery on Mount Athos, which would ultimately become the strongest cultural and creative colony of Georgians outside their own country. In the late tenth and early eleventh centuries, a number of outstanding Georgian thinkers gathered there with the goal of making the wisdom contained in Byzantine manuscripts accessible to their compatriots. There was hardly a significant Christian work that was not translated from Greek into Georgian at the Mount Athos 'school' by the masters Eptvime and George Mtatsmindelis and their colleagues and students. Besides the translations carried out on Mount Athos, the collection there includes manuscripts written at the Oshki monastery in south Georgia as gifts for the Mount Athos monastery. These include a collection of maxims dating from 977, a Bible copied into Georgian in 978 (the *Oshki Bible*), and a *Life of John Chrysostom*. Their colophons, in explaining why these manuscripts were being given as gifts, offer information about the family history of Tornike Eristavi, his victory over rebel forces, and the founding of the Mount Athos monastery.

A new monastery was established in the eleventh century in Jerusalem. Called the Jvari ('The Cross'; see IV.3 regarding the church of the same name in Georgia itself), it was founded by Georgi Prokhore Shavteli. For centuries it was a center for Georgian scholarship. The most important members of the Georgian colony in Jerusalem congregated there, continuing the tradition begun elsewhere in Palestine and on Mount Athos. Thus copies and translations of biblical texts into Georgian were done at Jvari – and are still housed there – as well as copies of manuscripts done by Eptvime and George Mtatsmindelis on Mount Athos and also by Ephrem Mtsire. An important example of these is the single extant manuscript of *The Life of Gregory Khandzteli*, founder of a monastery complex in Tao-Klarjeti. Other works executed at Jvari have ended up elsewhere; for example, a version of *The Lives of the Palestinian Church Fathers* is now in the British Museum. And the Khanmeti texts, the palimpsests of which are among the oldest written Georgian documents, were rewritten at the Jvari monastery, but they are now in the Institute of Manuscripts in Tbilisi and the National Library in Vienna, Austria. Much of the remainder of the enormous Jvari library is now housed at the Greek Patriarchal Library in Jerusalem.

Another important Georgian monastery founded in the eleventh century is the one in the village of Petritsoni (now Bachkovo) in Bulgaria. This monastery was established in 1083 by Gregory Bakurianidze, a high-ranking official in the

Manuscript recounting the *Life of St John Chrysostom*, written in Nuskhuri script, 10th century AD

monks were gradually pushed out of the site in favor of Byzantine Greeks.

The Gelati monastery in western Georgia, however, is considered the successor to the traditions of the Petritsoni school. Founded by King David the Builder (1089–1125) in the early twelfth century, the Gelati monastery became not only a center of manuscript-copying, but an important academy of broad educational principles and a center for philosophy and theology. The well-known Georgian philosophers Arsen Ikaltoeli and John Petritsi taught there. An enthusiastic medieval chronicler refers to Gelati as 'the second Jerusalem' and 'the new Athens,' comparing it with the then-renowned Mangana Academy in Byzantium. Important works were written or translated into Georgian there, such as *The Great Law of Justice* by Ikaltoeli and *The Elements of Theology* of Proclus Diadochus, with original commentaries and explanations by John Petritsi. Written in the twelfth and thirteenth centuries, they still survive, as do Georgian translations of the works of John Xiphilinus. The works of Xiphilinus have been lost in their Greek original, surviving only in Georgian.

International interest in ancient and medieval Georgian texts continues to grow, and the circle of Kartvelologists – scholars studying Georgian culture – continues to widen. This is not only because of new interest in Georgia itself, but because Georgian texts offer information regarding aspects of the Byzantine Christian world that have otherwise disappeared, thus offering a double significance for the world of scholarship.

western part of the Byzantine Empire. Besides founding the monastery, Gregory himself compiled a *Typicon* in Georgian and Greek.

Unfortunately, only two manuscripts from the Petritsoni monastery's collection have survived. One is a collection of liturgical works, dating from the fourteenth century, housed at the Institute. The second is the *Petritsoni Typicon*, which, currently preserved in Greece, in the Korais Library on the island of Chios, is a thirteenth-century copy of the long-lost eleventh-century original by Gregory Bakurianisdze. There is also a nineteenth-century copy of that work in the Bulgarian National Library in Sofia. Other manuscripts executed at Petritsoni have been lost, as the Georgian

3 Rustaveli and the Epic Tradition

Ori Z. Soltes

Epic poetry is poetry that focuses on the actions of a hero. Many cultures are defined by such a tale, whose story often captures what the culture values most. Thus the Greek heroes Achilles and Odysseus, for example, embody outstanding individual accomplishment at nearly any cost (a consistent Greek trait) whereas their Roman counterpart, Aeneas, consistently represents the obligation to subsume individual need into that of the group (an ultimate Roman value). Rustaveli's *The Knight in the Panther's Skin* both expresses Georgian values and offers a heroic adventure that fits comfortably into the epic patterns of world literature.

Epic heroes tend to have one particular trait in common: a connection with forces beyond the human. Heroes stand, as it were, with one foot in the human realm and the other in the divine. Thus at the heart of the *Mahabharata* the hero Arjuna is assisted by the god Krishna in the battle that is the action centerpiece of the great Hindu epic. In the *Iliad* and the *Odyssey*, respectively, Achilles' accomplishments are in part the result of his semi-divine parentage – his mother is a sea goddess – while Odysseus's successes are in part made possible by the continuous assistance that he receives from the goddess Athena. In the *Aeneid*, in turn, one is not surprised that a divine parent, Venus, assists Aeneas in his struggle to find a new home for his people.

The medieval Anglo-Saxon hero Beowulf is able to do battle with and destroy the monsters Grendel and his mother, even in the depths of the lake where their lair is found, after they have carried off and devoured ordinary men; Siegfried walks unharmed through a wall of fire to claim Brunhild in the Germanic *Nibelungenlied*; the medieval French hero Roland (with a warrior archbishop at his side) and his men hold off the Muslim enemy although greatly outnumbered,

withstanding five successive onslaughts before finally succumbing. All these figures have the strength and the skill that others lack; they are idealized extensions of what others wish they (we) could be. The same is true of Dante's alter ego, endowed by the poet with extraordinary intellect and spiritual passion – and the good fortune that the deceased Roman poet, Virgil, author of the *Aeneid*, was sent by the Mother of Mercy to guide him into the *Inferno* and through the *Purgatorio* to the *Paradiso* and back.

Dante's journey emulates the journey of Aeneas into the underworld, which in turn echoes Odysseus's arrival at the outer edge of reality, where he finds an entrance to the underworld. That adventure into another reality – beyond the realm of the everyday, the familiar, the safely circumscribed in time and space – is part of the epic tradition that, in Western and Near Eastern literature, may be said to begin with the journey of the Mesopotamian hero Gilgamesh to the underworld to find the flower of immortality. Structurally, that journey is also taken by Moses when he ventures to the edge of the wilderness while a shepherd in Midian, where he encounters a bush that defies the norms of our reality. This sets in motion a yet larger adventure, in which, ascending toward the Other on Mount Sinai, he plucks the flower of spiritual immortality – the Ten Commandments – and brings it back to the ordinary people who await him below in everyday reality.

Into this rich and diverse tradition Shota Rustaveli's twelfth-century masterpiece *The Knight in the Panther's Skin* fits comfortably. It tells the tale, first, of the quest of the young warrior Avtandil for the knight of the poem's title, whose extraordinary prowess and sudden disappearance have provoked the distress of Rostevan, king of the Arabs. Interwoven

with this quest is the love story of Avtandil and Tinatin, King Rostevan's daughter. Avtandil seeks her hand in marriage, which doubles the imperative for heroic action on his part. After wandering the edges of the world, Avtandil eventually finds the knight he seeks, Tariel – which leads the story into its second, yet more central quest: to find the kidnapped/ disappeared Nestan Darejan, the lady-love of Tariel. This in turn leads to questing, as it were, even beyond the edges of that edge. As the tale proceeds, a third hero, the knight Pridon, joins his forces to those of Avtandil and Tariel. Both the story within this story – of the circumstances that led to Nestan Darejan's disappearance – and an array of other intertwined subplots, substories, and subadventures unfold one after the other, comprising the majority of the epic. The tale concludes in grand and glorious victory, marriage and happiness-forever-after for the chivalric knights and their sweethearts.

The classic elements of a heroic adventure are there from the beginning, from the call to adventure (the mysterious appearance and disappearance of the Knight, which impels Avtandil out) to the constant and delightful digressions of tales within the larger tale (so that the ultimate quest, not for Tariel but for his lady, does not become clear until well into the poem; and our arrival at the dénouement is continually delayed). Reluctances and obstructions, approaches to and withdrawals from the goal, so that the story is extended and the reader's/listener's gratification in the accomplishment of the goal delayed, play a central part.

So, too, the classic kinds of imagery – similes and metaphors on the one hand and epic hyperbole on the other – are well represented. Young heroes are consistently as slender and tall as cypress trees; Tariel and Avtandil are bright like two suns, 'or as the moon which scatters its beams on the meadow beneath it' (quatrain 278). When strongholds filled with treasure are opened up, 'never had mortal eye beheld such abundance of treasures!' (quatrain 451). In his initial return to Tinatin, before having to go forth again (for while the goal of finding the Knight has been attained, this has proven to be only the prelude to the real adventure: that of finding the Knight's lady-love), Avtandil is 'an unscathed battle-worn lion who had roamed the fields with lions' (quatrain 684). When he arrives in the city of Gulansharo and

enters the home of Patman Khatun, a wealthy merchant's wife, 'when the crystal and the ruby, the jet and the enamel [his dark hair and fair skin] entered the building, those who beheld him compared his arms and feet to a lion's (quatrain 1062).

When Tariel weeps over the loss of his lady-love, 'the tears that flow from his eyes are sufficient to fill up the Tigris' (one of the two major rivers in Mesopotamia; quatrain 840). And when Avtandil weeps in thinking of Tinatin while he lies reluctantly in Patman Khatun's arms (in order to make sure of her help in his quest), 'his tears flowed to mingle with oceans. Two vessels of shining black jet shone brightly in ebony pools' (quatrain 1241). (We are reminded, somewhat, of Odysseus weeping – only after seven years, however – for home and Penelope, at the entrance to Calypso's cave, as we are also reminded of the help both Calypso and Circe extend to Odysseus after his dalliances with them.)

This is a more complex epic than most, in that it offers two heroes: even if the eponymous Knight is the greatest warrior of them all, nevertheless most of the story focuses on the adventures of the hero Avtandil (the mightiest knight in his own kingdom, with his own loyal retainer, Shermadin), who modestly appoints himself the loyal retainer of that knight. Other epics have analogous figures. Achilles has such a retainer, Patroclus, and Gilgamesh has a friend and fellow warrior, Enkidu, whose valorous skills equal his own – but there is no question that Achilles is the hero, not Patroclus, and it is Enkidu's very illness that sends Gilgamesh alone on his quest in the first place. Only in the Georgian epic do we find truly a 'double hero' on a double quest.

For (to repeat) Avtandil's quest, as he begins it, is to find the Knight in the Panther's Skin, Tariel; having found the Knight, his quest becomes that of finding the lady whose loss has turned Tariel's existence into a vale of tears – she is the flower of immortality that will cure Tariel's (love-)sickness. Indeed, the poem not only complicates the traditional role of the epic hero and offers new twists to the varied turns toward a goal that epic quests habitually take, it also complicates the standard values of epic poetry by placing romantic love on an equal footing with collegial love, inter-twining them both at the center of the epic's tapestry. And the prologue is overrun with instructions regarding what proper love is, and with instructions for the lover, as the stage is set

for the story. Rustaveli's poem, which is simultaneously epic and lyric, anticipates such interweaving in European literature by five centuries.

Again, although the interweaving of *eris* and *eros* (conflict and love) is not uncommon in epic poetry, elsewhere the erotic element is neither so idealized nor so central to the plot. Achilles' argument with Agamemnon may focus on a girl, but his primary 'significant other' is his close friend Patroclus, whose role as an alter ego is mainly a means of setting the tragedy in final motion. Odysseus has any number of women, but his primary concern is himself. Aeneas's love of destiny is greater in the end than his lust for Dido. Siegfried has Brunhild and Nala (in the *Mahabharata*) has Damayanti as sidebars to their central actions. But only in Rustaveli's epic do we find such focused emphasis on constant and substantial devotion both between friends and between lovers, expressed by those wandering forth and those waiting behind, by making war and resisting the temptation to make love (except when necessary to further the quest of regaining the lost lover). This is a love poem that is simultaneously charged and chaste.

Perhaps this is in part a consequence of the fact that the poem is dedicated to a woman, Queen Tamar (r. 1184–1213), or rather to the remarkable fact that a woman could overcome the various misogynistic patterns of those around her, succeeding not only as queen, but also in bringing the Georgian Golden Age to its ultimate level of grandeur during her reign. Queen Tamar is the object of the poet's devotion, and she is represented by the heroic women in the poem, just as the poet's own alter ego is the series of heroes in love with those women.

Moreover, in likening his patroness to a panther in the nineteenth quatrain of the prologue, the poet forges a link between Tamar and the knight for whom his poem is named. Tariel is the initial goal of Avtandil, as Tinatin waits behind; he (Tariel) becomes the one waiting as Avtandil goes forth, alone, to find Nestan Darejan on Tariel's behalf, which makes Tariel at one and the same time like Tinatin (awaiting Avtandil's return) and like Avtandil (when the two eventually set forth together and fight side by side to claim Nestan Darejan). That the Knight in the Panther's Skin who thus transgresses traditional epic gender boundaries should be so

directly linked to a queen who, as kingly ruler, transgresses boundaries by definition is perhaps not accidental. It is in any case perfectly appropriate to the originality of the culture that spawned the epic.

Moreover, Rustaveli invokes supernatural power, as other epic poets do, at the inception of his poem. But he invokes the all-good God to assist him against the wiles of Satan's evil, not to help him shape his poem. Part of the backbone of the story is the importance of believing in a God that is ultimately good, logical, and in charge of things, as when Avtandil assures Tariel that they will find Nestan Darejan: 'Why did the Lord create you, if he wished to part you forever? Why should he wish to embitter your life with unending sorrows?' (quatrain 919). At the same time, the cultural influences of the non-Christian world are still evident, as when (quatrains 946–53) the seven planets associated with pagan religion (the residue of which is found in astrology, by definition un-Christian, since it assumes that powers other than the one God's are up there affecting things down here) are invoked.

Similarly, magical powers play a considerable role, as in the ultimate battle between the good hero-warriors and supernatural evil forces. It is not merely that the heroes can overcome supernatural malefactors, but that (one recalls how Odysseus overcame the supernatural wiles of Circe with superior supernatural assistance), in quatrain 1355 and elsewhere, the power of the bad *kaji* (evil sorcerers/demons) is inferior to the good power of the *devis* (more powerful sorcerers/demons) assisting the heroes: white magic over black magic; stronger over weaker. In the end, these heroes, like other epic heroes, have supernatural assistance, yet this theme does not proceed in the obvious direction it might have taken: to assert the greater power of Christian over all other forms of spirituality. Indeed, Christianity plays no role in the poem at all. Although Rustaveli is a Christian poet, he sets his tale (borrowed, as he tells us in the prologue, from the Muslim Persians) in Arabia, Persiá, India – in short, in the lands whose forms of spirituality have been antithetical for centuries to that of his native Georgia; and although the Muslim Turks (presumably Seljuks) are an almost off-hand reference to evil, his Muslim characters are presented with the utmost sympathy.

Cat. 155 (detail) | Illustration in
a manuscript of *The Knight in the
Panther's Skin*, 17th–18th century AD:
Avtandil Roasting a Pig

In part one might conjecture that the entire arena of the narrative is set in lands that are simply intended to be exotic for Rustaveli's audience, by virtue of being part of a different and distant reality, an other-than-familiar-Christian reality. Yet it would and could have been just as logical to offer chivalric Christian heroes battling against Muslim or similar foes, perhaps even in a Crusades-evoking context. Thus positive portrayal of his Muslim heroes suggests, rather, an open-mindedness which is not so remarkable for Georgia – indeed it is quite typical of Georgian cultural history – but is extraordinary for the world at large (especially during Rustaveli's era, the height of the Crusades) and the epic poetry across it.

If the poem itself reflects an openness to other cultures, so that its setting and its heroic figures all derive from the world that is medieval Georgia's spiritual enemy, it should not surprise us that some of the most exquisite illuminations that accompany manuscripts of the epic throughout the centuries reflect the clear influence of other cultures that have made an impact on Georgia.

Thus, on the one hand, one manuscript folio in the current exhibition is uniquely Georgian in its conception: the beautiful series of animalia that overrun the page offer the continuum of a visual tradition which begins in the early Bronze Age (the third millennium BC) – that of depicting myriad tiny animals in a range of media. And when King Rostevan drinks, toward the end of the poem, from a golden bowl (quatrain 1542), we can easily enough imagine it as one of the most celebrated objects in the present exhibition – the semi-precious-stone-studded goblet from the middle Bronze Age perhaps (1700–1600 BC), or the medieval Bedia (possibly Eucharist) Cup commissioned by King Bagrat III in 999.

On the other hand, several seventeenth-century manuscript folios illustrating scenes from the epic are stylistically drawn from the vocabulary of Safavid Persian and Ottoman Turkish miniatures, with flat, stylized landscapes and horsemen just appearing over the horizon. At the same time, there is irony in a representation of the roasting of what appears to be a pig (but echoing quatrains 831 and 937, where the hero roasts a goat): a surer knowledge of the tenets of Islam would have led the illuminator to know that Rustaveli's Muslim heroes would have perished before consuming pork – even if such an action occasionally appears in Ottoman illuminations! The combination of this distinctive culmination of Islamic artistic style with occasional lapses in illustrative content offers an appropriate complement to the narrative illuminated. For this epic, like the culture of which it is part, has been defined by a uniquely complex relationship to the world around it through the centuries. And Georgian culture, overrun by and often interwoven with a variety of other civilizations over the millennia, has managed both to extract and to embrace the most interesting visual, verbal and other features from those civilizations while maintaining a firm sense of its self.

III

GEORGIAN ANTIQUITY

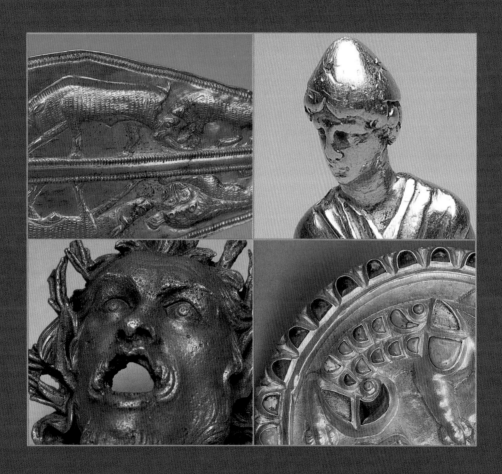

1 Stone and Copper Age Prehistory in Georgia

Tamaz Kiguradze

I

The human species in the Transcaucasus presents the paleontologist and archaeologist with an extraordinarily ancient and continuous history. Hominids started to settle in what we now call Georgia in the early part of the Paleolithic era (2,000,000 to 25,000 years ago). The lower jaw of a hominid estimated to be between 1.5 and 1.7 million years old was found at the site of Dmanisi in south central Georgia. This is the oldest evidence yet discovered of a hominid presence in Europe or Asia. It belonged to an early representative of *Homo erectus*, with the same morphology as African hominid jaw bones of the same era. The Dmanisi jaw was found together with primitive stone artifacts and the bones of animals of the early Stone Age, including ostrich, southern elephant, woolly rhinoceros, antelope, and giraffe. This discovery offers the oldest instance outside Africa of animal remains found alongside human implements, suggesting an early hunting society.

Later animal remains have been discovered at the Akhalkalaki site in southern Georgia, dating from 1,000,000 to 800,000 years ago. Sites dated to the following, Lower Paleolithic period (approximately 800,000 to 100,000 years ago) have also been located in southeastern and western Georgia, where several non-stratified assemblages, as well as material in caves in the Tsona and Kudaro gorges, have been discovered, the oldest layers of which are dated to the middle part of the Lower Paleolithic period (600,000 to 400,000 years ago).

Moreover, more than two hundred sites identified as Mousterian have been found all over the territory of Georgia. Mousterian culture, characterized by stone-flaked tools and stone-tipped spears, developed during the Middle Paleolithic era, from about 100,000 to 40,000 years ago. Western Georgia (where a moister climate seems to have invited much more extensive early settlement than to the east of the Surami mountain range) is particularly rich in both open-air and cave sites from this period, indicating fairly intensive inhabitation. Not only implements, but skeletal fragments of Neanderthal Man have been found in a number of cave sites. The Jruchula cave in particular, which contained a high volume of carefully wrought stone-flaked tools – also called Levallois tools – presents a classic site of this period, with hundreds of typical scrapers and points.

The Upper Paleolithic period – which carries the Old Stone Age into its last phase, between 40,000 and 10,000 years ago – is also well represented in western Georgia. Artifacts from the period have features similar to those of so-called Aurignacian culture: bevel-flint and carved-bone tools and weapons resemble those from sites of the same period in the Balkans, Syro-Palestine, Iran, and elsewhere. In Georgia, as in the Middle East, patterns of cave art are not found. Even movable, sculpted art begins to appear only at the very end of the Paleolithic era.

Consistent human inhabitation across the *entire* territory of Georgia – east as well as west – evolved later, in the late Mesolithic period (about 10,000 to 9000 years ago). Sites dating from that epoch are found both as continuations of Upper Paleolithic sites and as new settlements in the mountainous regions of north central and eastern Georgia, as well as in the volcanic mountains of southern Georgia with their rich obsidian deposits. Most of the new Mesolithic sites are in caves and natural rock-shelters.

Ultimately Georgia came to be quite intensively populated in the Neolithic period that followed – between about 7000

and 4500 BC. By this time, polished stone tools and ceramics have begun to appear. In the earliest, transitional phase – the pre-pottery phase that continues into the first part of the Neolithic period in western Georgia – two different traditions of stone industry are in evidence. The Anaseuli I type is based on the blade-core industry, and characteristic of lowland sites. The Paluri type, on the other hand, is based on the stone-flake industry and is found in the foothills and the mountains. By the end of the Stone Age, this second type of stone culture spread to eastern Georgia (or Inner Kartli, as Georgians would themselves come to call it – see I.1, I.2, III.8, IV.1).

Most of the Neolithic sites are located in the lowlands and foothills of western and southern Georgia. In the southwest, obsidian seems to have been the preferred material for making implements. This is particularly interesting because in both the previous and the following periods flint was the primary material in use. The Neolithic sites of western Georgia are mostly open-air settlements; the use of caves and rock-shelters is very rare. Because of the high level of acid in the soil and high humidity, organic remains in such locations are few and far between, which makes it difficult to learn much about the Neolithic economy. So, too, since the settlement remains are for the most part represented only by thin layers, the dwelling type can very rarely be identified. However, on the basis of the placement of apparent holes for pillars, dwellings have been deduced as square in shape.

The pottery-dominated middle and late Neolithic period (sixth and fifth millennia BC) in Georgia goes by the name 'Odishi' culture, so called after one of its primary site areas along the northern Colchian coast. Indeed, it encompasses the entire Colchian coastal plain, from Adjara in the southwest to Abkhazia in the northwest. Odishi sites are represented by open-air settlements. The chipped-flint and -obsidian industry in evidence is based on the core blade technique. A range of ground and polished tools is present: scrapers, burins, drills, and geometric microliths (small stone implements, such as arrowheads and spindleweights). Larger tools, such as spearheads, choppers, and blades, have also been found.

Odishi pottery is coarse hand-made monochrome with a smooth, red-burnished surface. Simple jar-like shapes generally have flat, low-heeled bottoms. The ceramics of some settlements are characterized by incised ornamentation and perpendicular or oblique incisions, perforations, shallow grooves, or crinkling along the lip. Relief decoration is extremely rare.

II

Pottery of the late Neolithic (c.5800–4000 BC) and early Copper (Chalcolithic) Age (c.4000–3000 BC) is particularly associated with the sites of Shulaveri-Gora and Imiris-Gora, due south of Tbilisi, in the southeastern region called Kvemo Kartli – so that assemblages of the earlier part of this period (down to about 4600) are generally referred to by the name 'Shulaveri'. In contrast to the preceding periods, the era of the Shulaveri culture is richly represented in the archaeological record. Tools made of bone, antler, and stone, architectural remains, pottery, paleozoological and paleobotanical remains offering the possibility of radiocarbon dating abound. Sites appear throughout nearly the entire territory of eastern Transcaucasia, extending south through Kvemo Kartli into the northeastern corner of Armenia and the northwestern corner of Azerbaijan. Shulaveri archaeological sites recall mounds found in Anatolia and the Near East. These mounds, called *tels* (in Arabic) or *tepes* (in Turkish), are artificial hillocks resulting from a pattern, over the centuries, of repeated settlement, destruction, and resettlement. Georgian sites are generally groups of three to five small hills, situated in the fertile river lands. The cultural layers are usually 13–17 feet (4–5 metres) thick, and in rare cases even thicker. The majority of the hills are 265–335 feet (80–100 metres) in diameter. There are also several smaller sites, as well as a few that are much larger. The most important of the large settlements, called Khramis Didi-Gora, is located due southwest of Tbilisi, near the Armenian and Azerbaijanian borders. Occupying a site of nearly 100,000 acres (40,000 hectares), it presents cultural deposits more than 23 feet (7 metres) thick.

Shulaveri communities lived in villages comprising grouped circular structures. Dwellings and other household buildings are placed around a round yard and connected by circular walls. Such construction form is very similar to the widespread circular architecture associated with the Halaf culture (c.5000–4500 BC) in the Near East. These circular complexes are in turn grouped around a central square.

There are several such squares at Khramis Didi-Gora. Hog-back brick was used as construction material, plastered over with a mix of straw and clay on both the inside and outside of walls.

Shulaveri ceramics are coarse, hand-made, and mono-chromatic, without handles, and with either flat or heeled bottoms. Simple egg-shaped jars are most common. The earlier assemblages include relief knob decoration and incised geometric ornamentation. Ceramics from the later sites have no incised elements, offering only relief knobs and raised S-curved, V-shaped, U-shaped, and almond-shaped decoration. Very occasionally, there are human or animal motifs. All these various shapes are similar to those on ceramic pieces found in Near Eastern sites of the same period.

Shulaveri flaked-stone implements are mostly made of obsidian. An abundance of well-made conical cores to be fashioned into wide and middle-sized blades and various knives, scrapers, and burins have been found. During the later phase of the period, sickle blades made of blunt flint appear, and these have come to be viewed as the most distinctive implements of late Shulaveri culture. So, too, numerous polished axes and adzes, as well as grinding slabs and mortars, are located at all sites.

Bone and antler implements of the Shulaveri period are notable for their quantity and diversity. There are awls, knives, combs, spatulas, pointed tools for pecking soil, so-called baton heads, and hoes. Hoes are most often made from the shoulder and larger leg bones (e.g. the femur and the tibia) of cattle rather than from stone. Small anthropomorphic figures made of clay are also found – mostly stylized female figures. However small, a handful are naturalistic and very expressive works of great artistic power. These figures also

relate to similar works of the Chalcolithic period in the Near East. Occasional instances of metalwork also show up in late Shulaveri culture – one copper bead and fragments of another bead were found, for instance, in the upper layers of Khramis Didi-Gora.

Analysis of bone remains at several sites suggests that from the early stage of the culture cattle, goats, sheep, pigs, and dogs were domesticated. The evidence of hunted prey is small – perhaps because animal husbandry and agriculture were becoming so well-developed. The remains of nine species of wheat, several species of barley, as well as rye, oats, millet, lentils, and peas have been identified at these sites. Vine grape seeds at the transitional stage from wild to cultural have also been found at several sites (see III.3). Along with those found at Shomu Tepe in western Azerbaijan, these are believed to be the oldest grape seeds in the world.

Cat. 5 | Obsidian core from Kvemo Kartli, 6th millennium BC

III

Radiocarbon dating places the organic materials of the Shulaveri culture between the early sixth and early fifth millennia BC. Stratigraphic analysis of its vast supply of material enables a subdivision into five stages of development (ignored in this account in the interests of space). In eastern Georgia (Kartli) and its environs, a late fifth-/early fourth millennium cultural complex called 'Sioni' (after a site well to the southwest of Tbilisi) completes the transition into fully-fledged Georgian Chalcolithic development. Sioni sites are located in the lowlands, uplands, and foothills.

Sioni pottery is hand-formed, its shapes simple. Relief ornament is very rare, in contrast with the previous periods. Incised decoration is also rare, except for occasional linear patterns made by a comb-like object or a chip, and straight and oblique cuts, perpendicular or oblique shallow grooves, perforations, folds, and serrations along the rims of vessels. The surfaces are slightly burnished. The quality of stone implement also seems gradually to decline, and bone and antler implements are rare. But metal tools have been found at Sioni sites, including awls, a knife-like implement, and diverse fragments. These suggest that metal was not yet in widespread use but that its production was evolving.

By the late period of the Sioni culture, large straw-tempered jars with funnel-like necks are in evidence at several sites; their origin is linked to the Near East. At Berikldebi the remains of a substantial enclosed brick wall and a mud brick temple (46 x 23 feet or 14 x 7 metres) have been found. This hint of monumental architecture confirms the idea that the Sioni cultural complex is the final launching platform for Georgia's late fourth- and early third-millennium Kura-Araxian culture, which would connect Transcaucasia to the central and eastern part of the northern Caucasus Mountains, northern and central Iran, eastern Anatolia, and Syro-Palestine to the south, in what was to become the far-flung early Bronze Age.

2 Early Metallurgy in Georgia

Mikheil Abramishvili

Georgia figures prominently in the history of ancient metallurgy. Archaeologists there have found evidence of every stage of early metallurgical development. These advances occurred thanks to the region's rich natural resources and its geographical location close to eastern Anatolia (Turkey), where the earliest copper artifacts were apparently produced. Hundreds of ancient mines of antimony and polymetallic ores have been found in the Greater and Lesser Caucasus Mountains. It is clear that copper ores from Kvemo Kartli, in southeastern Georgia, were being extensively worked in the third millennium BC (the early Bronze Age). The earliest mining in the Svaneti and Racha regions – the northwest Caucasus – is believed to date from the early second millennium BC (the middle Bronze Age). However, ancient mining activity is more fully documented archaeologically over the period of the late Bronze and early Iron Ages, between about 1500 and 700 BC.

The earliest copper artifacts to appear in the southern Caucasus region (at the Shulaveri-Shomutepe sites) date to the sixth millennium BC. In the fifth and fourth millennia BC, the Chalcolithic tribes in this area would already seem to have been acquainted with the technique of alloying copper with nickel and arsenic. Furthermore, they had begun to alloy copper with tin to yield bronze. Bronze pins and awls dating from the same period and containing up to four per cent tin have been found at the settlement of Delisi in Tbilisi. Together with a few objects found in the Near East, these are the oldest tin bronze artifacts currently known. Excavations at the Delisi settlement have also revealed bronze droplets, showing that the artifacts were cast at the site.

In the subsequent Kura-Araxes culture (c.3500–2400 BC), arsenic-bronze artifacts seem to have been more common than those of tin-bronze. The latter became more widespread in Georgia after the emergence of the so-called Kurgan cultures, between around 2500 and 2300 BC (see III.4, 5), when bronze widely replaced stone and obsidian for tools and weapons. These cultures demonstrated advanced skills both in bronze metallurgy and in working with precious

Cat. 7 | Bronze fibula from Urbnisi, early 3rd millennium BC

metals. The last centuries of the early Bronze Age present a wide variety of copper and bronze tools and weapons. Spearheads of this period apparently originate in eastern Anatolia; axes and tetrahedral bayonet-type weapons show links, in terms of size and shape, with the Near East. However, the discovery of metallurgical workshops in the settlements of third-millennium BC southeastern Georgia prove that such artifacts were produced locally.

During the middle Bronze Age, the flourishing Trialeti culture introduced more advanced types of bronze weapons, among which the long bronze swords are particularly interesting. These appear in Transcaucasia and the Aegean world almost simultaneously – in approximately 1750–1500 BC – but the simplicity of design of the Transcaucasian swords suggests that they predate the Aegean ones. Another type of weapon associated with Trialeti culture is an exquisite bronze spear with a silver ring, which also finds close parallels in Aegean weaponry.

Yet another type of bronze weapon can be traced to the late Bronze Age (about 1500–1200 BC) in eastern Georgia. This is the blunt-edged slashing sword that evolved from the east Georgian (Kakhetian) type, which in turn originated as the dagger of the Near Eastern type. This development is observed in the Lchashen-Tsitelgori culture, which displayed exceptional skills in bronze metallurgy. Alone among Eurasian artisans of their era, metalsmiths of the Lchashen-Tsitelgori culture used a complicated lost wax openwork-casting technique to produce hollow bronze objects, including small statuettes and handles of daggers and swords. The first appearance of iron artifacts in Georgia is also associated with the Lchashen-Tsitelgori culture. However, iron did not become common in the area until around 1200 BC, when it began to spread from southeastern Georgia.

The late Bronze Age culture of Colchis (western Georgia) deserves separate mention in the discussion of the development of metallurgy. Its numerous bronze artifacts and ingots have been found in hidden caches, where metal artifacts were sometimes stored over periods of several hundred years; this suggests that they were produced for exchange. One of the distinguishing features of this culture is the production of the so-called Colchian axeheads, which demonstrate both advanced metallurgical skills and artistic values.

Cat. 42 | Typical Colchian axehead from Shida Kartli, late 7th to early 6th century BC

In contrast to the case of eastern Georgia, the extensive use of iron in Colchis does not seem to have started until the beginning of the first millennium BC. However, some iron smelting furnaces discovered in Colchis date from as early as the mid-second millennium, when the iron-bearing sands of the southeast Black Sea shore were apparently used as raw material. The existence of such early if limited ferrous metallurgy is strongly supported by Classical writers who maintain that the Chalybes tribes – considered the 'inventors of iron' – lived in the area. Furthermore, written evidence from the seventh century AD identifies the Chalybes as the Chan tribe, who spoke a western language of the Kartvelian (Georgian) group.

Parallel to the evolution of the use of bronze and iron, of course, is the extraordinary working of precious metals that forms a leading strand in Georgian cultural history from the early Bronze Age to the end of the medieval period. That story is told elsewhere in this catalogue (see III.6, IV.7).

3 Georgia as Homeland of Winemaking and Viticulture

P. E. McGovern

It has long been claimed that the earliest 'wine culture' in the world emerged in the mountainous regions of Transcaucasia – modern Georgia, Armenia, and Azerbaijan – during the Neolithic period (c.8500–4000 BC). The wild Eurasian grape subspecies (*Vitis vinifera sylvestris*) still thrives at higher elevations in this region. Permanent Neolithic communities had been established here by at least 6000 BC, in which other essential preconditions for this momentous innovation (e.g. pottery-making) also came together for the first time in human history. Once viticulture had taken hold in Transcaucasia, it appears to have radiated out to other parts of the Near East and eventually to Europe and the New World. Supporting this contention, the proto-Indo-European root meaning 'wine', from which the modern Indo-European (including Slavic, Germanic, Italic, and Hellenic branches) and Semitic words are all derived, is believed to have had its origin in the Transcaucasus.

The earliest Neolithic evidence for the beginnings of a true wine culture, in which wine dominated social and economic life, comes from Georgia. Shulaveri, along the River Kura in southeast/central Georgia, has yielded what may well be the oldest domesticated grape pips (*Vitis vinifera vinifera*), dating from the early sixth millennium BC. The domesticated vine's main advantage over the wild type is that it is self-pollinating, and thus able to produce a large and predictable fruit crop. Besides selecting plants that yielded larger, juicier, and tastier fruit with fewer seeds, the early Neolithic horticulturalist also discovered how to duplicate a desirable grapevine by rooting and grafting branches.

The invention of pottery during the Neolithic period was crucial for processing, serving, and storing wine. Again, sixth-millennium BC sites in Georgia – Shulaveri and Khramis

Didi-Gora – have yielded the earliest, most important evidence. Jars with reddish residues on their interiors (wine 'lees') were decorated with exterior appliqués that appear to be grape clusters and jubilant stick-figures, with arms raised high, under grape arbors.

The importance of viticulture in Georgian life seems to have intensified in later periods, finding new forms of cultural expression. For example, impressive and unique artifacts characterize the so-called Trialeti culture of the early second millennium BC. Large burial mounds (*kurgans*; see III.4, 5) at Trialeti itself, west of modern Tbilisi, and other sites of the period have yielded marvelously ornate gold and silver goblets, often depicting drinking scenes or ceremonies (see note on Trialeti goblet, p. 66). Grapevine cuttings were even encased in silver, accentuating the intricate nodal pattern of the plant. The latter specimens, with their nearly 4000-year-old wood still intact, are on display, together with several Trialeti goblets, in the treasury room of the Georgian State Museum.

In parts of Georgia today, especially in the regions of Kakheti (to the east) and Rioni (to the southwest), wine is still made in the traditional way by being fermented, sometimes for several years, in large jars (*kvevri*) buried up to their necks underground or in artificially created hillocks (*marani*). While the earliest instance of this tradition can be traced back to the Iron Age (eighth–seventh centuries BC), numerous *maranis* of the Roman and Byzantine periods have also been excavated. Wine production continued unabated after the country's conversion to Christianity and throughout medieval times, which was partly assured by the centrality of wine in the Eucharist. Today, as any modern visitor to Georgia will discover, secular life is permeated by wine conventions:

Cat. 72 | Fragment from a large wine vessel, called a *kvevri*, from Samadlo, 3rd century BC (see also cat. 73)

hardly a meal passes without the host assuming the role of toastmaster (*tamada*).

Long-standing traditions of cultivating the grapevine itself are reflected in the numerous modern red and white grapevine varieties, with such exotic names as *Saperavi* and *Rkatsiteli*, whose origins are probably to be found in the Neolithic period. Professor Revaz Ramishvili, the head of the Georgian Agricultural University's viticultural institute, identified the domesticated grape pips at Shulaveri. Both he and his father were pioneers in the botanical study of the Eurasian grape. An intermediate type between the wild and domesticated varieties, first identified by and named for the elder Ramishvili, attests to Georgia's crucial role in domesticating the plant.

Modern scientific analysis and further archaeological investigation of Neolithic sites are needed to fill out this brief overview of Georgia's wine culture. Chemical research on what may be the lees inside the early Neolithic jars will

Cat. 72 | Fragment from a large wine vessel, called a *kvevri*, from Samadlo, 3rd century BC (see also cat. 73)

establish whether or not wine was actually being produced. DNA analysis of ancient grape remains, along with modern cultivars, will enable the genetic history encoded in the Georgian grape varieties to be reconstructed. This will help to determine when and where the Eurasian grapevine was first domesticated. The so-called Noah hypothesis, named after the biblical patriarch who is said to have planted a vineyard on Mt Ararat (in modern-day Turkey, not far from the current Georgian border) after the Flood, posits that this horticultural advance very probably occurred in Georgia. If this is substantiated, Georgia's impact on human civilization will have been very significant and far-reaching indeed.

4 Georgian History and Culture in the Early and Middle Bronze Ages

Antonio Sagona

During Transcaucasia's early and middle Bronze Ages, conventionally assigned to the period 3000–1500 BC, the land of Georgia played a pivotal role in the development of some of the most widely known archaeological cultures to have arisen in the Caucasus. In the earliest of these, termed Kura-Araxes or early Transcaucasian, people lived as livestock-breeders and farmers in village communities which, in terms of social complexity, may best be described as tribal societies or simple chiefdoms. After the late Chalcolithic period, during which these groups are likely to have emerged (around 3500–3400 BC), the immense highland zone of eastern Anatolia and northwestern Iran provided new opportunities for economic change. Western Georgia, however, remained unaffected by this expansion for reasons not yet clear, and the formidable Greater Caucasus Mountains acted as an effective barrier to the settlement of the Eurasian steppes to the north.

Within this divided landscape, these pioneering transhumant (i.e. annually migrating with their livestock) and farming groups are today represented by numerous archaeological mound sites – mostly of modest proportions, averaging about 500 feet (150 metres) in diameter – that contain the accumulated debris of prehistoric settlements. Larger sites exist, especially along the Turkish Upper Euphrates region at the western periphery of this 'culture province' – that is, the area defined by its similarity of artifacts, and thus presumably of general culture. Here the commingling of several cultural traditions has been attested. Similar artifacts have also been found in northwestern Syria, on the plain of Amuq, and in northern Palestine (Israel and the West Bank), in a derivative form labeled Khirbet Kerak, after the archaeological site of that name. The processes involved in this swift and astonishing dispersal are still unclear, but evidence suggests it to be the migration of populations to a large extent.

The Kura-Araxes cultural assemblage is distinguished through multiple regional adaptations, reflecting a conscious definition of group and individual identity. Yet, on the whole, communities tenaciously preserved its fundamental elements. In Georgia this character is best reflected in the distinctive remains uncovered at Kvatskhelebi, Khizanaant-Gora, Tsikhia-Gora, and Amiranis-Gora in central Georgia. Excavations at Kvatskhelebi, west of Tbilisi, along the River Kura, one of the most important sites of the Kura-Araxes tradition, have revealed a settlement of twenty-five free-standing rectangular dwellings with wattle-and-daub walls supported on a framework of posts, the preferred mode of construction in the forested region of Shida Kartli. There is remarkably little evidence of differentiation among the Kvatskhelebi houses, which tend to have a standardized interior: a squarish room with a narrow forecourt, a central post that may have supported a thatched roof, a circular terracotta hearth built into the floor, a bench along the back wall, and portable, horseshoe-shaped, horned hearths. Elsewhere in the Transcaucasus and the adjacent highlands, mud-brick rectilinear agglomerations, like those found in the Near East, and circular architecture emphasize the strong sense of regional diversity.

Kura-Araxes crafts include highly distinctive ceramics, which for many archaeologists define this period. Vessels are invariably built from rings or slabs of clay (the pottery wheel was never employed), which points to a mode of production that was probably seasonal and domestic. Although the earliest ceramics of this complex, such as those from the sites of Khizanaant-Gora, Didube, and Treli, are plain and

pale-colored, in time clay vessels at such locations were often ornamented with relief, fluted, and incised designs, burnished, and then fired to a black or red color. Some examples were polished to a lustrous finish, presumably to imitate metal containers. Metal technology, too, developed during this period. The rich copper-bearing deposits in the mountains surrounding Georgia provided the fundamental ingredient for Bronze Age metallurgy. Kura-Araxes metalsmiths initially favored copper-arsenic alloys, but then, toward the end of the third millennium BC, regularly used tin to produce a limited repertoire of bronzes – mostly ornaments, dress pins, lunate (crescent-shaped) earrings, spearheads, and shaft hole axes – whose purpose had more to do with display and prestige than with utilitarian tasks.

Around 2300 BC, or perhaps slightly earlier, toward the later part of the early Bronze Age, the fortunes of communities living in Georgia began to change. In the archaeological record this is reflected in a number of large and striking elite tombs found throughout the Transcaucasus, whose construction and contents differed markedly from the modest and simple pit inhumations of the preceding millennium. Termed *kurgan* burials and first identified in Georgia in the Trialeti region of south central Georgia, these new barrow inhumations and their rich assemblages included vessels of precious metals and, in some cases, a vehicle with four wheels of solid wood. These *kurgans* are generally seen as the hallmarks of a new age distinguished by fundamental social changes (see also III.5).

Early *kurgans* are found at Martkopi, Trialeti, Samgori, Bedeni, and in the Alazani Valley (in the easternmost part of the region). Their internal tomb architecture varied from shafts dug into the ground and covered with timber planks (as at Trialeti) to substantial log burial chambers, measuring up to 37 x 33 x 7 ft (11 x 10 x 2 metres), as at Martkopi. In each case a mound of earth and stone rising up to 50 feet (15 metres) covered the internment, making it a conspicuous feature on the landscape. The dead were either cremated or their bones ceremoniously placed on a wooden platform. In most cases the deceased were accompanied by symbols of power accorded to the emergent class of elites – bronze weapons, now the universal medium of prestige, gold and silver jewelry, textiles, animal furs, well-finished pottery, and

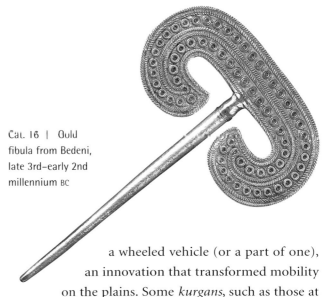

Cat. 16 | Gold fibula from Bedeni, late 3rd–early 2nd millennium BC

a wheeled vehicle (or a part of one), an innovation that transformed mobility on the plains. Some *kurgans*, such as those at Bedeni, contained the remains of several individuals – a practice suggestive of human sacrifice.

Impressive though these early *kurgans* are, the wealth of Bronze Age chieftains is most vividly expressed in the later middle Bronze Age burials, especially those at Trialeti. Among the dazzling array of objects deposited with the deceased was the embossed silver goblet depicting a procession of human and animal figures in two friezes shown in this exhibition (see note on p. 66) and a silver bucket edged with gold. Collectively, these finds, in terms of both technical execution and iconography, reveal a fusion of local and foreign influences that in turn reflect ancient Georgia's growing participation in a far-flung system of exchange, which extended to the shores of the eastern Mediterranean during the second millennium BC.

A curious element of this society, in view of its sumptuous tombs, is the lack, so far, of any archaeological record of its dwellings. No architecture has been found that compares in size and durability with the structures built for the dead. The few dwellings that have been found are remarkably modest and semi-permanent structures, not unlike those of the earlier Kura-Araxes complex. Indeed, considering the links in material culture between the Kura-Araxes and early *kurgan* complexes, especially with regard to ceramics, it is not implausible to suggest the continuity of at least one stratum of the preceding early Bronze Age society well into the second millennium BC.

5 From the Middle Bronze Age to the Early Iron Age in Georgia

Otar Japaridze

I

At the end of the early and the beginning of the middle Bronze Age in Georgia, two distinct cultures emerged, the so-called early Kurgan and Trialeti cultures.

Early Kurgan culture, prevalent in south central Georgia during the last few centuries of the third millennium BC, is so called after the spread of *kurgan*-style burials, which connect to no prior local tradition (see III.4). These burials are typical of the nomadic, cattle-breeding tribes north of the Caucasus from whom they must have spread. Indeed, cattle-breeding appears to have become a significant part of the economy throughout the region during this period. Ethnic changes must also have occurred with the arrival of a new mass of people. At the same time there is a noticeable overall decrease in population; the archaeological record suggests that people have begun to leave the well-cultivated plains and moved elsewhere, for unknown reasons. The Indo-European elements recognizable in the Georgian language might be linked to these events.

The early Kurgan culture spread through most of eastern Georgia. Two sites have thrown particularly useful light on this process: Martkopi and Bedeni. At Martkopi black, polished pottery occurs frequently, showing a certain resemblance to earlier Kura-Araxes. Metal tools and jewelry are well represented, including axes made of copper mixed with arsenic, daggers, arrowheads, and so on. Beads and other accessories made of carnelian, enamel paste, and mother-of-pearl are also found, as well as jewelry made of animal teeth and fangs. Jewelry made of precious metals also first appears during this time. Silver and gold beads and wide gold finger-rings have been found, together with an ornamental gold brooch showing an unusually high level of workmanship.

At Bedeni, more luxurious, better-made pottery has been found. Wooden four-wheeled chariots appear for the first time. Metallurgy has apparently advanced, as objects made of copper mixed with tin begin to appear alongside those of copper mixed with arsenic. Necklaces, pins, rings and head decoration – temple pendants – occur. A golden lion statuette, found in one of the *kurgans* in the Alazani Valley that extends all the way to the east, is particularly noteworthy; it is the first sculptural image of its kind found in the Transcaucasus area.

The differing quality among grave goods also makes it clear that class distinctions were emerging within the later Kurgan period, a process that deepened in the Trialeti culture – the 'brilliant culture of the great *kurgans*', as it has been called – which followed. The Trialeti culture ranged from the foothills and mountains of eastern Georgia to the southern border of what is present-day Georgia during the first part of the second millennium BC. No settlements from this period have yet been found, but it is richly represented by grave objects that suggest further advances in metallurgy and other crafts.

Within large, luxurious *kurgans* with substantial 'burial halls' the cremated dead were sometimes interred with four-wheeled carts. The black, polished pottery was now decorated with geometric ornamentation and occasionally replaced by painted pottery. Axes in distinctive shapes, long swords, and daggers appear, together with spearheads decorated with silver. The quality of the metal improves; bronze mixed with tin is more widely in evidence. Objects made of antimony, mostly jewelry, appear.

It would seem that mining and its associated crafts were at a high level in the Trialeti culture. Semi-precious stones of various colors were used to decorate gold surfaces. The

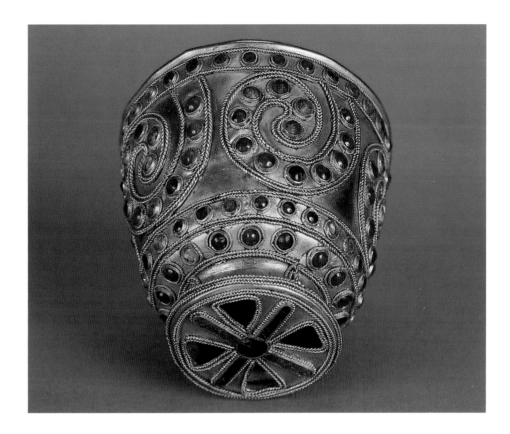

advance in jewelry-making might be linked to the increase in contact with the Near East, but this type of jewelry is not found anywhere else, either in the other regions of the Caucasus or outside it. Metal vessels such as bronze casseroles, gold and silver bowls, cups and goblets (including a well-wrought gold goblet inset with semi-precious stones) are found for the first time (see III.4 and the note following the present essay). Among the metal jewelry are necklaces decorated with tiny granulations and sometimes inlaid with stones of various colors, such as the agate pendant set in gold shown in this exhibition.

The luxurious *kurgans* associated with Trialeti and the culture called by that name begin to disappear by around the middle of the second millennium BC – the early part of the late Bronze Age – as the economy seems to have gone into a decline.

Western Georgia differs from eastern Georgia in its topography and climate, so it is not surprising that the culture that emerged in the west was rather different from what emerged in the east. In the early Bronze Age the first villages appeared in the Kolkheti lowlands, which had been virtually unpopulated before. So, too, dolmen tombs made of huge stones are in evidence spreading into the northern and western parts of Kolkheti. These tombs were smaller during the early Bronze Age, larger and better-built by the middle Bronze Age. Copper metallurgy advanced rapidly. The remnants of metal workshops with clay gauges, construction tubes, and the like have been found in the excavations of settlements, together with agricultural implements such as axes and hoes.

During the early second millennium BC, the process of intensive settlement of the Kolkheti lowlands and the nearby foothills continued. As in the previous age, the settlements were organized as small villages. Peasant houses made of wicker were built on piles or on squares made of logs to protect them from heavy ground water. Moats surrounding the dwellings may have had a defensive function but were also used for drainage. Pottery decorated with distinctive ornamentation and stone implements, including axes, hoes, flint sickles, hand-mills, and kitchen utensils, have been found, as

have metal tools such as triangular hoes and various types of axes for agricultural use. It is only by this time that bronze implements – and copper mixed with arsenic or antimony – appear for the first time in Kolkheti.

The axe and hoe – and thus metals – occupy a special place in the economy of the fertile Kolkhetian lowlands. Copper was mined in Racha, Svaneti, and Apkhazeti (in the southern foothills of the central Caucasus). Remnants of ancient copper products still turn up in the mountains, together with mining implements such as wooden, mortar, and stone trays for carrying ore. Population growth, the development of cattle-breeding and the advance of the mining industry pushed further settlement up into the mountainous regions.

II

The culture of the late Bronze and early Iron Ages spread across eastern Georgia in the second half of the second millennium BC and continued up to about 700 BC. During that period patterns of life changed as the plains became more populous and more stable and stationary settlements were established. Tombs for the elite are no longer found. Goldsmithery seems to disappear, although pottery and metallurgy in general advance, wheel-made pottery appearing as well as hand-made, in a range of shapes and ornamentation. Variously decorated bronze tools and weapons are also found.

In the early part of the late Bronze Age (c.1600–1400) a unified culture spreads through eastern Georgia. Later (c.1400–1100) that unified character disintegrates and two distinct cultural regions are identifiable, one located in the basin of the Iori and Alazani rivers in Kakheti (bordering Azerbaijan to the east), and the other spreading through inner Kartli (the area just northwest of Tbilisi).

Decorated daggers, swords, spears, and axeheads of bronze mixed with tin are common to Kakheti. At the same time, in inner Kartli the so-called Samtavro culture is characterized by bronze weapons of a distinctive type: leaf-shaped dagger blades and spearheads with open sockets. Ruins are mostly located on hills with obviously defensive structures often attached to them. But from the end of the second millennium inner Kartli is strongly influenced by the Iori-Alazani

culture to the east; Kakhetian-style weapons begin to appear at inner Kartlian sites. Thus by the early first millennium the gradual process of cultural unification in eastern Georgia is again apparent. Iron objects become more common, the earliest of them copies of analogous works in bronze.

From about 800 BC iron was widely used throughout most of Georgia. Thereafter bronze was mostly limited to jewelry-making. Iron ore is found locally, mainly in Kvemo (or lower) Kartli. Contact with the Urartean kingdom in eastern Anatolia – domination by Urartu of some of the southern parts of Transcaucasia – also contributed to the development of the iron industry. Somewhat later, first the Cimmerians and then the Scythians (from the north) started to move through Transcaucasia to the south, toward western Anatolia. Scythian features are well reflected in the metal-work of that period (see III.8).

Incursions from outside encouraged alliances among the tribes inhabiting Georgia. The development of irrigation systems was a difficult and labor-consuming process possible

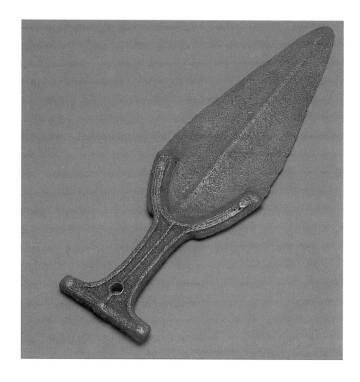

Cat. 22 | Bronze dagger from Orkhevi, second half of 15th–14th century BC

Cat. 43 | Bronze Colchian
axehead from Ozhora,
early 6th century BC

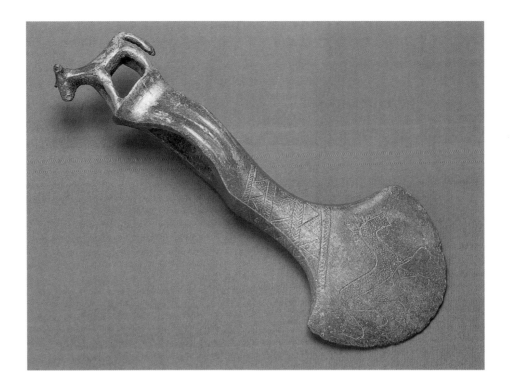

only if a closely-linked community existed. By the middle of the millennium conditions were in place for the formation of a centralized government in eastern Georgia and the birth of the kingdom of Kartli.

In western Georgia, Kolkhetian culture continued to spread in the second half of the second millennium BC. The southwestern region was particularly advanced; a mining complex near the River Chorokhi was functioning at full capacity and with interchange with the Near East. Typical Kolkhetian implements such as bronze segment-like tools and *tsaldi*, i.e. axe- and hoeheads, were produced here; the plains as well as the mountains had become densely populated. The type of settlement seems not to have changed from the previous period. Wood continued as the principal construction material; dwellings were still built of logs. Farming seems to have been widespread, in particular the cultivation of fruit.

Kolkhetian culture extended across the south and deep into eastern Anatolia during this period. Intricately decorated axeheads had become its hallmark by the eighth century. Although iron production was introduced early, the high level of the bronze industry seems to have slowed its develop-

ment. But by mid-millennium the use of iron had become widespread, as is evidenced by the weapons and agricultural implements found in the burial sites of that period. By then a new burial custom had spread throughout Kolkheti. Along with individual graves there are collective burial grounds and square burial sites where secondary burial followed partial or complete cremation. At some sites the remains have been placed in large clay pots. Social stratification is also reflected in the burials. By the end of the period of Kolkhetian culture, objects made of precious metals, without immediate precedent, appear in some graves. The level of their execution is quite high. It seems that the foundations of Colchian goldsmithery, which would achieve such renown during the following, Greek-dominated period, were being laid.

Late in the eighth century BC first the Cimmerians and then the Scythians attacked Kolkheti. Although the Cimmerians left no imprint in the material culture, the region's relationship with the Scythians is as well reflected in the archaeological record as it is with Kartli. As in the east so here in the west, a process of cultural and political consolidation is apparent in the centuries that follow, eventually leading to the establishment of the Kingdom of Egrisi (Colchis).

A Note on the Trialeti Goblet

Karen S. Rubinson

Since its discovery well over half a century ago, the intriguing relief-decorated silver goblet from Trialeti, in south central Georgia, has provoked much discussion and debate as to the sources and meaning of its imagery and the technique of manufacture. Scholars have often compared the imagery to the art of the Hittites, who dominated much of Anatolia (modern Turkey) through substantial portions of the second millennium BC. From Kuftin (1941, pp. 89–92) to recent exhibition catalogues (Miron and Orthmann, 1995, p. 238), these comparisons have sometimes included efforts to suggest ethno-linguistic interpretations (Kuftin, 1941, pp. 90–91).

It seems likely, however, that the closeness in imagery between this object from Transcaucasia and Hittite art from Anatolia is due to a shared source of inspiration for both: the imagery found on the Anatolian-style seals from the Assyrian trading colony period sites such as Kultepe Karum Kanesh and Acemhoyuk in northeast Anatolia (Rubinson, 1977, p. 243). This suggestion, although not new, has been strengthened by the recent excavation of a related silver goblet of the Trialeti culture from the site of Karashamb in Armenia. This new find has a more complex group of images, but they also echo Anatolian-style seals (Oganesian, 1992; Santrot, 1996, pp. 65–67). It is likely that this imagery was introduced to the Trialeti culture-sphere in Georgia as part of an economic exchange, as has happened in other times and places, for example, the West Asian imagery found in Tang China (Vollmer et al., 1983, passim).

One example of the shared imagery between Trans-caucasia and Anatolia is a distinctive hoofed offering table (or altar), seen on both the Trialeti and Karashamb goblets. Examples of the hoofed table are found on several Anatolian-style seals from Kultepe Karum Kanesh (Ozguc, 1965, pl. IV, 11a; pl. XXIV, 73; pl. XXV, 75b). Also from the early centuries of the second millennium, hoofed offering tables or altars are shown on cult basins from Ebla in Syria (Amiet 1980, p. 388, figs 448, 450). The art historian Pierre Amiet has noted the similarity of the Anatolian-style seals to the Ebla basins (1980, p. 164), and it is impossible to determine the primary source of this imagery. But given geographical proximity, Anatolia is the likely source of many visual elements found on the Transcaucasian goblets. This is not to say that the Trialeti goblet was not made in the region where it was found. It simply means that the imagery was probably inspired by objects brought from elsewhere.

Recent close examinations of the goblet have caused experts to wonder about the sequence of execution of the ornamentation of the goblet. This issue can be discerned most clearly in considering the upper figural register, which contains the seated elite individual and 22 walking figures holding goblets, in addition to the offering table or altar, the stand with bowl, the tree or plant, and recumbent animals.

Certainly the principal scene with the seated figure was completed first, probably along with all elements between the 'first' and 'last' walking figures. From noting details of spacing and crowding between the various walking figures, it appears that the figure directly on the opposite side of the goblet from the seated figure – that is, the eleventh figure after the tree – was completed next, giving a framework for the additional figures. Possibly the two walking figures to either side of the central scene, or figures one and twenty-two, were then executed, followed by the sixteenth figure from the tree, approximately dividing the left 'half' of the goblet into quarters. On the opposite side, it seems that either figure eight or nine was executed on the right 'half' before the composition was filled in with the other figures.

A microscopic examination would be able to confirm or disprove this description of the process, but by looking at where feet are crowded together, where figures' noses cut into the goblet tops, and where the goblets themselves crowd the figures in front of them, we can begin to approach the Transcaucasian silversmith's sequence of work.

Cat. 19 (detail) | The Trialeti Goblet, 18th–17th century BC

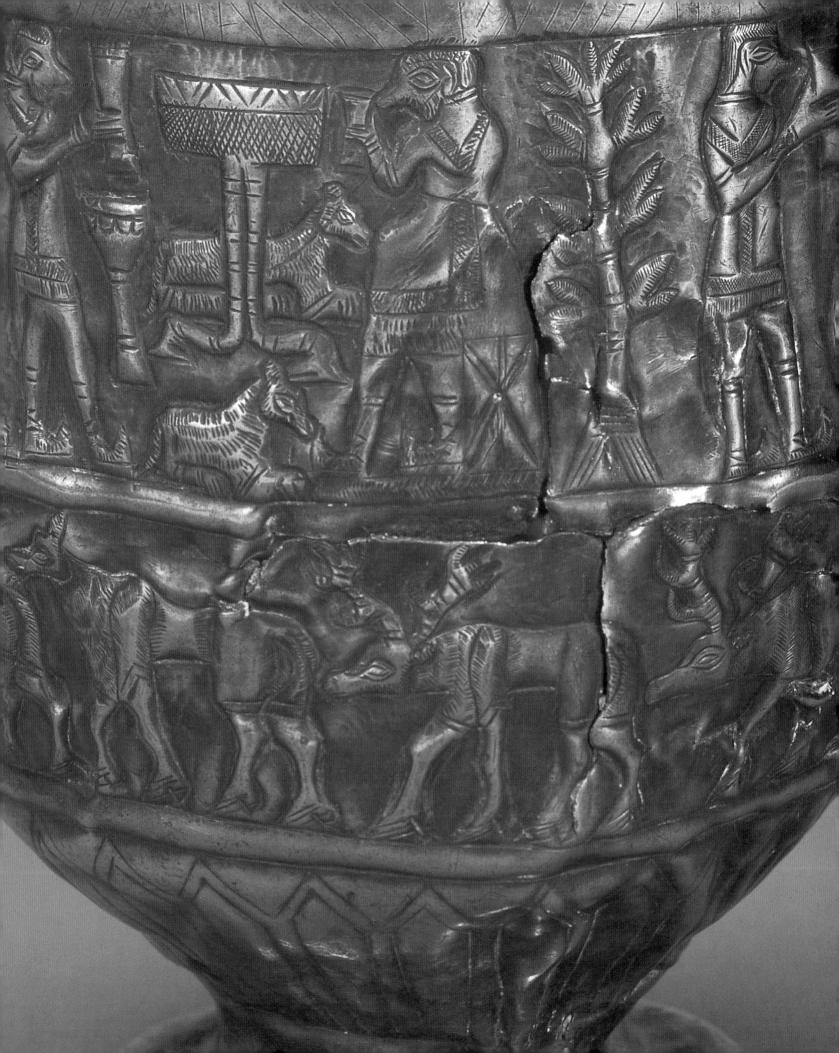

6 Georgian Goldwork in the Classical Period

Otar Lordkipanidze

I

Between the sixth century BC and the third century AD, two states flourished on the territory we now call Georgia (see I.1, I.2, III.7): the western state, Egrisi, called 'Colchis' by the Greeks and Romans, and the eastern state, Kartli, called 'Iberia'.

The aristocracy on both sides of the Surami mountains that separated the two states shared a taste for luxurious symbols of their power and prestige – for public as well as private use, and for formal as well as casual occasions. The rich sepulchres of Egrisian and Kartvelian nobility – kings, governors, magistrates and their families – well illustrates this desire and its fulfillment. Tombs from a range of classical Georgian sites offer the historian an enormous variety of gold and other luxury items.

The development of local goldsmithery was made possible, in part, by rich resources: gold-mines in southern Kartli and gold-bearing rivers in Egrisi. Greek and Roman authors – like Strabo in his *Geography* (XI.2.19) and Appian in *The Wars of Mithridates* (chapter 103) – report on the method of collecting gold from the Egrisian rivers: using sheepskins as sieves, so that the gold grains would get caught in the fleece. This method is still practiced in the mountainous regions of western Georgia, in Svaneti, for example. It is these authors who first suggest a connection between this method, with its attendant image of glittering fleeces drying in the sun, and the myth of Jason and the Golden Fleece.

In general, ancient Greek literature preserved legends about Egrisi as a country that was 'rich in gold' – in the words of Pseudo-Aristotle in *Peplos* (third century BC). Greek authors used various poetic descriptions to stress this feature of an exotic, distant land. Thus in the seventh century BC the poet Mimnermus wrote that Aeetes, king of Colchis, lived 'in a palace of gold'. The Colchian princess Medea not only gives her 'gold crown' away, but prepares her celebrated medicines and drugs in 'gold cauldrons' in Euripides' account of her in his late fifth-century BC play *Medea*. And in the first century AD the Roman writer on natural history, Pliny the Elder, wrote of the Colchian King Savlak that 'when he came into possession of some uninhabited land, it is said that he extracted enormous amounts of gold and silver for his country, the same country already celebrated for the Golden Fleece' (*Historia Naturalia*, XXXIII.52).

Such literary comments find strong support in the archaeological record. The earliest examples of Colchian (i.e. Egrisian) goldsmiths' work date from the eighth and seventh centuries BC. In a tomb at the site of Ureki on the Black Sea coast, for example, pendants designed to hang at the wearer's temples, richly decorated with granulation and the sculpted heads of predators, have been found. Seventh- and sixth-century BC treasures found at a number of sites contain granule-decorated goldworks in the shape of broken crosses and meander patterns – the same shapes often used locally to decorate engraved bronze axes.

Gold granulation attained great variety and technical excellence in the fifth and early fourth centuries. Outstanding examples of this come most particularly from the site of Vani, in the western lowlands just south of the River Rioni. Vani was one of the most important political and religious centers in Colchis. Exquisitely crafted gold diadems, with braid-patterned holders and diamond-shaped plaques adorned with repoussé images of fighting animals, recall similar scenes throughout ancient Near Eastern and Archaic Greek art. On one diadem found at Vani two lions attack a wild boar; on

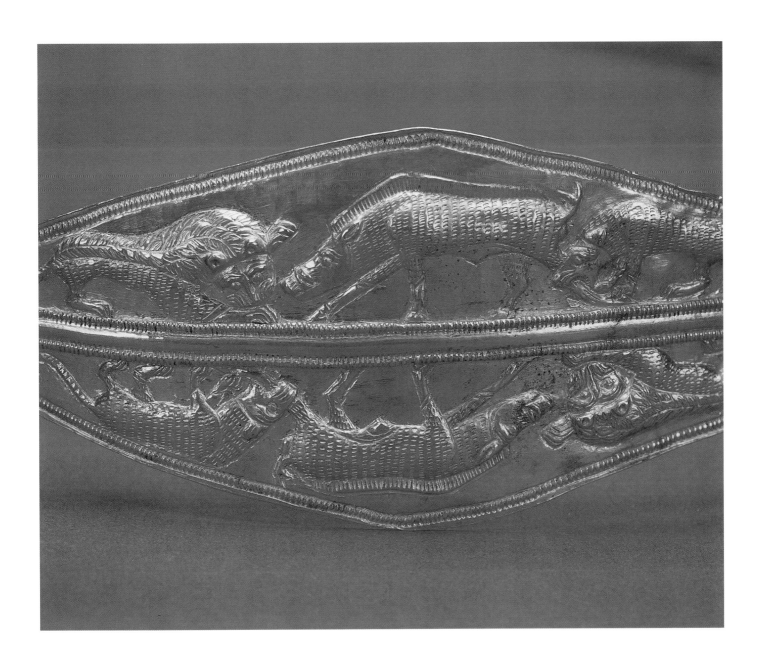

Cat. 52 (detail) | Gold diadem from
Vani, first half of 4th century BC

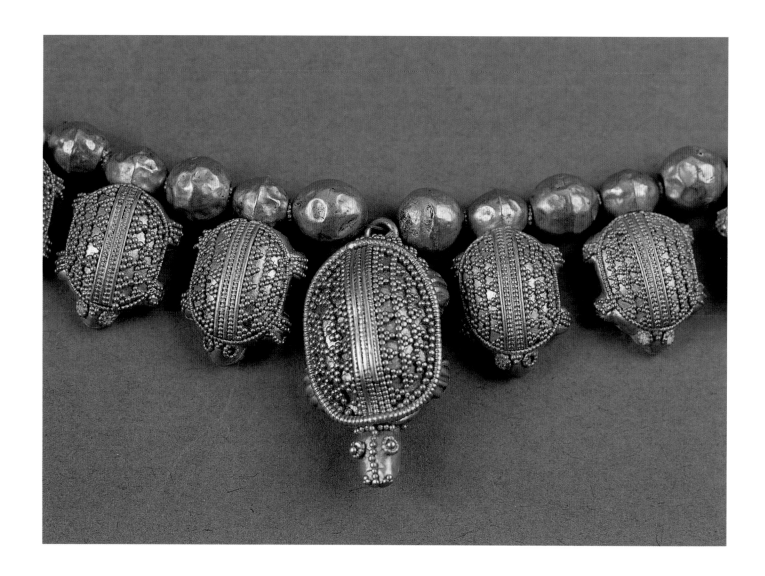

Cat. 56 (detail) | Gold necklace
from Vani, 5th century BC

Cat. 90 (detail) | Pendant and
hanging flagon from gold necklace
with semi-precious stones, from
Armaziskhevi, 150–200 BC

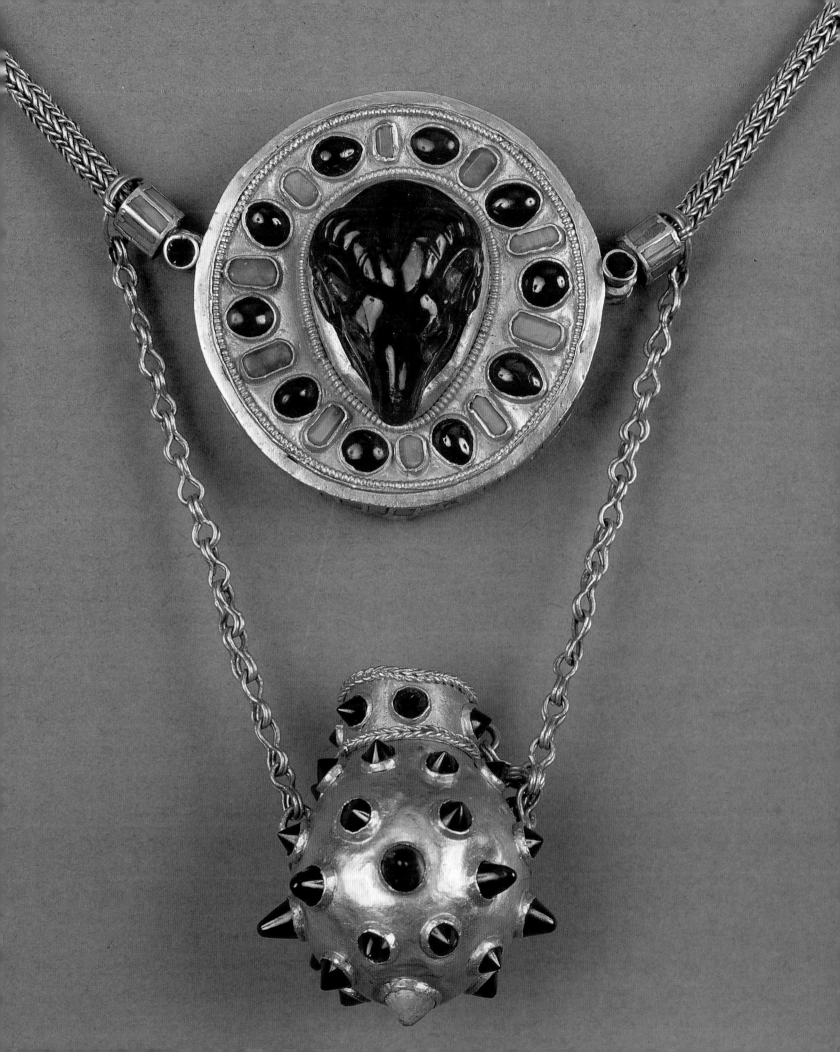

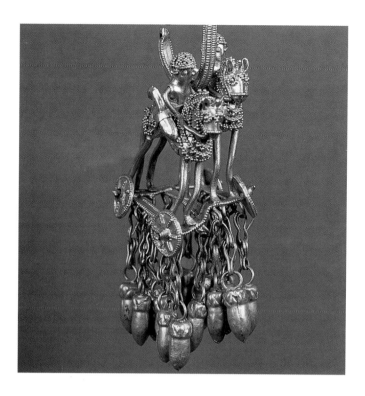

Cat. 62 (detail) | Gold earring from
Vani, first half of 4th century BC

Eastern ear and temple decoration of the same period not only in their radial, spherical, and diamond-shaped typological features, but also stylistically, with the characteristic rosette and the original use of granulation for making the additional pyramid and triangle decorations; iconographically, with the unique handling of the bird motif; and technically, including small apertures on the end of hoops for fastening.

As a whole, the plethora of such objects offers clear evidence of the existence of a distinct and original Colchian goldsmithery style. The Colchian 'school' emphasized extensive use of the granulation technique in combination with filigree, as well as both familiar and fanciful combinations of animal and other forms. Colchian sepulchres of the sixth to fourth centuries BC have yielded lavish necklaces with miniature figures of birds and the heads of calves, goats, and rams – perhaps none more impressive than a gold necklace from Vani composed of dozens of tiny granulation-adorned turtles.

Arm bracelets reflecting both local rounded forms and the Achaemenid style – with concave reverse sides and animal heads – were clearly in favor with some members of the Colchian aristocracy. One of the more splendid gold phials of the 'Achaemenid type' – featuring an omphalos center encircled by a dozen ovoid forms (see III.8) – was also found in Vani. There is, too, in the present exhibition a splendid gold pectoral with a fibula and a pendant decorated with inlaid cloisonné images of griffins and birds (see IV.6). These inlaid images seem to have been imported from, or at least inspired by, the Egyptian province of the far-flung Achaemenid Empire.

If we shift our focus eastward, to Iberian (i.e. Kartlian) sites contemporaneous with Vani, the evidence of Achaemenid Persian influence becomes more pronounced. For example, a splendid fourth-century BC pectoral from the Akhalgori treasure at Sadzeguri, northwest of Tbilisi, was apparently inspired by Achaemenid art. It is composed of a series of thin, repoussé plaques with depictions of winged griffins on them. The griffin motif repeats on handsome gold seal-rings. However, other gold rings at Kartlian sites were apparently imported from Greek workshops along the west coast of Anatolia.

another lions attack a bull. The adaptation of the composition to a triangular frame suggests familiarity with Archaic Greek relief sculpture on temple pediments, just as the details of animal faces and legs evince an awareness of Assyrian and Achaemenid Persian models. The harmoniously structured three-figure compositions with clear and precise contours and convincing depictions of the animals' features in any case suggest the work of a skilled master.

Earrings and temple pendants are found in abundance at Vani and elsewhere in Colchis – most frequently, granulated circular hoops with decorative 'rays' extending from them, adorned with tiny granulated representations of birds. One of the most extraordinary pairs of earrings from Vani presents, on each ring, a pair of tiny, carefully formed horsemen, with the legs of the horses terminating as a frame with wheels; from these, in turn, hang tiny chains that end in acorn finials. Minuscule filigree rosettes and pyramid-shaped groups of tiny gold grains complete the decoration. These Colchian masterpieces differ greatly from Greek and Near

Indeed, perhaps the most extraordinary of the Akhalgori treasures is a pair of pendants designed to hang from a horse's bridle at the temples. Each of them is crafted in the shape of two horses, with chains and acorn shapes hanging below, and a band crowned by a rosette above. In addition, each pendant is overrun with typically Colchian granulations in chevrons and pyramids.

II

This sort of cultural interchange is typical, of course, of the Hellenistic period – the late fourth century to the mid-first century BC – in general. In both Colchis/Egrisi and Iberia/Kartli during this period, new visual ideas emerge – like the use of the Gordian knot motif in necklaces and diadems, and the increased tendency to mix media for more varied texture and color effects.

Artistic synthesis – like so many other features from Hellenistic culture – continues into the Roman period. Especially in the second and third centuries AD, a frequent characteristic of Georgian goldwork is its decoration with multicolored precious and semi-precious stones. During this period, Colchian earrings and bracelets were often decorated with granulations formed as bunches of grapes. Plaques and fibulae were often festooned with garnet and turquoise inserts. We see this in pieces from Kldeeti in Egrisi, as well as at Armaziskhevi, located in the Kartlian capital of Mtskheta. Diverse and numerous small plaques that seem to have been parts of an articulated belt – the buckle has survived to confirm this hypothesis further – have been found at Mtskheta. Each plaque is enhanced by granulations and inlaid with gems and colored stones. Similar plaques found at Kldeeti have been additionally surmounted by tiny pairs of heraldic birds. A pendant found at Gonio, on the southwest coastal corner of Colchis, features the same granulations, gemstone inlays, and heraldic birds. In addition, it bears the repoussé figure of a horseman in the center of the plaque and three smaller pendants hanging from the larger one by delicate chains.

Such objects reflect styles of decoration widely spread through the Black Sea regions and the Roman Empire during the first several centuries AD. Given the frequent use of such

Colchian goldsmithing traditions as granulation in triangular configurations – first used in the region five centuries earlier – one wonders whether objects from Gonio and Kldeeti reflect a revival of earlier Colchian goldwork or a new wave of style and artistry, also visible at some sites in the northern Caucasus in the early centuries AD.

In general, the closest parallels to works from Colchian sepulchres of this period are those in the Iberian kingdom of the same era, as we have seen. Diadems, bracelets, earrings, rings, necklaces, and clasps from the second and third centuries have been found in the east as well as in the west. The use of multicolored stone decoration is a distinctive feature of Iberian goldwork of the era. The most remarkable instances of this come from the previously mentioned aristocratic necropolis of Armaziskhevi in Mtskheta. One is a lush, garnet- and amethyst-studded gold perfume bottle which hangs from a chain to which a somewhat larger round case is attached. The case is adorned with an amethyst cut in the shape of a ram's head. A second example is an intricately worked choker necklace dominated by a large circular case encrusted with gold granulation and semi-precious stones.

Gold finger-rings inlaid with carved stones imported from locations throughout the Near East and East Mediterranean are numerous. By the first century AD, however, local stone-cutting studios seem already to have existed, led by foreign as well as local masters. In the local workshops a complicated method was used for rendering intaglios – tiny relief-carved scenes – with gold foil. Among the works produced locally are delicate portrait-gems (sometimes with the name of the owner inscribed), which turn up, in particular, in the Armaziskhevi necropolis. One such ring presents a sardonyx gem with a carved profile portrait of its owner, with his name and title in Greek letters – the *pithiakhsh* (i.e. governor) Aspauruk.

Perhaps the most touching instance of gem-carving of this period is a garnet intaglio with a double portrait of a man and a woman. An inscription in Greek encircles the portrait: 'Zevakh – my life, Karpak,' which, from the context in which it was found, appears to be a memorial ring. The ring of which the gem became part is in turn part of the rich legacy of Georgian goldwork of the pre-Christian era.

7 Georgia in Classical Myth and History

David Braund

Ancient Georgia has left no written account of itself, apart from a very few inscriptions which happen to have survived on bronze, brick, stone, seal-stones, and coins. Of course, archaeological investigations in Georgia have been very fruitful, as the present exhibition amply testifies. However, archaeology is not well-suited to providing narrative history, and still less to giving insight into ancient thinking. Accordingly, modern knowledge of the myth and history of ancient Georgia depends almost entirely on texts by Greek and Roman authors. Their perspectives were largely those of Mediterranean outsiders, whether mythographers, geographers, imperialists, colonialists, library-bound scholars, or some combination of any of these.

Classical writers, as we have seen (1, 2), perceived ancient Georgia largely as two major regions: west and east. Western Georgia ('Colchis') embraced most of the Black Sea coast and its hinterland in a great arc from the region of modern Sochi (Russia) in the north as far south as modern Trabzon (Turkey). The Byzantines called the region 'Lazica', while Georgian medieval tradition termed it 'Egrisi'. From a Mediterranean perspective Colchis was of much more immediate interest than eastern Georgia, for it was closer and accessible by sea. When Greek literature began, in the ninth and eighth centuries BC, Colchis already had a place in Greek myth and geography. For while Hesiod knew the names of Black Sea rivers, before him Homer and Eumelus of Corinth knew of a myth of the Golden Fleece, kept in Colchis by King Aeetes.

The Greeks imagined that the first ship to sail into the Black Sea, the Argo, had created a route as far as Colchis, from where its captain, Jason, brought the Fleece and Aeetes' dangerous daughter, Medea. The women of the region are accorded a fearsome reputation in Greek myth, not only Medea but also Circe, Medea's father's sister: both were sorceresses. It is tempting to explain their talents, at least in part, by reference to the well-known botanical riches and diversity of the region. The Amazons too, who were variously located in antiquity, were imagined by some to be found in the Caucasus.

However, the Fleece had come from Greece, for Zeus's magical Golden Ram had earlier carried the young Phrixus and his sister Helle through the air from central Greece to Colchis. Helle had fallen off the Ram and landed in what was subsequently termed the 'Hellespont' (now the strait of Dardanelles), the 'sea of Helle' in Greek. As Greeks settled in Colchis, from the early sixth century BC onwards, the Argonautic myth acquired a particular significance, showing, for example, the importance of establishing positive relations with the local Colchians. Meanwhile, under the influence of Greek myth, the local rulers of Colchis seem to have claimed Aeetes as their ancestor: the name itself became popular among the local elite.[1]

Among the material remains of early Georgian culture there is some very fine goldwork. It is tempting to connect this with the myth of the Golden Fleece, particularly as some Greeks tried to explain the myth as the reflection of an actual practice in Georgia, according to which gold was strained from mountain streams with fleeces. However, the myth is Greek, not Georgian in origin: golden sheep are also found elsewhere in Greek myth. Further, Colchian gold was almost all produced in the fifth and fourth centuries BC, much later than the creation of the myth. As to earlier gold, the impressive early and middle Bronze Age objects from Trialeti in

1 Braund, 1994, pp. 8–39.

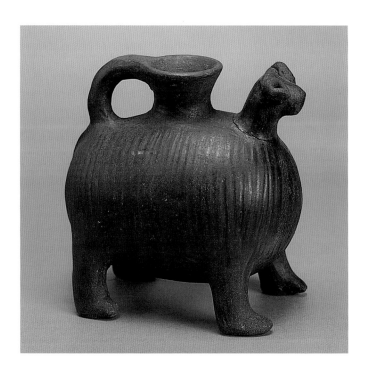

Cat. 37 | Zoomorphic ceramic
vessel in the form of a stylized ram
from Treli, 8th–7th century BC

extent to which Amirani's myth was influenced by the Greek myth.[3] The Prometheus story was also among the oldest Greek myths,[4] and unlike the Golden Fleece, it may reflect a Greek awareness of early Georgian metallurgy. For the production of iron was established in Colchis during the second millennium BC, centuries earlier than in Greece. The current exhibition offers some fine examples of this. Prometheus's crime had been to give humankind the secret of fire, which is also the sphere of Hephaestus, the Greek blacksmith-god (thus relating Prometheus's gift to metallurgy). In Greek myth the particular innovators in iron-working were the Chalybes, located in or near southwestern Colchis.[5]

Greek settlement in Colchis, from the sixth century BC, was focused upon modern Sukhumi (ancient Dioscurias), Ochamchira (Gyenus), Poti (Phasis), Pichvnari (ancient name unknown), Tsikhisdziri (later Petra), and Batumistsikhe (probably Bathys Limen). As elsewhere in the Black Sea area, the Greeks of Miletus, in the eastern Aegean, seem to have taken the leading role in this process. Early settlers seem to have been male, entirely or overwhelmingly, and to have married local women, as the mythical Phrixus and later Jason had done. Accordingly, Greek settlements were also substantially Colchian. Most seem to have been agricultural communities, benefitting from trade where possible, but Phasis seems to have been different. Its very marshy location suggests that trade was its prime concern, for while good land was very scarce there, it was in a fine place for trade. The River Phasis (modern Rioni) and its tributaries, together with other nearby waterways and a series of canals, made Phasis a fine entrepôt for exchange between the Mediterranean world and the Colchian hinterland and beyond. An early Byzantine tradition claims that traders came there from as far afield as India.[6] Archaeology indicates that the Colchian elite soon developed a taste for the fine pottery and wines of the Greek world, besides its local products. In exchange, they seem to have given slaves: one of them became a first-rate potter at Athens, known simply as Kolkhos, or 'The Colchian'.

southern Georgia had nothing to do with Colchian culture from the Greek mythographic perspective (although obviously they have everything to do with the larger picture of Georgian culture). Meanwhile, the use of fleeces for collecting gold has been claimed only for Svaneti in the mountains of northwest Georgia, where there have been stories of the process and substantial modern interest, but no more than that. In general, Greeks liked to rationalize their myths: the story of gold-collecting is one of several attempts to rationalize the Golden Fleece; another explanation imagines it as a glowing sheet of parchment, for example.

Heracles, who was fated (through oversleeping the day the ship was leaving) not to reach Colchis on the Argo, nevertheless got there alone on another occasion and released Prometheus from the Caucasian crag to which Zeus had chained him, to have his entrails eaten by eagles. There are similarities between Prometheus's story and that of Amirani in later Georgian traditions, for Amirani too was attached to a crag as divine punishment.[2] What we do not know is the

2 Charachidze, 1986.
3 Lang, 1966 and 1970.
4 Recalled by the poet Hesiod in *Theogony*, pp. 506–616.
5 Braund, 1994, p. 90.
6 Braund, 1994, pp. 40–2.

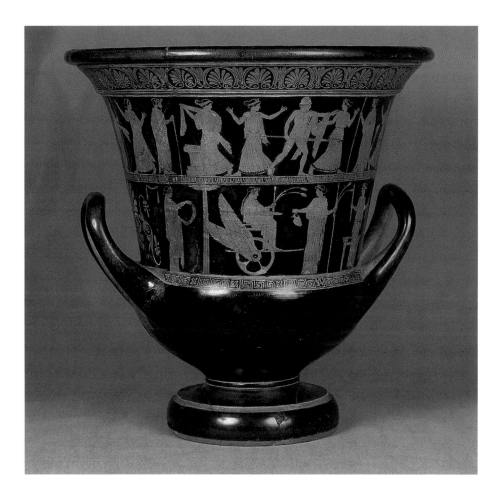

Cat. 59 | Red-figured crater
from the Greek necropolis at
Pitchvnari, 460–450 BC

By the fifth century BC, Colchis was established as a tribute-paying ally of the Achaemenid Persian Empire; as tribute, Colchis again offered slaves, according to the Greek historian Herodotus.[7] The symbols of Achaemenid power start to appear in Colchis, particularly in the hinterland at Sairkhe. Aramaic also appears in the region, spread from Persia. Yet Greek culture persisted here (as elsewhere) within the sphere of Persian influence, so that Greek and Aramaic inscriptions can be found side by side. The spoken language of the region was a form of Georgian (Kartlian), for it is pre-Indo-European, but Georgian seems to have had no script until the fifth century AD.

Colchis was marginal to both Persia and Greece. In the aftermath of Pericles' Black Sea expedition of the 430s BC, some of the towns of the Colchian coast were nominally members of the Athenian empire.[8] After Pericles, Greek sources largely neglect Colchis, though a pupil of Aristotle devoted a treatise (largely lost) to Phasis, *The Constitution of the Phasians*. The surviving fragment of the work offers a colonialist perspective: the Greeks, it claims, had settled Phasis and transformed it from a place of inhospitable barbarism to one of hospitable civilization.

However, with Alexander the Great the Caucasus region again becomes significant in Greek thought: accounts of Alexander's campaign (by contrast with medieval Georgian tradition) make it very clear that he did not enter the Caucasus proper, but that some of his entourage chose to flatter him by interpreting the mountains he crossed further south, towards the Himalayas, as the Caucasus, since traversing them was considered noteworthy. Indeed, in that context Alexander is said to have spent a night with an Amazon queen, who hoped for a child by him – and so to have tied history together with the double myth of place and persons.

7 *Histories* 3:97.
8 Braund, 1994, pp. 124–5.

8 The Meeting of Pre-Christian Civilizations in Georgia

Ori Z. Soltes

Two of the most extraordinary features of Georgian history and culture are that such a small polity has yielded such a rich and varied range of artifacts, and that unlike the cultures of so many civilizations of antiquity which collapsed under the weight of time, Georgia has moved from one phase of accomplishment to another over a span of several millennia. Indeed, from the Neolithic period onward, one catches glimpses of what might be termed 'Georgianness', even as one recognizes the myriad influences that Georgia has embraced from the cultures that have criss-crossed its territory over time.

Given its location at a geographic meeting point of the worlds of the Near East, Anatolia, and the eastern Mediterranean, and the Caucasus Mountains and south central Asian steppes beyond them, it would be surprising if Georgia had not been the recipient of political as well as cultural input from all sides. Archaeologists cannot always be certain which objects unearthed in Georgia were created there and which were imported, yet the artifacts all help contribute to our sense of Georgia as a crucible of visual and other ideas.

One of the most obvious ways in which, from early on, one detects visual and conceptual connections between Georgia and nearby lands is in the symbolic representation of the 'Other' by artisans. Divinities are depicted with a combination of human and animal traits. Scorpion-men, lions who walk on two legs and hold objects with their forepaws, rampant bulls with human faces – these are all part of the visual vocabulary of the Near East, at least as far back as Sumer (now southern Iraq) in the early Bronze Age. So, too, are depictions of offering-processions (see, for example, the figures on the side board of the harp from the Tomb of Queen Putabi at Ur, cylinder seals from Sumer, and the sculpted alabaster vase from Uruk, to say nothing of Hittite processions such as that at Yazilikaya). In both style and content this kind of imagery is visible on the splendid silver goblet from Trialeti (see note, p. 66), dating from the eighteenth–seventeenth century BC. The upper register on the goblet has men with tails and animal heads bringing offerings to a similarly-visaged enthroned figure who raises his own goblet. Moreover, that figure is flanked by the kind of 'tree of life' image that repeats from Persia to Anatolia across the centuries. These similarities suggest a close cultural connection between Georgia and surrounding civilizations by the middle Bronze Age.

Such quasi-anthropomorphic creatures – border creatures, contrived of elements from different realms – offer protection from all the possible forces that threaten the owner of the object from beyond the border of his region of security, be the threat divine or human. They reflect the desire for survival against unpredictable forces. That desire underlies every religious tradition and its rituals, and is expressed not only verbally, through prayer and myth, but visually through such depictions, which represent the forces of the 'Other' in benevolent relationship to us and in control of those which would be malevolent toward us.

Virile animalia such as bulls and rams, which represent not only strength but the life-sustaining force of fertility (infertility is, after all, another road to destruction), are part of Georgian art, as they are endemic to the art of the Near East and eastern Mediterranean. In Georgia one finds not only the obvious – wonderful figurines of rams and twisting ram horns, reminding one of the association with the story of Jason and his quest in Colchis for the Golden Fleece – but also, on the polished black pottery of the early Bronze Age

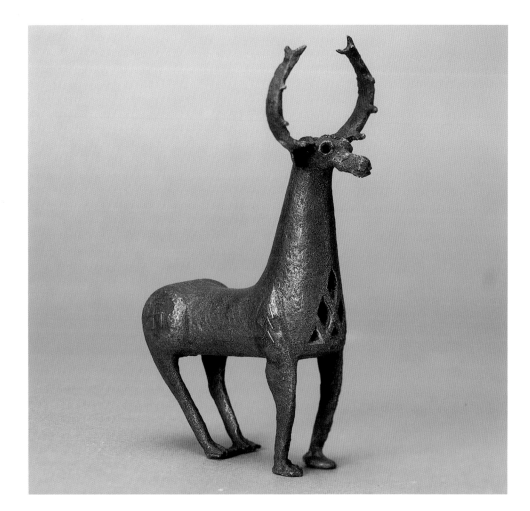

and its south central Georgian Kura-Araxes culture, repeated incised images of stylized ram horns. Many centuries later this imagery will emerge as the stylized ram horns of the Aeolic capital, and still later as the Ionic column capitals that will be carried as a visual idea through Anatolia to its western coast and into Greece.

On the other hand, a range of other animalia, such as the distinctive stag-finials in this exhibition, derive from (or at least relate to) pre-Scythian nomadic art (from the north) and carry all the way to the Hittite site of Alaca Huyuk in northern Anatolia by the beginning of the middle Bronze Age. So, too, the kind of embodiment of female fertility that may be seen repeatedly back in the Neolithic period – as, for example, at Hasuna and Halaf in Mesopotamia – is found in Georgia, represented in this exhibition by a crouching clay female torso and lower body, with prominent breasts and

thighs, from Khramis Didi-Gora. Quite opposite in visual conception is the series of phials from the fifth to second centuries BC, in silver and gold, in which a series of concave ovoid (egg-symbolizing) forms repeat in circles around a convex circle. The navel – called an omphalos – at the center of the object seems to suggest the center of the universe. Such abstract suggestions of birth and rebirth echo similar silver bowls produced by the Achaemenid Persians of the sixth to the fourth centuries BC, such as that of Ataxerxes in the fifth century.

The issue of cultural connection carries in a number of further directions. The well-crafted gold diadems from Vani (see III.6), with scenes of pairs of lions attacking boars, recall similar symbolic expressions of the principle of order over chaos in Near Eastern as well as Scythian art. (Indeed, the custom for Colchian nobility, from at least the sixth

century BC onward, to be buried with their horses seems to derive from the Scythians.) The notion of order over chaos is visually expressible as a three-figure composition: either two figures, representing order, attack a symbol of chaos between them (as in stone relief-carved scenes of Greeks fighting the Amazons, or Hellenistic mosaics of two hunters attacking a stag), or a central figure, as master or mistress of the beasts, controls two wild animals that flank it (as in the case of a bronze Achaemenid open-worked cheekpiece from Luristan depicting the hero between two beasts, or the image of a Minoan Cretan priestess with two serpents in her up-stretched hands).

Such scenes express both mastery of nature and fertility as parallel principles. One of the most original, uniquely Georgian handlings of this idea is found in the nearly two hundred square belt buckles dating from the last few centuries BC and the first few centuries AD from various Georgian sites. These distinctive open-worked bronze objects (recalling the previously-mentioned cheekpiece from Luristan) offer an infinitizing chevron pattern as a frame, punctuated at the corners by omphaloi, and in the center a large animal – a horse, aurochs (wild ox), or stag – surrounded by smaller creatures as acolytes, such as birds or dogs, as if the larger animal were the mistress of these other beasts. The connection with goddesses such as the Greco-Roman Artemis-Diana, patron of the hunt but also protector of the hunted and, paradoxically, with the signature story of her turning Actaeon into a stag who is then *attacked* by his dogs – is palpable. Moreover, since the Roman writer Arrian, in the second century AD, mentions a cult center at the mouth of the River Phasis sacred to a goddess perceived in the third century as Artemis (enthroned, with lions beneath her and a cymbal in her hands), then this interpretation's layers may not be far-fetched.

Of course, there are a range of hunter-cum-mother goddesses with similar cults in pagan antiquity, from Meso-potamia's Nana to Persia's Anahita to Anatolia's Cybele. Each of these could thus be associated with the Bronze Age version

Cat. 91 | Bronze Colchian buckle from Gebi, 1st–3rd century AD

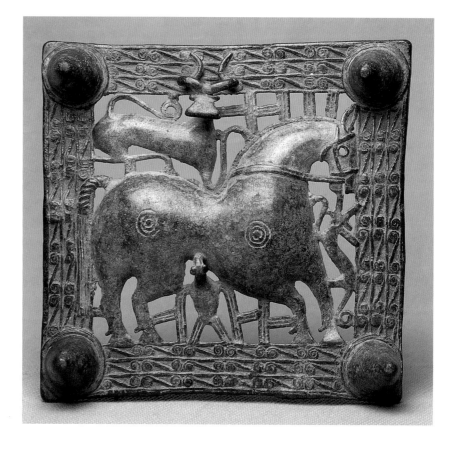

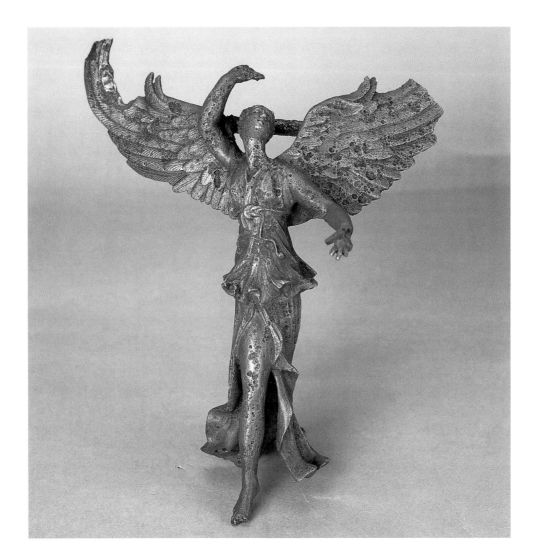

of Artemis as mother and protector but also with the Classical Artemis as Virgin hunter. Indeed, Georgian culture from the last five centuries BC through the first few centuries AD is simply loaded with Anatolian and Greco-Roman connections. While the earlier omphalos phials recall Achaemenid Persian art, three silver phials from the old east Georgian (Kartlian) capital of Mtskheta suggest other connections. The first presents a Hellenistic-style portrayal of the goddess Tykhe-Fortuna in the center; the second portrays Antinuous, favorite of the Roman emperor Hadrian (who ruled from AD 117 to 138); and the third has an unidentified Roman-looking bearded man at its center – perhaps a member of the nobility, who dared to have his portrait thus placed, or perhaps, as some assert, the Roman Emperor Marcus Aurelius. So, too, a

fully realized winged Victory from a second century BC bronze vase found at Vani brings the Greco-Roman world in by either import or imitation. Moreover, high-relief heads of Pan, Ariadne, a satyr, and a maenad suggest connections with the cult of Dionysus. Might the wine god's cult, which originated in Anatolia, have gone both west into Greece and east into Georgia during this period? Or, given the strong possibility that viticulture began in Georgia (see III.3), might the cult of the god have *begun* there and travelled west?

In any case, a large mosaic floor representation of Dionysus and his bride Ariadne at Dzlisa, in the Mukhrani Valley in eastern Georgia (Kartli), indicates that Dionysus was the object of a pre-Christian cult in Georgia. On the other hand, given the myriad Hellenistic representations of

Dionysus astride a panther (another variation on the theme of mastering chaos by subduing wild beasts), it certainly seems possible that the superb little first-century BC gold panther from Mtskheta in this exhibition may relate to Dionysus rather than to the twelfth-century national epic poem *The Knight in the Panther's Skin* (see II.3). But such a cult would have competed with others for devotees. If the enormous second-century BC sanctuary at Dedoplis-mindori is correctly understood by archaeologists, it was created in the Zoroastrian tradition that derived from Achaemenid Persia, where Zoroastrianism was born in the sixth century BC. For the eight temples and assorted related structures, the harmonies of which make quite clear that the whole complex is part of one architectural conception, recall the Zoroastrian fire temples of Persia.

The interplay of ideas in Georgia extends from the minute to the monumental and from the visual to the linguistic. The remains of early Bronze Age dwellings recall Aegean megara of that era, with their pillared porches and central hearths; and conically roofed houses and tombs anticipate Mycenaean beehive tombs and even the Roman Pantheon, as well as the distinctive church domes of medieval Georgia itself. Among the tiny gold items found at Sairkhe are disks upon which the Zoroastrian personification of light and good, Ahura Mazda, is shown – identifiable with Armazi in the Georgian pantheon. At the same time at both Sairkhe and Vani, small gold eagles with outspread wings echo that image on the Achaemenid royal standard. And the hooked bill of a large gold bird of prey at Sairkhe also suggests influence from the north, across the Caucasus Mountains. From yet a later period – the first few centuries AD – a range of coins at different sites underscores the fact of political, economic, and cultural confluence: Roman coins (*denarii*) dominate a range of west Georgian (Colchian/Egrisian) sites while in the east (Iberia/

Cat. 55 | Gold Achaemenid-style plaque in the shape of an eagle, from Vani, 5th century BC

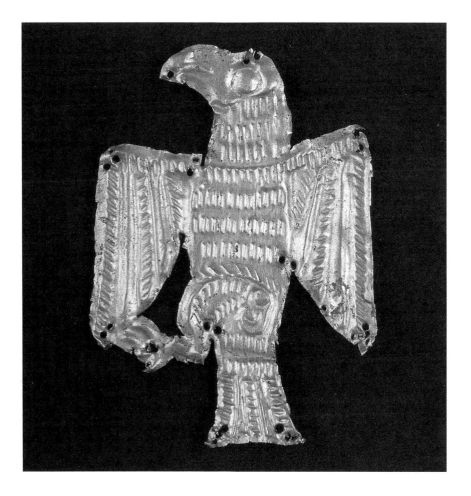

Kartli), a fairly even distribution of *denarii* and Parthian *drachmas* is found.

Even where language is concerned, there is not only cultural interface but uniqueness in Georgia. In late antiquity, Greek was the language of the elite in Colchis, while Aramaic was the language of the upper crust in eastern Georgia. But a variant of Aramaic script – often called Armazic or Armazian – was in use throughout much of Transcaucasia, including both eastern and western Georgia. This writing system was quite different from the Aramaic script used throughout the Achaemenid realms (including Iberia) by the imperial government. Armazian may have evolved from a script upon which two other Persian scripts were based: Parsi, the religious language of the Zoroastrians, and Pahlavi, the language of the later Sassanid Persian Empire.

Of course, according to tradition, the Georgian king Parnavaz had developed a singular writing system for Kartlevi (the Georgian language) by the third century BC. Whether or not that tradition is true, by the fifth century AD a uniquely Georgian writing system was in full use. By then

Georgia had not only become the focus of the power struggle between the Byzantine and Sassanian empires, which had succeeded Rome and Parthia in that as in other roles, it had also begun to sustain the conflict between Christianity and Zoroastrianism championed by the two imperia. Appropriately, one of the earliest surviving works to make use of the Georgian writing system is *The Martyrdom of St Shushanik*, in which the Iberian saint chooses Christianity, and with it execution, over the Zoroastrianism accepted by her husband, an official who preferred to please the Sassanian ruler.

As antiquity gave way to the medieval period, the conflict between Byzantium and the Sassanian Empire, in which Georgia (Suania and Lazica, as by then the two parts of the region were called) was a focal point, continued – until the arrival of the Muslims in the late seventh and early eighth centuries reshuffled both the political and the religious decks. Thereafter, Georgia and its art would reflect a centuries-long interface between Christianity and Islam, visible in an array of types of work, from stone carving to illuminated manuscripts. But that is another story…

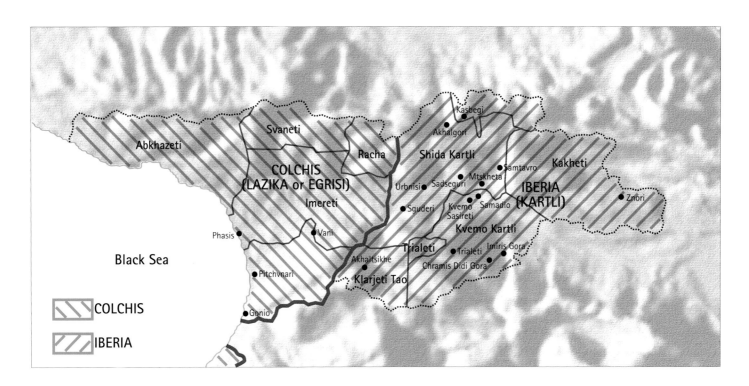

GEORGIA IN GREEK AND ROMAN TIMES

IV

MEDIEVAL GEORGIA

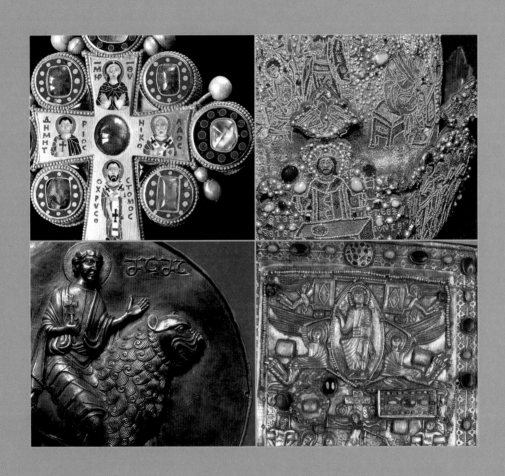

1 Medieval Christian Georgia
(c.330–c.1450)

Stephen H. Rapp Jr

Around the year AD 337, the king of the eastern Georgian realm of Kartli embraced the faith of Jesus Christ, thereby inaugurating the official sanction and support of the Christian Church in Transcaucasia. In some ways the implantation of Christianity was revolutionary. The newly invented Georgian alphabet, for example, was probably intended to transmit Church teachings, but it also enabled the recording of pre-Christian Kartvelian traditions, hitherto transmitted orally. The new faith accommodated existing institutions and so preserved the existing social fabric. Much of Georgia was socially and culturally integrated into the greater Persian world, which dominated the Middle East. This circumstance persisted even centuries after Georgia's conversion. But Christianization also gradually awakened an unprecedented relationship with the Byzantine Empire, centered at Constantinople (modern-day Istanbul). Indeed, the precarious balance between East and West is the essence of the pre-modern Georgian experience. Georgian lands were a Eurasian crossroads par excellence where Armenian, Jewish, Syrian, Persian, Arabo-Islamic, Greek, Roman, Byzantine, northern Caucasian, Turkic, and numerous other cultures commingled.

A visitor to fourth-century Georgia would be profoundly struck by the absence of political cohesion. There was no single 'Georgia' and no monarch governing all Georgians. Rather, the region was a patchwork of independent kingdoms and autonomous districts. Though the peaks of the Surami mountains did not pose an absolute barrier between East and West, they did contribute to the divergent experiences, as is implied in the medieval Georgian place names Amereti (on this [i.e. eastern] side) and Imereti (on that [i.e. western] side). The inherent Kartvelian – i.e. east Georgian – perspective is to be noted.[1]

Georgian history is rich with interaction between the highland peoples and the inhabitants of the lowlands, a legacy that has repercussions even today. In the medieval period, the Georgian lowlanders were particularly concerned with preventing nomadic raids from the Caucasus and sought to control the few major crossings through the mountains, including the famous Dariel Pass, known to the Romans as the Caspian Gates.

In the core region of eastern Georgia, Kartli, an indigenous kingship, arose in the late fourth century BC. Kartvelian society and culture were highly sophisticated, and it was the Kartvelian tongue – called Kartuli by its speakers,[2] but referred to as 'Georgian' in this essay – that became the written idiom of the Georgian family of languages. Accordingly, the vast majority of medieval Georgian histories are written from a Kartvelian perspective and express Kartvelian concerns. When a unified Georgia was established in the early eleventh

1 Some scholars agree that, as the historian C. Toumanoff has persuasively argued in *Studies in Christian Caucasian History* (Washington, DC, 1963), pre-modern Caucasia was in many respects a single social unit; one cannot understand Georgia without Armenia and vice versa. In terms of Armeno-Georgian exchanges, the bicultural frontier was of enormous significance. The myriad Georgian and Armenian peoples intermingled in an extensive southern frontier zone, whose districts were Tao, Shavsheti, Klarjeti, and Javakheti. (These lands were southern from the Georgian perspective. The toponyms given here are the Georgian forms; the Armenians had their own designations for them.) It was in this region that the permanent branch of the thousand-year Bagratid dynasty first established itself in the Georgian domains. Another region where groups intermingled was found to the north in the Caucasus Mountains. Several tribes, including the Svans and the Ovsis, dwelt in its valleys.

2 The Georgian language does not distinguish capital letters.

century AD, the remote Kartvelian past was transformed into the Georgian past. In a sense, then, we are justified in following the 'Kartvelo-centric' nature of the received sources, though it must always be remembered that 'Georgia' was, and is, considerably more extensive than its Kartvelian nucleus. Even within eastern Georgia, Kartli was not the only major territory. The inhabitants of Kakheti, east of Kartli, sometimes established their own kings, although the Kartvelian monarchy more often than not considered Kakheti an integral part of its own realm. Hereti was another sometimes autonomous eastern region.

The Georgian peoples were encircled by Persian influences. Armenia to the south was highly Persianized, as were the tribes of northern Caucasia, including the Scythians and Sarmatians. Many of the Georgian peoples, too, were imitimately tied to Persian civilization. This is demonstrated by the considerable number of Persian, Median, Avestan, and northern Iranic loan-words incorporated into their languages. Even some of the Georgian terms fundamental to Christianity are of Persian derivation, for example *eshmaki* (devil, Satan), *tsminda* (holy, saint), and *beri* (monk). Greco-Roman historians and Persian inscriptions clearly place eastern Georgia within the Persian sphere.

On the other hand, the western Georgian domains were more affected by Greco-Roman civilization (see III.7, III.8). Though this influence was felt most strongly along the Black Sea coast, inland eastern Georgia was not untouched. Its conversion to Christianity had made possible a future alliance with Christian Byzantium (although this did not come to its fruition until the ninth century). One revolutionary aspect of Kartli's conversion was the formulation by Christian clerics of a specifically Georgian (i.e. Kartvelian) alphabet, so that biblical, patristic, and liturgical texts could be made accessible to the local inhabitants (see II.1, II.2). Significantly, the Georgian alphabet, like that of the Armenians, seems to have been deliberately invented by Christians as a device to propagate and fortify the faith of Christ.

Although we possess no absolute historical evidence, western Georgia is traditionally said to have been converted at about the same time as eastern Georgia. But the experiences and processes differed. For example, a special alphabet does not seem to have been invented for the western Georgians.[3]

Greek was the primary ecclesiastical language here. Though the Kartvelians had an alphabet, relatively few original literary works were composed in Georgian prior to the eighth century – perhaps because the hierarchy of the early church in Kartli was dominated by foreigners: Greeks, Armenians, Syrians, even Christian Persians, none of whom had a stake in developing Georgian literature. The earliest works were direct translations of religious texts. But by the end of the fifth century some Kartvelian churchmen were producing original literary tracts – hagiographies describing the exemplary lives of holy men and women who had worked their good deeds throughout the Caucasus.[4] The earliest such text, composed at the end of the fifth century, celebrates the martyrdom of the Christian Armenian princess Shushanik at the hands of her apostate Kartvelian spouse Varsken (see II.1). In this and other early Georgian hagiographies, generic Christian rather than ethnic affiliation was the key consideration.

II

The sixth century was an epoch of great transformation for the Caucasian churches. At the start of the century, during the reign of Vakhtang I Gorgasali (447–502), indigenous sources attest to the growing autonomy of the church in Kartli. But the events occurring under King Parsman VI (r.561–?) were of far greater importance. It was during his reign that Kartvelian aristocrats seized the office of *Katalikos* (Greek *katholikos*), the chief ecclesiastical post. Now the Kartvelian church became virtually autocephalous, or independent of Byzantium in its internal affairs. Kartvelian clerics were increasingly bold and their church began using the Kartvelian vernacular. The Kartvelian church thus emerged as one of several 'national' churches comprising the world of Eastern (Orthodox) Christianity.

3 A few experts have speculated that the inhabitants of ancient Egrisi possessed their own alphabet, e.g. Akaki Suguladze, *Kartuli kulturis istoriis narkvevebi*, vol I, Tbilisi, 1989 [with English summary, *Review of the History of Georgian Culture*, p. 480].

4 Translated excerpts of these texts are found in D.M. Lang, *Lives and Legends of the Georgian Saints*, rev. ed., Crestwood, NY, 1976. Note that the familiar term 'Transcaucasia' is inappropriate for this period. 'Transcaucasia', from the Russian *zakavkaz*, 'on the other side of/beyond the Caucasus mountains', reflects a decidedly (and considerably later) Russian perspective.

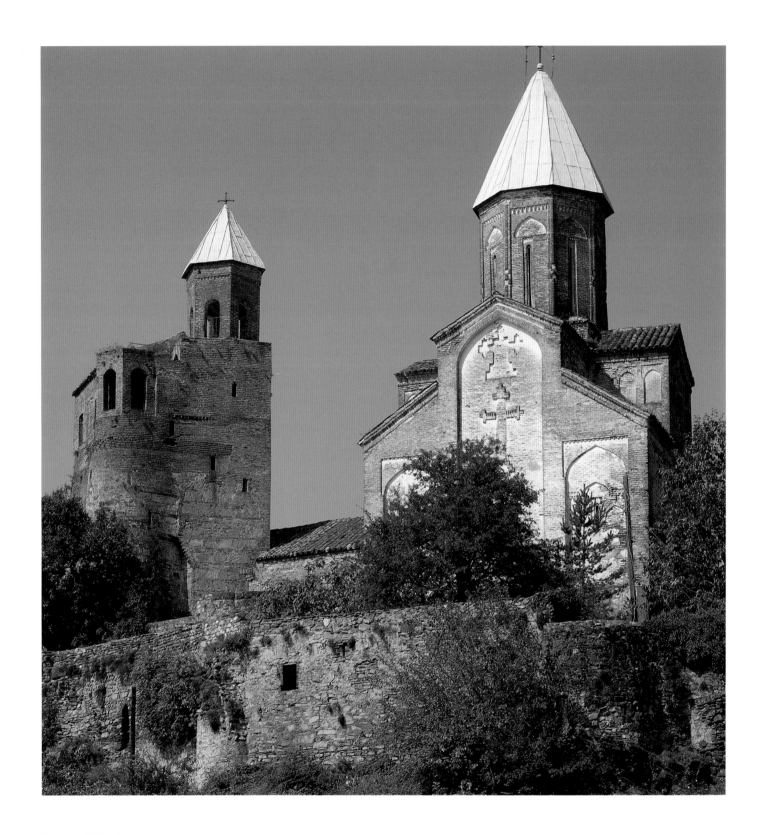

Gremi (in Kakheti): the
remains of the fortified
town, 16th century AD

But as the Kartvelian church grew stronger, the monarchy degenerated. Caucasia was the common frontier separating the Parthian/Sassanian and Roman/Byzantine empires, and many wars had been waged over control of the region. Imperial hegemony thus vacillated between the two great powers, and the contest was hardly decided by the early fourth century when, within a few decades of each other, the Karthian and Armenian kings converted to Christianity. Their realms, which had been in the Persian orbit for centuries, seemed to be slipping into the Roman/Byzantine fold. In 363 the Sassanid Great King won an important victory that led to renewed Persian dominance in the region.

The resultant Persian interference in local politics proved catastrophic. Many aristocratic families threw their support behind the Sassanians, and with their assistance the Armenian monarchy was dismantled in 428. The same fate loomed for the Kartvelian crown. By the 520s its authority had been substantially eroded, and around the year 580 it was abolished outright by the *Shahanshah*. In about 588, as a countermeasure, the Byzantine emperors appointed a 'presiding prince' to serve as the nominal ruler of kingless Kartli. He and his successors wielded relatively little power. As Kartli moved forward without its own king, these 'presiding princes', in order to preserve their position, sometimes aligned themselves with Byzantium's rival. By the middle of the seventh century that rival had become the Islamic caliphate, which replaced Sassanid Persia as the major power of the Near East. Some princes were even confirmed by both powers.

Throughout the Georgian domains, religious contacts with the Byzantines burgeoned. Even the Kartvelians were pulled inadvertently into debates wracking the church. The principal controversy revolved around the nature of Christ: had he been human, divine, or some combination of the two? In the opening years of the seventh century, the Kartvelian *Katalikos* Kwrion broke with the Armenian christology that reigned supreme throughout Caucasia, and embraced the Byzantine view. The Armenians were infuriated, and at the Third Council of Duin, held in 608/9, the Armenian prelate condemned Kwrion and set into motion a formal schism between the Kartvelian and Armenian churches. Religious contacts between these two peoples were curtailed, although other contacts persisted throughout the pre-modern age.

The religious break between Kartli and Armenia had tremendous consequences. Kartli's virtual ecclesiastical independence compelled Kartvelian clerics to write down, and in some cases to manufacture, a distinct tradition of their own conversion to Christianity.[5] Local hagiography became less generic and more narrowly focused on the Kartvelians and Kartli. The first Georgian-language account of the conversion of King Mirian, *The Conversion of Kartli*, was written down less than a century after the 609 schism. The anonymous work was embellished further in a ninth- or tenth-century text called *The Life of St Nino*. The Kartvelians' literary activity was fueled not only by religious controversies but also by the political disaster of the Islamic invasions a few decades later. Kartli was a principal target. Its capital, Tbilisi, barely a century old, was transformed into a Muslim city.

Two consequences of the Islamic conquest of central Caucasia stand out. First, there was an exodus of thousands of nobles, scholars, and clerics from Kartli proper. Some sought refuge in the eastern territory of Kakheti, while others poured into the protected southwestern regions, such as Klarjeti, Shavsheti, and Tao. The ramifications of this migration are not well understood, but it is indisputable that, at least in the southwest, the Kartvelian element became dominant. A veritable neo-Kartli – a Kartvelian polity in exile – was established. Unable to continue their political lives, the Kartvelians turned to religion, the arts, architecture, and literature, realms over which they could exercise direct control and try to make sense of the tragedy that had befallen them. The church was the major cultural institution and it was energized in this era. Its enhancement is graphically illustrated by the series of extensive monastic complexes that thrived in neo-Kartli, including Khandzta, Opiza, Ishkhani, Bedia, and Shatberdi. The very active ninth-century monk Grigol Khandzteli (Gregory of Khandzta) is associated with many of these foundations.

Secondly, as part of the cultural efflorescence some aristocrats strove to record, manipulate, and even manufacture the

5 There were other forms of cultural flowering, for example the stone, cruciform-domed cathedral of Juari (modern Jvari) overlooking the old capital of Mtskheta was constructed at the end of the sixth and beginning of the seventh century.

secular Kartvelian past. The earliest known Kartvelian histories were composed by three anonymous authors in the period beginning about 790 and ending in 813. Perhaps the oldest of these is *The Life of the Kartvelian Kings*. It describes the pre-Christian Kartvelian past from the ethnogenesis of the various Georgian peoples down to the eve of Mirian's conversion. *The Life of the Kartvelian Kings* brilliantly expresses Kartli's position between the Near Eastern and Christian worlds. While its unknown author set Kartli's ultimate origin in the context of the Hebrew Bible (and specifically the genealogy of peoples enumerated in Genesis), he set its early history in the context of the epic pre-Islamic Persian past. The other two histories, known collectively as *Tskhovrebay Vakhtang Gorgaslisa* (*The Life of Vakhtang Gorgasali*), address the reign of Vakhtang Gorgasali (447–502) and those of his successors down through the eve of Bagratid rule. Perhaps as early as the ninth century, but certainly by the eleventh, all three histories were joined together so as to constitute the initial version of the medieval historical corpus known as *Kartlis Tskhovreba*, or *The Life of Georgia*, also known informally as *The Georgian Chronicles* and *The Georgian Royal Annals*.[6]

There can be no doubt that our three Kartvelian historians of around AD 800 tapped old oral traditions. A historically accurate core occupies the heart of each work. Yet the three authors simultaneously projected their own times and values upon antiquity. Early ninth-century 'Georgia' was politically debilitated. Through their celebration of the glorious past, these historians desired the restoration of the Kartvelian crown. Sometimes the past was deliberately manipulated so as to rekindle support for the lapsed monarchy. Consider, for example, the reconstituted memory of the historical king Vakhtang Gorgasali (447–502).[7] Vakhtang's biographer employed terms and imagery that would have been familiar to a ninth-century Kartvelian audience, and these terms were not unlike those that circulated elsewhere in contemporary Asia. The imagined Vakhtang divulges much more about the issues confronting the Kartvelians in the early ninth century than he does about the time of the historical king.

Within a decade or so of the composition of Vakhtang's biography, the political situation shifted dramatically. The establishment of a neo-Kartli in the southwest had given the Kartvelians direct access to Byzantine civilization by virtue of a shared border with Anatolia. The relationship intensified further with the resurgence of Kartli's political vigor. In the early 770s, several prominent Caucasian aristocratic houses raised a violent insurrection against their Muslim overlords in eastern Georgia. The Caucasian nobles were routed in 771–772. As a consequence, some of the members of the defeated Bagratid[8] house fled to the Armeno-Georgian frontier – the extremity of southwestern Georgian domains. Within a few decades these Bagratids seized control of neo-Kartli and governed the Georgian territories for the next thousand years.

The Bagratids are emblematic of the cosmopolitanism of medieval Georgia.[9] Within a century of their settlement in neo-Kartli, the Bagratids' acculturation had been so rapid that some local writers already regarded them as ethnic Kartvelians. They had ascended to prominence with Byzantine sanction and support. Furthermore, once the Bagratids consolidated their hold over the Kartvelian polity, they embellished received Judeo-Christian and Armenian traditions so as to imbue themselves with incomparable legitimacy. By the tenth century they boldly declared themselves to be the direct biological descendants of the biblical King David.

There were also new developments in the northwest. Around the year 795 the independent kingdom in Apkhazeti

6 S. Q'aukhishvili (ed.), *Kartlis tskhovreba*, 2 vols, Tbilisi, 1955 and 1959. The first volume has been printed with a new introduction by S. Rapp, *Kartlis tskhovreba: The Georgian Royal Annals and their Medieval Armenian Adaptation*, vol. 1, Delmar, NY, 1998. See also the English translations of R.W. Thomson, *Rewriting Caucasian History: The Medieval Armenian Adaptation of the Georgian Chronicles* (with original Georgian texts and Armenian adaptation), Oxford, 1996; and K. Vivian, *The Georgian Chronicle: The Period of Giorgi Lasha*, Amsterdam, 1991.

7 I accept Byzantine and Armenian sources of the time which indicate that Vakhtang was not a particularly powerful monarch, yet his early ninth-century Kartvelian biographer portrayed him as a king equal to and perhaps surpassing the Byzantine and Sassanid emperors! In Vakhtang's person were merged local, Persian and Christian forms of identity.

8 The Armenian form is Bagratuni; the Georgian, Bagratuniani or Bagrationi.

9 Some scholars maintain that they were an ancient Armenian family with deep ties to the Persian world.

(modern Abkhazia) was established on lands that had comprised much of the former realm of Egrisi. Diverging from Kartvelian tradition, the Apkhaz church continued to use primarily Greek, just as coins minted by the Apkhaz kings were inscribed in Greek.

III

Historians possess far more documentation and material artifacts for the Bagratid epoch than for the preceding centuries. Further, the Byzantine Empire was a civilization very much based on the written word; Georgian churchmen, hundreds of whom took up residence in foreign monasteries (see II.2, IV.2, IV.8), were struck by the Byzantine preoccupation with the written word and thus they undertook a mammoth effort to copy old texts, to translate Greek ecclesiastical texts carefully into Georgian, and generally to increase the number of books. The copying of the Bible into Georgian reached a high point in the ninth and tenth centuries. The Georgian obsession with written texts also affected historiography. Thus the historical texts originally written before Bagratid rule are now preserved exclusively in Bagratid-era manuscripts.

This titanic literary venture was concerned primarily with ecclesiastical tracts until the eleventh century, but from that era the Bagratids began to sanction original historical writings. One explanation for the revival of historiography was the attainment of a politically unified Georgia, which came to be called Sakartvelo.[10] From the time when Ashot I ('the Great') seized political power in neo-Kartli for the Bagratids in 813 to the death of David 'of Tao' in the year 1000, Bagratid domination grew. David's reign demonstrates the complexity of the Georgian–Byzantine relationship. The Emperor Basil II (r.976–1025) petitioned David for assistance during a major rebellion led by Bardas Skleros. David provided troops for the force led by his friend the Byzantine general Bardas Phokas. When the insurrection was quashed, David was entrusted with select Byzantine territories in far eastern Anatolia (present-day Turkey). But just a few years later, David threw his support behind a revolt against Basil *led* by Bardas Phokas. This rebellion was also put down and David was compelled to promise the surrender of some of his lands to the Byzantines upon his death. David did not

want this to happen. With the assistance of his energetic advisor Ivane Marushisdze, David secured the first unified Georgian throne for his own adopted son Bagrat III (d.1014). Bagrat succeeded in expanding the kingdom by assembling Kartli, the western kingdom of Apkhazeti (Abkhazia) and neo-Kartli into a coherent realm in 1008. This marked the first time that these three separate Georgian lands had fallen under the authority of a single indigenous ruler. Eventually, many of the outlying domains, such as the independent kingdom of Kakheti as well as Svaneti in the north, were brought under the authority of the all-Georgian monarch.

In order to account for and commemorate this unprecedented state of affairs, the Bagratids rejuvenated historical writing in the first half of the eleventh century. Several works were composed in the heyday of the medieval Georgian Kingdom, between 1008 and the Mongol conquest in the thirteenth century. Histories written in this era, especially those composed after the eleventh century, differ substantially from those produced on the eve of Ashot's accession. Bagratid historians discarded select images and models obviously connected with the Near East. In terms of both historiography and art, royal imagery became more attuned to Byzantine concepts. Bagratid monarchs were no longer described in terms reminiscent of the hero-kings of the Sassanid Persians, as their predecessors had been.

Historical tracts of the period reflect the Bagratids' gradual attempt to place their royal authority on equality with that of the Byzantine emperor. But it should be noted that the Georgians did not claim authority *over* Byzantium in any way. Byzantine imperial insignia and ceremonies were adapted to an unprecedented level, but King David II ('The Builder'; r.1089–1125)[11] eventually jettisoned the use of titles conferred on Georgian kings by the Byzantine emperor because they implied subordination to the emperor. Georgia's identification as a bastion of Christianity was

10 Literally, 'the land where the Kartvelians dwell'.

11 This king is commonly referred to as 'David aghmashenebeli', or 'The Builder'. Some scholars reckon him as David IV or even David III. The disparity results from the fact that there were three major – but nevertheless related – branches of the Georgian Bagratid family, and scholars have yet to agree on a standardized assignment of ordinals.

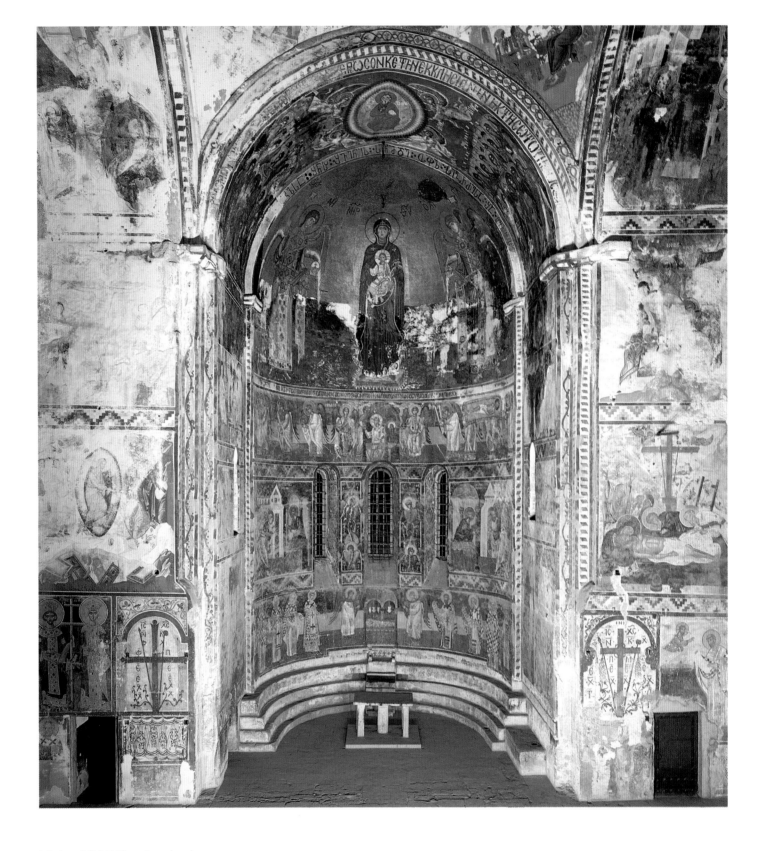

Interior of Gelati Monastery church
apse with mosaics and wall paintings;
the Virgin and Child are flanked by
the archangels Michael and Gabriel,
1120–1130 AD

strengthened by David's sponsorship of magnificent religious monuments and foundations. First among these is the famous Gelati monastic complex near Kutaisi. Its very structure was intended to mirror the splendid monuments of Constantinople itself. Countless other churches were renovated and built throughout the Georgian realm (see IV.2, IV.3). The unprecedented bond with the Byzantine world helped make this a great age of manuscript production and illumination, wall painting, cloisonné enamels, and repoussé work (see IV.4–8).

David's reign was punctuated by an effort to consolidate Georgia's position as the leading Christian power in the northern Near East. Internally, he enlarged the bureaucracy and instituted ecclesiastical reforms granting the monarch the ability to intervene legally in church affairs. The church now became an organ of the state. In the few years before David had ascended the throne, waves of Turkish invaders – especially the Seljuq Turks – had pushed into Caucasia. Soon afterward, Georgia had been forced into making protection payments, but in 1099 David ceased them once and for all. In a bid to gain the upper hand, he negotiated the resettlement of 40,000 nomadic Tsumani-Qipchaq families along the northern border. With their pivotal assistance, he succeeded in recapturing Tbilisi from the Muslims in 1122, thus ending their four-century occupation of the city. So extraordinary were David's victories that news of them spread among the Crusaders in the Holy Land.

During the reign of Tamar (1184–1213), David's great-granddaughter, medieval Georgia reached its zenith. She was the first Bagratid woman to rule any Georgian territory in her own right. The equalization of the Georgian monarch with the Byzantine emperor acquired an enhanced meaning with the sacking of Constantinople by the Crusaders in 1204. Some prominent members of the imperial Byzantine Komneni family, who happened also to be relatives of Tamar, made their way to Georgia and took up residence at the queen's court. With the support of the Georgian army, these Komneni royals seized the city of Trebizond in Anatolia and established a Byzantine kingdom in exile that was destined to outlive the fall of Constantinople itself in 1453.

Although Bagratid-era historians made a concerted effort to clothe their monarchs in Byzantine imagery, Georgia was

Cat. 131 | Silver coin of Queen Rusudan, 1230 AD

by no means divorced from the Near East. As the Georgian Kingdom became an Empire under David II, large numbers of non-Georgians came under Bagratid rule. Much of the northern zone of the Near East fell under Georgian hegemony, including Caucasian Armenia, northern Caucasia, eastern Anatolia, the area today called Azerbaijan, and even parts of northern Iran. Georgia's population thus included a sizeable Muslim minority. Contemporary Georgian coinage of the time clearly reflects the situation: on one side, the legends are typically written in Georgian, while on the other they are inscribed in Arabic. Muslim, and especially Persian, motifs were applied by Georgian artists. Similarly, the splendid Georgian astronomical tract copied in 1188 draws heavily upon Middle Eastern scientific knowledge. At the court of Queen Tamar, we also find a revival of Persian literature. The Persian epic (in its oral form) had been an instrumental part of the pre-Bagratid Georgian historical tradition. By the eleventh century, writers no longer couched the Georgian historical experience in a Persian setting, endeavoring instead to paint the Bagratid monarchs in Byzantine colors. Yet in the thirteenth century some of Tamar's courtiers began to write poems that echo Persian style and content. The most renowned of these poems is Shota Rustaveli's *The Knight in the Panther's Skin* (see II.3)[12]

The Armenians, however, comprised the largest minority

12 See, for example, the English translation by V. Urushadze, Tbilisi, 1986.

in the Georgian Empire. Much of Caucasian Armenia was annexed by Georgia, and large numbers of Armenians made their way into the Georgian administration. Two generals of Armeno-Kurdish extraction, Zakaria and Ivane Mqargrdzeli, led the Georgian army to great military triumphs under Queen Tamar. It was perhaps at their urging that *Kartlis Tskhovreba* was abridged and then adapted into the Armenian language.

For all its dramatic accomplishments, medieval unified Sakartvelo was relatively short-lived. Having been established in 1008, it reached its peak under David II and Tamar. But just a few decades after Tamar's death in 1213, the unified Georgian Kingdom disintegrated. This collapse has yet to be adequately explained, but is usually attributed to the Mongol invasions, which were certainly a factor. But other factors were surely Georgia's overextension of its resources and the crash of central authority due to the incompetence of Tamar's children, Giorgi IV Lasha (reigned 1213–23) and his sister Rusudan (reigned 1223–45). The situation had deteriorated so much that Rusudan and her successors were forced to negotiate with the papacy. Eventually a Latin bishopric was even established in Tbilisi in 1289. The religious make-up of Caucasia was complex, comprising the large number of Muslim inhabitants, various forms of Christianity, and the continued influx of other faiths, notably long-tolerated Judaism, which continued to be well-treated.

Despite the breakdown of central political authority, the Bagratids retained their titles, although their 'kings' now had to be confirmed by the Mongol khans. The western Georgian domains were relatively unscathed by the Mongol conquest, and so once again became a haven for the Kartvelian elite. A second neo-Kartli was established. In 1258 the Bagratid kingdom of Imereti in western Georgia declared its independence. By the 1270s the southwestern domains were gathered into a new province called Samtskhe.

A unified Georgian kingdom briefly resurfaced under Alexander I (r.1412–42), but the multiplicity of local centers of power and the devastation that had been effected by the invasions of Timur (Tamerlane) from 1386 to 1403 rendered the unification tenuous and superficial. In the second half of the fifteenth century Georgia splintered yet again, this time into the kingdoms of Kartli, Kakheti, and Imereti. In addition, five autonomous (non-Bagratid) princely houses were established in the western domains: the Jaqelis of Meskheti, the Dadiani-Gurielis of Guria, the Dadianis of Samegrelo (Mingrelia), the Sharvashidzes of Abkhazeti, and the Gelovanis of Svaneti. With the exception of Meskheti, all these princedoms survived until the Russian conquest.[13] It is worth noting that in this era of political instability and fragmentation, the arts and literature once again flourished. For example, the vast majority of surviving manuscripts transmitting historical texts were copied at this time.

With the fall of the Byzantine capital of Constantinople to the Ottomans in 1453, Georgia lost an important Christian ally. The Russian Empire declared itself the successor of Byzantium, and some Georgians looked to it as a potential savior against the Muslim danger posed by the Safavid Persians and the Ottoman Turks. Georgia's relationship with Russia evolved from mere curiosity, to the 1783 treaty making the independent kingdom of eastern Georgia a Russian protectorate, to the outright annexation of Georgian lands by the Tsars beginning in 1801 (see I.1, I.2). The Georgians had been the object of imperial conquest before, and despite the employment of new technologies, the Russians (and then the Soviets) – like the imperial powers before them – proved unable to extinguish the distinctiveness of Georgian civilization. Yet at the same time the Georgians tapped into Russian culture, incorporating select elements of it, and through Russia gained unprecedented access to Europe. Once again, Georgian identity showed itself to be flexible and able to accommodate itself to the constantly fluctuating political realities of greater Eurasia.

13 C. Toumanoff, 'Armenia and Georgia', in *The Cambridge Medieval History*, vol. 4/1, Cambridge, 1966, p. 628.

2 The Transmission of Artistic Ideas in Georgia

Antony Eastmond

Throughout this exhibition, it becomes clear that Georgia has for millennia been a meeting place for peoples traveling between Europe and Asia. Many have come seeking conquest, both in the Caucasus and with their eyes on more lush prizes beyond, but men and women have also traveled through Georgia seeking riches, protection, trade, or spiritual goals. This constant flow, both welcome and unwelcome, has left its mark on Georgian culture. It has given Georgian art a sumptuousness and variety seen in few other countries, as new ideas have been combined with local traditions. Easily portable works of art such as icons, manuscripts, metalwork, and enamels could be and were brought into Georgia and so influenced the local culture. Georgian rulers based much of their wealth on tolls exacted from the trade caravans that passed through their cities, such as Artanuji, which was famed in the tenth century for its merchant wealth. And in the thirteenth century the Armeno-Georgian noble family, the Mqargrdzelis, seem to have built a series of caravanserais (all based on Seljuk Turkish designs) to attract trade to their chief city of Ani (currently in Armenia), which they ruled as a fiefdom under the Georgian crown. Ideas and artistic forms were also siphoned through the many portable art objects that could be carried and traded on such trips.

But this model of transmission was not just a passive force: Georgians did more than simply 'absorb' whatever cultural ideas the dominant power of the time imposed. They were careful to take only what they needed and could control, and were able to adapt these ideas to their own requirements. There was also a strong local culture to which the Georgians could turn for strength and inspiration. This is particularly apparent in the early centuries of Christianity, when the Georgian church and the neighboring Armenian church

shared precisely the same belief system. From this period a series of monuments survive from both countries which are very similar, but unique in the wider Christian world. The complex interplay of internal spaces seen in the famous church of Jvari overlooking Mtskheta (see IV.3) is almost identical to that seen in the Armenian church of Echmiadzin; and the unusual long-sleeved dress worn by the donors of Jvari, as depicted on its reliefs, is worn by Armenian nobles portrayed at Mren. In later centuries the Georgian and Armenian churches were to split, but this legacy of artistic ideas remained.

Moreover, Georgians actively looked abroad for inspiration to supplement what they had at home. We know, from chronicles, of medieval Georgian merchants traveling throughout the eastern Mediterranean world; they are recorded, for example, at the great annual fair devoted to St Demetrios in Thessaloniki in northern Greece. Noblemen also traveled abroad to make their names in the larger arenas that the great empires could provide. In 1083 Grigol Pakourianisdze, who had made his fortune as the Grand Domestic in the West (a military title) to the Byzantine emperor, founded a monastery at Bachkovo (in modern Bulgaria) which, according to its foundation charter (see II.2), was reserved for Georgian monks. It was used by monks on their way to visit Constantinople to study. Its most famous inhabitant, Ioane Petritsi, was an important neoplatonic scholar. He was subsequently appointed abbot of the new monastic foundation of Gelati, outside Kutaisi, built by King David *Aghmashenebeli* ('The Builder'; r.1089–1125). Earlier in the century, Melkisedek, the *catholicos* of Svetitskhoveli, in Mtskheta, had made two trips to Constantinople and on each occasion, we are told by the medieval chronicler of *Kartlis*

Tskhovreba (*The Life of Georgia*), was given 'ornaments for churches, icons and crosses, vestments for prelates and priests' by the emperor. The number of Byzantine objects that survive in the museums of Tbilisi, Kutaisi, and Mestia bear eloquent testimony to the quality and beauty of the objects that were brought to Georgia by such personal contacts and individual travelers.

These monks and clergymen formed a second trading network, parallel to that of merchants and laymen. They traveled from monastery to monastery, taking with them ideas and objects to and from Georgia. Georgian monasteries were established in the main urban centers (Constantinople, Antioch, Jerusalem) and in broadly monastic areas (Mount Athos, Mount Sinai, the Black Mountain) as well as elsewhere in the East Christian world, including Cyprus (see II.2). Some of these monasteries, notably Iviron ('the monastery of the Iberians', i.e. Georgians) on Mount Athos, were specifically founded to produce Georgian-language translations of major theological works to send back to Georgia. The importance of the work done by the early translator monks, such as

Ekvtime and Giorgi Mtatsmindeli, was such that they were revered as saints from soon after their deaths. The texts they produced and decorated helped to modernize the Georgian church. Thus in the eleventh century, beautifully written and illuminated manuscripts which were taken to Georgia revolutionized the practices of the church there, and led to a shift in religious orientation away from the ecclesiastical centers of the south (Antioch and Palestine), and their more antiquated liturgical styles, towards Constantinople.

Growing ecclesiastical contacts with Byzantium coincided with closer relations between the Bagratid royal family and the imperial dynasties of Byzantium. Georgian rulers traveled to Constantinople to make alliances and receive honorific court titles; many gifts were exchanged. The royal families intermarried, the most famous example being between Emperor Michael VII Doukas (r.1071–8) and Princess Maria (Martha), daughter of King Bagrat IV (1027–72). This marriage was commemorated in a beautiful enamel plaque, which shows the couple being crowned by God. It is probable that it was sent to Bagrat as a gift at the time, and was then

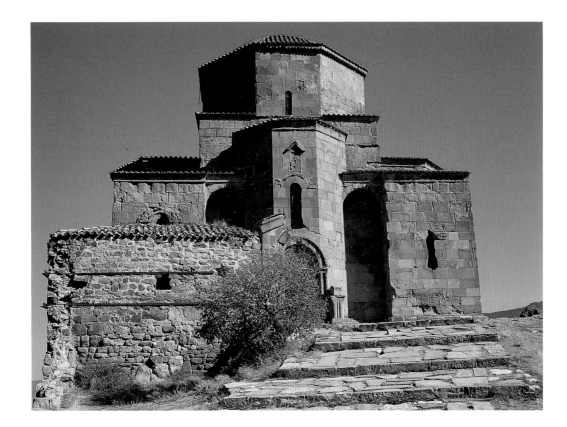

Jvari Church (Church of the Cross), on bluff overlooking Mtskheta, c.586–604 AD

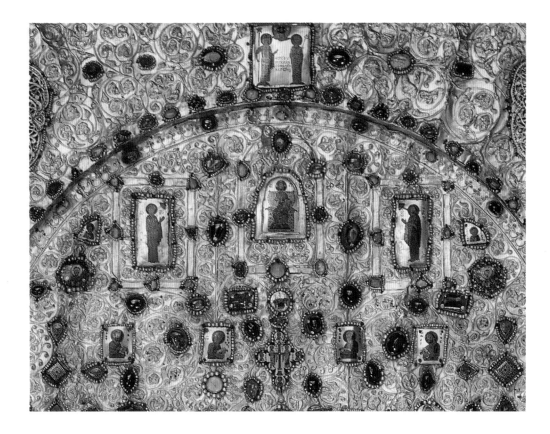

given pride of place above the Mother of God on the Khakhuli triptych (see IV.6).

Byzantium was the dominant cultural force in the region well into the thirteenth century, and the impact of its religious and cultural ideas is apparent in all aspects of Georgian art, from enamels and manuscripts to wall paintings and even architecture. King David the Builder's foundation of Gelati, with its hospitals and academy in addition to the normal array of monastic buildings, is clearly modeled on the imperial Byzantine philanthropic foundations of Constantinople, such as Alexios I Komnenos's *Orphanotropheion* (Royal Orphanage) or John II Komnenos's *Pantokrator* monastery.

However, this Byzantine influence was always tempered by local traditions, and it was never an exclusive model. The Georgians remained open to ideas from other cultures, notably that of the local Muslims. Tbilisi had, after all, been a Muslim emirate for four centuries before its recapture by King David the Builder in 1122, and as Georgia expanded, its territories came to include many Muslim subjects. We

know that King David and his son Demetre I (1125–54) both attended Friday mosque in Tbilisi and supported Muslim scholars and mystics. Ibn al-Azraq, a Muslim writer who was employed as a secretary to the Georgian king, wrote that he had witnessed on King David's part 'such esteem towards the Muslims as they would not enjoy even if they were in Baghdad.' It is from this period that we find bilingual Georgian–Arabic coins and Georgian translations of Persian scientific manuscripts. The most famous example of this Persian strand in Georgian culture is the *Astronomical Tract* of 1188 (A-126; see IV.1, 8), whose delicate line drawings of the zodiac symbols draw heavily on Persian models. Contemporary portraits of Queen Tamar show her with very similar features (such as a round face and narrow eyes) to those of the personification of Virgo in this manuscript, indicating the importance of Persian ideals of beauty at the Georgian court.

After the Mongol invasions of the thirteenth and fourteenth centuries, the center of gravity in Georgia in political and cultural terms shifted even more profoundly to the east,

toward Persia. In the sixteenth century, the Persian empire of the Safavids, which indirectly controlled much of eastern Georgia, became particularly powerful. In the west, Muslim Ottoman sultans had replaced the Christian Byzantine emperors by the middle of the fifteenth century, and now competed for power and influence in western Georgia. Georgia was thus surrounded by Muslim states, and this inevitably affected the art that was produced during these centuries.

What is most striking, however, is that despite the enormous pressures brought to bear by these two powers, the Christian traditions of Georgia remained strong. Some families and regions converted to Islam for convenience, advantage, or belief, but most of the country remained resolutely tied to Christianity. However, the church could never be the great innovator in Georgian society that it had been before. The Georgian monasteries abroad were lost one by one, through slow decline, heavy taxation that forced the monks to leave or sell their institutions, or war and terrible devastation. These losses made the church more insular and confined, and the churches, wall paintings, icons, and ornaments that were produced in these later centuries inevitably reflect the limited access clergymen and monks had to the wider Christian world. More and more, they looked to the past traditions in their own country, and modeled their art on what had been produced in earlier centuries. This did not mean that Georgian art became sterile or static – indeed, the icons and churches of the fifteenth to the nineteenth centuries show how much vitality there was in the continued refinement of traditional Georgian art forms. However, there was certainly no longer the same vigor for innovation that had existed in the past, stimulated by external ideas.

The more dynamic sphere in Georgian culture in these later centuries was the secular world, led by the nobility of Georgia, many of whom were employed or educated at the court of the Persian Shah. They began to explore and appreciate the potential of Persian art. As in the previous periods, the main vehicle for the transmission of these ideas and motifs back into Georgia seems to have been manuscripts, but now manuscripts of secular poetry rather than of theological texts. A series of manuscripts of Shota Rustaveli's epic poem *Vepkhistqaosani* (*The Knight in the Panther's Skin*),

which were copied and decorated from the sixteenth century onward, show how well the courtly ethos of the poem was suited to the decorative aesthetic of Persian miniature painting. The rich colors and picturesque 'carpet' layout of the images convey the romantic aspects of the poem and its exoticism particularly vividly (see II.3).

This interest in Persian forms had an impact on architecture, and here is one area where it is possible to trace the influence on specifically Christian art. The pointed brick arches and tiled exteriors that were used to decorate the great Safavid mosques of Isfahan, Persia, can be seen echoed in the broad pointed arches of the sixteenth-century gatehouses at the entrances to many monastic complexes, such as that at Timotesubani, in the very center of the country, or in the decorated brick belltower at Ninotsminda, in the northern central province of Racha.

Similarly, eighteenth-century portraits of the Georgian nobility look to the court styles of Persia for their inspiration. Yet the faces (narrow and long, with wide eyes) and dress styles of the men and women depicted once again reflect the resilience of the Georgians' own fashions and culture. And they have little in common with the neoclassical fashions of the court of Catherine the Great in Russia. She looked to Western Europe to import art and architecture into her country, but at the same time her growing empire was just beginning to look to the south – to the Christian Caucasus – as a possible avenue of imperial expansion. Even after the Russian annexation of Georgia in 1801, the impact of Russia on Georgia was slow to filter through: although the Russians welcomed Georgia as a Christian bulwark against Islam, it was still regarded as a wild and uncouth place – to which dissidents like the poet Lermontov were exiled. Georgia responded as it always had: absorbing what was useful, resisting the imposition of what was unneeded, and continuing to maintain and evolve what can only be called its Georgian sense of self.

3 A Brief Introduction to Georgian Architecture

Gia Marsagishvili

I

More than ten thousand medieval architectural monuments have survived in Georgia, mainly from the periods of Christian domination. These include monastery complexes, churches and cult constructions, sepulchres, palaces, fortresses, and towers, as well as houses and commercial buildings. The history of Georgian architecture, however, does not begin in the Middle Ages – Christian architecture grew from architectural ground that was already mature. A substantial array of prehistoric and pre-Christian constructions or their remains are known from archaeological excavations.

In Georgia, as in other places, humans found shelter initially in natural caves during the Paleolithic period. The earliest examples of architectural enterprise known at present derive from the late Neolithic period (fifth and fourth millennia BC) and are located at Shulaveri-Gora and Imiris-Gora. Archaeological data enable us to understand the plan and particular details of certain structures – such as the early circular form of domestic dwellings, which later, by the third millennium, became squared – and also to garner important information about early building techniques. We can also define the categories of construction and their compositional peculiarities, and even reconstruct their appearance with some precision.

Greek and Roman authors of the last half-millennium BC and the early Christian era wrote about the high quality of Georgian architecture. Xenophon (fifth–fourth century BC), Strabo (first century BC–first century AD), and Vitruvius (first century BC) describe the architecture of Colchian (Egrisian or western Georgian) cities, their canal systems, fortifications, palaces, and tastefully decorated houses – noting the turrets attached to wooden structures and the tiled roofs – as well as marketplaces and public buildings.

The Georgian Middle Ages are defined as the period from the adoption of Christianity in the early fourth century AD through the end of the eighteenth century. During this period, as in Europe, Christianity and the feudal economy were the main factors impelling social and cultural development. The majority of surviving evidence concerns ecclesiastical architecture, on which the greatest resources were lavished, but there is some evidence for secular architecture, too.[1]

However, it is from ecclesiastical buildings, which were always the principal architectural focus for Christian communities, that we can learn most about Georgian building. Georgian churches most effectively reflect the style of a specific national character as it emerged during the long medieval epoch. Throughout their history, moreover, most Georgian churches were built of well-dressed ashlar stone, which has meant that they and their carved sculptural decorations have survived as well.

1 Most secular buildings were constructed of wood and so have not survived. Of those that do survive, most are defensive structures, including castles and the famous stone tower villages of Svaneti and Tusheti in the northwestern and central mountains (where defence was required against feuding neighbors as much as against foreign invaders). Remains of a large fortified palace with a central audience chamber survive at Geguti, in the western part of the country, just south of Kutaisi, and textual sources indicate how lavishly such royal sites were decorated. We can also piece together some aspects of medieval life from rock-cut citadels such as Vardzia, in the southwest, since water channels, stables, living quarters, kitchens, and storage areas (for both food and wine) are all preserved in the rock. From the seventeenth and eighteenth centuries examples of wooden housing survive, the majority with beautifully carved façades, and also *darbazis*, hall houses with conical domes constructed by building up square or octagonal frames of ever-decreasing dimensions. – ed.

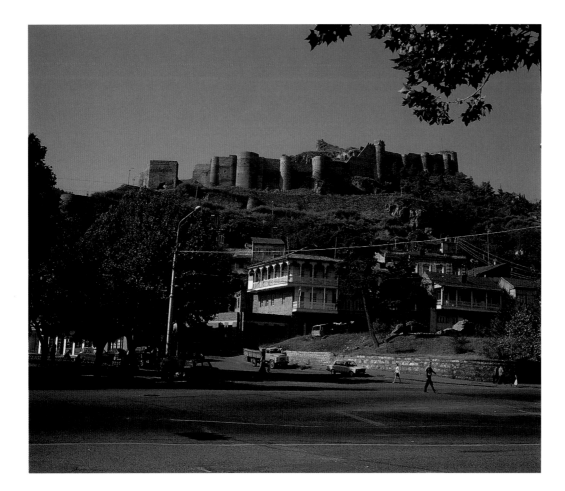

Tbilisi: the remains of
the ancient citadel of
Narikala from the
4th–8th century AD,
rising above the old city

II

The types of churches built in Georgia are in part familiar from elsewhere in the Christian world. In the first centuries of Christianity, from the fourth century until the Arab-Muslim invasions of the seventh century, two principal types of building developed in parallel: the basilica (a rectangular construction whose interior is usually divided lengthwise into three aisles, separated by colonnades, and which focuses on a rounded apse at the end) and the centralized dome building. We also find many small single-nave hall churches; most of the village churches belong to this category. Georgian medieval ecclesiastical architecture is notable not only for its vast scope (as noted in various written sources), but also for its complex and varied artistic solutions developed by masons and builders to deal with the various architectural problems posed by the liturgical requirements of the church. Naturally, the methods of church construction were initially

imported from the early centers of Christianity, but such importation swiftly moved beyond mere imitation. New and original processes of visual thought emerged as new ways of artistic expression were sought. These included variations on familiar stylistic elements.

The basilica structure, which had spread throughout Georgia during these early centuries as a legacy of the Hellenistic and Roman world, offered a form completely foreign to local architectural tradition. Examples include those at Dzveli (Old) Shuamta and Tskhrakara ('Nine Gates') in Matani in the easternmost part of the country (both dating from the fifth century). The design was soon adapted to local needs, and by the end of the fifth century a new stage of development offers churches with the usual characteristics of a basilica but with certain Georgian modifications that will fast become national characteristics. The earliest and most imposing examples of this type are the Sioni (Zion)

church (at Bolnisi) and Svetitskhoveli basilicas. Both structures add two additional side corridors to parallel the nave and aisles. The latter structure was built by King Vakhtang Gorgasali to replace the fourth-century wooden church ascribed to King Mirian, but is actually known only through excavation, as it was in turn replaced, between 1010 and 1029, by the present domed cathedral.

From this basic, three-aisled design (sometimes with an additional gallery on each side, as seen at Bolnisi Sioni), the basilical form developed in more dramatic ways. The most unusual of these is the so-called 'triple-church' basilica. From the exterior this appears to be a normal basilica, but its interior structure is completely altered: the nave and aisles are separated by solid, continuous walls instead of by colonnades. This effectively divides the interior lengthwise into three virtually separate churches. Two of the earliest examples of this are found at Kvemo (Lower) Bolnisi in the south and Vanati in the north (both dating from the fifth to sixth century). Basilicas of this type are unique to Georgia and continued to develop until the end of the tenth century, when the various separated elements began again to be reunited back into the same space.[2]

The second design used for churches, which developed during the same period, was that of the domed, tetraconch monuments. In these the central dome is surrounded by four apses of roughly equal size, which give the church a cruciform shape visible on both exterior and interior. Early examples of these churches include the first church at Manglisi (fifth century) and the Dzveli (Old) Gavazi church (sixth century). The tetraconch form gradually began to evolve as more elements were combined with this basic design to produce churches which, in ground plan, have an extremely sophisticated interplay of spaces. In its 'intermediate' form, as at Ninotsminda, in the northeast, side bays were set between each of the four apses; the tetraconch form culminated in a spectacular series of churches, whose most famous example is the church at Jvari, overlooking Mtskheta (built between c.586 and 604). Here the side bays were converted into corner chambers and the four semi-circular apses were brought almost completely within the thickness of the façades.[3]

At Jvari we witness a harmonious relationship between interior and exterior forms. Moreover, many figural and decorative scenes are carved on the church façade, particularly around the south doorway and main, east apse. By the seventh century the erection of freestanding stelae had become redundant, and the decoration of church façades became more common. From this point on, the execution of the façades of churches gained a new independent artistic importance. Moreover, after Jvari, domed structures became dominant in ecclesiastical architecture.

The articulation of the exteriors of churches was further developed in the seventh century (626–34) at Tsromi, in an unusual building with its dome held up by four freestanding columns. This church introduced a new system of façade decoration by employing a blind arcade to emphasize and unite elements of the east façade. This device was to become an almost universal feature of Georgian architecture, and in many churches the blind arcade runs all round the exterior.

III

The Arab invasions at the end of the seventh century ended this first phase in the development of Georgian architecture, as the country was plunged into economic and political collapse. It was only at the beginning of the ninth century – as the political life of the country began to revive – that church building began again in earnest. At first it was concentrated in the region of Tao-Klarjeti, in the southwest of the country, where Ashot I Bagrationi had established himself as king, on the border of the Byzantine Empire. Many of the domed churches erected within his realm were the work of the energetic monk Grigol Khandzteli (Gregory of Khandzta), who was later declared a saint. This was to prove very important as it was through the communities of monks

2 The purpose of these small, divided spaces is unclear. It is assumed that they were used for the separate celebration of the liturgy, although their awkward shape (many are very long and thin) would make this difficult. – ed.

3 This is a design with very close parallels in contemporary Armenian architecture. It results in an exterior that can be plotted within a clear rectangle, but an interior that is divided among many spaces. When seen as a ground-plan drawing, the clarity and beauty of these designs is apparent. – ed.

that Grigol established at each new site that agriculture was re-established, the areas were repopulated, and his efforts thus helped to revive the economy.

As the Christian rulers established and extended their power in the course of the tenth century, many Georgian churches were rebuilt and enlarged to accommodate the growing needs of the recovering communities. This process culminated at the end of the century, when the greatest period in Georgian architectural innovation began. A series of churches was built which, combining the longitudinal axis of the basilica with the domes and multiplication of separate spaces of the centralized churches, were of unprecedented scale, complexity, and majesty. The church at Oshki (160 x 105 feet, or 49 x 32 metres), built by David Kuropalates between 963 and 973, has apses to the north, south, and east of the crossing dome and a long nave to the west. On each

side of the three main apses are two stories of chapels, and long divided aisle chapels run along either side of the nave. The function of all these spaces has still not been satisfactorily established.

Built by the ruling elite of Georgia at a time of national unification, these churches are located in all the regions that came to be controlled by the Bagratid dynasty and are often of enormous dimensions: Bagrat's cathedral at Kutaisi measures 165 x 120 feet (50 x 37 metres), that at Alaverdi in Kakheti measures 163 x 145 feet (50 x 44 metres), and Svetitskhoveli Mtskheta, rebuilt by the *catholicos* Melkisedek, is 200 x 87 feet (60 x 26 metres). Such structures are all far larger than anything being erected by the emperors of Byzantium at this time.

In the following centuries, the Golden Age of Georgian history, many hundreds of churches were built, but most to

Opposite | Jvari Church of the Holy Cross, on bluff overlooking Mtskheta across the Aragvi and Kura rivers, c.586–604 AD

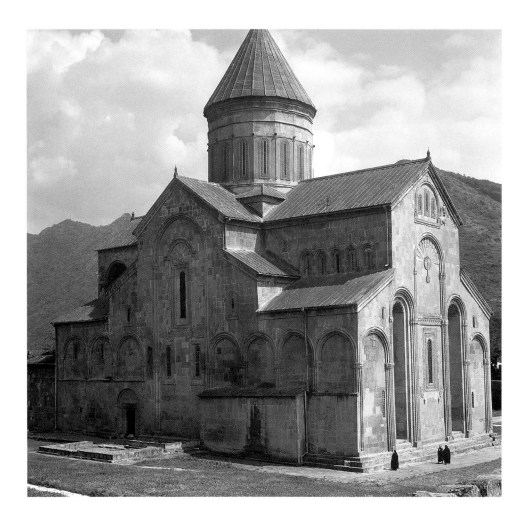

Left | Svetitskhoveli Mtskheta cathedral, 1010–29 AD

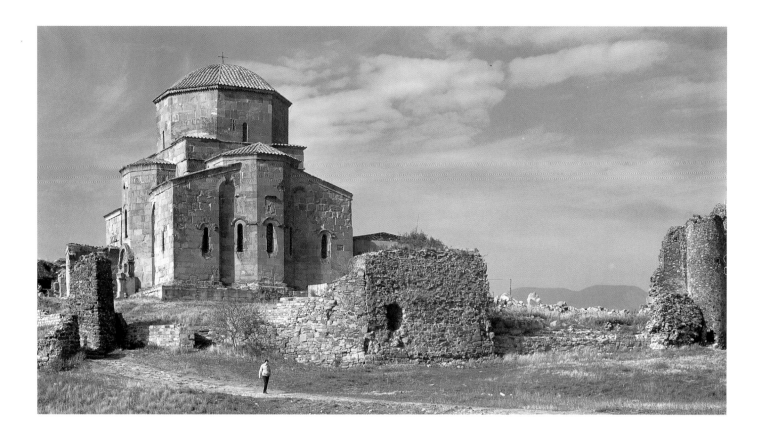

a rather simpler design. They were also generally built to a smaller scale than the giant structures of the late tenth century, but are no less magnificent in their design, construction, or decoration. The most perfect example of these is the church at Samtavisi, in the center of the country (c.1030). Its design is a cross-in-square with a dome above the crossing of the nave and transepts and with a main apse and side chapels to the east. This is similar in form to Byzantine churches of the same date, but with many characteristic Georgian features: the whole church is built of fine ashlar stone, it has a high conical dome, and it is still rigidly held within a rectangular ground plan. The apses remain within the thickness of the east façade and are articulated only by niches and the arcading of the exterior wall as well as by magnificent carved decoration, centered around a large relief cross over the main window. Variations on this theme can be found well into the thirteenth century, as at Pitareti and Tsughrughasheni.

After the Mongol invasions of the thirteenth century and the later devastations of Tamerlane in the fourteenth century, there was significantly less architectural innovation, and in later centuries many Persian influences can be discerned. However, in general, Georgian architecture retained the forms developed in the eleventh century. The new capital of Gremi built by Levan of Kakheti in the mid-sixteenth century has a royal church which copies the earlier models, although now built of brick, with tile decoration on the exterior and a significantly elongated dome; and in the seventeenth century the fortress church of Ananuri, on the Georgian military high road in the center of the country, takes the same form.

The enormous wealth of material that has survived allows the history of Georgian architecture to be traced in great detail, although many questions about how the earlier churches functioned remain to be answered. The strength of local building techniques, especially in the use of stone, arcading, and external carved decoration, has carried into modern building and was even adopted for many public buildings of the Soviet period, such as the Parliament building on Rustaveli Avenue in Tbilisi, which, by means of its enormous, attenuated, soaring arches, connects the immediate past to centuries gone by.

4 Medieval Georgian Painting

Zaza Skhirtladze

I

Georgians began to decorate the interiors of their structures in the country's early Christian period. Among the earliest instances of this are the fifth-century floor mosaics in the church of Bichvinta (Pitsunda) on the northwest coast of Abkhazeti, which depict symbolic animals, birds, and fruits; and slightly later pieces in the baths at Shukhuti on the central coastal plain, which depict more abstract, ornamental, and symbolic images. The first monumental figurative images appear in the sixth and seventh centuries: for example, the relief sculptures on the exterior of the church of Jvari, outside Mtskheta (built between 586 and 605), the mosaics of Christ and attending angels in the apse of the church at Tsromi (built c.630), and the beautiful wall paintings in the church of Udabno within the David Gareja monastic complex situated southeast of Tbilisi (built in the seventh and eighth centuries). All these works served to enhance rather severe structures.

Until the end of the tenth century, paintings in Georgian churches decorated only the main areas of the interior, such as the apse and the central cupola above it. Decorative stone-work, in alternating horizontal and vertical rows of bricks, was often integrated with monumental painting to create a single work of art. In the early period, two types of wall painting emerged: aniconic (non-figurative) images, composed of symbolic images, ornamental motifs, and inscriptions – as at the Sioni church at Athens near Gori (seventh century) – and figurative images, generally of Christ and the saints. Images intended to connect Georgia to the Holy Land included sacred scenes set there. Thus mosaics and frescoes that focused on Christ as Savior and the narrative of his death in Jerusalem and ascent to heaven became common. Indeed,

the Ascension was also represented more abstractly by means of the image of the cross ascending to heaven, placed in relief in the church cupola.

The iconoclastic period of the eighth and ninth centuries in Byzantine art barely affected Georgia. On the contrary, icon-making and reverence for icons continued uninterrupted throughout the medieval era. The iconographic themes of the early Christian period continued to develop during and beyond Byzantine iconoclasm. And Georgian wall paintings of the eighth and ninth centuries exhibit a consistent stylistic pattern, although each work is unique. Thus, for example, the wall paintings of Telovani (eighth century), Mravaltskaro (mid-ninth century), Armazi (864), and the four churches at Sabereebi (ninth and tenth centuries) – all due northwest of Tbilisi – share similar traits: a hieratic two-dimensionality, with no attempt to convey volume or naturalistic body proportions. On the other hand, this stylization is balanced by individualized detail, especially the dilated eyes and enlarged palms of the hand, which are distinct for each figure. The wall paintings of this epoch are also marked by a particular relish for decorative elements, especially in the complex handling of drapery folds.

These are features which depart from the Classical style extending back into the Roman and Hellenistic periods. They echo similar efforts throughout the world of early Christian art to subordinate the imagery of the material – a full, volumetric representation of the human body – to that of the spiritual. They also mark a first step on the road to developing a national idiom in painting. In the eighth and ninth centuries, isolation from Byzantium, which was in part a result of the Arabo-Islamic invasions, contributed to the acceleration of this process. On the other hand, the gradual

Detail of mosaic church floor
of Bichvinta (Pitsunda),
5th century AD

liberation of the country from Muslim control and the push toward a unified state in the tenth and eleventh centuries helped further to impel the creation of a national Christian culture. Thus the hagiography of national saints developed, with the art that depicted their actions. St Nino, who solidified the presence of Christianity in Georgia; St John Zedazneli, bringer of monasticism to Georgia; Saints Shio Mgvimeli and David Garejeli, two of the thirteen Syrian fathers who introduced the notion of a strict, ascetic life to Georgia, all became the subject of individualized iconography. At the same time, wall paintings began to be used to promote the secular hierarchy as depictions of Georgian kings, aristocrats, and prominent church figures, all of whom were important as donors and patrons of church construction and decoration, became part of the program of church wall painting.

II

The Golden Age in Georgian Christian art begins to take shape at the end of the tenth and beginning of the eleventh centuries. From that time onward through the next 300 years, the decoration of Georgian churches with monumental paintings, including entire fresco cycles, flourished and became part of the whole design scheme. The repertoire of scenes and images was similar to that of Byzantium, but by no means identical, as the iconography remained connected to earlier Georgian patterns. Thus, for example, paintings in the cupolas of Georgian churches generally depicted the Ascension of the Cross in the hands of angels or the Cross in a mandorla, rather than the image of Christ as *Pantocrator* typically found in the cupolas of Byzantine churches; and the image of the Deesis* or Christ in Glory or Enthroned with the Virgin Mary at his side in the apse of the church.

Wall paintings of this epoch are distinguished by monumentality and simplicity: large compositions present a few prominent figures, which are clearly discernible against simple landscapes or architectural backgrounds. A strong,

* Image of the crucified Christ flanked by the Virgin and usually the Evangelist John (sometimes John the Baptist), with the two of them looking out toward the viewer and gesturing toward the figure of Christ, as if 'presenting' him, and his sacrifice, to the viewer. – ed.

supple line is evident, in contrast to the less emphatic line of Byzantine monumental painting in which gradation of color is more important than emphasis of form, and brilliant colors and warm tones contrast with the more restrained colors of Byzantium.

Distinct schools of painting gradually begin to emerge in the tenth century in different parts of the country – in Tao-Klarjeti in the southwest, Gareja in the eastern part of the country, and Svaneti in the north. Some of these monastery-centered schools continued for several hundred years. Each had separate historical phases, as this one or that fell under the spell of a brilliant master whose work contrasts with the more mediocre frescoes of local artists. To the art historian, however, the work of both is important in telling us about the two ends of the artistic scale: artistic innovations as well as the survival of popular traditions.

The most important of these regional schools was that in Tao-Klarjeti. In the second half of the tenth century and the beginning of the eleventh, this was the principal center of Georgian political as well as cultural development. The frescoes in the monasteries and churches of Otkhta Eklesia, Khakhuli, Oshki, and Ishkhani were commissioned by members of the royal Bagrationi family between the end of the tenth and the beginning of the eleventh century and all attest to the high level of artistry that was achieved at that time. They were clearly influenced by artistic developments in Constantinople, which the artists combined with local traditions; and, in turn, these paintings influenced developments elsewhere in Georgia, as can be seen in the fragmentary eleventh-century paintings in the cathedrals of Kumurdo in Javakheti, and Manglisi in Kartli. The paintings in Tao-Klarjeti vary from the monumental and grandiose at Oshki (which was painted in 1036) to the refined and ethereal at Ishkhani. The magisterial image of the Ascension of the Cross in the dome shows four angels, their bodies in sinuous curves and their robes a dense mass of rippling folds, hovering against a star-filled sky. Above their heads they hold a colossal radiant, jewel-studded cross, and their elegant faces shine forth with emotion. This is one of the masterpieces of Georgian painting; indeed, it ranks as one of finest paintings from anywhere in the East Christian world in the mid-eleventh century.

The art of the Tao-Klarjeti school would yield still later progeny: works at the Sioni church in Ateni, in the center of the country, continued the Tao-Klarjeti tradition in the second half of the century. The wall painters at Ateni solved the problem of how to integrate their work into the architectural format of the old – seventh-century – Church of the Mother of God. They followed the tetraconch articulation of the walls (see IV.3), decorating each of the four apses with four separate narrative cycles. Thus the Virgin Mary as Mother of God, together with archangels, is featured in the eastern (the main) apse. The northern apse offers the life of Christ; the southern balances this with a narrative cycle of the life of the Virgin; and a Deesis* surmounting a representation of the Last Judgement occupies the vault of the western apse. Although created by a group of different artists, the work is a unified whole, its integrity strongly present in the uniformity of the expressive faces, elegantly proportioned figures and picturesque poses and gestures, emphasized by black borders, and the charming floral finish to the compositions.

Meanwhile, at Gareja in the semi-wilderness of Kakheti in eastern Georgia, wall painting also flourished at the large monastery complex founded in the sixth century by the hermit St David Gareja (one of the Syrian Fathers; see IV.5). The extensive wall painting program throughout the complex of cave churches and monastic living spaces reflects a creative history extending from the ninth to the thirteenth centuries. It is sufficiently distinct to be viewed as constituting its own stylistic school. The composition is simple, using a palette of yellow gold, dark red, green, blue, and white. In the portrayal of Christ's life in many monasteries, the images of monks as well as of the cycle of St David's life are often also included. In the refectory, appropriately enough, the Hospitality of Abraham to the Three Angels is portrayed, together with other meal-related scenes such as the Last Supper and the Miracle of the Loaves and Fishes; and the locally important scene of God sending does to St David and to his disciple, St Lutcian, to provide them with milk.

Unique stylistic elements are associated with the school of wall painting that evolved in Svaneti, in the mountains of northwestern Georgia. The most striking works at Svaneti were executed by the court painter Tevdor (Theodore), a Svanetian by birth. Inscriptions tell us that, aside from his work for the royal house, he served several local feudal lords, thus decorating the Church of the Holy Archangels at Iprari in 1096, the church of Sts Quiricus and Julitta (Kvirike and Iviita) at Lagurka in 1112, and the church of St George at Nakipari in 1130. His style ranges from serene earlier works to more dynamic and ultimately more decorative later works, in which his epitome of the main features of Georgian, and specifically Svanetian, wall painting of this period includes a distinctive representation of faces with large eyes, long but well-proportioned features, and passionate expressions.

One chronological step beyond the later work of Tevdor is the Church of the Savior at Matskhvarishi, decorated by another Svanetian painter, Mikael Maglakeli, in the 1140s. Mikael's is a more decorative style than that of Tevdor, yet also more archaic in its harsh lines. His work includes a unique subject, the coronation of King Demetre I, in which the elaborate ceremonial practices and garb of twelfth-century Georgian royal and noble life are visually explored.

One of the outstanding examples of church decoration of this period is to be seen in the principal church of the monastery at Gelati, in the region of Racha, south of Svaneti (1130s). The vault of the Gelati church apse is covered by a mosaic that presents the Virgin with the Christ Child on her lap, flanked by the Archangels Michael and Gabriel (see illustration, p. 90). The gold background contrasts dramatically with her dark-blue cloak and the emerald-green, gold, and light-purple of the angels' military cloaks. The ascetic faces recall Byzantium; the linear quality of form is typically Georgian. So, too, the manner in which the Virgin's left hand supports the Child and the lightness of the figures is unique in the Georgian art of the period. It seems likely that this is the work of a Georgian artist who studied in Constantintople.

In the narthex of the same church, fragments of the twelfth-century paintings survive, showing a subject not often depicted: the Seven Ecumenical Councils to decide all church doctrine. In imitation of these, David the Builder (see IV.1) convened two councils of his own, one at Ruis-Urbnisi in 1103 to reform the Georgian church, and a second at Gelati itself in 1123–5 to discuss church unity with the Armenian church. In the images at Gelati, the Miracle of Saint Euphemia at the Council of Chalcedon, in 451, is given extra prominence, since it was this miracle that proved the

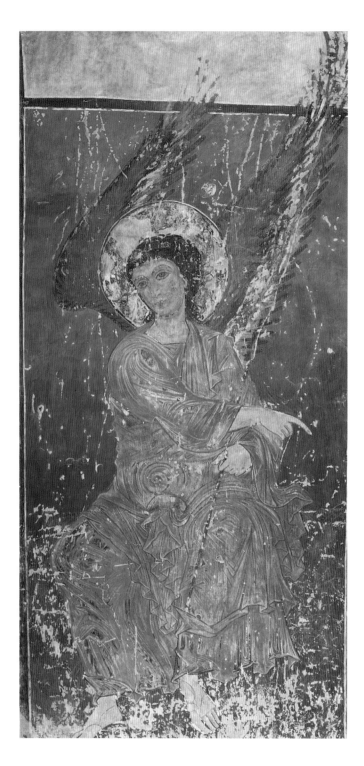

Detail of wall painting from
church in Kintsvisi, located
in a gorge of the Dzama River
in the Kareli Region, the angel
gesturing to the empty tomb
of Christ; early 13th century AD

fallacy of the Monophysite (Armenian) doctrine. In stylistic
contrast, the side chapels were painted in the last quarter of
the thirteenth century and in the fifteenth century, in what
resembles the Byzantine Paleologus style, characterized by
shifting tones and a kind of chiaroscuro, as opposed to the
traditional flattened, linear quality of the earlier works. The
frescoes of the central part of the interior of the church
belong mainly to the sixteenth century. There are also layers
of seventeenth- and eighteenth-century wall paintings in the
northern aisle and in the narthex. These frescoes include
portraits of more secular subjects: kings, local nobility, and
historical figures from different epochs. The range of subjects
thus complements the range of stylistic periods in this
church's decorative scheme.

III

The next phase of Georgian monumental painting occurred
during the second half of the twelfth and first half of the
thirteenth century. It is characterized by a tendency toward a
decorated style (as in the churches of Ikvis, Pavnisi, and
Ikorta), a growing dynamism, the integration of lengthier
inscriptions into the decorative scheme, and a progressively
cooler palette. The most clear-cut instances of the new style
are associated with the reign of Queen Tamar (1184–1213),
and are found in the Vardzia church complex, the main
churches at the Bertubani and St John the Baptist monas-
teries in the Garedzi desert, and the St Nicholas churches
at Kintsvizi and Betani – in the last two of which superb
portraits of Queen Tamar and members of her family are
among the images.

Together with paintings at Timotesubani, Ozaani, and
Akhtala, these frescoes reflect the elegance of a circle of court
painters. The Betani and Vardzia cave church complexes have
wall paintings full of striking colors: dark blue, red-brown,
grey, and white figures against grey-blue backgrounds. The
murals at Kintsvizi present shades of pale green, blue, golden
yellow, deep red, and white against an intense lapis lazuli-
like blue. Golden stars in the deep night sky further enhance
the imagery, which offers an elegant, flowing style of inscrip-
tion. At the desert monastery of Bertubani, more limited but
powerful color schemes include dark blue, scintillating
white, and various shades of red-brown. Subject-matter in

this culminating era of Georgian political power emphasizes royalty and attendant nobility.

The Golden Age of Georgian painting, then, peaking from the time of David the Builder (r.1089–1125) to the Mongol invasions of the 1330s, is well represented in these monastery and church complexes. In the wall paintings of the Racha region, a close visual relationship in composition, iconography, and facial type with that of neighboring Svaneti is evident. There are frescoes in the Church of the Archangels at Zemo Krikhi, destroyed in the earthquake of 1991, showing *kritors* (local rulers) in the late eleventh- and early twelfth-century iconography that later yields to the portrayal of David's great-granddaughter, Queen Tamar.

In the second half of the thirteenth century, with the Mongol invasions, Georgian wall painting followed time-honored decorative paths. In western Georgia, which suffered less from the devastation, there is evidence of a turning back toward Byzantium and its artistic traditions. By the end of the century a new Paleologus style began to assert itself in Georgia, first evident in the Church of St George at Atchi. This style soon spread through much of the country. Thus, for example, the painting on the eastern wall of the south transept of the church at Gelati – which can be precisely dated from the pair of portraits of King David IV Narin (1245–93; he appears once in royal robes and once as an old man in the garb of a monk) – exhibits the elongated bodily proportions and dynamic movement of the new style. The Paleologus tendency is found in paintings of this era in the southern Georgian province of Samtskhe, in churches at Khobi, Martvili, and above all Zarzma. Church paintings of the era abound in portraits of patrons: members of the Jakeli family at Zarzma, and of the family of Shergil Dadiani at Khobi. A few decades later, the family portraits of King Alexander I and the local nobility appear in paintings made between 1413 and 1431 on the walls of the church at Nabakhtevi.

An important step in the rising dominance of the Paleologus style was the invitation by the nobleman Vamek Dadiani to the Greek artist Kyr Manuel Eugenicus to come from Constantinople in order to paint the interior of the church at Tsalensikha from 1384 to 1396. The resulting work, to which local Georgian artists also contributed, is the best preserved example of wall paintings of the Constantinople school of the end of the fourteenth century. The fourteenth-century paintings in the far northern churches of Lagami, Lashtkhveri, Svipi, and Ienashi reflect the influence of this style, even as local traditions – of strong, sober colors and emphatically balanced compositions – were never lost.

During this period paintings began to appear on the outer façades of churches, as at Lagami and Lashtkhveri. At the latter site there are scenes from Georgian folklore – for example, the titanic struggle of the popular hero Amirani and his brothers against demons. Such a scene absorbs the tradition of secular – and particularly battle – subject-matter that, according to chroniclers of the time of Giorgi III, had decorated the walls of palaces (in Rustavi and Gudarekhi, for example, in the southeast and south center of the country respectively) in the twelfth and thirteenth centuries, some fragments of which survive.

Georgian wall painting continued with vigor through the sixteenth century, with particular intensity, for example, in Kakheti during the reign of King Levan, who lived from 1520 to 1577. The late Paleologus style of his era reveals a connection with, and perhaps the importation of, artists from the Mount Athos monastery complex in Greece. A number of western Georgian churches were decorated with new wall paintings in the seventeenth century, their features suggesting Safavid Persian influence, as shown in clothing style and an increasing tendency toward secular subject-matter and a flat, schematic style.

By that time, indeed, the urge to originality had waned, waiting to be reborn in the nineteenth century, when – under the new conditions of a relationship with Tsarist Russia – Georgian painting would reinvent itself on the easel-mounted canvas.

5 Cults and Saints in Georgia

Antony Eastmond

I

The development of Christianity in Georgia was a gradual process. Although the east Georgian kingdom of Kartli was officially converted in the fourth century when King Mirian accepted Christianity after the evangelization of St Nino, it took many centuries for a fully Christian culture to emerge in what was still essentially part of a Persian commonwealth. In these centuries of transition, older pre-Christian cults were absorbed into the church, later to re-emerge in a new Christian guise. This intermingling of older traditions and the new religion led to many features that distinguish the church in Georgia from its other branches around the Mediterranean. New, specifically local saints were venerated, and saints common elsewhere in the Christian world (such as St George or St Simeon Stylites) also became the focus of cults, but in ways unique to Georgia. This mixture of the old and the new, the local and the imported, and the distinct reworking of existing cults makes Georgian Christianity a fascinating object of study.

Pre-Christian images appear in some of the major early churches in Georgia – for example, the great cathedral at Bolnisi (built between 478 and 93) – showing the ways in which successive forms of religion were interwoven in the early centuries of Christian Georgia. Pre-Christian sculptures of bulls' heads are also incorporated into the façade of the entrance gatehouse and the main building of the cathedral of Svetitskhoveli in Mtskheta. To find work of this kind here is doubly surprising, since not only is this the principal church of all Georgia, but we also know that these sculptures were placed here as late as the eleventh century, when the church was rebuilt by the patriarch Melkisedek. Old traditions die hard.

II

The principal cult venerated in Georgia was that of the Cross – the Tree of Life, pre-eminent symbol of Christian salvation. In the same way that a vision of the Cross was central to the conversion of Constantine the Great and the Roman Empire, so too its miraculous appearances and the miracles it performed were at the heart of the official conversion of Kartli, the eastern Georgian kingdom ruled by King Mirian. Unlike the situation in other Christian countries, however, in Georgia the Cross remained one of the central images of veneration. On his acceptance of Christianity, Mirian had three large crosses erected on the mountains overlooking his kingdom, at Tkhoti in the west, at Ujarma in the east, and on a mountain overlooking the capital city of Mtskheta. These crosses proclaimed the new faith and acted as symbolic defenders of the kingdom. They were eventually enclosed within churches, the most impressive of which, Jvari ('the Church of the Cross', built in Ca 584–604), is one of the masterpieces of early Georgian architecture (see IV.3).

Subsequently, the idea of the Cross became a dominating aspect of all Georgian churches, and was represented frequently in all media. Beautiful painted or carved crosses appear in almost all Georgian churches, often in the vaults of porches and in the main domes over the nave. In the Heaven-symbolizing dome of a Byzantine church one would expect to find an image of Christ *Pantocrator* ('Christ as Ruler of All'). However, in Georgia this is normally replaced by an image of the Glorification (or Ascension) of the Cross, with three or four angels carrying the Cross to Heaven, surrounded by a mandorla of holy light. The east façade of many medieval churches is adorned with giant relief crosses carved with exquisite decorative patterns. And at Ananuri, not far north

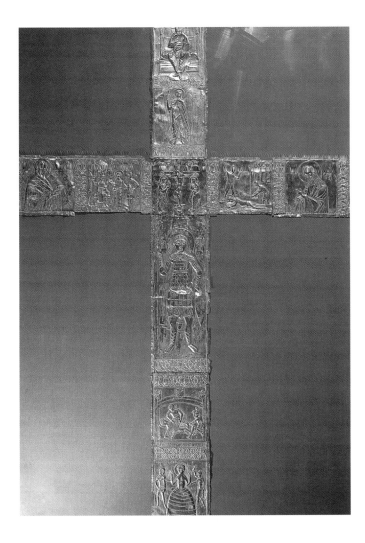

Cat. 139 | Large processional cross dedicated to St George, made of silver, gilded silver, and precious stones, 16th century AD

nave of the church, in front of the altar. Decorated with scenes from the life of Christ or of local cult saints such as St George, they stand up to eight feet (two and a half metres) tall, dominating the interiors of these tiny village churches. Their gold surfaces reflect the small amount of light trickling in through the church windows – and in the past, no doubt, reflected that of the many candles that once lit their interiors.

As a symbol of the sacrifice of Christ, his willing acceptance of humiliating death in order to save all mankind, the Cross acts as a powerful image of the central tenet of Christianity, but it has broader ramifications too. It was believed by medieval Georgians that at the end of the world, all men and women would have their sins judged in front of the Cross and other objects associated with the passion and death of Christ. As a result, the Cross not only looks back to the death and resurrection of Christ, but also forward to the end of time and the judging of souls. It is difficult ever to escape reminders of this in Georgian churches, many of which have enormous images of the Last Judgement on their west walls, portraying the gory perils of Hell alongside the rewards of Heaven. In the apses of churches up to the thirteenth century, Christ appears more often as the fearsome judge of souls than as a compassionate intercessor for man's salvation.

III

In the various regions of Georgia, which were for so long independent of one another, different saints have been venerated, but some saints are revered throughout the Georgian-speaking lands. The most important of these is St Nino, the slave girl brought to Georgia who converted King Mirian in the fourth century. Georgia is almost unique in having been converted by a woman; but despite her importance, St Nino appears very rarely in Georgian art. Very few icons or wall paintings before the twelfth century depict her. It was only when Queen Tamar came to the throne in 1184 that St Nino's cult was more intensely promoted. It seems that Tamar adopted St Nino as a model of the importance and power of women, which reflected her own position as queen.

The impact of foreign saints in Georgia – and the way in which they were transformed into specifically Georgian saints – is shown most clearly by the lives of the Thirteen Syrian Fathers. This was a group of monks who moved to

of Tbilisi, on the south façade of the large seventeenth-century church, the Cross is accompanied by vines bearing an abundant harvest of grapes. This refers both to the story of how St Nino made the first cross in Georgia from vine branches tied together with strands of her hair, and also to the Georgians' long history and love of viticulture.

Perhaps the most striking images of the Cross are to be found in churches in the mountainous northern province of Svaneti. Here large metalwork crosses are often placed in the

Georgia in the sixth century to escape persecution in Syria. They brought with them the practice of ascetic monasticism, living in remote and often inhospitable places, and seeking to emphasize their spirituality by deliberately neglecting their own bodies and overall material needs. All thirteen saints attracted disciples in Georgia, and through them monasteries were established, many of which went on to become some of the most powerful and wealthy religious centers in the country. The Syrian Fathers performed extraordinary feats of endurance, notably St Shio Mghvimeli, who dug a pit deep

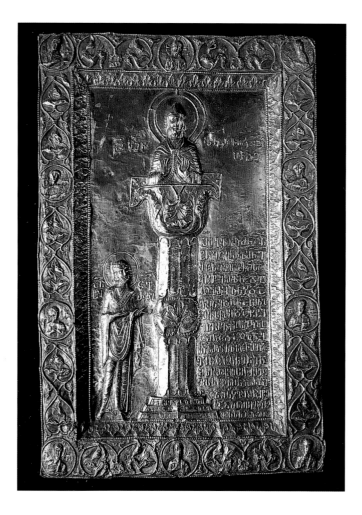

Gold-plated silver icon of St Simeon Stylites, 11th century AD; the long inscription on the right records the icon's history and identifies the artist as Master Philip

into the ground near Mtskheta, at the bottom of which he lived for much of his life. The most famous of the Fathers was St David Garejeli, who lived on Mtatsminda (the Holy Mountain) in what is now Tbilisi before retreating to a cave in the hostile desert region of Gareja (on the modern border with Azerbaijan). David's food was provided by God in the form of tame deer that offered their milk, and drinking water that appeared in caves. The desert location became particularly popular for men trying to escape from the world. At the height of Mtatsminda's popularity between the eleventh and thirteenth centuries, there were some eighteen major monasteries cut into cliff faces in the various parts of the desert, not to mention many small anchorite sites where individual hermits lived in even greater seclusion.

This form of monasticism has parallels in the rock-cut monasteries of the Judean desert and of Cappadocia in Anatolia, but in Georgia it is distinguished by the way in which the monks lived in painstaking harmony with nature. The asceticism of these individuals was remarkable, but their technological astuteness should not be underestimated: they developed techniques to carve impressive rooms, cells, churches, and refectories into the rock. They also constructed very sophisticated water-collecting systems to catch and keep what little rainfall there was. The desert monasteries received a good deal of support from the Georgian royal family, the Bagrationi, especially in the thirteenth century. But they continued, even after the political fragmentation of the country, as active spiritual centers well into the nineteenth century. It was only in the Soviet period that they were finally all closed down as the region was declared a military zone, but in the past decade monks have begun to return to the main Lavra monastery.

Another foreign saint who was particularly venerated in Georgia was the famous stylite monk, St Simeon Stylites the Elder. In the fifth century, Simeon attained his sainthood by reputedly remaining for more than forty years on top of a 60-foot (18-metre) column (the Greek word for column is *stylos*) in the open air in the Syrian desert without once descending to the ground. Simeon and his main successor, St Simeon the Younger, came to be greatly venerated in Georgia and they appear frequently in wall paintings and on icons. Many Georgians gathered at the monastery of Simeon

the Younger on the Wondrous Mountain (as it is called; also known as the Black Mountain) near Antioch, at the northeast corner of the Mediterranean, and this became one of the major centers of Georgian monasticism outside Georgia itself up to the tenth century. The reason for the choice of the two St Simeons for veneration is not clear, but they had a major impact on the Georgians, and the size of the monastery on the Wondrous Mountain meant that it became a point from which many new religious ideas from Syro-Palestine could enter Georgia itself. Such was the popularity of these so-called stylite saints that as recently as 1848 a Georgian monk was recorded as living on top of a pillar in emulation of his holy predecessors.

The most intriguing area for the study of saints in Georgia is the region of Svaneti. Cut off by snow for much of the year, and with a much more resilient pagan culture than other parts of the country, Svaneti offers many instances of Christian saints whose cults are grafted onto earlier pagan beliefs. Thus a thin veil of the new religion disguised the old beliefs. St George, the formidable warrior saint – who would later be taken over as patron saint of England, with a particular emphasis on his chivalric nature, and who tends to be generally thought of as derived from the figures of Perseus and/or Bellerophon in Greek mythology – seems in Georgia to have been a Christian reincarnation of a form of pagan sun deity (or perhaps a Persian moon deity). Alongside him, St Barbara, whose image appears in many Svanetian churches, may have been the Christian version of the moon goddess. The cult church at Lagurka, high above the River Ingush, is dedicated to Sts Kvirike and Ivlita (known in the West as Quiricus and Julitta). These two saints may be linked to pre-Christian hunting rites. In addition, St George is often depicted killing, not a dragon, but the pagan emperor Diocletian, who was supposedly responsible for his martyrdom. Here is a specifically Georgian twist to this otherwise universally venerated figure.

All these saints appear in Georgia, of course, in addition to the customary roster of apostles, saints, and scenes from the life of Christ that can be found in churches throughout Christendom. Their presence, reflected in the distinctive and fascinating art that was created to venerate them, gives a unique flavour to the Georgian church.

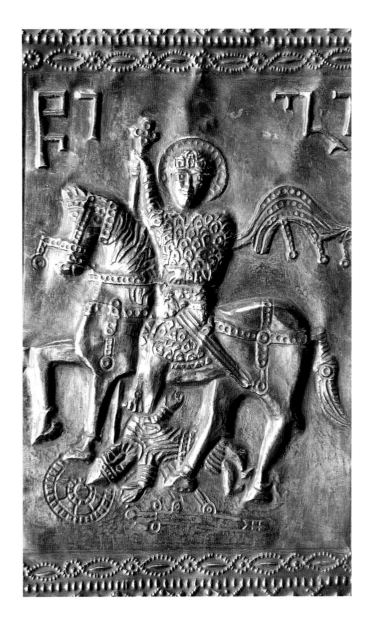

Cat. 117 (detail) | Silver icon of St George slaying Diocletian, from Tsvirmi-Tchobemi, 10th–11th century AD

6 Cloisonné Enamel Art in Medieval Georgia

Leila Khuskivadze

I

The art of cloisonné enamel was as widely spread in medieval Georgia as it was in Byzantium. Though a large number of Georgian pieces have been lost or destroyed over the centuries, the remaining pieces are sufficient to demonstrate its amazing variety and characteristic richness. Indeed, among the few centers of cloisonné enamel production in the medieval world, only Georgia rivals Byzantium. All medieval Georgian enamelwork was executed in the cloisonné technique, in which the enamel is applied to raised cells, created out of soldered wire filaments. The only known example carried out in the champlevé technique, in which enamel is applied to cells carved out of a metal backing, the Jumati Icon of the Archangels, is currently lost.

Like their Byzantine counterparts, Georgian cloisonné enamels were mostly made on a baseplate of 24-carat gold – a material that is not only easy to shape but also susceptible to high-temperature fusion. Sometimes a pale yellow gold-and-silver alloy commonly known as electrum was used; this had the advantage of making the enamel firmer. The baseplate was shaped to form a well. Fine gold wire filaments were then attached to the metal base to form cells (known as cloisons), which were filled with the glass powder that forms the enamel mass. This was then repeatedly fired and thoroughly polished to produce the translucent objects that we now see.

Georgian enamels are all found on religious objects. They form parts of icons and crosses as well as individual plaques and medallions that were used to decorate other metalwork objects. They are generally small in size, although occasionally (as, for example, in the plaques representing the Feasts of the Church and the miracles of St George) they

are comparatively large. The central icon in the Khakhuli Triptych, the image of the Virgin (of which only the face and hands remain), is the largest medieval cloisonné enamel in the world.

The subjects illustrated in Georgian enamel include images of the Savior, the Virgin Mary, various saints (both full- and half-length figures), as well as compositions of the Deesis (see footnote, p. 104), scenes from the cycle of Holy Feasts, and miracles associated with St George. The images are usually accompanied by inscriptions in Georgian or Greek or both languages together, generally executed within the enamel, or, particularly in earlier pieces, within the gold background sections.

Approximately two hundred pieces of cloisonné enamelwork survive in the Georgian State Museum of Fine Arts in Tbilisi. These reflect a wide chronological scope and in most cases are of high artistic quality. The most famous piece is the above-mentioned Khakhuli Triptych, which unites Georgian and Byzantine cloisonné enamels from different periods – the eighth to the twelfth centuries – into one harmonious whole completed early in the twelfth century. Like the *Pala d'Oro* altarpiece at San Marco in Venice, it is its own 'museum' of this branch of art.

A number of important Georgian enamelworks are found not in Tbilisi but in the museums at Kutaisi and Upper Svaneti. Still others are abroad, in various museums and private collections, including the Hermitage Museum in Petersburg, the Armory Museum in the Moscow Kremlin, the Metropolitan Museum of Art in New York City, the Cluny Museum in France, the Museo Lazaro Galdiano in Madrid, the Museum of Historical Treasure in Kiev, and the Museum of the Orthodox Church of Kuopio in Finland.

II

The earliest Georgian cloisonné enamels date from the eighth and ninth centuries. These enamels feature representations of the human body – well before figural imagery appeared on Byzantine enamels (Byzantium long forbade the representation of the human body in religious art). Georgia was not associated with, and was perhaps even unaware of, Byzantine iconoclasm.

Georgian enamelworks of the eighth–ninth centuries are characterized by the following specific features: the use of a distinctive semi-transparent emerald-green background; generally restrained coloration due to the use of such semi-transparent tones of emerald green, purple-brown, and blue; a semi-transparent ground with ornamental decorations; inscriptions executed within the gold partitions; faces with large round eyes and a single continuous gold line connecting the nose with the eyebrows; long and thin partitions defining the folds of clothes; and flat, non-volumetric imagery. This first stage in the history of Georgian enamelwork is connected visually with the early stages of Georgian sculptural art; the stylistic elements and particularly their character of line separate them from those of Byzantium (see, for example, the eighth-century Quadrifolium with the Crucifixion on the Khakhuli Triptych or the ninth-century Deesis of Martvili).

What might be termed the national characteristics of Georgian enamels coalesce by the tenth century. Some traits, such as a widening format and the substitution of enamel backgrounds for gold ones – technically known as the change from *Vollschmelz* (full enamel) to *Senkschmelz* (sunk enamel) – connect works from this period with those of Byzantium. But at the same time, the differentiation of figures and background ornamentation – by a general tendency to outline figures against the gold background and make them more volumetric – relates them to corresponding developments in Georgian plastic art. Both enamels and relief sculpture in Georgia have a marked decorative quality and expressiveness. This contrasts with Byzantine enamels, which aspired to depict ancient forms. An example of such a Georgian style is offered by the Shemokmedi Quadrifolium – which may be dated from the inscription naming King Giorgi II of Abkhazeti (922–57) as its commissioner – with its swaying crucified Christ and expressive faces. A different circle of

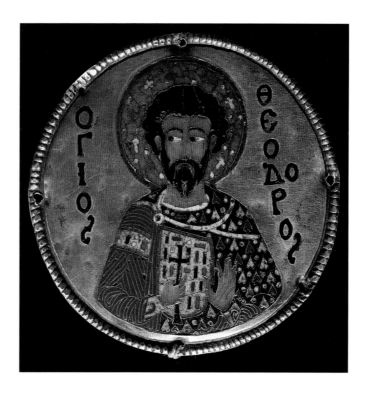

Cat. 125 | Gold and cloisonné enamel medallion of St Theodore, first half of 12th century AD

works is also extant from the same period: those of the proto-Byzantine school, such as the so-called Kvirike Cross (the Cross of St Quiricus, tenth century), with its inclusion of Greek together with Georgian inscriptions, which appears on the Khakhuli Triptych.

Georgian enamels of the eleventh century are characterized by the same intensified orientation towards Byzantium that is also reflected in other branches of Georgian culture. The style presents a more fragmentary, somewhat mosaic-like aspect, faces are especially strained, and numerous thin partitions define the image. Such features are common to both Georgian and Byzantine enamels of the period. Yet some of them can be ascribed to local masters, as, for instance, the three oval medallions that appear on the Kakhuli Triptych. These depict queens, with tiny details, a certain sense of facial emotion, and looser execution. This stage of Georgian enamelwork, with its aspiration towards the refined details of Byzantine culture and the technical perfection of

the Byzantine masters, paved the way for the creative upsurge in Georgian enamels that would reach full strength in the twelfth and thirteenth centuries.

Works from this golden-age period are marked by thin partition networks, a surprising boldness of color, dynamism, a sense of volumetric form in figures, and the occasional attempt to emphasize the separate parts of a composition through outlining and strong emotional emphasis. In this context one notes the earlier-mentioned twelfth- and thirteenth-century plaques depicting the Holy Feasts of the Church, marked with gentle lyricism; or the dramatic scenes on the Kortskheli Icon (thirteenth century); or the individualized images – one might say 'portraits' – of saints, with their simple faces full of human feeling (as seen, for example, on the medallions on the Gelati and Tsalenjikha icons of the first half of the twelfth century), which lack the doctrinal strictness characteristic of Byzantine images.

Even the enamels of the proto-Byzantine school display the high level and distinctive flavor of Georgian enamel art of this time. Thus the celebrated medallions of the Jumati Icon of the Archangel Gabriel – nine of which are in the Metropolitan Museum of Art, one of which is in the Cluny Museum, and another in the Tbilisi Museum – are closely linked with other groups of medallions (located in Kiev and Madrid) which, in their looseness of style and expressiveness, have no direct analogues in Byzantine enamel art.

Works from the twelfth and thirteenth centuries are the last in a continuous line of development in Georgian cloisonné enamelwork. Two late (fifteenth-century) icons depicting St George show the features characteristic of the preceding period. By the fifteenth century, however, Georgian enamel evolution has come to an end.

The legacy of Georgian enamels is connected, then, with that of Byzantium, yet stylistic peculiarities contrast with Byzantine taste. Georgian works have gentle, wavy, imprecise, sometimes rough, but ultimately expressive lines; a freer system of drawing; bright, rich colors with strong contrasts; simply modeled but very vivid faces, with large eyes and thick brows, sometimes placed on different levels; ingenuous and emotional faces. Byzantine artists favored regular, clear, and refined lines; halftones for shading; the strained impression of faces modeled with light and shadow, with thin brows and narrow eyes. Indeed, it is to be noted further that the facial complexion of Georgian images is sometimes wine-colored, because of the local manganese which was used by Georgian masters.

All these differences are conditioned, one might say, by the different world outlooks of Georgian and Byzantine masters, their different attitudes towards religion – the Georgian mood more earthy and relaxed, the Byzantine more ethereal and strict – and different psychologies. Even the respective timings of the development of Georgian and Byzantine enamels do not fully coincide. Whereas Georgia reached its most intense creative upsurges in this field in the tenth century and again in the twelfth and thirteenth centuries, Byzantium arrived at the climax of its evolution in the tenth and eleventh centuries. In spite of close connections with the Byzantine world, Georgian craftsmen followed their own path of development within the overall history of Georgian art.

7 Medieval Georgian Repoussé Work

Temuraz Sakvarelidze

An extraordinary number of repoussé works have survived from medieval Georgia – more than 2500 pieces. As the English art historian David Talbot Rice has noted, although in the Middle Ages the same techniques were used in the Byzantine world, Venice, Germany, and France, it is doubtful whether all the surviving work from these places combined would yield even a tenth of what is found in Georgia. The level of productivity of Georgian repoussé masters must have been astounding, especially when we consider that during the Middle Ages Georgia suffered from endless invasions, destruction, and pillage. Georgian repoussé work, however, is impressive not only for its quantity but also for its quality.

Since the publication – in 1957–59 – of fundamental works on the subject by the Georgian art historian George Chubinashvili, the significance of Georgian gold repoussé has become well known. These studies enable us to follow the continuous thousand-year path of development of Georgian metal-chasing from the eighth and ninth centuries AD through the early nineteenth century. Nearly the entire body of this material – mainly ecclesiastical objects: crosses, icons, cups, ripids, and manuscript covers – is now held by the museums of Georgia in Tbilisi, Kutaisi, Zugdidi, Mestia, and at the branches of the Mestia Museum in the treasuries of several village churches of Upper Svaneti in the mountainous northwestern region of Georgia.

Georgian repoussé work – also called 'chasing' – did not come into being in a vacuum. Archaeological discoveries (mainly in grave sites) reveal a great number of metal pieces that evince a high level of metallurgical skill in the territory of Georgia as far back as the early and middle Bronze Ages (third and second millennia BC). Through a succession of eras the tradition of superb metalwork persisted. It was on that strong base that a new and magnificent art flourished under the conditions and environment of Christian culture.

In Georgia, as elsewhere, Christianity brought changes not only in theology and philosophy, but also in art. But influence continued to derive from a variety of sources. Thus while Georgian sculpture of the early Christian period makes use of forms brought in by Christianity from the outside, it also makes use of indigenous pagan imagery that precedes the advent of Christianity in Georgia. The only monuments that survive from the early Christian epoch (the fifth through the seventh centuries) are stone reliefs on the walls of churches, stone stelae, and stone crosses.

An independent style of Georgian sculpture began to take shape in the eighth and ninth centuries, which is also the period during which the history of medieval Georgian metalwork begins. This is the era when Georgian goldsmiths turned away from readily available antique forms imported from foreign countries, and indeed from specific methods of sculpture (volume, modeling, and seeking to reproduce naturalistic forms), and turned toward a more flattened, stylized aesthetic.

The monuments of the eighth and ninth centuries – above all the *Icon of the Transfiguration* from Zarzma (886), with the place it gives to each individual figure within the composition – point the way toward the rounder, more sculptural forms that emerge in the tenth and eleventh centuries. By the middle of the eleventh century an abundance of high-quality, somewhat volumetric, and finely detailed works is being produced – in Ishkhani, Breta, Brili, with their icons and processional crosses; at Bedia, with its renowned gold cup (999); plaques from Sagolasheni and Shemokmedi with images of saints, and a splendid processional cross from

Martvili. A great interest in the large-scale embellishment of churches with glittering metalwork can be seen in the number of pre-altar crosses that survive – a unique feature in Georgian art. These large wooden crosses were covered with repoussé work, depicting either the life of Christ or one of the saints. One eleventh-century example, still kept in a church in Mestia, contains the earliest surviving cycle of scenes from the life of St George, concentrating on the many tortures that led to his martyrdom. Such works echo what was being produced at that time in stone reliefs and wood carving. Hence, this process of development is a natural and organic phenomenon, encompassing all of Georgian sculpture. It is noteworthy that in Byzantium such evolution is not seen in the monuments that have survived: the style remains constant. In this sense, the closest analogy for Georgia's metal sculptural development during this period may be the evolution toward and from Romanesque sculpture in Western Europe during the eleventh and twelfth centuries.

But that analogy is by no means perfect: ultimately, in the West, sculpture continued to develop, so that by the end of the thirteenth century it began to reach – and thus circle back – to fully three-dimensional, volumetric, classical forms. Such sculpture did not develop in medieval Georgia. One of the main reasons for this, perhaps, is the influence of the prohibition of three-dimensional sculpture by the Orthodox Church centered in Byzantium. The iconoclastic period that began with the denunciation of images at the Council of Nicea in 787 and lasted for several centuries never deeply affected Georgia, yet perhaps its influence was felt in this area. Where pure plasticity is concerned, Georgian goldsmiths had achieved everything possible within the limits of relief sculpture by the first half of the eleventh century. But by the twelfth century they seemed to have lost the desire to reveal volumetric sculptural form in portraying the human figure, and from that time directed their talent toward the decorative aspects of their works. This concern for decorative elements – already evident in the tenth and eleventh centuries, as in the decoration of crosses and icons with inlaid precious stones and cloisonné enamel – now blossomed with greater intensity.

Thus from the twelfth through the eighteenth centuries, Georgian repoussé reached no heights of greatness in strictly sculptural terms. Figures evolved into somewhat mechanical repetitions of works produced during the tenth and eleventh centuries – indeed, sometimes entire scenes were copied. But even during this later period, every once in a while a Georgian master would create a work with a clear compositional structure and a stunning variety of ornamental motifs, demonstrating skillful execution and achieving a unified artistic effect. Striking examples of this are two works in the State Museum of Art in Tbilisi: the *Khakhuli Triptych of the Holy Virgin* composed in the twelfth century, of diversely dated parts; and the beautiful late twelfth-century *Anchi Triptych of the Savior*, in part, the work of the master goldsmith Beka Opizari, who was perhaps the greatest artist of the period of Queen Tamar and Shota Rustaveli. In one later period, during the sixteenth to the eighteenth centuries, a number of notable smaller works were produced: icons, crosses, and other objects made in the various goldsmiths' workshops of Georgia's western and eastern regions.

What is remarkable is that, under the harshest of political and economic conditions, during a period that saw an overall decline of culture, and in spite of the penetration of various foreign elements – Mongol in the thirteenth and fourteenth centuries, Persian in the fifteenth, Ottoman Turkish in the sixteenth and seventeenth, and finally European and Russian in the eighteenth and early nineteenth – Georgian gold repoussé work retained its own stylistic 'personality. It maintained its own traditions and distinctive sense of self, through which it found, and has retained, its place in the history of world culture.

8 The Art of Georgian Manuscripts

Helen Machavariani

Manuscripts (books written by hand) have played a cultural and artistic role since late antiquity, when they first emerged to replace scrolls. The creation of the Georgian alphabet, the efforts to form a Georgian state, and the spread of Christianity all contributed to the development of book-making. With strong cultural centers established in churches and monasteries, often with royal assistance, manuscript production was a paramount enterprise both in Georgia and abroad (see II.2).

In the early medieval period Georgians used leather as a material on which to write and illustrate. From the twelfth century onward, some illustrated manuscripts were also executed on paper. However, the majority of surviving manuscripts are written on parchment, which is known to have been produced in Georgia. Manuscript folios from monasteries in Gelati, Vani (in western Georgia), and Alaverdi (in the east) provide ample evidence that Georgian masters possessed excellent knowledge of such technology from an early date. But great attention was also paid to the artistic design of manuscripts, from the chasing of the metal book covers (see IV.7) to the often breathtaking calligraphy of the texts, executed in Asomtavruli and Nuskhuri (old Georgian alphabet styles) and the present-day Mkhedruli alphabet style. Fifth- and sixth-century palimpsests (parchments or other materials from which previous writing has been erased to make room for newer texts) are not just important literary monuments of the early Christian period, but offer evidence of the high artistic level of Georgian book-making.

From the fifth century to late in the eighteenth century, a spectacular range of Georgian manuscripts was produced in the monasteries and their schools. This required a range of interdependent skills, including the preparation of the parchment, writing out the text, painting the illuminations and illustrations, binding the folios, and chasing (hammering and incising the designs of) the metal covers – often both front and back covers. Each step demanded its own master craftspeople; as a result each manuscript is a unique masterpiece. Georgian masters clearly believed that their work would be immortalized. Added by the scribe, the words 'The creator will pass away, but the creation will remain as a treasure' can often be read in the postscripts (called colophons). Various kinds of text, from Gospels to works by Church Fathers and theologians such as Gregory the Theologian to *synaxaria* (calendars of readings for the church year), were decorated with drawings. By the eleventh century a standard ornamental decorative program for a Gospel text seems to have been completely formed. This comprised elaborate capital letters, decorative headpieces at the opening of each text, decorative frames, and miniature compositions of scenes from the life of Christ. In addition there were images showing the Evangelists seated, writing their texts, examples of which include the twelfth-century Gelati (Q-908)* and Jruchi Gospels (H-1667), and the fourteenth-century Mokvi Gospels (Q-902). In these three manuscripts about eight hundred miniatures include two hundred and forty scenes from the life of Jesus. In the manuscripts from Gelati and Jruchi, each of the four Gospels has an independent series of drawings (hence there is considerable repetition in them). In the Mokvi Gospels, by contrast, one complete cycle of Christ's life is presented across the entire text of the four

* These references are inventory numbers of the Georgian Institute of Manuscripts in Tbilisi.

Gospels. Thus most of Matthew is illustrated (more than half of the one hundred and fifty-two Mokvi miniatures accompany the text of Matthew); the illustrations for Mark, Luke, and John fill in the rest of the story of Christ's life. A similar pattern is followed for the thirteenth-century Largvisi Gospels (A-26). The illustrations read as a series of miniature wall-paintings.

Although there is some range of content, most of the illuminated and decorated manuscripts that have survived – particularly those up to the end of the fifteenth century – are ecclesiastical in nature. But illustrated manuscripts of secular content, such as the epic poems *Vepkhistqaosani* (*The Knight in the Panther's Skin*), *Kilila and Damana*, *Visramiani*, and *Joseph Zilikhaniani* (the story of Joseph and Potiphar's wife), begin to appear more frequently from the sixteenth to the eighteenth centuries.

II

Not surprisingly, manuscripts were very expensive in medieval Georgia and thus commissioned only by the wealthy. For example, in the fourteenth century the cost of hiring a lawyer is estimated to have been half the price of a horse, which in turn cost less than a well-made book. The colophon for the seventeenth-century gold-bordered manuscript (H-54) of *The Knight in the Panther's Skin* in this exhibition notes both that the manuscript has been decorated extremely well and that a client who commissioned it paid a large sum of money for it. It is evident from their colophons that all of the finest, most richly ornamented manuscripts were ordered by a king, *Katalikos* (the highest ecclesiastical position in Georgia), or bishop. Thus, for example, the text of the twelfth-century *Vani Gospels* (A-1335), decorated in Constantinople by the Greek artist Michael Coreseli, was ordered by Queen Tamar (1184–1213) herself. (In fact, according to the colophon, Queen Tamar was viewed as already elevated to sainthood while still living. Indeed, manuscripts were often donated to honor the dead and/or for the spiritual well-being of the donor's family.)

The metal cover of the thirteenth-century Lapskhaldi Gospels was chased in the monastery church of Gelati on the orders of King David Narini (1245–92). A famous minor eleventh-century *synaxarion* (A-648) and a few decorated manuscripts connected with it were written and decorated at the well-known Khora Monastery in Constantinople by order of Zakarias, the bishop of Bani, who is also referred to in the colophon as the bishop of Valashkerti.

The colophons of manuscripts were often written from the point of view of the person who had commissioned them (who was unlikely actually to have been the scribe). But since the person who ordered a manuscript paid a good deal of money for it, he or she would have the option of having not only his or her name (less expensive) but perhaps his or her image (more expensive and far rarer) placed in it. Moreover, just as persons who financially contributed to the construction and decoration of churches were generally represented on the building façades and frescoes in the company of saints and even Christ, so those who financed the decoration of manuscripts were, when portrayed, often represented within, or instead of, a Deesis (see footnote, p. 104) or Anastasis (Resurrection of Christ) scene. For instance, in the thirteenth-century Ienashi Gospels, the *Katolikos* Epiphane (the head of the Georgian church) is represented in the place of honor, in lieu of a Deesis, in front of a pillar. The manuscript must have been donated by him to the Svetitskhoveli Cathedral in Mtskheta (with its famous pillar). In the Mokvi Gospels referred to above, Daniel, bishop of Mokvi is depicted kneeling before the Virgin. This honors Daniel as the manuscript's patron while reminding the reader/viewer that the church in Mokvi was built in honor of the Virgin.

The portraits of patrons of manuscript illuminations that have survived, such as those of Eptvime Mtatsmindeli, Levan Dadiani, and King Vakhtang VI, are significant both as historical documents (since their colophons tell us something about them) and as works of medieval portrait art. Like icons and ritual objects, the manuscripts were part of the overall decorative program of a church. Indeed, in their postscripts Georgian Gospel manuscripts are often referred to as jewels of the church, and read and displayed as part of religious festivals.

III

The changing conditions of political relations between Georgia and its neighbors from Byzantium to Persia were reflected in two ways in the ornamentation and illumination

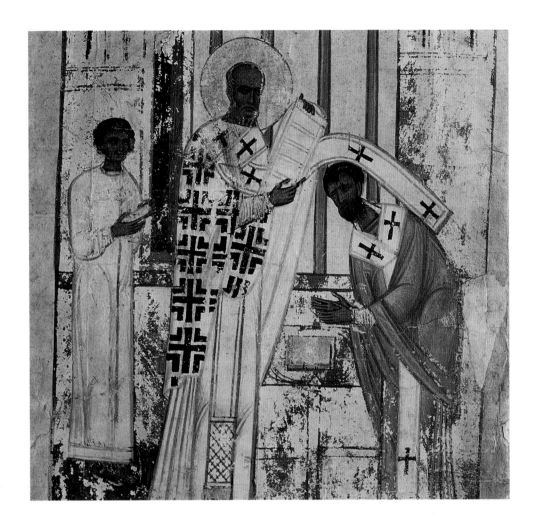

of Georgian manuscripts. First, certain artistic peculiarities in surviving works created in the scriptoria of Tao-Klarjeti (southwestern Georgia) offer evidence of the use of early Christian originals also reflected in the Byzantine tradition. Examples of this include the ninth-century Adishi Gospels (now in Svaneti), the tenth-century first Jruchi Gospels (now at the Institute of Manuscripts in Tbilisi), and the first Berta Gospels (now in the United States). The relationship with early Christian art is visible in the robust style of the nude figures, the youthful image of John the Evangelist in loose falling garments, and the marble-imitating columns which form a decorative framework round the table of canonical readings, as well as in the use of the background as a supporting line for the figures and in the sculptural quality of the plants shown growing out of the arches.

Secondly, many Georgian manuscripts, as we can tell from their colophons, were composed and designed in cultural and educational centers abroad (see II.2). From the eleventh century, Georgian decorative and book-making centers were connected with three main scriptoria outside the country – monasteries in Constantinople (modern-day Istanbul, Turkey), on Mount Athos (in Northern Greece), and on Black Mountain (near Antioch, Syria). Thus the magnificent Alaverdi Gospels (A-484) were produced at Caliposus Lavra, one of the main monasteries on Black Mountain. A manuscript presenting the work of Gregory the Theologian (A-92) was produced on Mount Athos. The above-mentioned minor *synaxarion* (A-648) and a second work associated with Gregory the Theologian (A-1), as well as the Vani Gospels (A-1335), were all produced in Constantinople.

The collaboration between artists and scribes within these three centers, as well as *among* them, is well known.

Cat. 132 | Psalter exhibiting extensive use of *Singuri* (red paint) and typical Georgian interest in diverse *animalia*, 13th century AD

example, in the motif of lines of circular floral ornamentation, the rich materials (such as the abundant use of gold and the use of ultramarine as a color), and the techniques of painting (a multi-layered writing technique and the use of thick, opaque paints to create a look similar to cloisonné enamel) – all of which are characteristics associated with the Byzantine style.

It should be emphasized, however, that Georgian masters were never blind followers of foreign originals; they always stamped their work with distinctive national features. After the Vani Gospels – decorated, as noted above, by a Greek master – were brought to Georgia, the Lapskaldi Gospels and the Matenadaran Gospels (currently in Yerevan, Armenia) were decorated. The Georgian masters, though inspired by the work of the Greek master Coreseli, followed local traditions. For instance, the master who decorated the Lapskaldi Gospels begins the arrangement of the symbolic representation of the months with September, in keeping with the Georgian calendar, rather than with March. Masters of both manuscripts ignored the system, so characteristic of Byzantine manuscripts, of placing the Evangelists in two rows, nor are religious festivals represented above the Evangelists. Further, the typical title-page scene – in which Christ blesses the Apostles – is not found on the title-page of either Georgian manuscript. Following the Georgian national tradition, a cross or a Deesis composition is depicted on the title-pages of such manuscripts, as in Georgian monumental paintings. The Greek tradition of representing the Ascension or Christ *Pantocrator* in manuscripts – as in most frescoes – was not adopted.

In any case, not all Georgian manuscripts are in the 'Byzantine' style; manuscripts in the so-called 'folk' style have also survived. Their decoration is characterized by a diversity of vine-leaf ornamentation. Paints with a transparency similar to that of watercolor are often added to the drawing, which accompanies a text executed in brown ink or *singuri* (red paint). Parchment soaked until it is drained of color is often used, which gives great lightness to the drawing. The *singuri* used in the decoration serves as a kind of punctuation point in the composition, as well as lending a charged emotional atmosphere to the palette. Pliny the Elder, writing in the first century AD, mentions a reddish ore, *kolkheti*, among what

Works translated from Greek by the highly regarded tenth-century figure Eptvime Mtatsmindeli were sent from Mount Athos to Constantinople. Vasily Malushisdze, who moved from Constantinople to Mount Athos, participated in finishing the manuscript of Gregory the Theologian (A-92). The book-making activities of David and Iovane Jibisdze, who went to Black Mountain from Georgia, are also well known. Following David's instructions, Iovane inscribed another eleventh-century *synaxarion* (H-2211) and decorated it with drawings.

The cooperation of Georgian masters with foreign craftsmen in book-making centers abroad had a marked influence on the art of eleventh- to thirteenth-century manuscripts in the so-called Byzantine style. That influence is seen, for

he terms the seven famous ores; its name is derived from 'Colchis', the Greco-Roman name for Georgia, where the ore was found in abundance. The availability of this ore no doubt helps account for the use of strong red colors in Georgian manuscript illuminations (see the Psalter H-75 [cat. 132] in this exhibition) as well as in Georgian wall-painting.

<div align="center">IV</div>

Unfortunately, the names of many of the artists who created these works remain unknown. They are rarely mentioned in colophons, although a few manuscripts offer interesting clues. The First Jruchi Gospels have a cryptogram inscription made by a certain Theodore. A master named Michael includes his name in the ornamental drawing of the Second Jruchi Gospels. In the Ienashi Gospels, the last will and testament of a certain Iona is inscribed in various colors in the frontispiece. Occasionally, the identification of a given scribe with a particular artist where the two worked closely together helps us to infer the name of the one from the other, but this opportunity is relatively rare.

Today, moreover, many manuscript miniatures and ornamental decorations are badly damaged, with the paint worn away. The miniatures of the Mokvi Gospels, which are drawn on top of a gold background, have suffered particularly in this regard. Such painting on gold leaf endangers the entire work, because if the gold lifts off the parchment, the painting comes off with it. Unfortunately, funds have not been, and are not currently, available for significant conservation or restoration projects.

It is to be hoped that this situation will change in the near future, because the high artistic level of medieval Georgian manuscript decoration makes it one of the cultural treasures of world art, studied by art historians and scholars from around the globe.

A Note on the Lailash Pentateuch
Ori Z. Soltes

The Lailash Pentateuch is one of the more enduring symbols of Georgia's history as a religious melting-pot and a land of diverse tolerance. This unique manuscript is a parchment text of the Torah (a handful of pages are missing) with Masoretic commentary. It has been generally dated, by means of paleographic analysis (the style of the script and the formation of the letters), to the late tenth or early eleventh centuries; more recently, it has been suggested that it could have been written as late as the early twelfth century. It is in any case among the early such texts with full vocalization. The Masorah forms a micrographic decoration in Mashait script around the periphery of the main text; three folios include additional geometric decoration in color.

The manuscript, currently in the Kekelidze Institute of Manuscripts of the Georgian Academy of Sciences in Tbilisi, was first noticed in the modern era by the scholar Joseph Judah Tchorni in the early 1880s, when it was in the possession of the Jewish community of Lailashi, a village in Lekhumi (some folios were in the hands of the *hakham* of Oni, who had religious jurisdiction over Lailashi) in northwest Georgia, where it was known as the 'Svanian Bible'. It was only with great difficulty that Tchorni was able to bring the manuscript to Tbilisi, where it might be both studied and better protected (first in the Historical and Ethnographical Museum of Georgian Jewry; later in the Manuscript Institute). The reason was simply that both the Jewish and Christian populations believed strongly in its miraculous powers, both for healing and, even more so, for the purpose of solving the broader problems of drought, flood, and other disasters. At such times the manuscript was apparently used in certain rituals. It was believed, indeed, to have been brought to the community in the arms of angels.

An analysis of its script style and the parchment itself by two French scholars, G. E. Weil and A. M. Gueny, based on the work of the Georgian scholar George V. Tsereteli,[†] suggests that the manuscript may in fact have been written in Palestine or Egypt, possibly even Persia – and it is they who suggest a date of perhaps as late as the early twelfth century.

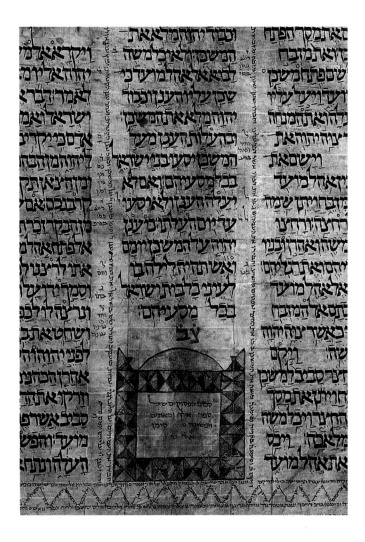

Cat. 121 (detail) | Pentateuch from Lailashi
(end of the *Book of Exodus* and beginning
of the *Book of Leviticus*), 10th century AD

evidence for the late eleventh century is the use of two *yuds* in lieu of the Tetragrammaton to indicate God's name, in the *Masorah magna* along the upper register (a scribal feature which apparently starts at about this time); and the use of *hey-yud* rather than *yud-hey* to indicate the fifteenth group of folios. *Yud-hey* is an abbreviation for God's name, which, used as simply a number (these two Hebrew letters have a combined numerical value of 15, since each Hebrew letter has a numerical value, and *yud* is equal to 10 while *hey* is equal to 5), would be considered sacrilegious. Hence the reversal of *yud-hey* as *hey-yud*, which then affected the rest of the group numbers 11 to 17 as well, causing systematic reversal of the norm in which *yud* is followed by the letter with a value of 1 to 7. This, then, suggests the late eleventh century as the date of composition.

The question of how the Lailash Pentateuch arrived in Lailashi (in the event that it was not brought by angels) also provides food for speculation. There is no evident reason, other than supposing that it simply belonged to some Jewish family who migrated from Egypt/Palestine (or Persia) and settled there, to account for its arrival in the small and impoverished community of Lailashi. Perhaps it was kept for some time in Kutaisi (hence the reference in folio 95a – but Kutaisi was called Kutatissi before the sixteenth century; thus the scribal continuum for the codex may be considerably longer than even at first extensive glance). Moreover, the fact that local people called it the Svanian Bible suggests (according to V. Silogawa of the Manuscript Institute) that it may have been brought to the monastery of Kala in Svaneti for safe-keeping (from wherever it first reached in Georgia), along with other precious items, during the time of the Mongol invasions. From Svaneti it may have gone to Kutaisi and thence to Lailashi (there is no direct communication between Svaneti and Lailashi). There, however it got there, it would remain, producing the miracles – or at least the intense belief in them – that would carry its reputation to Tbilisi and from there to the world community of manuscript scholars and friends of Georgia.

This might be so, at least for parts of the manuscript, since several different scribal hands are distinguishable, which might also reflect stages of the text's creation. But with the absence of the first and last folios, and thus of whatever colophon might have originally existed – bearing dedication, signature, and sale contract – it is impossible to know its ultimate provenance for certain. There appears to be mention of Kutaisi (a city near Lailashi) on the corner of folio 95a – which might be contemporary with or later than the main body of the codex.

Perhaps the most distinct and fascinating feature to offer

† Cf. the articles in *Philologia Orientalis*, Tbilisi, by Weil and Gueny (in French), 1976, and by Tsereteli (in Georgian with English summary), 1969.

9 Georgian Embroidery

Mzistvala Ketskhoveli

I

Embroidery has long been an important medium in Georgia. Embroidery artists' tastes and outlooks changed and developed with the passage of time, different stages of social development, and changes in individual artists' spiritual lives. Their talent always expressed itself in accordance with the times in which they lived, although with a consistent iconography through all periods, and each artist strove for an individual style. The more than occasional masterpieces clearly reflect the spirit of the times in which they were created, and proudly stand on equal ground with Persian, Indian, and Russian work of the same periods.

Georgian embroidery has evolved over the course of a thousand years, alongside icon-painting but with its own vocabulary of images. As with many other fields of art, it has served both secular and ecclesiastical purposes; consequently it reflects the tastes, interests, and cultural characteristics of both. By studying modes of fabric decoration, one can gain some sense of the character, moods, and desires of its creators, who strove to express their creative imagination through its language.

Skill in knitting and embroidery seems to have been expected of medieval Georgian women, although this is an inference with scant documentation to prove it. The limited historical sources that describe crafts carried out in Georgian monasteries during the Middle Ages do not mention textiles, so we must draw our conclusions on the basis of a combination of available information regarding other crafts and more recent knowledge about textiles – for example, the fact that folk-art traditions, together with the methods and techniques of artistic embroidery, are even today passed down from mother to daughter.

II

Before the appearance of ritual objects such as chalices and pectoral crosses, early medieval Georgians must have satisfied their need for visual–verbal connection with the spiritual through carved inscriptions. For stele-crosses in the provinces of Kartli and Kakheti (central and eastern Georgia) are overrun with prayers and appeals, together with the record of who financed them; indeed, such inscriptions serve as a kind of memorial to the donor. Such stele-crosses were also popular, it seems, as objects of veneration. Their function parallels that of the ornately carved Armenian *khachkars* (funerary stelae) produced during the fourth to seventh centuries. Later in the medieval period, these stele-crosses began to disappear, but obviously the need to address or appeal to God did not. Instead of inscribing such monuments, those seeking divine favor would donate painted icons and other ritual objects – plaques and medallions as well as chalices and pectoral crosses – to the church.

The donation of ritual objects to the church was an obligatory routine for members of the upper classes; as with the inscribed stele-crosses that preceded them, they were believed to provide the donor with peace of mind and soul (and perhaps political favor) in this life and the hereafter. Among the accessories necessary for the liturgy – which were also among the items donated with the greatest frequency – were pieces of embroidery, including, most noticeably, *epitaphioi* (mourning shrouds), *omophoria, oraria* (stoles), liturgical cuffs, aers, *epigonatia*, mitres, and robes.

As already noted, no specific information has survived regarding Georgian embroidery studios, although one might infer that there was a pattern similar to that in feudal Russia, where such studios are known to have existed in the courts

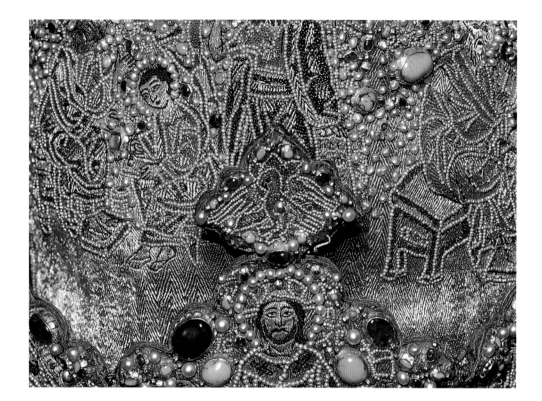

Cat. 152 (detail) | Bishop's mitre from Gelati Monastery, made of gold and silver twisted threads and precious stones, 17th century

and palace complexes of tsarinas, princes, boyars, and even merchants. In Russia, however, the execution of a single piece of embroidery was carried out by different specialists. For example, the floral ornamentation might be made by one person, the inscriptions by a second person, and facial images by a third. But in Georgian embroidery, inscriptions on several *epitaphioi* indicate that the various components were usually the work of the same person.

The inscription on the *epitaphios* donated to the church by Tinatin, the daughter of Kaikhosrau, is typical. It reads: 'I, Tinatin, the daughter of the patron of this house, Kaikhosrau, undertook the task of designing and decorating this *epitaphios*.' Tinatin and Kaikhosrau are not mentioned in any other sources, nor does Tinatin offer the date of creation (although it has, for other reasons, been dated to c.1664), making this *epitaphios* all the more intriguing. Even when the creativity was shared, though, the production generally remained within the same family, and in any case the sharing separated only the inscription from the rest of the work. An example of this is an *epitaphios* made by a mother and daughter in the early eighteenth century.

Ekaterine (Elene as she subsequently called herself after becoming a nun), the daughter of Khosrau (a Kakhetian king of the late seventeenth and early eighteenth centuries), embroidered the inscription that honors her father, King Khosrau. As for the images upon it, 'my daughter, the nun Anastasia, designed and decorated this piece.'

III

The earliest extant textile pieces, beyond some tenth- or eleventh-century fragments found at Ipkhi and Katskhi, date from the twelfth or thirteenth century. They are a pair of liturgical cuffs from Katskhi. A multi-figured composition spreads onto both cuffs; owing to the high quality of the material and the refined embroidery technique, it gives the impression of being a print. The energetic outlining of the figures suggests a visual connection with other Georgian art forms of the time, particularly metal chasing and enamel-work.

In general in the early works (up to the end of the four-teenth century), the background is covered with *okromkedi* ('gold cover', meaning that gold threads were woven among

the other – usually silk – threads). Thus, for example, an outstanding *orarion* with an *okromkedi* background was produced in 1312 in the Anchi studio. Commissioned (or possibly made) by Tamar Kherkheulidze, it was dedicated to the icon of Anchiskhati in the church of Anchi. The *orarion* was, in turn, added to an *omophorion* by Natela, daughter of Qvarqvare Atabagi, in 1358. Natela added two inscriptions and an ornamental border of silk. Figures are rendered in relief through the thickness of the embroidery. For the next three centuries or so, style – flatness of figurative representation, great interest in decorative detail, and restrained color tonalities – remains largely unchanged.

One of the earliest instances of embroidery for which the date is identified by its own inscription – and the earliest of the *epitaphioi* that form the fascinating core of Georgian embroidery – refers to Giorgi VIII, a late fifteenth-/early sixteenth-century king of Kartli. He also financed the making of an *epitaphios* decorated by his sister Astandar, in 1505–1525. In it she 'revived the passion of our Savior with the help of patron Giorgi's money and her own skill,' the inscription informs us.

Relying on the rather meager information contained in some inscriptions, we conclude that those who embroidered also usually designed and decorated their pieces. Not only women but men were also apparently engaged in embroidery – as one inscription informs us: 'I, the metropolitan Grigol, son of Bezhan Dadian, decided to sew this *orarion*.'

The inscriptions also tell us that the work of embroidery crossed class boundaries; it was carried out by servants as well as aristocrats. An example of this is an *epitaphios* made by Zilpijan, servant of Queen Mariam (1646–82) of Kartli. Indeed, according to the Georgian historian Platon Ioseliani, women of humble origins as well as noblewomen were employed at the court of Teimuraz II, king of Kartli (r.1744–62). An inscription decorating an *epitaphios* belonging to Tamar, Teimuraz's first wife, states that Tamar herself started to decorate the *epitaphios*, but she was unable to finish it. After her death 'her servant finished it, to commemorate her patron,' the inscription states.

For his grandson Giorgi, Teimuraz II commissioned a prince's flag from Anastasia, the daughter of Roin Amirejibi and widow of Rostom Tsitsishvili (so the inscription informs

us – we know little else about any of them other than their names). As King Giorgi XII, that ill-fated, briefly ruling (1798–1801) grandson had gathered a considerable sum of money for the building of a palace, but when he became seriously ill the whole project was canceled and the king ordered the money to be used instead for building churches and producing ecclesiastical objects instead: *barom-peshkhums* (chalices), *oraria*, *omophoria*, and so forth. Numerous people were appointed to fulfill this directive. According to an early nineteenth-century chronicle, 'the Queen and the King's daughter-in-law, noblewomen of the court, their companions and tutors, and the tutors' servants sewed night and day'; and even beyond the palace 'there was not a single house where *oraria*, liturgical cuffs, aers, *phelonia*, and *sticharia* were not being sewn out of expensive and simple silk.'

From such words (however exaggerated) one can conclude, even without other documentation, that embroidery studios existed in Georgia at the royal court; they would have been found in churches and monasteries as well. There would have been studios in the Sion Cathedral in Tbilisi, the Svetitskhoveli Cathedral in Mtskheta, the Tsilkani and St Nino's churches in Sagarejo, and at churches in Katskhi, Tsaishi, and Anchi, among others. Works produced in different studios vary in manner of execution and in palette. Early examples are very rare, since textile material would wear out and the church decreed that worn-out objects be disposed of so that the clergy would appear before their congregations in appropriately imposing new vestments.

IV

From the second half of the seventeenth century, European – and particularly Italian – influence is visible. This is evident, for example, in the *omophorion* of Queen Mariam, with its scintillatingly colorful gold-and-silver-accentuating depiction of the Annunciation. Russian influence is seen in the 1660 *omophorion* claimed by a certain Rodam, where the background of the Ascension scene includes an onion-domed Russian Orthodox church. Russian influence is also visible in color combinations on various ritual objects. For instance, a curtain dated 1773, from the church of Sioni at the northern border of the central eastern part of the country, has a red satin center and light blue edges.

As a general rule, facial images are present in ecclesiastical embroideries produced before the 1720s and 1730s. Thereafter floral and geometric ornamentation becomes more common. Also generally, fine gold thread commonly referred to as 'gold hair' was increasingly in use by then, as well as *okromkedi* and also *vertskhlimkedi* (silver cover) as materials for the background, in which gold and silver threads were twisted around silk threads. In the case of what is termed *zezi*, the color of the silk was visible through the gold and silver, so it was possible to achieve different color variations. Further, since it is not possible to thread gold and silver threads through fabric, the makers used the couchwork technique: they laid the metal threads on top of the backing and affixed them with silk threads, using fine, small stitches. The stitching of the 'gold hair' in the later embroidery is almost always straight, whereas in earlier works it is wavy – as in the *epitaphios* of Giorgi VIII – or spiral (for which the Georgian terms are *kanetil* or *klapiton*), as in the *epitaphios* of Tinatin.

A whole range of different embroidery techniques is used throughout Georgian textile history, each with its own Georgian name. The couchwork technique is used in every piece, but the amount of reinforcing silk and gold or silver 'hair' braided in one knot and the number of knots per square inch varies, resulting in different effects. So, too, the use of pearls and precious stones in combination with *zezi* and straightforward silver and gold threads yields a varied depth of visual expression. The relationship among these elements, crossing competence of technique with thoughtfulness of composition, defines the skill of particular craftspeople and the quality of their work.

The best Georgian embroideries, those that have survived through the centuries and display the greatest skillfulness of method, expressiveness of form, and harmoniousness of palette, those whose power transforms a simple blueprint into a work of art, belong decidedly to the masterpieces of medieval world culture.

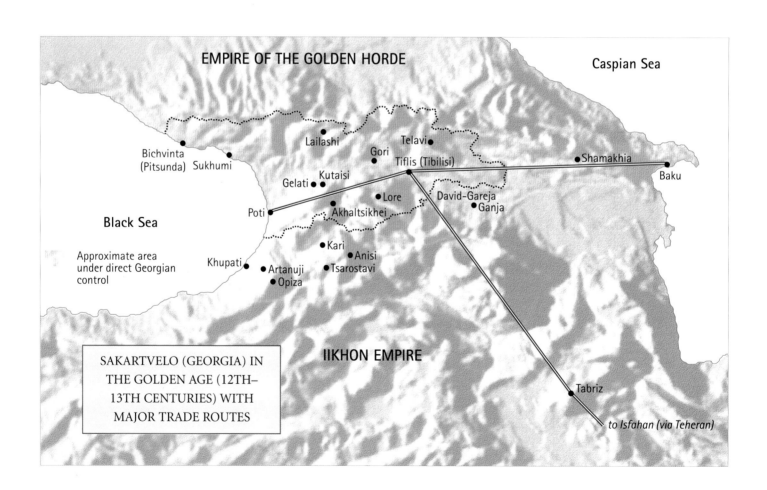

EMPIRE OF THE GOLDEN HORDE

Caspian Sea

Lailashi

Telavi

Gori

Tiflis (Tibilisi)

Shamakhia

Bichvinta (Pitsunda) Sukhumi

Baku

Kutaisi

Gelati

Lore

David-Gareja

Poti

Akhaltsikhei

Ganja

Black Sea

Kari

Approximate area under direct Georgian control

Khupati

Anisi

Artanuji

Tsarostavi

Opiza

IIKHON EMPIRE

SAKARTVELO (GEORGIA) IN THE GOLDEN AGE (12TH–13TH CENTURIES) WITH MAJOR TRADE ROUTES

Tabriz

to Isfahan (via Teheran)

V

POSTSCRIPT:
EARLY MODERN GEORGIA

The Life and Art of Niko Pirosmani
(c.1862–1918)
Erast Kuznetsov

The twentieth-century painter Niko Pirosmanashvili (or Pirosmani, the customary shortened version of his name) is regarded by Georgians as the national painter of their modern era – a symbol of Georgian culture as surely as Shota Rustaveli is the national poet (see II.3) and Svetitskhoveli, in Mtskheta, the national cathedral (see IV.3). Not surprisingly, his image appears on the most common of public documents, the one *lari* bill – Georgia's equivalent of the one dollar bill. Pirosmani captured the spiritual and national character of his people in a way that nobody before him had done.

In the eight decades since his death, Pirosmani has been the focus of many essays, plays, films, and works of music and art. His life and death symbolize the tragically romantic fate of a talent that goes unrecognized. Indeed, little is known of his actual life; much of his 'biography' is derived from legend. Niko Pirosmanashvili was most probably born in 1862. For most of his adult life, as far as anyone knows, he was a homeless, wandering painter. He worked for owners of small businesses – often in exchange for wine and food – in and around Tiflis (now Tbilisi), which then, as now, was the political, economic, and cultural center of the Caucasus. He slept wherever he was working, and his belongings consisted of his brushes, his paints, and the clothes on his back. Over a less than twenty-year period, from about 1900 until

Cat. 165 | Niko Pirosmanashvili (Pirosmani), *Kalooba*, or 'On the Threshing-floor', oil on cardboard, 1916

Cat. 162 | Niko Pirosmanashvili
(Pirosmani), *The Kakheti Train*,
oil on cardboard, 1913

his death, he created two hundred paintings that are known to us – but it would seem that only a relatively small part of his output has survived. Some scholars believe that he actually painted more than a thousand works.

The young Russian futurists noticed his work in 1912, and a year later four of Pirosmani's paintings were included in an exhibition of modern art in Moscow. But this exposure did not change the artist's impoverished existence. The cataclysmic events of that decade – World War I, the 1917 Revolution and the fall of the Russian Empire – muffled any interest in his life by either the public or private patrons who might have made a difference to it. In the spring of 1918, seriously ill and suffering from alcoholism, the artist died in Tiflis and was buried in a location that remains unknown even today.

Pirosmani was completely self-taught. One of the important twentieth-century primitivists, he has been compared to the much better-known Henri Rousseau. The course of his life offered no opportunity for formal training, and so his work followed no standard painting rules or norms – it was driven by his own emotions and by his visual impressions of the world around him. However, this did not prevent him from evolving what distinguishes a real artist: his own painting system – logical, stable, and distinctive – within the confines of his own artistic world.

In some senses, Pirosmani's system is similar to art of the early Italian Renaissance, especially the work of Giotto. In others it resembles European art of the late nineteenth and early twentieth centuries, as exemplified by the work of Cézanne and by early Cubism. For Pirosmani did not seek to reproduce everything he saw in naturalistic detail. Rather, he was guided by his subject, his own internalized impressions of it, and his sense of its interior structure. When he painted, it was as if he were reinventing the world around him.

As a practical matter, Pirosmani's artistic system was subject to the circumstances in which he painted – mainly the rigid need to economize in both work time and art supplies. But these same conditions became the source of his expressiveness and the richness of his painting. He worked in oils, but could not afford canvas. Instead, he painted on black oilcloth, which was less expensive. This helped to determine the extraordinary course of the technique that intrigues all who look at his work. Rather than adding pigments darker than the light canvas to which they are applied, as is customary, he added lighter pigments – thus the black oilcloth itself became an active determinant of the tones of his paintings. Necessity called for a terseness of interpretation in both form

and color. Indeed, Pirosmani used only a small number of pigments – often not more than four and sometimes only three in any given painting. This required him to create various combinations and color nuances without attempting to reproduce the natural colors of his subjects – instead, inventing his own simple, elegant visual language.

Thus, although Pirosmani's world is fully based on representational reality – rather than being abstract – it is so completely transformed that it may be viewed at the same time as fantasy. But his external source was reality. He was inspired by the images and ideals of pious Georgian village life. The artist himself came from such a world – like his viewers and clients, who adapted to city life but within their souls remained connected to village life and retained strongly nostalgic feelings toward it, which no doubt grew the longer they remained in the city.

Every aspect of village life interested Pirosmani, who presented it as offering the idealized condition of man living in harmony with nature. He portrayed country people and scenes from their lives and labors with the objectivity of a chronicler and the emotions of a poet. Among his many works are several enormous paintings, one of them nearly seventeen feet (just over five metres) wide, which portray vast and endless fields, populated by people both working and relaxing, happy and sad. The simultaneously everyday and heroic quality of these scenes, as seen by a wise and loving observer, has prompted some art historians to characterize his work as epic.

As for city life, Pirosmani perceived it as disconnected, disharmonious, and unworthy of independent attention, its only artistic interest being to portray individuals in isolation, apart from their daily routines. Thus his 'city paintings' capture individual urban characters as monumental and serious. All these figures have a certain similarity of physical and even psychological presentation: they are, like their rural counterparts, people of one race.

Some of the artist's most successful works underscore this nationalist quality, by grouping figures, for example, around a holiday table. He thus introduced a specific genre to late nineteenth-/early twentieth-century Georgian painting: *kutezhi* paintings – from the Georgian word for 'feast'. The settings of these works are either outdoors – in the spirit of traditional Georgian celebrations – or, even more often, beyond normative time and space. Pirosmani's *kutezhi* works are very still and static, with clearly organized compositional structure. Rather than reflecting on everyday routine, they convey a vision of the eternal holiday as part of the higher spiritual meaning of the communal feast and its rituals, so important in Georgian culture.

Niko Pirosmanashvili's highly-strung nature was interwoven with his ability to observe intensely; his sensitivity to the processes of life was blurred by his intuitive grasp of history. Having emerged as a painter in a country defined as a political and cultural crossroads, during a transitional historical moment – that of the transformation from one century to the next, and of the technological and aesthetic shaping of modernity he expressed his impression of that extended boundary moment. There is a certain bitterness at the inevitable collapse of the old world, with its stable system of spiritual beliefs and values, and the arrival of a new, complicated, and worrisome world. Yet the artist's vision is not frighteningly apocalyptic. His paintings are serious and reserved, offering a balanced sense of the beauty of reality, with an atmosphere of mysterious expectation. His feasts – his *kutezhi* – are friendly but somehow not simply cheery, and his images of people and animals stare out at us with a certain sadness and bewilderment, as if inquiring about the future fate of the world.

Unless otherwise indicated, all dimensions are in
inches; height x width x depth (where relevant)

ASM	Atchara State Museum, Batumi
GSM	Simon Janashia State Museum of Georgia, Tbilisi
GSAM	Shalva Amiranashvili Georgian State Art Museum, Tbilisi
KSM	Kutaisi State Museum, Kutaisi
IM	Georgian Academy of Sciences Kirneli Kekelidze Institute of Manuscripts, Tbilisi
SAM	State Archaeological Museum, Batumi
SSM	Sighnaghi State Museum, Sighnaghi
AD	Alexander Djavakhishvili
AE	Antony Eastmond
AK	Amoran Kakhidze
EG	Elguja Gogadze
ES	Eter Sulkhanishvili
GB	Gulnazi Baratashvili
GG	George Gagoshidze
GN	Guram Nemsadze
HK	Helen Kavlelashvili
HM	Helen Machavariani
IG	Iulon Gagoshidze
IKo	Irakli Koridze
IK	Izolda Kurdadze
IM	Izolda Meliqishvili
KJ	Ketevan Javakhishvili
LC	Levan Chilashvili
LG	Lili Glonti
LK	Leila Khuskivadze
LP	Leila Pantskhava
MD	M. Davitashvili
MJ	Mindia Jalabadze
MK	Mzistvala Ketskhoveli
MM	Medea Menabde
MSh	Medea Sherozia
MT	Medea Tsotselia
NG	Nana Gogiberidze
NK	Nukri Kvaratskhelia
OZS	Ori Z. Soltes
RR	Ramin Ramishvili
TD	Tsira Davlianidze
TK	Tamaz Kiguradze

NOTE Full bibliographical references are provided
at the end of the Catalogue section.
Exhibits are listed by catalogue number first and
exhibition number in parentheses.

CATALOGUE

1 Female figure [1]
6th millennium BC
Clay, unfired
1⅝ x ⅞ in
Khramis Didi-Gora, Shulaveri culture (Kvemo Kartli)
GSM 110-973:226

This sculpted figurine of a female in a seated position, with legs held closely together and knees bent upward, is modeled with great skill in a largely naturalistic style. In spite of its small size and lack of hands or a head, its effect is impressive. This is one of the best examples of seated figures found at Khramis Didi-Gora which, together with more schematic figures, expresses the idea of female fertility. Precise analogues are not found beyond Khramis Didi-Gora, but general parallels are found in works of the Halaf culture in the Near East. TK

2 Ceramic shard [2]
6th millennium BC
Ceramic
6¾ x 6½ in
Khramis Didi-Gora, Shulaveri culture
(Kvemo Kartli)
GSM SH-XXI-63

A fragment from the upper part of a large hand-made pot, with both a rough and a smooth brown burnished surface. It is decorated with a schematic high relief representation of a male figure, with arms upraised in what might be a gesture of prayer. The neck and body are indicated by a vertical line, and the outstretched legs by horizontal and oblique lines. The symbol of male fertility extends from the torso. Close analogues are found in works at Kvemo Kartli (Aruhlo I and Imiris-Gora). More generally, similar clay pottery ornamented with anthropomorphic reliefs occurs in a number of neolithic and chalcolithic sites throughout the Near East. TK

12 A, B Two spiral rings [11 A, B]

2500–2300 BC
A: gold; B: gold over copper core
A: ½ x ½ in; B: ⅝ x ½ in
Martkopi (Kakheti), kurgan 3,
Bedeni culture
GSM A: 6-979:45; B: 6-979:70

Each spiral ring makes one-and-a-half
loops around the axis, the open ends
being apart. The first one (A) was found
in the main burial chamber of the
kurgan and is made of a thick gold wire
with a slightly narrow middle part and
pointed ends. The second one (B) was
found in a secondary additional
sepulchre (also under the kurgan) and
is made of thin copper wire with gold
cover; the ends are pointed. As a result
of corrosion the gold cover is torn and
the copper wire is visible. Spiral rings
with one-and-a-half loops made of
different metals were widespread in the
southern Caucasus and eastern Anatolia
during the early Bronze Age. They have
been found in archaeological complexes
dated to the middle and second half of
the third millennium BC, but were still
in use in the Trialeti culture of the
following period. TK

13 Necklace [10]

2500–2300 BC
Gold
9½ x 9½ in (pectoral)
Ananauri (Kakheti), kurgan 2, Martkopi culture
GSM 1-995:1-3

This unique artifact consists of several objects found together in a small depression in the floor of the kurgan burial chamber. The central element dominates the other pieces by its size (2⅛ x 2⅜ in) and execution. It is a massive molded flat gold plate, identical on both faces, shaped as a double volute, with a wide round loop along the top, pierced horizontally with four vertical relief bands. From the edge, a double volute-like decoration consisting of herringbone relief ornamentation extends downward, echoed by similar herringbone relief ornamentation encircling the entire pectoral. The rest is open-work-decorated with spirals, triangles, and wavy lines.

The necklace also contains three pendants of somewhat varied sizes – 1½ x 1 in, 1½ x 1 in, 1⅜ x ⅞ in respectively – made of double-spiraled twisted convex wire. Their loop is a single thick strip which divides at its lower part into two wires. The necklace also has 22 'double bobbin-like' beads of different sizes, 33 biconical beads and 23 small cylindrical beads.

This necklace has no known analogues. The direct analogues of the 'double bobbin-like' beads have parallels in the Martkopi kurgan 4. TK

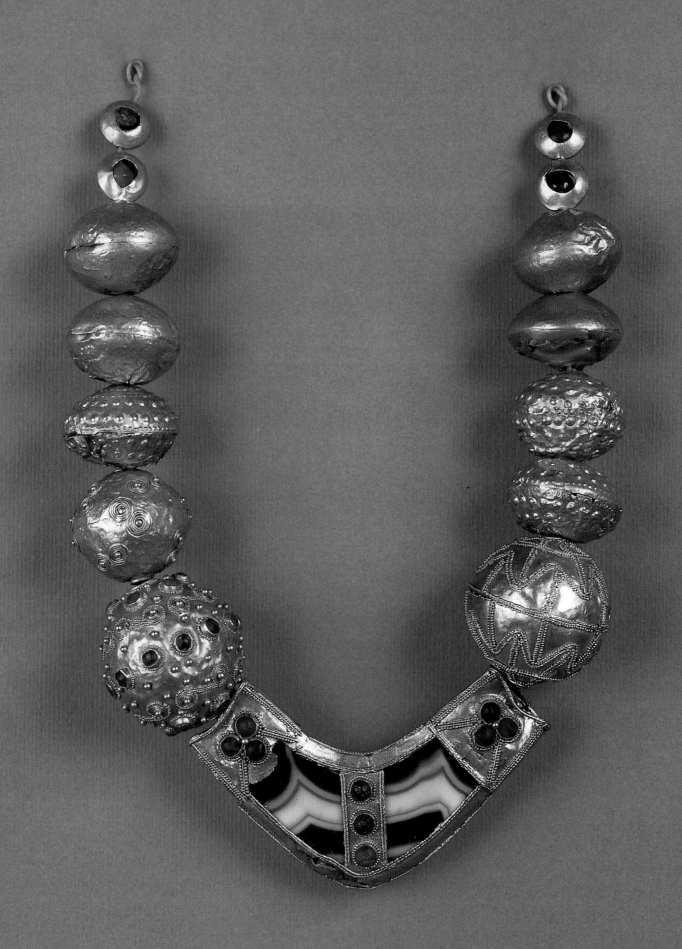

14 Necklace [16]

2000–1800 BC
Gold, agate, carnelian
3⅜ x 1⅛ in (pectoral)
Trialeti (southeast Georgia), kurgan 8
GSM 9-63: 622, 623, 624, 625, 626, 627, 628

This example of early goldwork is unique in its entirety. A series of fourteen hollow beads of increasing diameter (seven on each side) culminates in a central element created by an agate embedded and framed in gold leaf. The four smallest beads, closest to the top of the necklace, are carnelians inset in gold. Carnelian is also embedded in cells in one of the two largest beads, closest to the bottom, and in the gold leaf which holds the brown-and-white-striped agate in the pectoral. Most of the beads are also marked by repoussé dots or, in the case of both large beads, granulated decoration. The overall effect is both rich and complex. EG

15 Bear figurine [15]

Late 3rd–early 2nd millennium BC
Bronze
1⅛ x ⅝ in
Azanta (Abkhazia), dolmen 2, Dolmen culture
GSM 23-61:15

This tiny figurine, from a mold, must have been used as a pendant, given the remaining fragment of a rod connecting its front paws. The massive head is executed realistically. The grooved eyes are oval in shape. The muzzle ends at a slant. The body is stylized, with a round and hollow chest and belly. The legs are massive, with three short grooves on each paw representing claws. The tail is a barely noticeable hump. Narrow crosshatching represents fur. Analogues are unknown [but this is one among many tiny animal figurines that form part of the Georgian artistic vocabulary in antiquity. – ed.]. IKo

16 Fibula [14]

Late 3rd–early 2nd millennium BC
Gold
3⅛ x 2 in
Bedeni (Kvemo Kartli), kurgan 5, Bedeni culture
GSM 134-975:1

The double-volute head of this carefully detailed pin is decorated with two rows of circles, surrounded by double rope-twists on one side and a meander pattern on the other. The head is attached to an oblong-sectioned wand that diminishes to a sharp tip. A similar gold object has been discovered in kurgan 22 at Trialeti; a silver two-volute fibula is known from the Tsnori group kurgan 2, in the Alazani Valley. The technology to produce such high-quality pieces was clearly already well advanced in the Georgian territory in the second half of the early Bronze Age. MJ

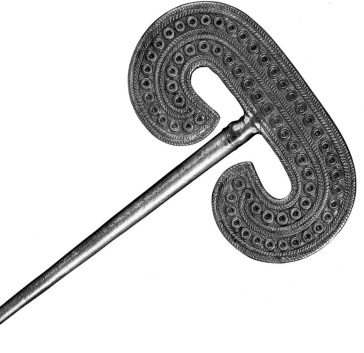

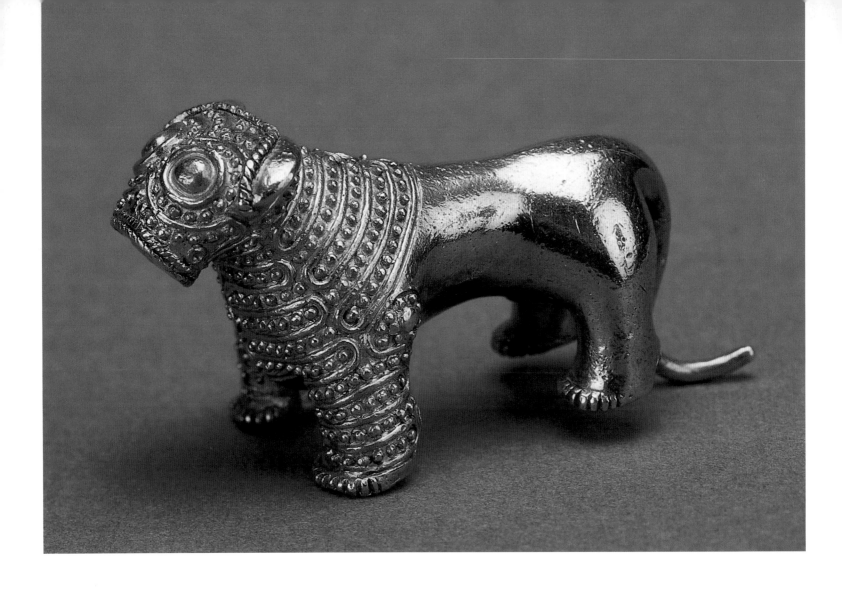

17 Lion figurine [13]
2300–2000 BC
Gold
1 x 2⅛ in
Tsnori (Kakheti), Alazani Valley, kurgan 12
GSM 140-975:1

This exquisite figurine is cast around a core, with the center filled with white-colored paste. Covering the abruptly terminating snout and front paws, as well as serving as a stylized mane, is relief ornamentation that imitates granulation and filigree but is also part of the casting. The ears and eyes are blank projections, and numerous cast notches at the front of each of the paws suggest multiple claws. The paws have holes on the bottom, suggesting that the figurine was once attached to some support, and this is further suggested by the fact that the long curved tail extends below the level of the paws so that the lion cannot simply stand on a flat surface. IG

18 Goblet [18]
18th–17th century BC
Gold, carnelian, lapis lazuli, amber, jet
2¾ x 3⅛ in
Trialeti (southeast Georgia), kurgan 17, Trialeti culture
GSM 9-63:981

This extraordinary double-walled gold goblet is decorated with filigree volutes set with colored stones. It was made on a lathe from a single piece of gold. The pedestal is hollow, with a flat, soldered bottom, also decorated. The volute cells were made separately and tightly attached to the walls by small hooks threaded through narrow soldered plates. The encrustation of colored jewels includes red sardine, carnelian, and lapis lazuli. [Blue-painted ceramic substances which imitate lapis lazuli are also evident in this goblet, probably part of a later restoration. – ed.] Amber and jet are set into circular and cruciform settings on the bottom of the goblet. Filigree is used around the cells to divide zones of decoration, and at the edge of the foot. This goblet is absolutely without known parallels. EG

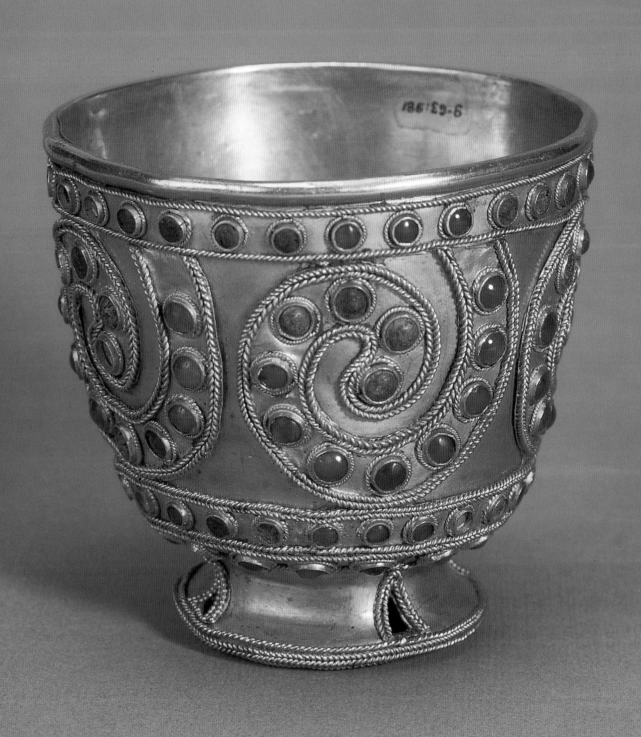

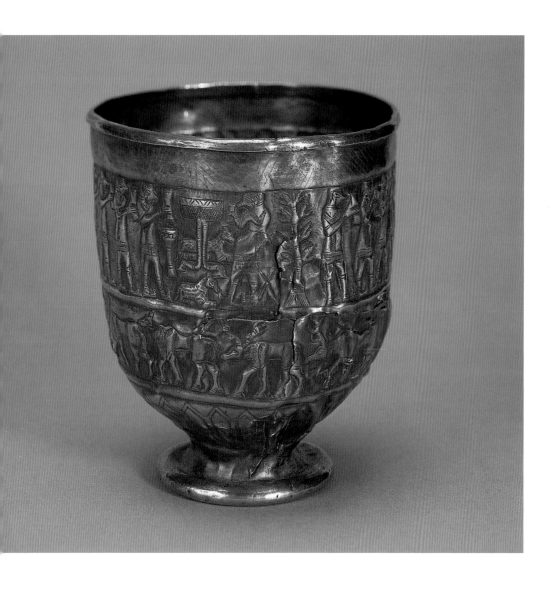

19 The Trialeti Goblet [17]

18th–17th century BC
Silver
4⅛ x 3⅛ in
Trialeti (southeast Georgia), kurgan 5,
Trialeti culture
GSM 9-63:348

This exquisite goblet is made from a single silver sheet. It is encircled by two friezes of hammered relief figures. In the upper register a ritual procession is depicted: 22 men wearing masks and ritual garments march towards the sacrificial altar and a god or a cult priest, behind whom surges the tree of life. In the lower frieze five stags and four does walk in a row. Details such as those of faces arc engraved. EG

[For a fuller discussion of this goblet, see I.1 and the note following III.5. – ed.]

20 Feline figurine [21]

Late 2nd–early 1st millennium BC
Bronze
4½ x 1½ x 1 in
Martazi, Mtskheta (Shida Kartli)
GSM 15-51:5

This figurine is in the shape of a feline – perhaps a panther. The animal is depicted with a wide-open mouth, distinct teeth and fangs, and extended tongue. Its wide ears stand up and forward, its eyes are carved bulging in relief, and it has raised shoulders and rump, back legs placed forward, and front legs more vertical. This is a stylized, yet naturalistic image, without any known precise analogues. It is, however, one of scores of various animal figurines found at Georgian sites of the Bronze Age and Early Iron Ages. TD

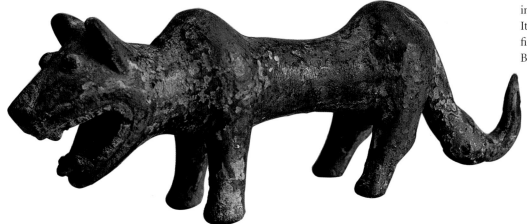

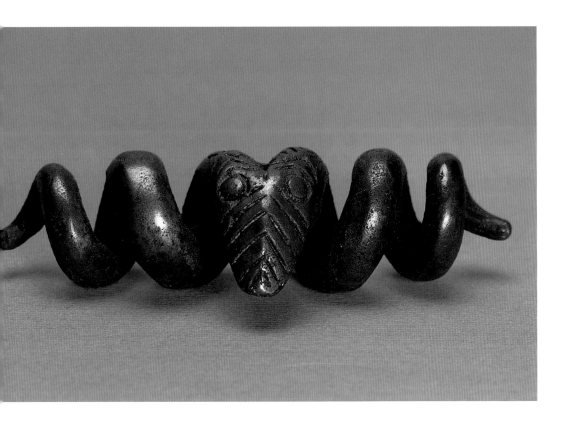

21 **Pendant** [19]

18th–16th century BC
Bronze
1¼ x 4 x ⅝ in
Racha, Brili cemetery, grave 12
GSM 221-39

This pendant, cast in bronze with some antimony and arsenic, takes the form of the stylized head of a ram with spiral-twisted horns. The animal's snout is decorated with slanting notches and the eyes are represented by incised circles.

Grave 12 in the Brili cemetery, where the pendant was discovered, is associated with a tribal leader from the Middle Bronze age mountainous region of Racha. It seems that this leader exercised both ecclesiastical and temporal power. Other cult and ceremonial objects found in this grave, e.g. insignia, are decorated with the same stylized rams' heads. TG

22 **Dagger** [22]

Second half of 15th–14th century BC
Bronze
10⅛ x 2⅞ x ¼ in
Orkhevi (Kakheti), kurgan 5
GSM 14-997:1

The blade and handle of this weapon were cast separately and subsequently attached to each other. The blade is thin, oblong, and leaf-shaped, rounded at the tip but with very sharp edges. A faint, rounded middle ridge runs up the center of the blade along the entire length on both sides. The handle guard is formed as a thick semicircular protrusion along the uppermost edge of the blade. The narrow handle widens at the top, terminating in a thick, straight horizontal edge decorated with three tiny round protuberances. A rounded hole has been placed in the center of the widened part of the handle with a narrow relief line just below it. The edges of the handle and guard are somewhat thickened and are decorated with wattle ornament in relief, worn out or damaged in places. Daggers such as this were widespread in eastern Georgia, especially in the valley of the River Iori, during the Late Bronze Age. MM

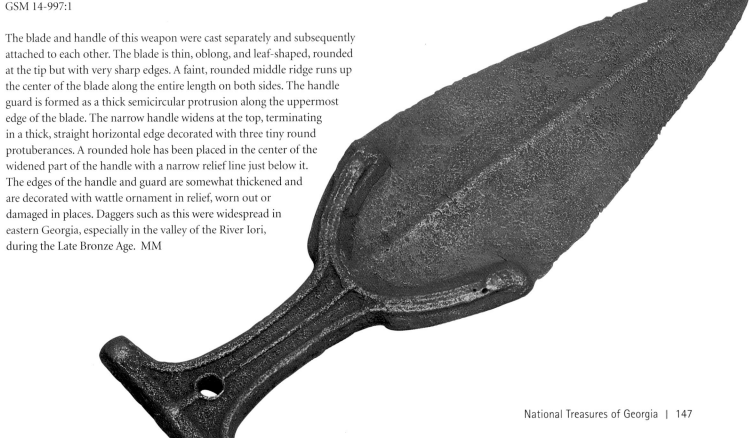

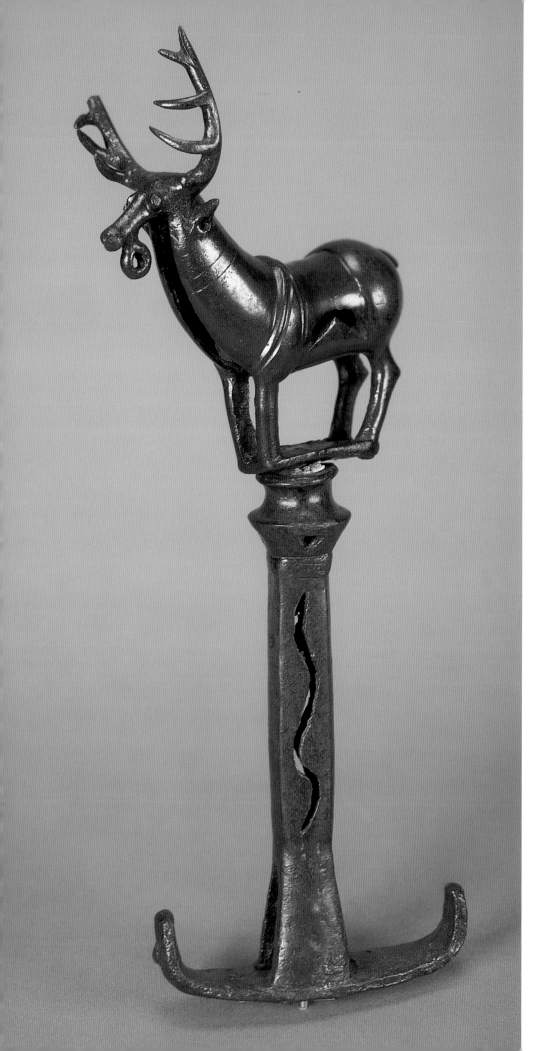

23 Standard with stag figure [23]
15th century BC
Bronze
11½ x 5⅛ in
Berikldeebi (Shida Kartli), kurgan 4
GSM 87-986:107

This carefully-wrought standard was fitted onto the pole of a chariot which was part of the burial of its owner. Placed on the front of the chariot, it was not firmly fixed, but could rock on its stand because of a special attachment: the small rod connecting the stag's legs has a wider lower part than the hole into which it fits on the stand. This detail is important in explaining a feature common to figurines of this type: in a cavity inside the body of the stag are pellets which would have rattled as the standard rocked. The figurine is hollow, its body a thin plate.

The surface of the figurine is smooth. It has massive, multi-pointed antlers, characteristic of a mature stag, with a thick neck and a massive, wide rump. The animal's eyes, ears, and muzzle are well formed. Incrusted with glass-paste, an incised snake image extends along the entire length of the stand on each side [perhaps, as elsewhere in the Near East, associated with fertility and thus with rebirth in the context of a burial – ed.].

Standards with bronze figurines are common to the central south Caucasian cultures of the Late Bronze and Early Iron Ages. They appeared in this region during the mid-2nd millennium BC and bear some resemblance to contemporary standards from Syro-Palestine. Examples of standards bearing such a resemblance were found in the same kurgan, such as a standard with a bronze figure of a bird and an anchor-like stand similar to the one shown here. Similar standards have also been found at Tsiteli Gorebi and Kvemo Sasireti. IKo

24 Pectoral [25]

14th–13th century BC
Bronze
6¼ x 3¾ in (9 in.; total length)
Melaani (Kakheti), Pevrebi cemetery, grave 85
GSM 7258

Along the upper semicircular edge and the
two lower horizontal edges of this complex
piece is a row of joined, relief wave spirals
thickening those edges. A massive tip is
attached to the crest of the upper edge.
Below the tip, a vertical ridge decorated
with five relief frogs connects to the lower
section. These frogs are similar in execution
to those found elswhere in the same burial-
grounds of Kakheti (Pevrebi – the same
cemetery, Gadreckili).

On both sides of the row of frogs, the
upper section of the piece is further decorated
by large cut-out swastikas.

The lower section of the pectoral is a
squared, open-work plate made of high,
narrow triangles, cut between the wave-spiral-
decorated edges referred to above. The plate
has hooks along its lower edge and at its
upper corners, from which open-work figures
of birds on chains are hung (originally there
were six chains; one is now missing and two
are seriously damaged). Numerous figures of
similar birds have been found incorporated
into objects dated to the same period in the
central Transcaucasus. The front and back
surfaces are identical. MM

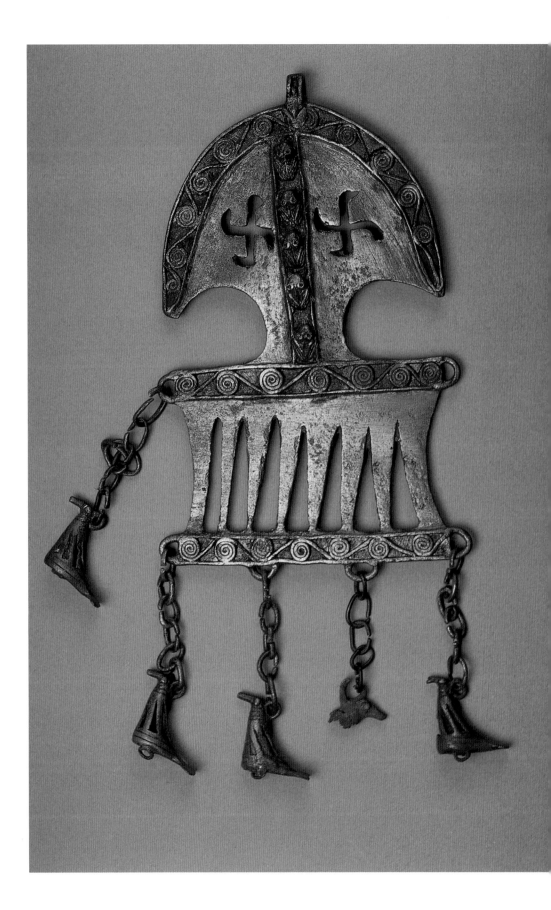

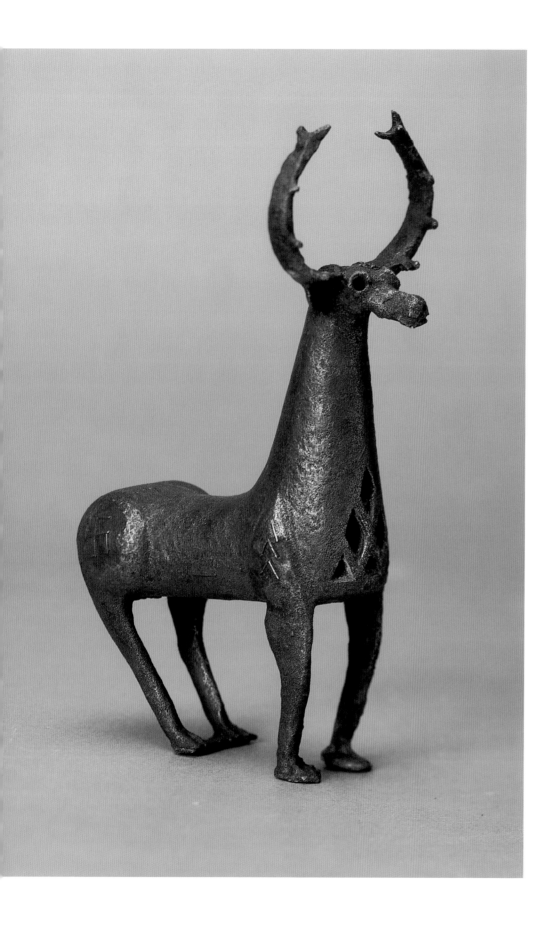

25 Stag figurine [24]

14th–13th century BC
Bronze
6 x 4⅜ x 1¾ in
Tsitelgorebi (Kakheti), kurgan 1
GSM 95-61:98

This figure of a stag, originally placed on a flat plate which was attached to a standard, was formed from a mold. The belly, with two pellets inside intended to rattle with movement, has a fissure along its bottom. The longish body is cylindrical in form, with a well-defined rump. The neck, assuming a conical shape, becomes thicker towards the bottom, merging with a prominent rounded chest, which has three rows of apertures; those of the lowest row triangular and the others rhomboid. Two punctures represent nostrils and a slit represents the mouth; two large sockets with high-relief edges represent the eyes. Flat-plate antlers are separated from the head by low-relief thickenings and form an open circle. The legs exhibit uneven thickness, their divided ends representing cleft hooves.

The figurine is handsomely decorated; on its back and rump are broken crosses (swastikas) [a decorative motif that originated in India and would have arrived by way of Iran – ed.], thorny ornamentation, and short horizontal lines once incrusted with copper and silver, which stand out in relief. Similar sculptures have been discovered at Berikldeebi (kurgan 4), Kvemo Sasireti, and other sites. They are typical of central south Caucasian cultures in the Late Bronze and Early Iron Ages. IKo

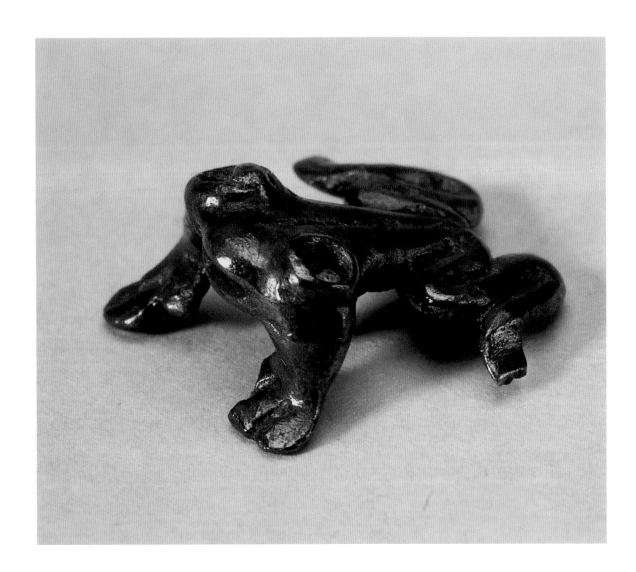

26 Frog figurine [26]
14th–13th century BC
Bronze
¾ x ⅜ in
Melaani (Kakheti), Pevrebi cemetery, grave 85
GSM 7262

This tiny figurine is executed in a fairly naturalistic style. The body takes the form of a rounded, flat triangle with its wide edge suggesting the face. There is an incision in that edge representing the mouth and, on its upper side, large protuberances distinctly represent rounded eyes. The frog stands, as it were, on two short front legs and two long, bent, back legs. On the belly are the remains of a small hook. Similar sculptures have been found in another burial-ground of the same period at the village of Gadrekili. MM

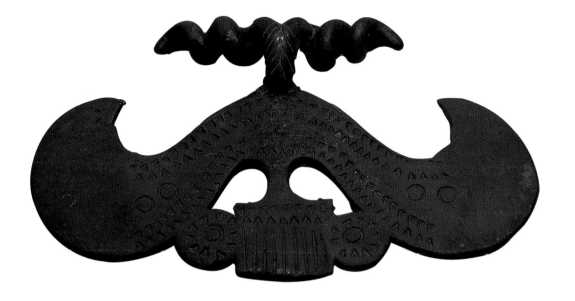

28 Bracelet [28]

14th–12th century BC

Bronze

3⅜ x 3⅜ x 1⅛ in

Orkhevi (Kakheti), grave 12

GSM 14-997:7

A massive molded open loop is decorated with groups of transverse high-relief ridges interspersed with additional diagonal ridges that form ornamentation resembling fish-bones and triangles. Two bracelets of virtually the same form were found in the same grave, but other analogues are unknown. IKo

27 Pendant [20]

18th–16th century BC

Bronze

5¼ x 2⅞ in

Brili (Racha), grave 12

GSM 87

This molded pendant echoes the form of the combat axehead found in the same grave. At the same time it seems to resemble a stylized bird with outspread wings. The space between the wings is filled with a richly incised decoration: four rows of wedge-shaped ornamental grooves and a pair of circles. The pendant is further decorated with the surmounted head of a ram (currently detached from the main body) with spiral horns. The eyes of the ram are depicted by incised circular grooves and its muzzle is covered with grooved ornamentation. The round neck and the 'body' form a further loop. Although a further exactly similar example of this pendant was found in the same grave, other analogues are unknown. IKo

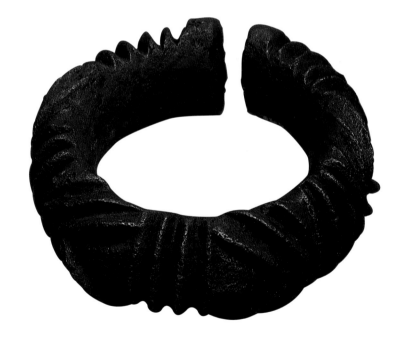

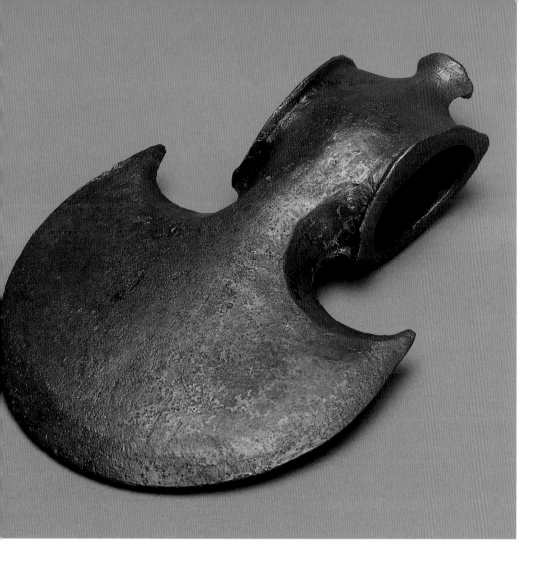

29 Axehead [27]
14th–13th century BC
Bronze
7¼ x 5 x 1⅝ in
Kvemo Sasireti hoard (Shida Kartli)
GSM 17-30:6

This is a molded central south Caucasian axehead; in the scholarly literature first called an Amazon, and later an eastern Georgian type. The blade is wide and symmetrical, with a prominent hump on the top and with high upward-pointing ends. The oval-shaped hole for the handle is encircled by a low-relief ridge.

Axes of this type were probably used in combat. They are ordinarily located in warriors' sepulchres, but are sometimes found together with such farming tools as flat axes and chisels. They are typical of the cultures of the late Bronze and early Iron Ages spread throughout most of eastern Georgia, but several examples, together with a mold (see 30), have been found in Colchis (western Georgia). Ultimately the range of such axes extended to Kars (in what is today northwestern Turkey) and a particularly large number were found in a hoard near the Mekhchri fortress. Such axes appeared in the late 14th–early 13th century and continued in use until the 7th century BC, when iron came into wider use and they were supplanted by other types of battleaxes. IKo

30 Axe mold [30]
End of 2nd–beginning of 1st millennium BC
Stone
7½ x 6¼ in
Natsargora settlement (Shida Kartli)
GSM A-5

A mold for what was first known as an Amazon and later as an east Georgian axe. More recent archaeological literature terms it a central Transcaucasian type of axe.

Axes cast in such a mold would have been massive, with a wide symmetrical blade, curving up at the ends, with pointed shoulders and an oval handle socket. Such axes are typical of cultures spread throughout the territory of eastern Georgia (mainly Shida and Kvemo Kartli) in the Late Bronze and the Early Iron Ages. A similar mold was also found in Kolkheti (western Georgia, at the site of the ancient town of Itkvisi). The earliest analogues for molds of similar types of axes date from the 14th and 13th centuries BC (found in the hoard at Kvemo Sasireti). IKo

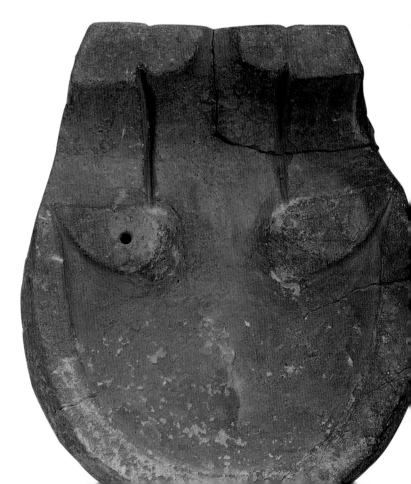

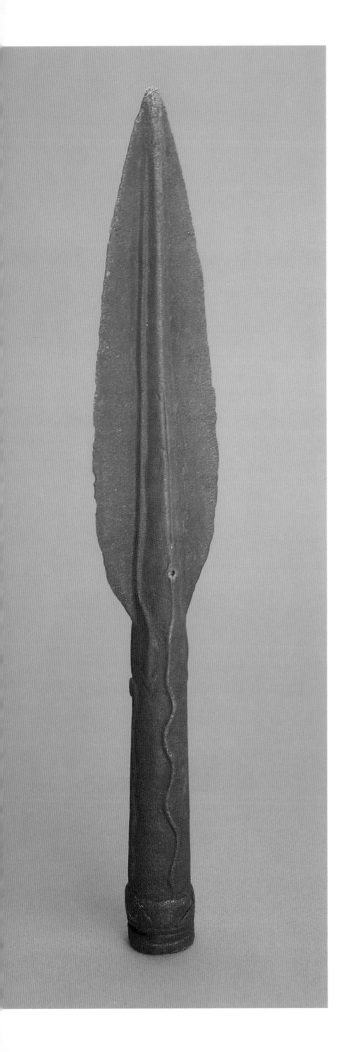

31 Decorated spearhead [29]
13th–12th century BC
Bronze
12⅞ x 2 in
Shilda sanctuary (Kakheti)
GSM 19:982/1425

The shaft of this spearhead is made of one molded piece of bronze encasing an oval blade. Around the edge of the shaft are slanted notches, three grooves, and below them zigzag lines. The blade has a high ridge along both sides which is an extension of the shaft, narrowing toward the tip of the blade. The zigzag lines are actually stylized snakes, their heads spirally wound in a circle; the larger zigzag which echoes these lines is also a stylized relief image of a snake, continuing all the way to the edge, where a punctured triangular head may be discerned. It is repeated on both sides of the shaft. Similar spear-blades have been found mainly at nearby sites in eastern Georgia, but this particular decoration has no known precise analogues. LP

32 A–C Three swords [31 A–C]
12th–9th century BC
Bronze
A: 23½ x 3⅛ in; B: 25¾ x 3⅛ in; C: 25¾ x 3⅛ in
Melaani (Kakheti), shrine, complex I
GSM A: I-58:2; B: I-58:3; C: I-58:12

These representatives of a large hoard of swords are all cast with a long blade narrowing to the top and rounding at the tip. The edges are sharp and a distinct middle ridge runs along the entire length of each blade on both sides. The shoulders are thick and slightly sloping at the handle, which joins the blade in an abrupt straight line. The blade of one sword is decorated with incised ornamentation: there are four lines on each side of the ridge, from which the side lines join each other in arched forms. Half of the space between these lines is further filled with slanting notches. At the top of the blade is a tall isosceles triangle pointing toward the handle. There are slanting notches between the sides of the triangle and small long herringbone ornamentation at the ridge. A rounded short handle is decorated with four symmetrical twisted relief lines, two of which (on the front side) end with double spirals. The pummel is a quasi-sphere designed as a two-tiered open-work series of triangles.

 The other two swords are identical to the first in overall form and handle ornamentation, but they lack any decoration on their blades. Weapons such as these were spread throughout eastern Georgia during the Late Bronze and Early Iron Age, especially in the region of Kakheti, which is why they are often called swords of the Kakheti type. MM

 [Georgian – and perhaps Roman – tradition associates the hoard of which these are part with the Amazons. – ed.]

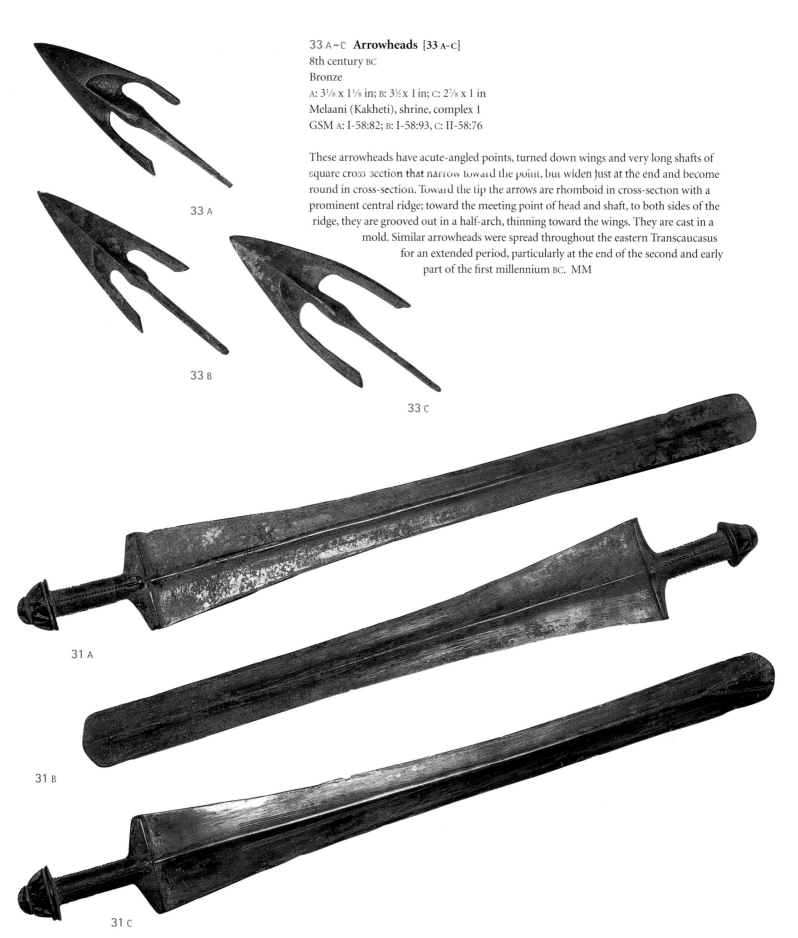

33 A–C **Arrowheads** [33 A-C]
8th century BC
Bronze
A: 3⅛ x 1⅛ in; B: 3½ x 1 in; C: 2⅞ x 1 in
Melaani (Kakheti), shrine, complex 1
GSM A: I-58:82; B: I-58:93, C: II-58:76

These arrowheads have acute-angled points, turned down wings and very long shafts of square cross section that narrow toward the point, but widen just at the end and become round in cross-section. Toward the tip the arrows are rhomboid in cross-section with a prominent central ridge; toward the meeting point of head and shaft, to both sides of the ridge, they are grooved out in a half-arch, thinning toward the wings. They are cast in a mold. Similar arrowheads were spread throughout the eastern Transcaucasus for an extended period, particularly at the end of the second and early part of the first millennium BC. MM

33 A

33 B

33 C

31 A

31 B

31 C

34 Male figure [35]

8th–7th century BC
Bronze
7⅜ x 2⅞ in
Melaani sanctuary (Kakheti)
GSM TSU175

A molded warrior and fertility symbol – perhaps a god – is represented by this naked figure. The hands on the outspread arms are well delineated, with fingers articulated by notches. In the right hand the figure holds a drinking horn, perhaps for offerings. The short, disproportionate egg-shaped head is covered by a faceted object that could be a cap or hair gathered into a bun. The features of the flat face are well detailed: the eyes are round knobs, surmounted by strong ridges as eyebrows, the nose large and rectangular, and the mouth indicated by a carefully incised slit; the ears are marked by oval and round punctures. A low round knob on the left-hand side of the chest suggests a breast; there is a wide hoop round the neck, and a dagger is hung on a strap over the shoulder. The figure is restrained but very impressive. Since most of the sacrificial objects found in sanctuaries were serially produced, this figure is quite remarkable for its originality . Analogues are known from Melaani, Zekari, Gori, Lechkhumis Sairme, and other sites. LP

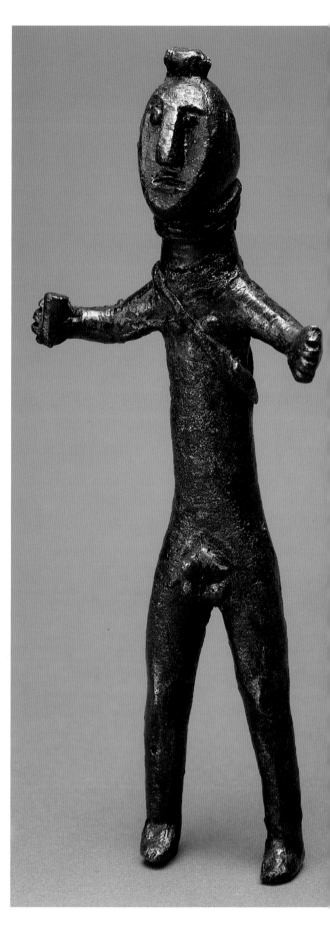

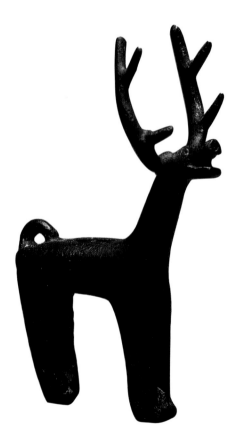

35 Stag pendant [32]

10th–9th century BC
Bronze
2⅞ x 1⅞ x 2 in
Mtskheta (Shida Kartli),
Samtavro cemetery, grave 96b
GSM 12-54:2155

A figurine made from a thin bronze plate. The body is cored, with rectilinear neck and legs. The front legs are joined together as are the back legs, but with a small oval cut in each pair to suggest separate feet. The body also has a decorative oval slit along its entire length. The place of the tail is taken by a hook. The head is raised from a long neck and is in turn extended, with its mouth wide open as if bellowing; the eyes and snout are indicated by incised decoration and the antlers rise in a pair of curves, each branching into two additional appendages. MM

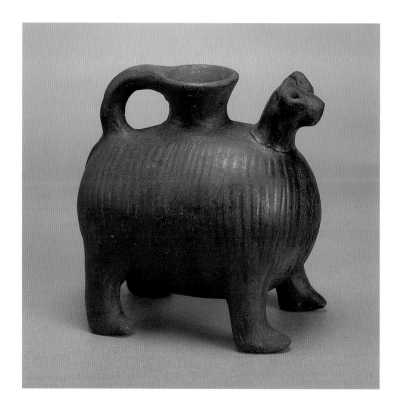

37 Zoomorphic vessel [36]

8th–7th century BC
Ceramic
7 1/8 in (diameter)
Treli (Shida Kartli), grave 16
GSM 11-1:70-39

The vessel, apparently intended for pouring liquid, and made of fine, sifted clay with a smooth gray-black surface, takes the form of a ram. Its highly stylized body is spherical and slightly distended horizontally. The body is covered with vertical grooves which represent the fleece. The head, executed with some attention to detail, is composed of a short, sharply cut-off muzzle and horns modeled with added-on spiral-shaped clay rods. A large round hole forms the mouth, as an exit point for liquid, which would have been poured into the vessel through the larger hole on its back. Short cylindrical legs thicken for stability at the bottom, suggesting hooves. The chest and back of the ram are decorated with geometric motifs. The belly is further enhanced by wavy crevices and lines along its entire length.

A similar vessel, slightly smaller, was found in the same grave, but other analogues are unknown. IKo

36 Miniature war chariot [34]

9th–8th century BC
Bronze
2 x 7 7/8 x 2 5/8 in
Mta Gokhebi, near Tsiteltskaro (Kakheti)
GSM A-7

The chariot body is divided into two equal parts, allowing for two riders, a charioteer, and a warrior. It is open at the back; its wheels turn on an axle. A crescent-shaped bronze piece found near the chariot must have been fastened to it from the outside part of the axle; on the war chariots of which this is a model, the purpose of such a part would have been to slash enemy infantry. A long pole extends from the front of the chariot body, fastened to a yoke with a thick wire. The yoke, made of a slightly curved thick bronze stem, rests on the necks of the open-mouthed horses and is secured to them from beneath with a wire. There are reins and the traces of a chain, perhaps of a bridle. This kind of war chariot was found throughout the entire Near East from the middle of the 2nd millennium BC. Later its use, by nobility serving in the military, extended into north Africa, southeast Europe and south central Asia. MM

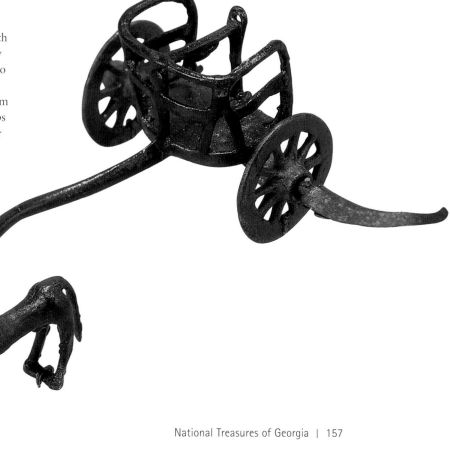

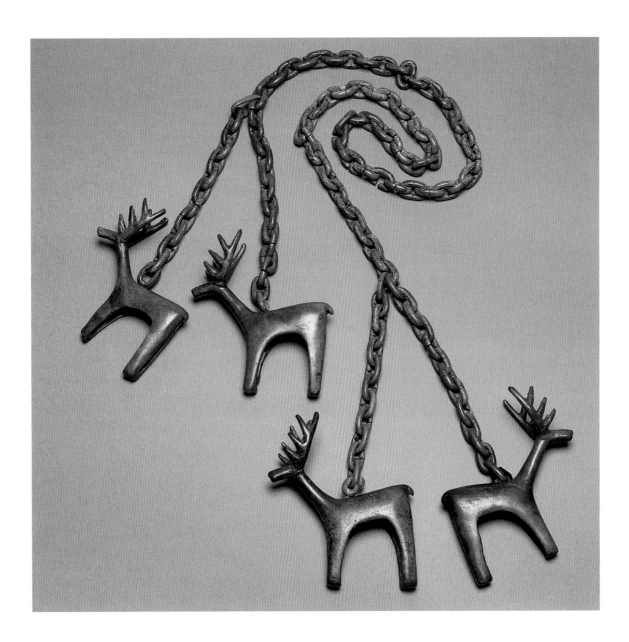

38 Chain with stag pendants [38]

8th–7th century BC
Bronze
3½ x 3⅛ in (each stag); 23 in (chain length overall)
Chabarukhiskhevi hoard (Shida Kartli)
GSM 27-61:65,66,67,68

Each of these four molded figurines has a flat geometrical body, slightly upraised rump and short tail. The belly and legs are hollow; the latter lack any detail and are placed close together. The expressivity of these tiny figurines is derived from their well articulated, elongated necks, heads, and antlers, which are executed with considerable attention to naturalistic detail: their mouths are slightly open, as if calling to one another. On each of their backs is a small hole through which a thread connecting to a chain is pushed; it is clear that they were designed to be hanging from something and were intended to be seen in profile, presumably worn on the chest as part of a necklace or a pectoral. The chain is made of oval, open rings.

The earliest examples of this type of sculpture have been found in the Samtavro sepulchre, and are therefore known as 'Samtavrian'. Similar figurines of deer have been found elsewhere in eastern Georgia, in the Pasanauri region of the province of Kartli. The most recent examples were found as part of the Kazbegi Treasure. LP

39 Belt/Girdle fragment [37]

8th–first half of 7th century BC
Bronze
8 x 16⅝ in
Mtskheta (Shida Kartli), Samtavro cemetery, northern plot, grave 276
GSM 12-54:7399

A single, round-cornered plate is engraved with a complex composition framed by four rows of joined open volutes producing a stylized wave motif. The middle of the field is covered with a similar motif, dividing it into two separate friezes. Both ends of the belt are decorated with elongated triangles filled with spirals, rhombs and dots; when fastened, the triangles form a rhomboid buckle. The two friezes are filled with anthropomorphic and zoomorphic figures of different sizes. Sometimes only a part of the whole body is depicted (e.g. the head of a deer). The figures in the upper frieze are placed in a straight line. At the center, the figures appear to be hunters, dogs, images of a wild boar (perhaps the object of the hunt), and a bird. On both sides of these figures are fighting stags, and behind them, other figures in pairs. On the lower frieze the figures are placed in a more irregular and asymmetrical pattern; they are smaller in size and more numerous than those of the upper frieze. Because of the asymmetry and multiplicity of figures it is difficult to find the compositional center, but it can be distinguished from the theme, two men sitting opposite each other, holding variously sized and shaped vessels in their hands. In addition to these figures are astral signs – stars and crosses.

Similar engraved belts from a Colchian workshop are often found in the early Iron Age art of Transcaucasia. LP

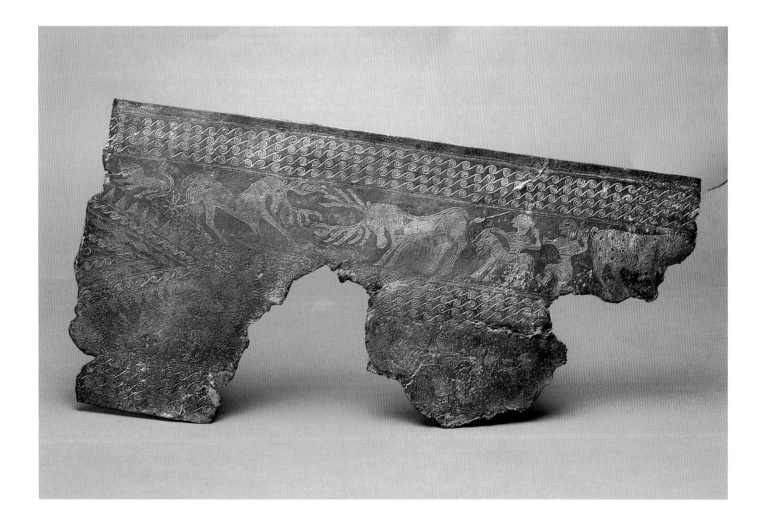

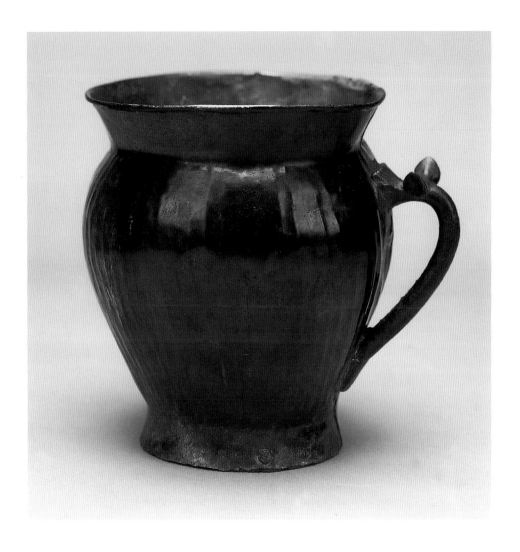

41 Colchian didrachm, second type [43]

6th century BC
Silver
7/8 in (diameter)
Western Georgia
GSM FH22466

OBVERSE: Human head, facing right. The hair falls down the back of the neck, within an incised circle.
REVERSE: Two human heads, facing one another, each in incised rectilinear lozenge.

Six types of Colchian coins are known, of which this is one of the earliest, typically found along the eastern shore of the Black Sea in the territory of Colchis (Egrisi). MSh

40 Situla (Pitcher) [39]

8th–7th century BC
Bronze
5½ x 5 in
Okureshi (Lechkhumi), Lajobispiri hoard
GSM 1-36:179

The body of this handsome vessel, embossed and covered with vertical flutes, narrowing toward the bottom and flaring out abruptly, is made of a single plate. A round zoomorphic handle (with lugs resembling animal ears) flattens at the ends where it is soldered to the shoulder and lower body of the vessel. The places where the handle is attached are marked by circular knobs on the interior. The edges of the body plate overlap and are fastened by five pins; the seam falls just to the right of the handle. The bottom has been made separately and attached to the body with four pins, forming a cored heel. At the mouth the metal is folded out to create a spout. Such vessels are typical of Colchian culture; they are found throughout western Georgia, as well as in the province of Kartli, to the east, and in the northern Caucasus area. MM

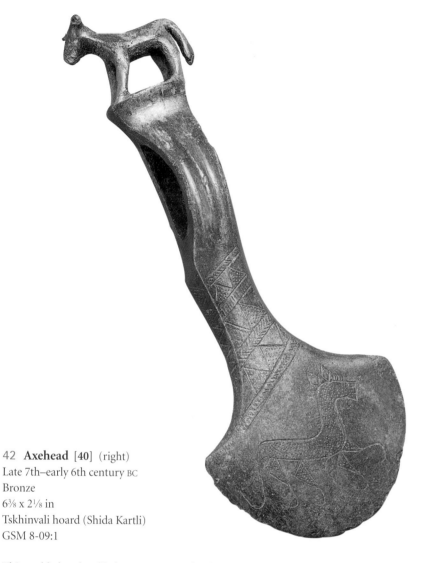

43 Axehead [42] (left)
Early 6th century BC
Bronze
6⅞ x 2¾ in
Ozhora cemetery (Shida Kartli), grave 5
GSM 7-59:47

This axe, made by the lost wax method, is most unusual: the edge is of type I and the body of type III, according to the Otar Japaridze classification of Colchian axes. The sculpted figure of a bull surmounts the top of the heel. The animal has a well-shaped head but lacks detailed features; there is a dotted triangle on its forehead, its snout is rounded and its horns are damaged. The body is well-proportioned – its tail is long, its front feet stand obliquely, its back feet are straight, and the hooves are not outlined. Each side of the axe is decorated with the incised image of a horse, executed in a schematic manner and a geometric form. The horse has a square head, rhomboid ears, and a short mane marked by striations; its rump is raised up; its feet are depicted by triangles ending with inward-turning, rounded lines; the tail is depicted as a single line. A row of triangles, filled with dots, is placed to one side of the horse. The waist of the axehead is further ornamented with triangles, rhombs and herringbone motifs.

The axe was one of the most important instruments in Colchian culture. The incised drawing and sculptural figurine decorating this axe reflect the artistic acumen of Colchian workshops and the luxurious aesthetic tastes of the upper classes of the culture of the area. Similar ornamentation is found on objects from the Tli burial-ground. LP

42 Axehead [40] (right)
Late 7th–early 6th century BC
Bronze
6⅜ x 2⅛ in
Tskhinvali hoard (Shida Kartli)
GSM 8-09:1

This molded axehead belongs to type I of Colchian axes as classified by Otar Japaridze. It is engraved with decorations forming a single composition. The central figure is typically situated on the wide, flat (cheek) portion. The decoration that extends from the cheek and across the narrow central area (the waist) is divided into three sections by double lines. The same ornamentation is found on both sides of the axehead: the main section, on the cheek, contains two adjoining triangular figures with their corners connected by straight and curved lines, which has been interpreted by Japaridze as the stylized image of an animal paw. This portion is separated from the two sections extending onto the waist by the above-mentioned double line; its motif is repeated on the upper part of the waist. Between these two frames, the middle section is marked by simple geometric ornamentation. Beyond the waist, on the ridge of the axe, is the image of a curving snake. On the back of the ridge is a geometric decoration.

Such Colchian axes, made by the wax extraction method, were common to western and eastern Georgia as well as to regions under the influence of Colchian culture (i.e. in the northern Caucasus) during the middle of the last pre-Christian millennium. Their sinuous shape and engraved ornamentation are unique to Colchian axes, which are thus a genre in themselves. LP

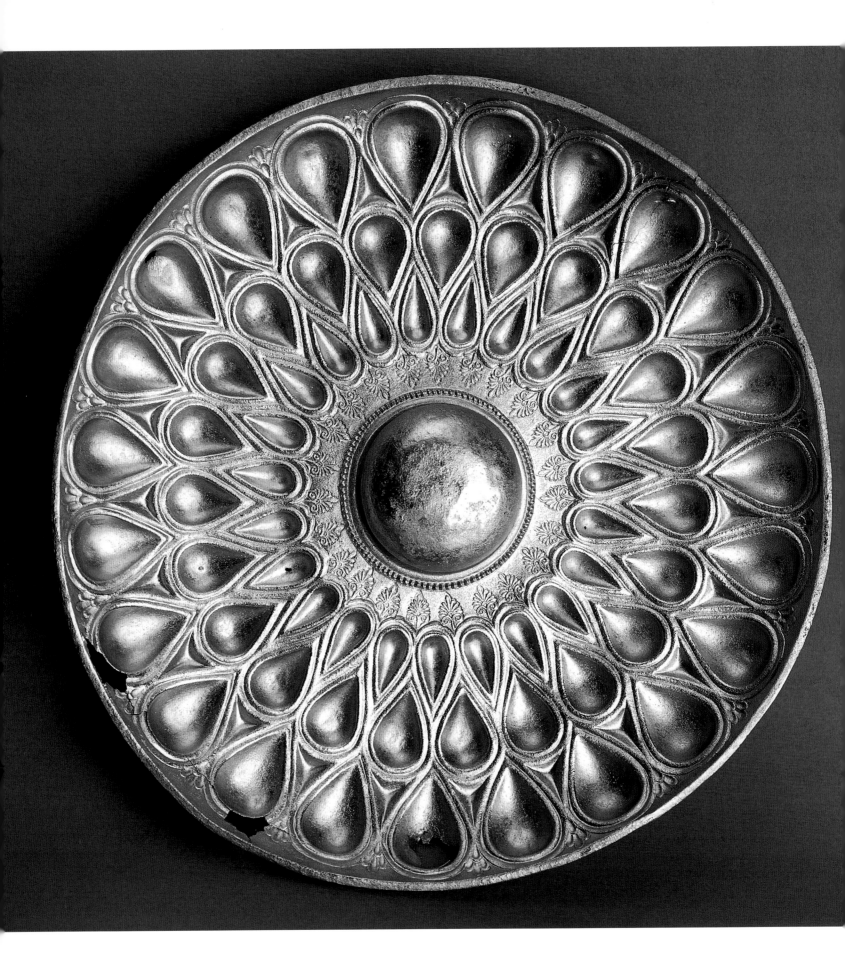

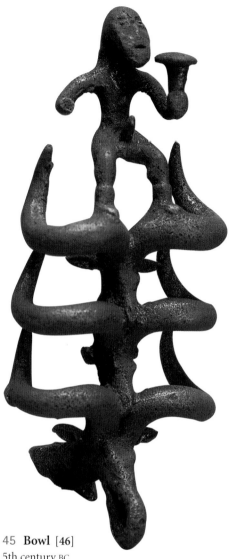

44 Standard with aurochs and human figure [44]

6th–5th century BC
Copper
6 x 3 in
Kazbegi hoard
GSM 2-021 1/177

Complex cult, ritual standards were typical of the ancient cultures of the mountainous regions of Shida Kartli and on both the south and north slopes of the Caucasus Mountains throughout the 6th–4th centuries BC. Cast copper points, consisting of animal and human images with bells, were often joined tightly to one another and attached to the lower parts of such standards.

This standard has a hook on which a cylindrical bell hangs from the copper ring. Stylized heads of sheep appear on both sides of a spool, with special holes for the bells in their lips. Two naked figures of men in squatting positions are depicted on the spiral-twisted ends of the horns. One of the men has an oval shield in his left hand, and the other holds an instrument resembling a lyre, which he is playing.

All the sheeps' horns are broken, as is the right hand of the man with the shield. Bells from this standard have been lost. IG

45 Bowl [46]

5th century BC
Silver
7⅜ x 7¼ x 1 in
Pitchvnari (Atchara), Greek necropolis, grave 110
ASM 19836

A bowl with a flat mouth and a smooth omphalos at the center/bottom. The surface is further ornamented with three almond-shaped concentric patterns and a row of palmettes among lotus flowers around the central omphalos. [Such bowls, variations on an omphalos-centered theme, were common in antiquity from Etruria to Persia. The omphalos may suggest a swollen womb, and therefore fertility, abundance, and, in short, survival, as it sits in the center of the universe of which the bowl is a symbolic microcosm. – ed.] AK

46 Hermaphroditic figurine [41]

7th century BC
Bronze
12½ x 4 in
Fersati (Imereti)
KSM 5668

This remarkable bronze piece personifies fertility and has both male genitalia and female breasts and hips. The outstretched arms and hands suggest that this figure was holding something and are associated with making offerings. The large eyes within a large head suggest the riveted attention familiar from Sumerian figurines to Archaic Greek statuary. The figurine was discovered on the banks of River Silashi in Fersati in 1914. OZS, NK

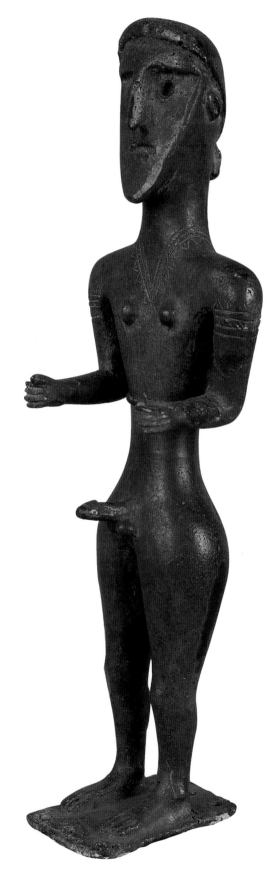

48 Aryballos [53] (below)
Second quarter of 5th century BC
Glass
3¾ x 2¼ in
Pitchvnari (Atchara), Greek necropolis, grave 137
SAM 150/1986

This vessel has a spherical body with round base, two
handles extending from shoulders to neck, and a wide
mouth. It is blue, with the body further decorated with
zigzag ornamentation between yellow and blue stripes.

 Analogous aryballoi have not been found on Georgian
territory, although such vessels were widely spread in
antiquity – as were other similar ointment and perfume
vessels, such as amphoriskoi and alabastra (see 49, 50, 51)
– throughout Greece, Italy, the Balkans, and along the
northern and western shores of the Black Sea. TD

47 Red-figure skyphos [52] (above)
475–450 BC
Ceramic
3¼ x 6⅛ x 3⅞ in
Pichvnari (Atchara), Greek necropolis, grave 118
SAM 124/1986

This drinking vessel is slightly convex, with a wide body narrowing to
the bottom and resting on a foot. Two handles, both horseshoe-like and
one horizontal, are attached to the mouth (this is a type B skyphos).
The vessel is nearly intact; it has been repaired at the horizontal handle.
The surface and painting are well preserved. The skyphos has a glossy
surface finish, except in the painted areas. A wide line on the inner side
of the foot and circles with a central dot in the middle of the foot are
glossy. Among olive branches on both sides of the body an owl is
depicted: the head is slightly turned to the right; eyes are represented
with black slip with a thick black dot in the center, and feathers and
beak are also rendered with black dots. Such details as eyebrows, wings,
and leaves are very delicate. The vessel is dated by its form and the
stylistic decorative features. TK

50 Alabastron [54] (below)
480–450 BC
Glass
4⅛ x 1⅛ in
Pitchvnari (Atchara), Greek necropolis,
grave 120
SAM: 129/1986

Ointment vessels such as this were widely
spread throughout the Greek world, the
Near East, and the Black Sea region.

Both this alabastron and 55 are well
preserved and of the same type, with a high
cylindrical body, narrow neck, and disk-
shaped wide mouth. Two small saddle-
shaped handles with laces are placed at the
shoulder of each. The two vessels differ
from each other somewhat in color and in
certain details. Both are made of blue glass
and decorated with encircling wavy yellow
and white lines. This vessel is slightly
asymmetrical. It is made of glass mixed
with a tiny amount of sand. A wide white
line encircles its upper body, which is covered
with white threads. Spiral laces evolving as a
zigzag ornamentation of varied thickness
decorate the neck and shoulders, near the
handles. Two narrow lines decorate the lower
part of the vessel. TK

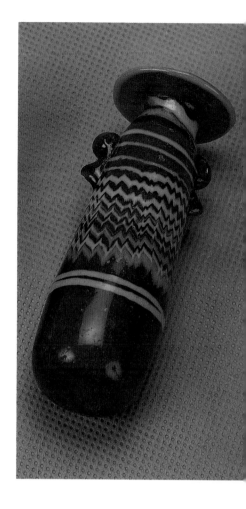

49 Amphoriskos [57] (above)
Mid-5th century BC
Glass
2¾ x 1¾ in
Pitchvnari (Atchara), Greek necropolis, grave 48
SAM 2/1979

This small, well-wrought ointment vessel has an
oval body, an open funnel-like mouth, cylindrical
neck, and an unstable, narrow round foot. Two
handles extend from the shoulders to the neck. The
entire piece is a deep blue, with the rim and upper
part of the body decorated with concentric yellow
stripes and a zigzag pattern decorating the body.

Amphoriskoi were one of the most widespread
forms of pottery and glass in the ancient world.
Glass ointment vessels such as this one have been
found in Georgia at a number of archaeological
sites (Vani, Brili, Enageti as well as Pitchvnari).
They no doubt derive from Egyptian and Syrian
workshops, from which they spread along the
shores of the Mediterranean in Phoenician
colonies and throughout Syria, Greece, and areas
under Greek influence. TD

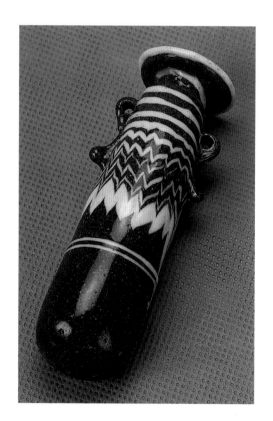

51 Alabastron [55] (above)
480–450 BC
Glass
3⅞ x 1¼ in
Pitchvnari (Atchara), Greek
necropolis, grave 120
SAM: 155/1986

The body of this alabastron is
more cylindrical than 54 and
cone-shaped (wide at the
bottom, narrow at the neck).
The mouth is decorated with
a light blue wide line. Spiral
yellow lines decorate the neck
and shoulders, interspersed
with a yellow and light blue
zigzag ornamentation. The
lower part ends with a double
yellow loop near the bottom.
See also 50. TK

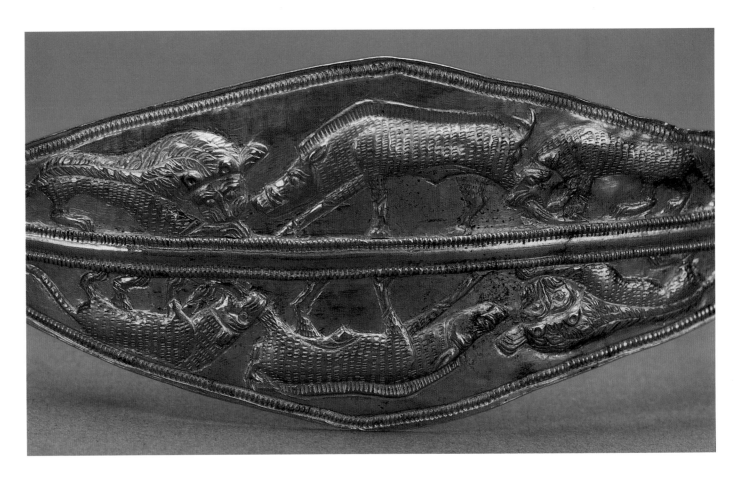

52 Diadem [50]

First half of 4th century BC
Gold
9¾ in (diameter)
Vani (Imereti), grave 6
GSM 11-974:1

A twisted open hoop terminates in connecting
hooks; at the center the hoop opens into a
diamond-shaped plate, divided along its
horizontal center by a threefold line (a tube
flanked by two beaded lines). These lines in turn
continue along the outer edges of the plate, but
in reverse: each of the two beaded lines along the
center becomes the center of the edge framing,
flanked by two tubular lines. The field is thus
divided into two flat isosceles triangles which are
mirror images of each other: in low relief, on
each in reverse, two lions attack a wild boar.

Such diadems are part of a unique style of
Georgian jewelry, made locally and spread only
in Georgia. Such scenes of fighting animals were
fairly widespread in Near Eastern and Eastern
Mediterranean art of the 6th and 5th centuries
BC, but the specific configuration and application
to a diadem such as this one is found nowhere
else. TD

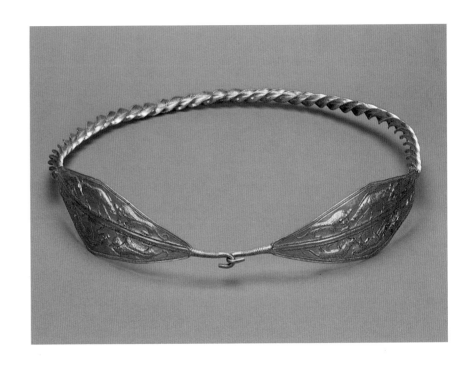

53 Beads [45]
Second half of 1st millennium BC
Glass
1 x 1¼ in and 1¼ x 1½ in (range of diameters)
Brili (Ratcha), grave 27
GSM 5-993:623,624

These seventeen large, semi-opaque beads range from deep to lighter blue. The darker blue beads have a white, yellow and sky-blue concentric stripe at their widest point; the lighter blue beads have dark blue and yellow patches. They are all vertically fluted. In each the hole for a string is wide and straight, suggesting that they were intended to be strung as a necklace.

Vertical flute decoration is not unusual in beads found on the territory of Georgia in antiquity, especially during the Hellenistic period, but these large-sized beads from Brili have no precise parallels elsewhere. TD

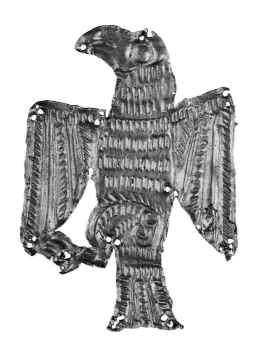

54 Colchian hemidrachm (triobolos), second type [49]
5th–4th century BC
Silver
¾ in (diameter)
Potskho, Martvili (Samegrelo)
GSM FH 25632

OBVERSE: Archaic-style human head, with hair falling in three tresses down the back of the neck, facing right, placed in an incised circular frame.
REVERSE: Bull's head, facing right, within an incised circular frame.

More than 5000 coins of this type have been found throughout western Georgia. MSh

55 Plaque in the shape of an eagle [51]
5th century BC
Gold
1¾ x 1⅞ in
Vani (Imereti), grave 11
GSM 10-975:71

Given the small holes at the edges of this small eagle-shaped plaque, it must have been sewn onto a piece of cloth or leather. The feathers are stylized and represented by means of grooves.

According to current discussions in the scholarly Georgian literature, and based on what is known of old Colchian beliefs, placing objects representing eagles – a sacred bird ('a bird of the sun') – in the grave reflected an elevated position of power for the deceased. TD

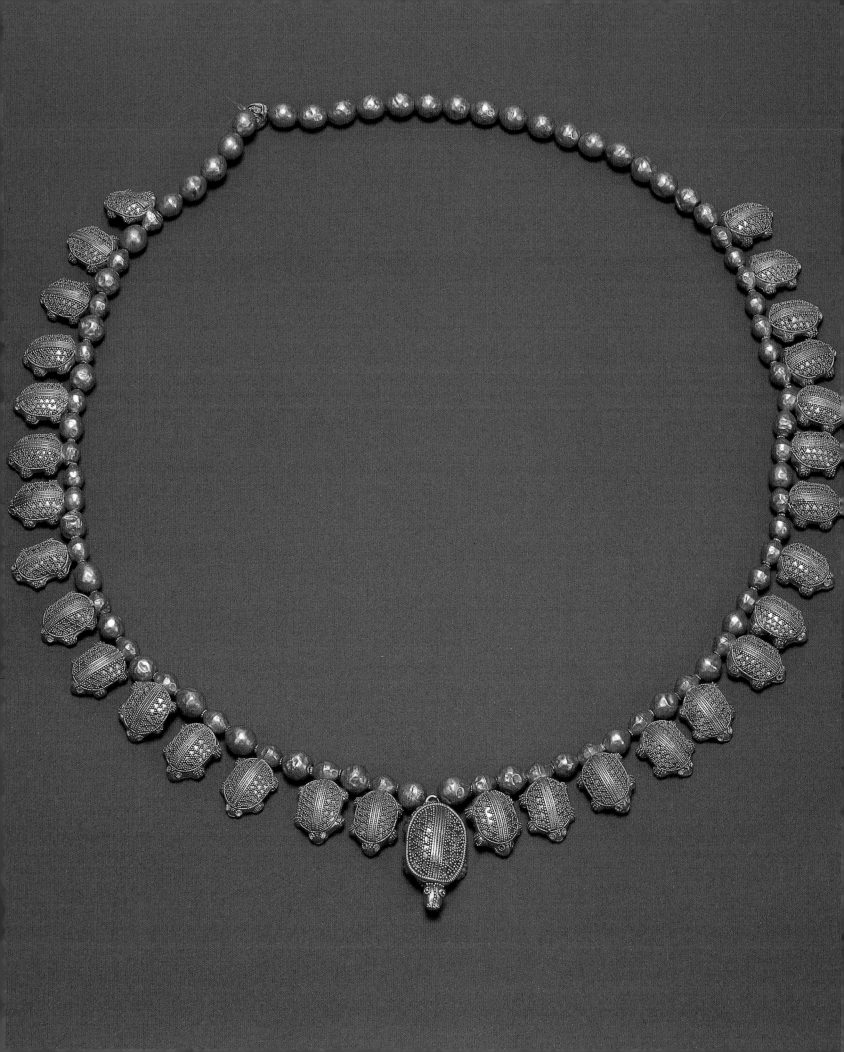

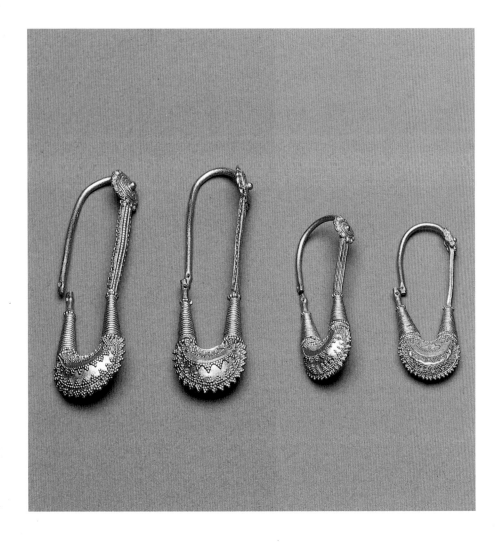

57 A, B Pair of earrings [58 A, B] (far left)
Third quarter of 5th century BC
Gold
2½ x ⅝ in
Pitchvnari (Atchara), Greek necropolis,
grave 104
ASM 22415/3

One vertical support side of each of these
long, open oval rings is plain (this is the side
that opens); the other is decorated with a
rosette and an ornamental strap. The lower
part of each ring thickens into a crescent
shape and is ornamented with fine granulated
beading in triangles and pyramids; it is
connected to the vertical supports by a spiral
of fine wire forming a cone shape.

Similar crescent-shaped earrings have been
found in a rich grave in Vani, and further
examples made in bronze were also found in
a Colchian grave in Pitchvnari. Jewelry of this
type was widely spread throughout the Near
East and East Mediterranean regions from the
8th to the 4th centuries BC. The present pair
differs from earrings found in non-Georgian
sites in having a pierced reverse and a front
decorated with a rosette and ornamented
strap. TK, TD

58 A, B Pair of earrings [59 A, B] (left)
450–425 BC
Gold
1⅝ x ⅜ in
Pitchvnari (Atchara), Greek necropolis,
grave 15
ASM 19708/7

These earrings are virtually identical to those
shown at 57, the main differences being the
smaller size of this pair, the greater simplicity
of the decorative strap, and the fact that the
lower part of the cone spiral is enhanced by
two rows rather than one of granulated
beads. TK, TD

56 Necklace [47]
5th century BC
Gold
10 in (diameter), each turtle ¼–⅜ in
Vani (Imereti), grave 11
GSM 10-975:56

This magnificent bead necklace has thirty-one pendants in the shape
of tortoises, one of which is noticeably larger than the others and
occupies the center of the configuration. All of the tortoises are
cored. Their surfaces are covered with rows of minute, carefully
placed grains of gold and wires. The tiny eyes of the tortoises are
encrusted with glassy white paste. The beads are spherical, with
surfaces decorated with plain or incised wires. This is a local product
and an excellent example of Colchian goldsmithery, without known
analogues. TD

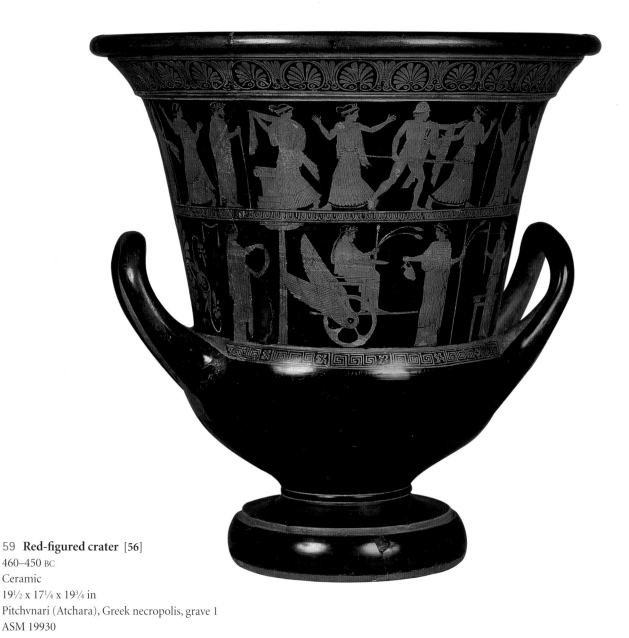

59 Red-figured crater [56]
460–450 BC
Ceramic
19½ x 17¼ x 19¾ in
Pitchvnari (Atchara), Greek necropolis, grave 1
ASM 19930

This very important piece has been restored from large fragments. It is a typical crater, with a wide mouth, a pair of upward-angled handles and a flat foot. The middle of the body surface is decorated with two majestically accomplished scenes. A belt wraps around the edge of the mouth, consisting of palmettes and lotus flowers, and a similar decorative belt separates the two friezes.

The upper scene shows the abduction of Helen (better known, because of her later abduction by Paris/Alexander and the renowned war at Troy that ensued, as Helen of Troy) by Theseus, the most popular hero of Attica (and better known for his destruction of the minotaur in the labyrinth at Knossos). Witnesses to this deed included the bearded figure of Zeus [or perhaps Pirithous, Theseus' friend – ed.], two of Helen's female friends, and other female figures. On the reverse of the upper frieze the winged goddess of the dawn, Eos, is shown pursuing Cephalos (one of several beautiful youths whom she attempted to abduct or seduce over time) who holds a lyre.

The front of the lower frieze shows Triptolemos, bringer of agriculture to Attica, driving the winged chariot which had been a gift to him from the goddess Demetre, and her daughter Persephone. On the reverse a feast scene is represented: men recline on couches and women stand before them in a scene of extravagant feasting.

The Pitchnvari crater may well be by the great Niobid vase painter, taking an honored place in his work. It is supposed that scenes from Greek mythology are represented on the crater. TD

[Such a crater underscores an important cultural link between Colchis/Egrisi and the classical world: Greek noblemen settling in Colchis and Colchian noblemen assuming Greek cultural attributes, both while alive and in their tombs – ed.]

60 Finial from a standard [48]

Mid-5th century BC
Bronze
4⅜ x 2 x 1½ in
Kanchaeti (Shida Kartli), kurgan
GSM 51/AP16

The base of this standard resembles an open wheel with six axles, with flat sculptures rising from it and connected to form an open cylinder. Two identical horsemen with animals behind them are depicted on opposite sides of a ram's head. A human figure with hands raised appears behind the horseman. Around the perimeter of the base are four tall human figures holding hands, and separated by a pair of loops. Fourteen rings for bells hang down from this central base. A similar bronze standard has also been found in the Akhalgori Treasure. IG

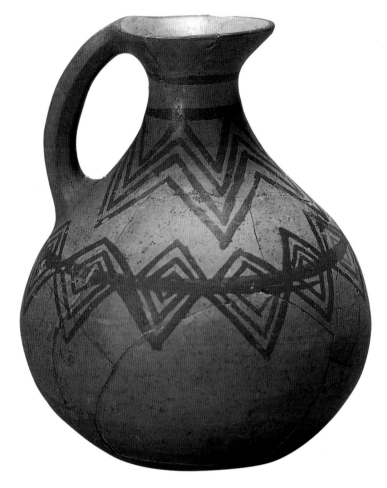

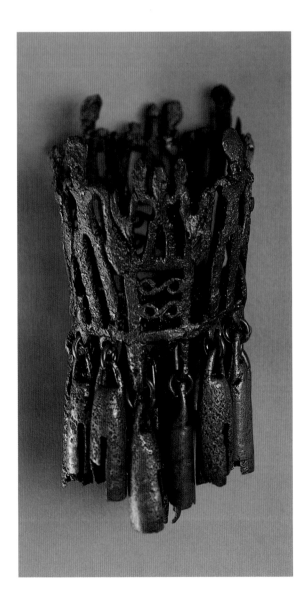

61 Pitcher [67]

4th century BC
Ceramic
6 x 4½ in
Takhtidziri (Shida Kartli), Tsitelbegebi cemetery, grave 36
GSM 97:36-1

Painted earthenware decoration is fairly rare in Georgia during the Late Bronze and Early Iron Ages. Ceramics with black or dark gray coating, often with a carefully polished surface decorated with relief or incised ornamentation, was far more common at that time. By the 5th–6th centuries BC, the situation began to change: burnt red ceramic began to appear, perhaps owing to influence from the south. More than that, the shape of vessels became radically new for Georgia. Notched and relief ornaments disappeared. The surface of vessels began to be partly or fully covered with a red coating. Painted decoration began to appear in the 4th century and spread from Kartli to western Georgia. Such vessels as those found in the cemetery of Takhtidziri (see also 71) have numerous analogues in different places
– Trialeti, Samadlo, Uplistsikhe, Urbnisi, Tskhetisjvari, Itkhvisi, Sairkhe, and Vani, to name the most prominent – and are of surprisingly high quality. They exhibit elasticity of shape and sensitive handling of surface, which is covered with a yellowish coating, carefully polished, and decorated with red or ochre-brown paints, usually in a frieze-like formation, covering the upper part of the vessel. As here, ornamentation is usually geometric. The production of such earthenware reached its apogee in Georgia during the Hellenistic period. IG

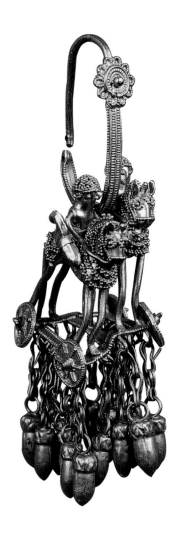

62 Earring [61]
First half of 4th century BC
Gold
3¼ x 1⅜ in
Vani (Imereti), grave 6
GSM 11-974:2

The earring consists of an oval, open ring with bored ends. The more decorated part, its width multiplied by several rows of granulations, terminates in a rosette. A pair of riders sits on two horses, the elongated legs of which rest on a four-wheeled base; the riders are connected by a hook which is also the means by which they hang from the ring. Acorn-like appendages complete the array, hanging by short chains from the wheeled base. Men and horses are lushly ornamented with granulation; their bodies are cored. The wheel rims and spokes are also replete with granulations.

Although the earring is one of a pair that is similar to cult objects from temples in Akhalgori (in eastern Georgia), it is the product of a different local Colchian workshop. Similar work has been found along the Lower Volga, in one of the kurgans of the burial-ground of Sazonkin Bugor, perhaps from Colchis. The article shown here is organically linked with other items found here and represents the finest work of local goldsmitheries. TD

63 Earring [62]
5th century BC
Gold
2¼ x 1⅛ in
Vani (Imereti), grave 11
GSM 10-975:54

One of a pair, this earring is formed with six stems attached to a ring in a radial configuration; the stems end in triangles made of granulations and, on the end pair, tiny figures of birds. The circle is open with bored ends. Its front half, enhanced by multiple beading and granulation, culminates in a rosette surmounted by a bird with a hooked back and four rows of incised wires. Similar objects, reflecting new patterns of jewelry-making which were spreading through Colchian territory during the early Ancient period, vary as to the number of stems that they exhibit – from one to seven. Typically Colchian, such objects, made in local workshops, have not been found outside Georgian territory; earrings similar to this one have been found at the burial-grounds of Brili, Mtisdziri, Kobulet-Pichvnari, and Chitatskali. TD

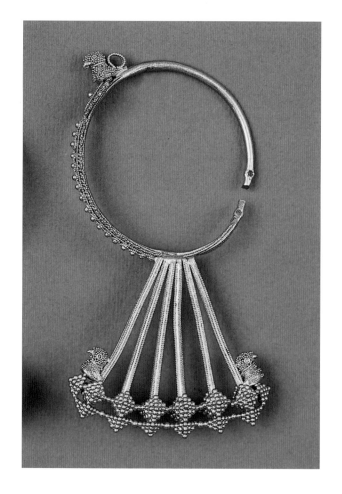

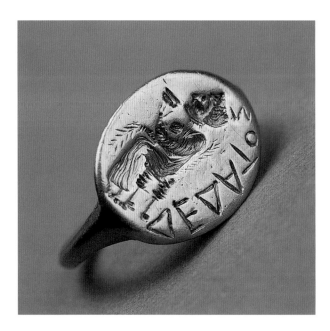

64 Seal-ring [68]
4th century BC
Gold
⅞ x ¾ x ⅝ in
Vani (Imereti), grave 9
GSM Glyptic N 1237

This ring has a faceted hoop which is thicker and slightly wider at the bezel. The bezel is oval, large, convex, and faceted from the reverse. The flat front façade shows what appears to be an elderly woman attired in a chiton and a himation, sitting on a stool. The left hand holds a shallow bowl and the right a palm branch. Similar foliage is depicted behind the back. The likelihood that this figure is a female is suggested by the hairstyle, which is reminiscent of that of Syracusan women, with a net-like cover over it. Moreover, the figure appears to be wearing a double necklace and earrings, and ankle bracelets are also visible. On the back of the woman's portrait there is a Greek inscription, 'Dedatos,' executed in large letters, which indicates the name of an owner (man) of the ring. KJ [If this inscription is the name of the person depicted – who may or may not also be the owner of the ring – it is a masculine name. Given that this is a seal-ring, it is reasonable to assume that the name, depiction, and ring-owner are one and the same, making the gender an intriguing and ultimately unresolvable issue. – ed.]

65 A, B Beads [70A, B]
4th–3rd centuries BC
Glass, paste
1 x 1 in
Kazbegi
GSM 337

Each of these cylindrical, polychrome beads with light blue and green background has three rough-hewn, mask-like relief-formed human faces – basically white, with eyebrows and pupils blue or black. There is white and yellow beading above, below and between the faces on each piece.

The Hellenistic period is characterized by the manufacture of a variety of polychrome glass objects, of which beads such as these are one manifestation. But they were not widespread in Georgia. They have been found both at the site of the ancient town of Vani, in the rich burial-ground of Dablagomi, and in Ureki among archaeological materials of the late Ancient period. But polychrome beads with different expressions on their faces have also been discovered along the north coast of the Black Sea (at Fanagoria, Khersones, and Oliva in the west Crimea) dating from the 4th–3rd centuries BC. Beads from Oliva are similar to those from Kazbegi shown here. Analogous artifacts have also been found in the Lugovo burial-ground in Ladzi in the northern Caucasus.

Beads with 'masks' from Kazbegi were imported rather than made locally. Similar beads have been found in great numbers on the shores of Asia Minor. Some scholars believe that they were produced in the polychrome glass workshops of Syria; others believe they are of Egyptian manufacture – from the workshops of Alexandria. TD

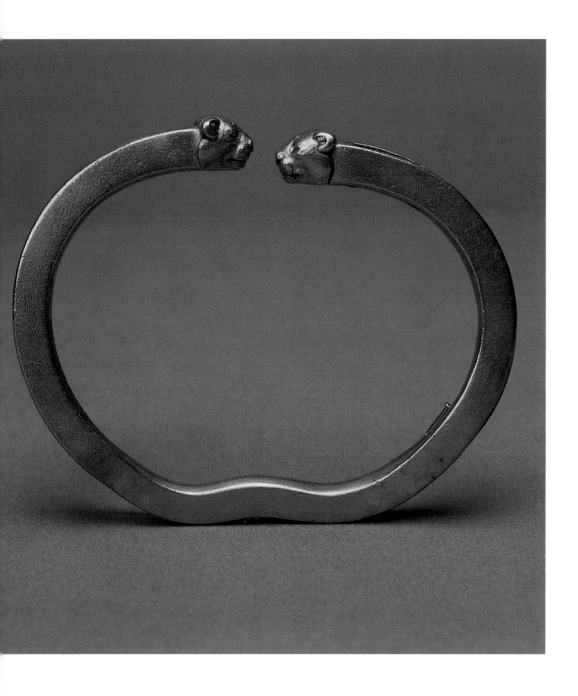

66 Arm rings [63] (opposite)
First half of 4th century BC
Gold
3⅞ in (diameter)
Vani (Imereti), grave 6
GSM 11-974:14

The cross-sectionally round stem of each of
these massive cast bracelets culminates at both
ends in the head of an aurochs, so that the two
molded animal heads face each other, nose to
nose. Bracelets decorated with animal heads
spread westward from the Near East. Such
bracelets have been found in Syria, Egypt,
Cyprus, and elsewhere. Although those from
the site of Vani are typical of the Achaemenid
style, it is possible that they were executed,
under the influence of the Achaemenids, in a
workshop of a neighboring country such as
Colchis itself. (See also 67.) TD

67 Arm ring [64] (left)
First half of 4th century BC
Gold
3⅞ in (diameter)
Vani (Imereti), grave 6
GSM 11-974:15

One of a pair, this bracelet is oval, with a
hollow back. The stem consists of thick plates
which terminate at both ends as heads of
female lions. There seem to be some remains
of inlay. The origin of such bracelets is
Achaemenid Persia (see also 63), from which
the style apparently spread to Georgia in the
early Hellenistic period. TD

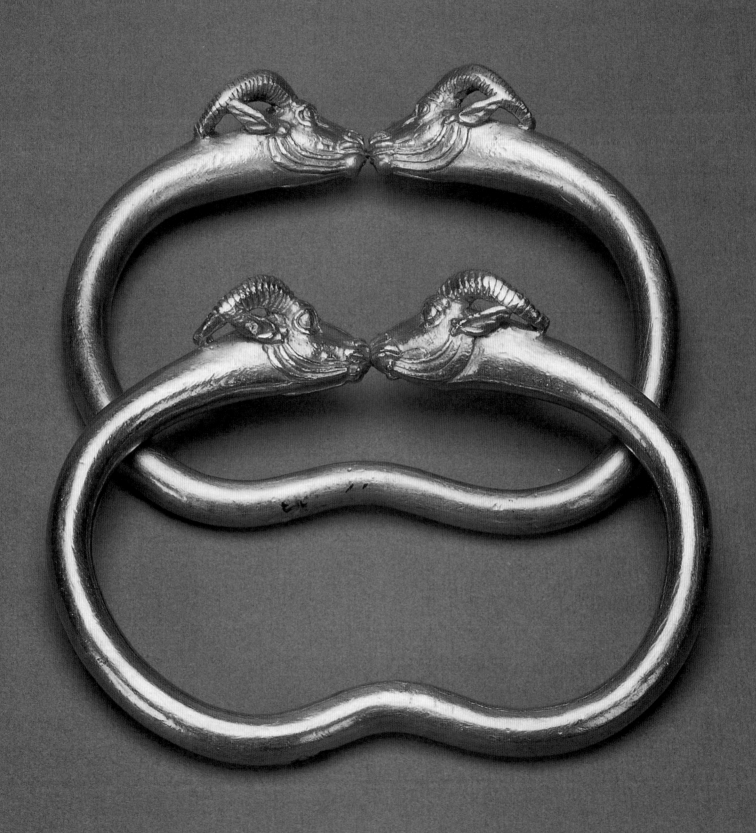

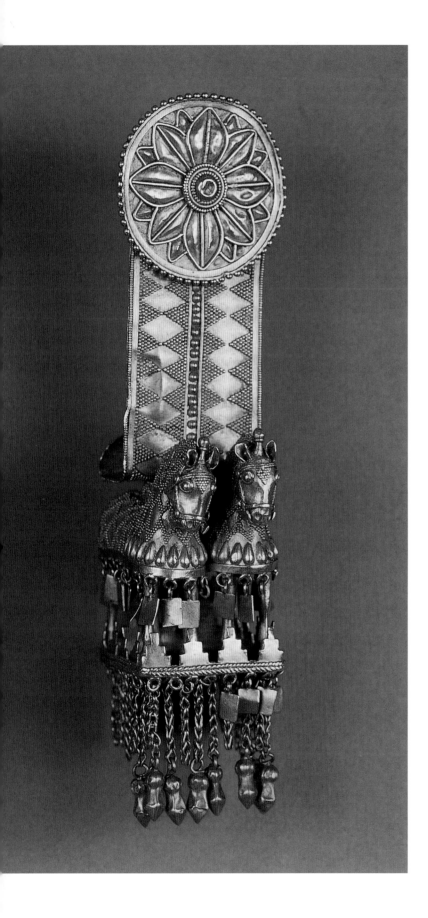

68 Temple pendant [69]

4th century BC
Gold
5⅛ in
Hoard of Akhalgori, Sadzeguri (Shida Kartli)
GSM SM-26

This extraordinary pendant, one of a pair, presents the cored figure of two saddled horses on a square platform ornamented with merlons and chains. Soldered to the backs of the horses is a vertical support. The support is an elaborately decorated plate, its back made of wires with holed ends. A medallion with a sixteen-foil rosette is soldered to the upper end of the plate. Small square plates and small acorn-like pendants hang from the platform on chains.

The temple pendant is richly decorated with granulation forming rows of triangles on the vertical support plate, and triangles and diamond netting on the bodies and heads of the horses. The chests of the latter are also ringed with almond-shaped droplets. The minute details of a naturalistic bridle appear on the heads of both horses.

The ornamentation – specifically the three-stepped merlons around the platform, the almond-shape droplets on the chests of the horses, and the lotus rosette on the vertical plate – is borrowed from Persian Achaemenid art, but the work would appear to be local, executed in Georgia and representing Georgian goldwork at its most extravagant. This is suggested by the style of the decoration – its richness of granulation, typical of Georgian jewelry of the 6th–4th centuries BC. The shape of temple pendants connected to earrings with radial decoration (see 62) and those with pairs of riders found in Vani kurgan 6 (see 61) are typically Georgian. Moreover, the type of horse bit adorning these miniature horses was widespread in Georgia only in the 4th–3rd centuries BC. IG

69 Pectoral [60]

First half of 4th century BC
Gold, inlaid with carnelian and turquoise
9¼ in
Vani (Imereti), grave 6
GSM 11-974:13

This trapezoidal hanging chest decoration is attached to
a fibula clasp from its upper edge by a clasp and delicate
chain. Eight more delicate chains hang from its lower edge,
terminating in inlaid pomegranate-shaped beads. The
pectoral plaque itself is inlaid with glass, turquoise, and
sardonyx, and divided by gold strips into two wide and
three narrow bands. In the center of the upper wide band
a lotus flower is depicted in inlay, with back-to-back
rampant griffins in profile, in gold. In the wide lower belt
two birds face to the left. The narrow bands are decorated
with round sardonyx stones, three in the upper and middle
registers and four in the lower register.

The background between the images is filled with
opaque glass. The lines separating the bands are decorated
with triangles made of alternating chunks of sardonyx and
turquoise. The entirety is an exhilarating exercise in
polychromy. The pectoral is made by the technique of
inlay without a golden background. It is a unique example
of the jeweler's art. This piece has no parallels in Georgia;
it was no doubt imported, since this type of jewelry is
known to have been fairly widespread in the Near East.
There are some features typical of Egyptian art and also
those reflecting the influence of Greek and Achaemenid
jewelry schools. TD

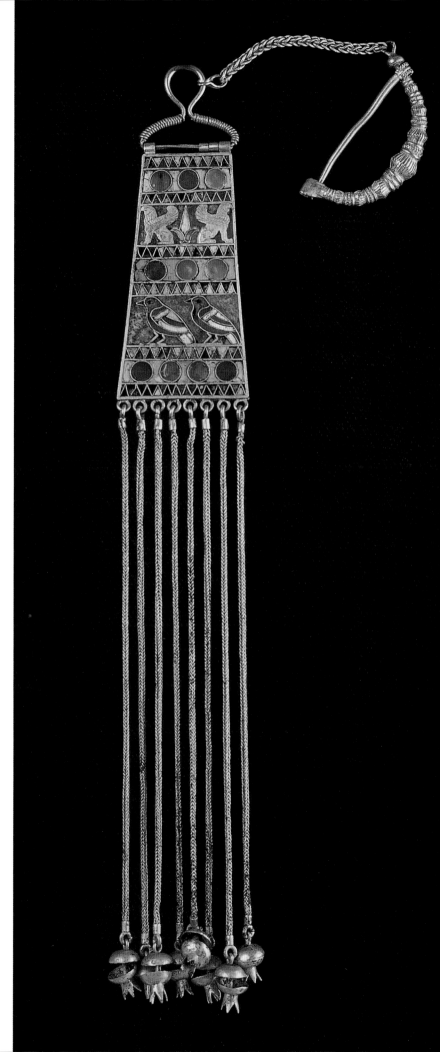

70 **Bowl** [65]
First half of 4th century BC
Gold
5¼ x 2⅝ in
Vani (Imereti), grave 6
GSM 11-974:39

A thin-sided bowl, with open mouth, round shoulders,
and an omphalos base. The body is decorated with twelve
almond-shaped knots extending from the center toward
the edge, alternating with stylized lotus blossoms. Beyond
these, separated from them by a simple depression parallel
to the edge, is a series of interlaced lengthwise lines that
continue to the edge of the bowl. According to Lushey's
classification (in Die Phiale) this bowl belongs to the
group known as flower bowls. Bowls ornamented with
omphaloi and knots derive from the Near East, eventually
spreading into the West. They became rather popular in
countries under the influence of Achaemenid Persia. This
bowl from Vani is one of the best examples of ancient
Georgian goldwork. A silver bowl with similar
ornamentation (45 in this exhibition) was found in
Kobuleti-Pitchvnari. TD

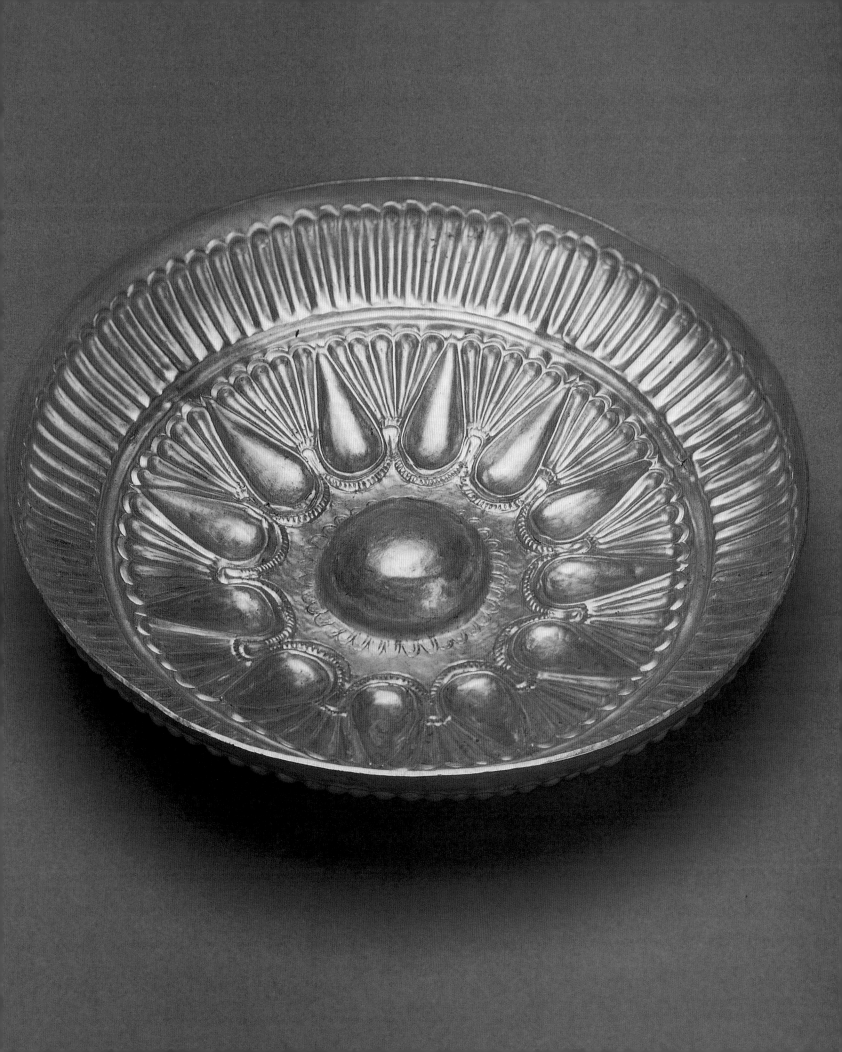

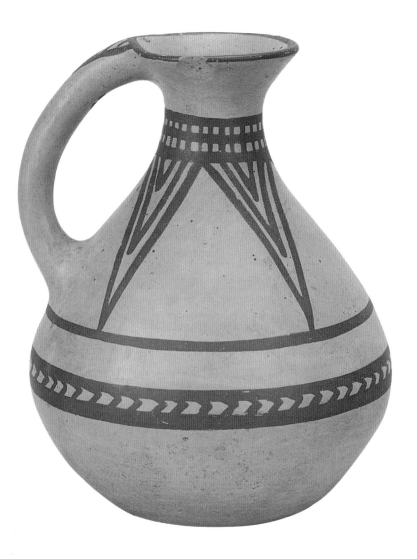

71 Pitcher [66]
4th century BC
Ceramic
5 x 5½ in
Takhtidziri (Shida Kartli), Tsitelbegebi cemetery, grave 6
GSM 96-65:1732

This tiny yellow-coated pitcher has a very rounded lower body, narrow neck, rounded mouth, and flattened bottom; its single handle, having a round cross-section, extends from the low shoulder (almost halfway down the body) to the mouth. Reddish-brown geometric decoration is painted over the coating; a net-like pattern is painted on the neck and body, just below the points at which the handle is attached, and elongated triangles connect the net patterns along the shoulder. Analogous ceramic works have been found in Georgia at Itkhvisi, Vani, Kushnci, Kamarakhevi, Uplistsikhe, Varsmiantkari, Asureti, Tbilisi, Shavsakdara, Dirbi, Tsikhiagora, and Samadlo. NG

72, 73 Fragments of a *kvevri* [71, 72]
3rd century BC
Ceramic
16¼ x 14 in; 13 x 17½ in; thickness of both fragments ⅝ in
Samadlo (Shida Kartli)
GSM 72-68:233 (both fragments)

The production of painted ceramics in Georgia reaches the climax of its development in the pre- and early Hellenistic period, in the 4th–3rd centuries BC. The decoration was usually executed by means of red or brownish ochre over the polished and yellow engobe-covered surface of the vessel. Side by side with geometric and floral ornamentation, there are often multi-figure compositions, depicting scenes of hunting, battle, and the like.

The two fragments shown here come from a large wine vessel, called a kvevri in Georgian, the height of which would have been approximately 68 inches, the widest diameter point approximately 58 inches, with a mouth diameter of approximately 26 inches and a capacity for holding 1100 liters of liquid. The vessel neck was decorated with relief plait borders and its surface was covered with painted decoration from top to bottom. The silhouette-style drawing is schematic but expressive and full of life.

The complete drawing takes the form of upper and lower friezes. The two upper friezes show figure compositions, in one of which there is a hunting scene: two riders, armed with spears and accompanied by two dogs, chase a stag. In the other, a battle scene shows two riders armed with spears and two men on foot armed with swords; they all fight against a rider and a gigantic man who holds a short sword and a shield. (A similar painted wine vessel was found at the same site, in which the end of this same battle is apparently depicted: the giant has been knocked down and killed with a spear.) The lower frieze represents a circle of men dancing and a row of swan-like birds. The fragments on exhibition show parts of the hunting and dancing scene from both friezes of the vessel. IG

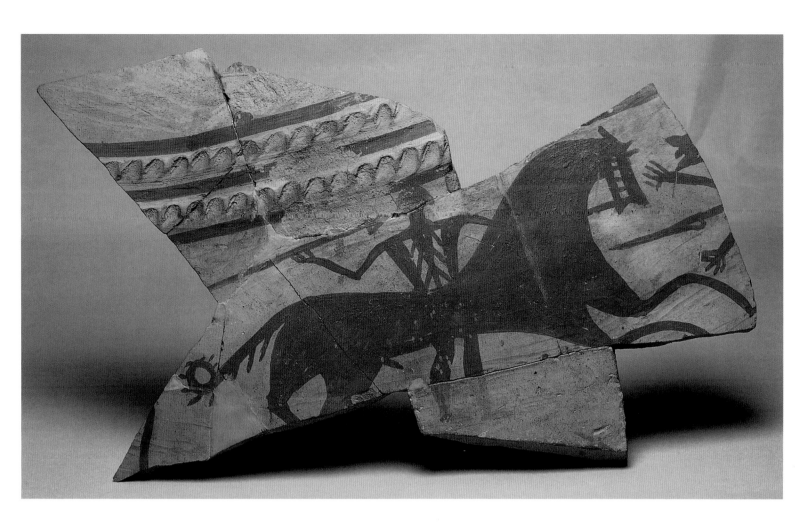

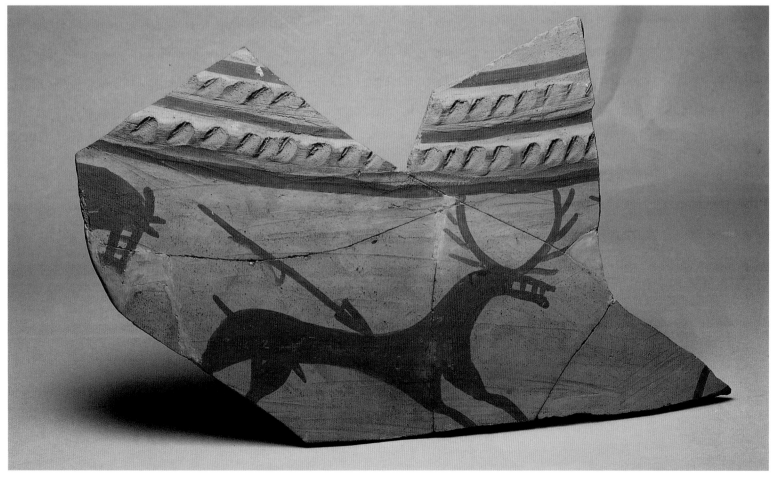

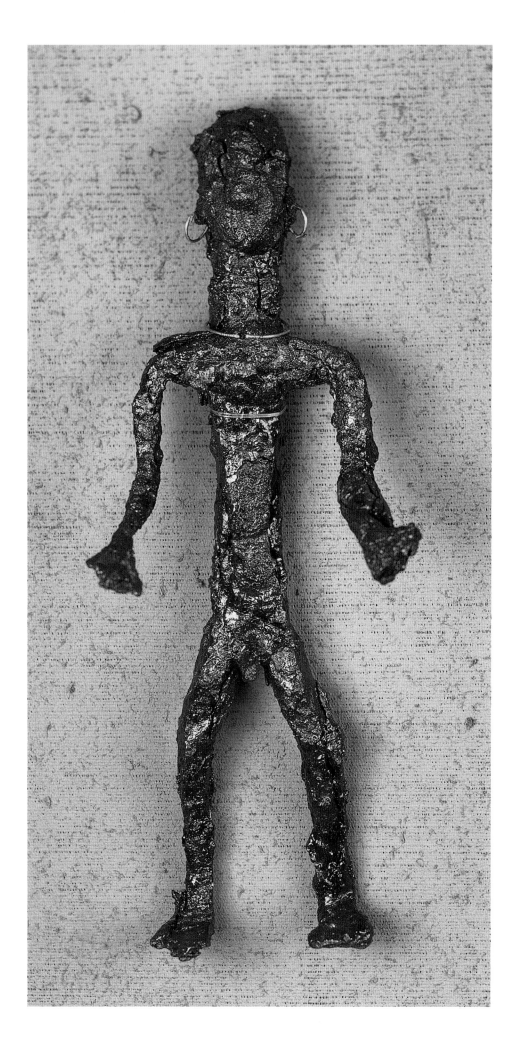

74 Male figure [75]
3rd century BC
Iron and gold
11¾ in
Vani (Imereti), grave 1
GSM 10-975:20

A rough-surfaced full-length male figure, adorned with gold earrings and a gold ring necklace. The idea that this figurine symbolized fertility in some cult place is suggested by the accentuation of the genital area. The position of the arms and hands – bent at the elbows and held out in what may be a pose of entreaty – further suggests a role as a cult object. The figurine was found wrapped in canvas sewn with gold rosettes and kylicks (drinking cups) and covered with a tile, as if the burial had been performed in a formal, ritual manner. LC

75 Head of Pan [77]
2nd century BC
Bronze
5⅛ x 3¾ in x 2¼ in
Vani (Imereti)
GSM 10-975:186

This dynamic relief is part of the decoration for a large bronze ritual vessel. The god has long hair down to his neck. Wavy locks cover his forehead and temples, and clumps of his matted hair stand up stubbornly. Long sideburns extend down the cheeks, a short beard covers the chin and a short curved moustache slopes down around the corners of the lips. The head is crowned with a wreath made of pine branches and a vine-leaf collar encircles the throat. Pan has large goat ears and horizontal wrinkles across his forehead. His mouth is wide open, revealing a full row of lower teeth. Dilated pupils glare upward, completing a strong facial expression. The impression one receives is of a Pan yelling a warning at those who would invade his domain. This is an imported Greek Hellenistic work. KJ

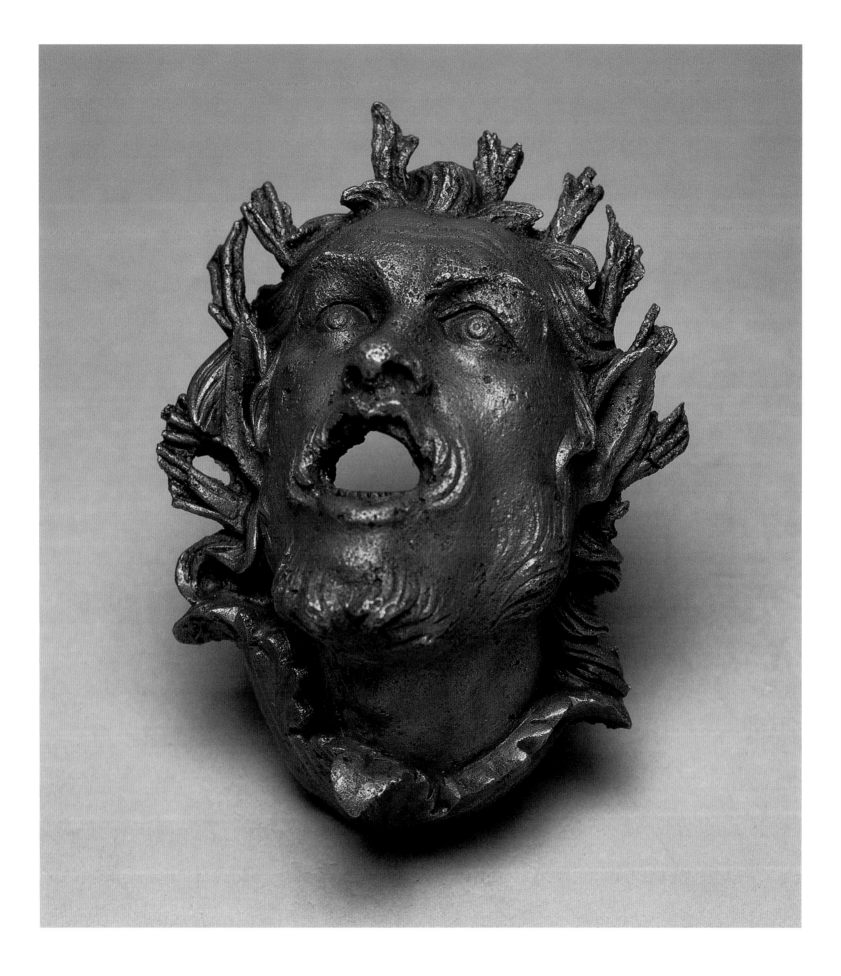

76 Stater of Alexander the Great [73]
336–323 BC
Gold
¾ in (diameter)
Chuberi (Svaneti)
GSM FH 10213

OBVERSE: Head of Athena facing right. She wears a crested Corinthian helmet adorned with a serpent, a single drop earring, and a necklace of pearls. Her hair falls in four formal curls behind her neck.
REVERSE: Winged Nike, with body and wings fully frontal, head facing left. She holds a wreath in her extended right hand, a trident in her left hand. Inscriptions in Greek are placed before and behind her: 'King Alexander' at the feet of the goddess. MSh

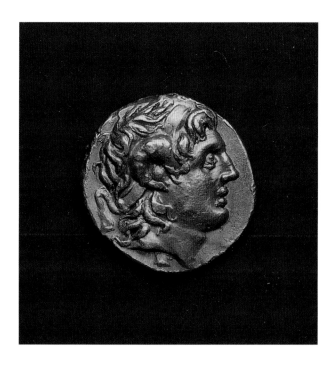

77 Stater of Lysimachus [74]
306–282 BC
Gold
⅞ in (diameter)
Svaneti
GSM FH 2229

OBVERSE: Head of Alexander of Macedon facing right with diadem and ram's horn of Ammon.
REVERSE: Pallas Athene seated on a throne, wearing crested helmet, facing to the left, and holding a spear in her right hand. On her extended left hand stands a small figure of Nike. Above the goddess hovers a bird. Behind and before her are inscriptions in Greek: 'King Lysimachus.'

Staters of Lysimachus (one of the eventual successors of Alexander the Great in the carving up of Alexander's extensive empire) were in widespread use in both western and eastern Georgia during the Hellenistic period. MSh

78 Georgian imitation of the staters of Lysimachus [76]

3rd century BC–1st century AD
Gold
⅞ in (diameter)
Tbilisi, Mari Street
GSM FH 5253

OBVERSE: Severely distorted profile of Alexander of Macedon.
REVERSE: Stylized and distorted image of Pallas Athene seated on a throne with her standard attributes: spear, trident, and small Nike figure. Before and behind the image are a series of parallel lines, in place of and intended to imitate a Greek inscription.

The majority of Lysimachus imitations have been found along the Black Sea coast as well as in eastern Georgia. MSh

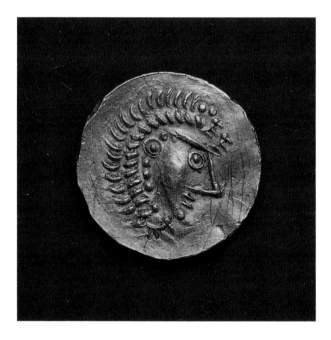

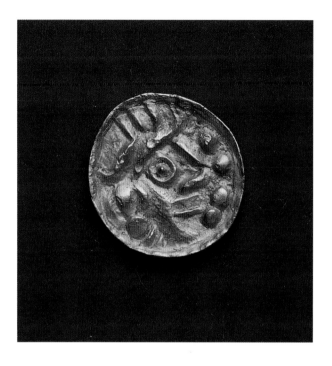

79 Georgian imitation of the staters of Alexander the Great [78]

2nd century BC–1st century AD
Gold
¾ in (diameter)
Magraneti (Tianeti), grave 13
GSM FH 12170

OBVERSE: Distorted representation of the head of Pallas Athene, facing to the right. Four pellets or balls to the right of the head.
REVERSE: Stylized and distorted representation of Nike with outstretched wings. Two pellets or balls to the right; two pellets or balls to the left.

The staters of Alexander the Great were spread widely throughout the civilized world including Georgia (Colchis/Egrisi and Iberia/Kartli) during the Hellenistic period. In the late Hellenistic and early Roman periods, local barbarian imitations of such coins as this one also began to appear. MSh

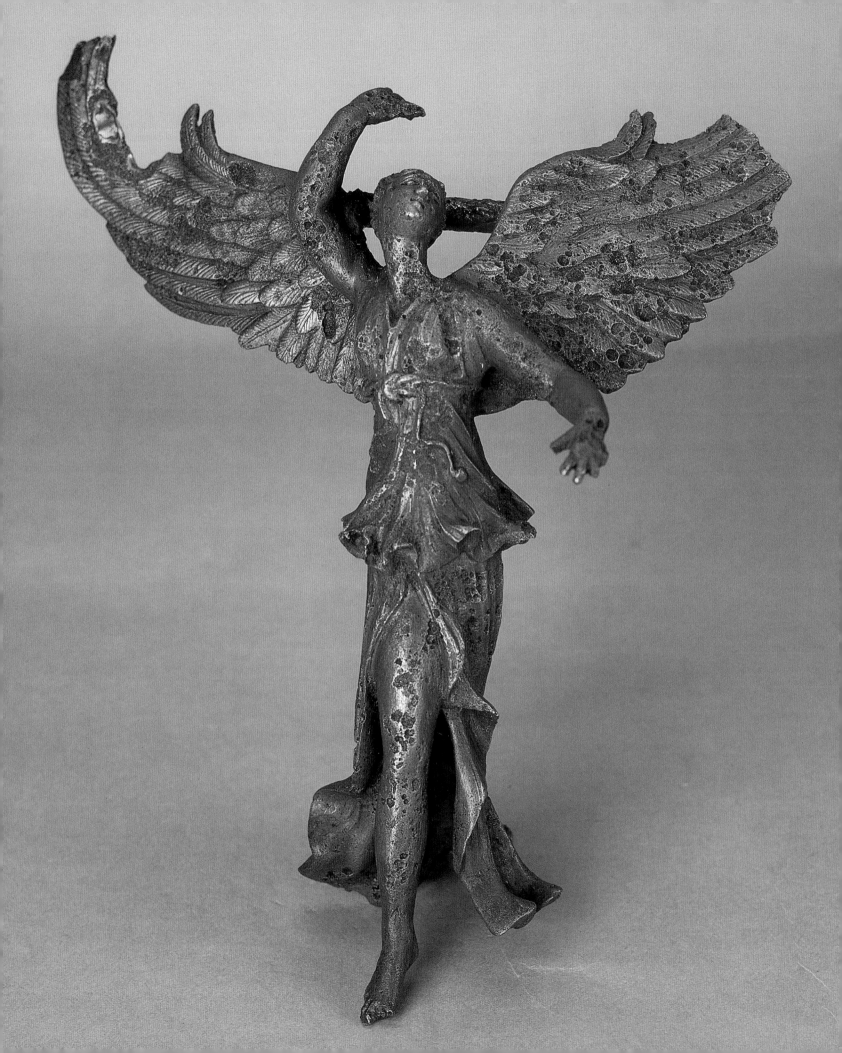

80 **Nike** [79]

Second half of 2nd century BC
Bronze
8½ x 7¼ x 2 in
Vani (Imereti)
GSM 10-975:186

This winged goddess – the personification of Victory – is a decorative affix from a ritual vessel decoration, depicted, with dynamic motion, swooping in to land. Her head is held up proudly, her hair is combed back, the garment covering her body thrown open by the wind of her motion, exposing a bare leg and causing her cloak to flow out behind her.

Damaged by a fire, the vessel from which the figurine derived (the other parts are also in the State Museum) stood on claw feet and was additionally decorated with the forms of three eagles and six high-relief images of figures associated with Dionysus and wine: Pan, a satyr, Ariadne and several Maenads, all cast in bronze. The vessel as a whole would have been a fine example of Hellenistic-period Greek art, with a close similarity to works from the vicinity of Pergamon. It is not known where precisely the vessel was made. Perhaps the temple where it was found was connected with the cult of Dionysus. TD

81 **Pitcher** [86]

2nd century AD
Glass
10¼ x 3½ in
Mtskheta-Samtavro (Shida Kartli), tile grave 159
GSM 12-54:10699

A slender bluish-green pitcher with a long, cylindrical neck, trefoil mouth, and tetrahedral body, narrowing toward the bottom, with rounded edges. It has a heel-like, hollowed circular bottom. Each side of the jug is subtly decorated with oblong indentations. A flattened, grooved, ribbon-like handle extends from the shoulder to the edge of the mouth, where it ends in a decorative flip.

This pitcher is regarded as Syrian work. There is a similar object, also regarded as Syrian, in the Museum of Natural History in Washington, DC. TD

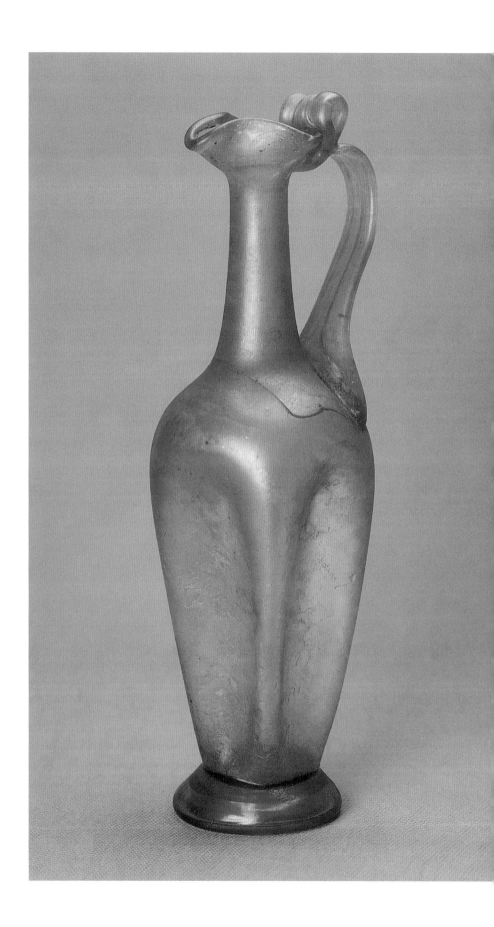

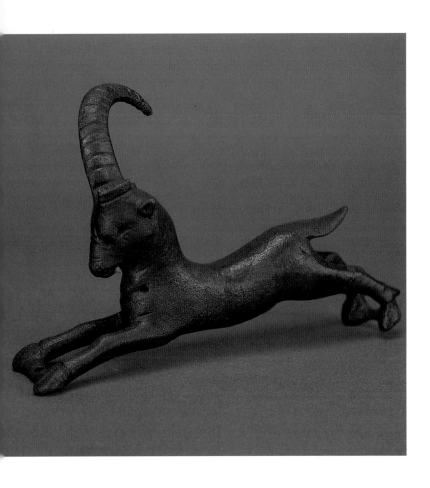

83 Gazelle figurine [80]

1st century BC
Bronze
4 x 5¾ x 1½ in
Mtskheta, Samtavro cemetery, 'cultural' layer
GSM 12-54:7166

The animal, cast and cored, is depicted in a flying gallop. The head, somewhat heavy in comparison with the body, is decorated with high, notched horns, curved toward the back and side (one horn is broken off). The well-extended legs are joined in pairs by small rods, which indicates that the figurine was a handle of a bronze vessel. The rod joining the two front legs has a hole in it, by which it would have been attached to the upper edge of the vessel.

Vessels such as amphorae, jugs, and low-sided bowls, with zoomorphic handles, were very popular in the ancient world, from the Archaic Greek to the Roman period (see 81). Given the dating of its place of discovery, this figurine must be from the early Roman period; stylistic features also point to the first century BC. IG

82 Leopard figurine [81]

1st century BC
Bronze
3⅛ x 4⅛ x 1in
Mtskheta, Samtavro cemetery, 'cultural' layer
GSM 12-54:7165

The sculpture is cast and massive. The leopard is depicted with considerable naturalism, its front left paw raised, its small head turned on its long neck to the left and back, its mouth open to show its teeth. The characteristic spots of a leopard have been indicated by incised circles. A lug on the bottom of the raised left paw suggests that the figurine could have been a handle for a metal vessel. Production of metal vessels with zoomorphic handles had a long tradition in the ancient world (cf. 83). This leopard is probably a Parthian work. IG

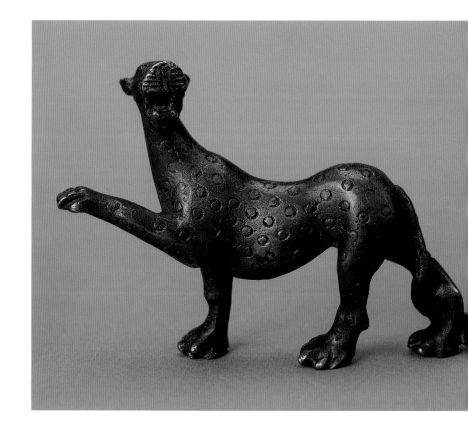

84 Figurine of a young male [82]

1st–2nd century AD
Gold
2⅞ x 1⅛ in
Gonio (Atchara), hoard
ASM 20110/10

The treasure of which this exquisite figurine is part was discovered by chance during building work near the village of Gonio at the Gonio fortress (Aphsaros). The figurine was found under a large stone among gold objects which had been placed in a metal container. The molded figure of a naked youth stands on a round disc-like pedestal. [Following the classicizing pattern of counterpoise, the figure's weight is carried by the straight right leg, while the left leg is slightly bent and relaxed, with its heel upraised; in contrast, the left arm is bent but held tightly up while the right arm is extended but relaxed. The muscular body is thus poised between motion and stasis, both tense and loose. – ed.] The head on the long, strong neck leans slightly forward, and the expression is a severe one; the straight nose has been somewhat flattened and the eyes are represented by relief pin-points.

The figure wears a conical cap decorated with three stylized stars on the middle part, with concave points and 'rays' (suggesting a connection with divinity) emanating from it. The front of the cap, resting on the forehead, is slightly split; to the rear, thick locks of hair rest on the nape of the neck and cover the ears. A chlamys round the chest and shoulders is folded up to the left side of the chest; the end of it is draped around the elbow of the bent left arm, hanging down from the left forearm. The extended right hand holds some round object – perhaps a bowl, or conceivably a discus. A thick round ring is soldered to the back for hanging, perhaps as a pectoral.

The figurine belongs to the circle of athletic Dioscuri or Cai figures that were widespread in the first centuries AD. TK

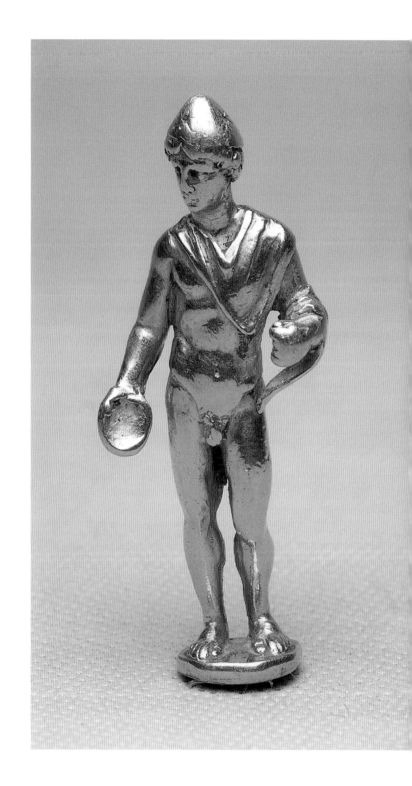

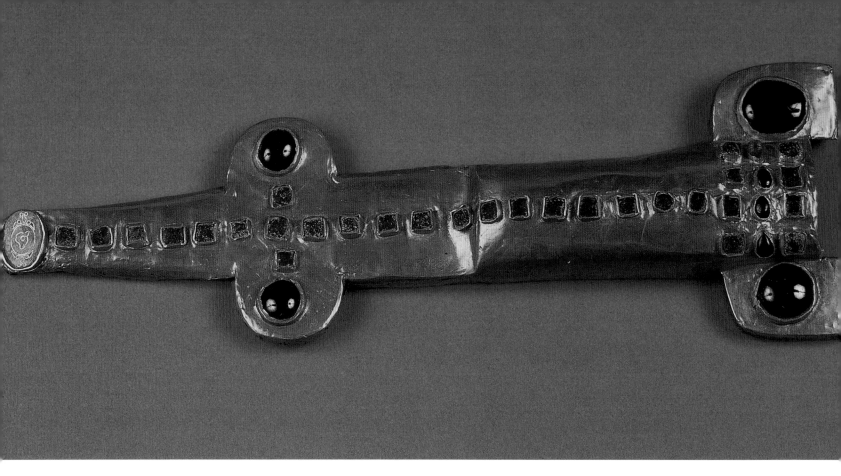

85 Dagger sheath [90]

170–80 AD
Gold, glass
9⅛ x 3 in
Mtskheta, Armaziskhevi, Pitiakhshes cemetery, sarcophagus 1
GSM 18-55:22

This cover is forged of a thick gold plate. Individual cells have
been soldered to the surface in which gold and glass stones
have been mounted. An oval cell of cloisonné enamel, with a
depiction of the head of a calf or sheep, is soldered to the tip.
This is the oldest extant example of cloisonné enamelwork
in Georgia.

The cover once decorated the scabbard of an iron dagger that
belonged to one of the pitiakhshes (noble retainers) of the kings
of Kartli (i.e. Iberia or eastern Georgia), who was buried in
sarcophagus 1 in the Armaziskhevi cemetery. The name of the
pitiakhsh was Asparuk. This is suggested by the gem found in the
same sarcophagus with a portrait and inscription in Greek. The
famous gem with a double portrait and inscription 'Zevakh, my
life, Karpak' (see III.6) was found here. It may well be that
Asparuk was the son of Zevakh and Karpak. LC

86 Dagger [98]

250–300 AD
Iron (blade), gold with inset almandin, turquoise (handle)
4⅛ x 8¼ x 1⅝ in
Mtskheta, Armaziskhevi (Shida Kartli), grave 3
GSM 18-55:56

The blade of this dagger has decomposed to a serious extent,
with the remains of a wooden scabbard in evidence. The blade
is also somewhat rusted and damaged, with the tip broken off.
There are wide grooves along the sides of the handle, which is
hexahedral, narrowing toward the middle and jeweled with
square plates of almandin, some of which are damaged. In all
there are 77 plates of almandin and 5 plates of turquoise on the
handle. The dagger belonged to a nobleman and bears his
insignia. Among the rich inventories of the necropolis of
Armaziskhevi noblemen such an insignia has been uncovered
only twice. LC

07 Buckle [84] (below)
3rd century AD
Gold
2⅜ in (diameter)
Vani (Imereti)
GSM 24-29:1

On this delicate round plate a young, naked Heracles is depicted fighting a lion [presumably the Nemean Lion, wrestling with which was one of his famed labors – ed.]. The head of Heracles is rendered in profile, the body turned at a three-quarter angle. Scenes depicting Heracles' heroic actions were very popular throughout the ancient world, and from around the 3rd century BC in Colchis. The Vani buckle renders this scene in a manner peculiar to that of local goldsmiths: the lion is in a bent-back posture and has seized Heracles by the chest and stomach – which is to say that Heracles is on the defensive, attacked by his eventual victim. The body of the lion is covered with short cuts to convey the idea of his pelt, a stylistic feature that also points to the tradition of local craftsmanship. TD

88 Buckle [83] (above)
1st–2nd century AD
Gold and turquoise jewels
5⅜ x 5½ in
Gonio (Atchara), Hoard
ASM 20110/2

This large circular buckle is made of a thin plate with the edges bent down. The main subject is framed by a ring inset with thirty semi-circular turquoise stones, two of which are missing. Between the stones are wedge-shaped repoussé protrusions. The main area of the plaque is occupied by a relief circle within which two animals are depicted fighting. The composition is dynamic and gives the impression of swirling, circular movement. A large feline predator (perhaps a panther) attacks a large mountain goat, which, its lotus-shaped tongue hanging out, twists its head back toward its attacker. Both animals are depicted in high relief by chasing and are encrusted with semi-circular, triangular, rectangular, circular, leaf- and comma-shaped colored stones or turquoise, several of which are also missing. Despite the highly stylized manner of execution, in order to fit the shape of the available space, the animals present a strong sense of naturalism. Faces, hair, paws, legs, claws and horns are carefully represented by excellent repoussé work and engraving. This splendid buckle stands out from the objects of the Gonio Hoard by its minute details. The style of representation connects it to Sarmation polychrome animal representations from the 1st century BC to the 2nd second century AD. TK

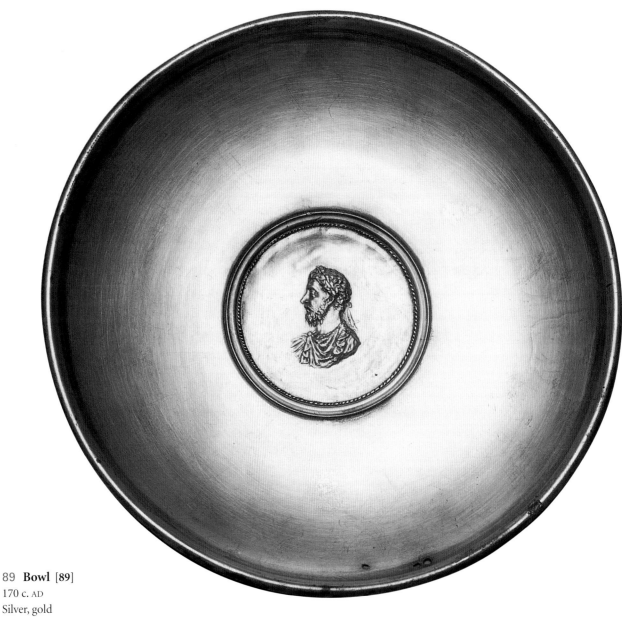

89 Bowl [89]

170 c. AD

Silver, gold

2¾ x 8⅛ in

Mtskheta (Shida Kartli), Bagineti necropolis, sarcophagus 1

GSM 13-57:7

This fine example of Roman metalwork is formed and polished by machine tooling. It has a low round foot and a thick edge. In the center is a round gold medallion with a low-relief profile portrait of Emperor Marcus Aurelius (r.161–80) facing to the left. This is the only specimen of Roman metalwork in existence with a medallion portrait of Marcus Aurelius. The emperor wears a cloak with a clasp on his shoulder. A laurel wreath – symbol of victory – is placed on his head. The portrait is distinguished by individualism – typical of Roman art – and expresses very well the nature of a stoic emperor, with his sense of aloofness from the problems of the world that rest on his shoulders. The bowl can be dated from the late years of the emperor's reign – between the time of the famous equestrian portrait and the bust that are located in the Capitoline Museum in Rome. AJ

90 Necklace with pendant and hanging flagon [88]

150–200 AD
Gold, amethyst, garnets, turquoise
13 x 1⅞ in
Armaziskhevi, Pitiakhshes cemetery,
Mtskheta, grave 7
GSM 18-55:148

The gold chain of this necklace is made of folded and tightly interlaced gold rings, making it quite massive but very elastic. It terminates in tubes. Those on the upper ends are attached to a fastening hook and ring; those on the lower end, attached to the pendant, are decorated with flat turquoise and garnets. The pendant is a flat cylindrical box of gold with a lid that opens. The surface of the lid is richly decorated with twenty turquoise and garnets set into cells. In the middle of the lid is a large cell outlined with incised wire to simulate granulation, in which a substantial high-relief cameo of a ram's head is mounted, cut of amethyst. A flagon with a lid hangs from the necklace chain by a second, more simply made gold chain. The flagon has a spherical body and cylindrical neck. The lid is designed as a flat cylinder and the whole is embedded with garnets.

The necklace was found in a sarcophagus made of a single stone in which a noble woman had been laid to rest, a family representative of the pitiakhsh (noble retainer) of the king of Kartli (Iberia). If the supposition is correct that Seraphita is the name of the woman placed in kurgan 6, then it is possible that her mother, the wife of pitiakhsh Zevakh, could have been placed here, in kurgan 7. This kurgan, judging by its numerous coins, is well dated to some time shortly after AD 156. IG

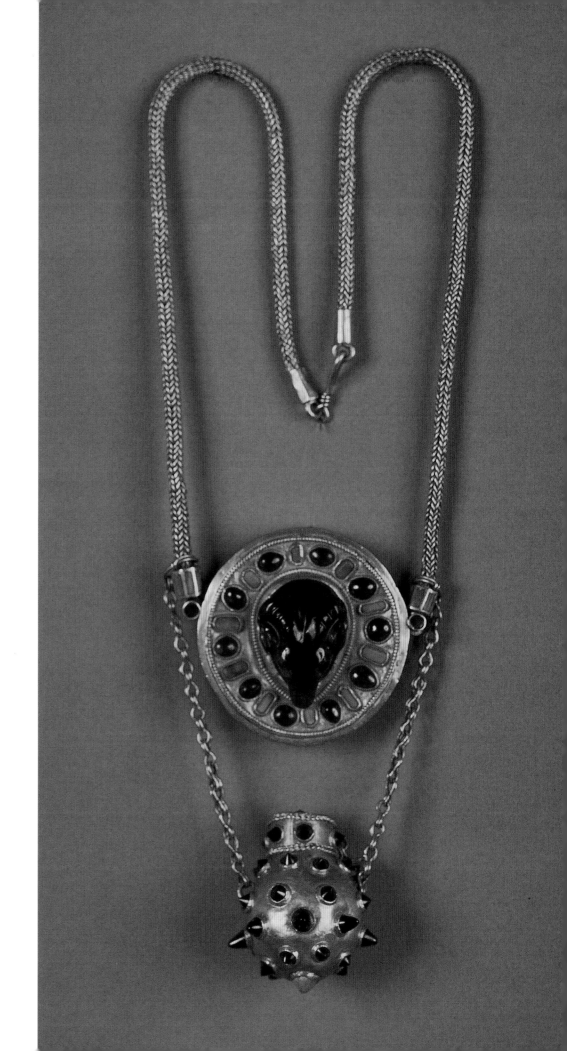

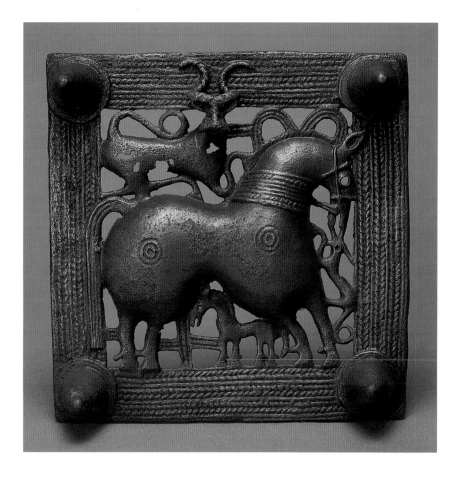

92 Buckle [85] (left)
1st–3rd century AD
Bronze
5¾ x 5⅝ in
Zekota (Shida Kartli)
GSM 8-52:1

This large and distinctive molded openwork rectangular buckle has a frame decorated with interwoven herringbone patterns and high conical protuberances at the corners. The central animal is a magnificent stylized horse executed in a high relief. Below the horse is a colt; above the horse is a bull. A small dog appears in front of the horse's chest. Similar buckles are unknown outside Georgia. LG

91 Buckle [87] (opposite)
1st–3rd century AD
Bronze
5⅛ x 5⅜ in
Gebi (Racha)
GSM 6-02:108/1021

This large and distinctive molded openwork rectangular buckle has a frame decorated with three rows of double spirals and high conical knobs at the corners, each framed by a circle. An open netweave of flat, incised rods connects four animals in the field to each other and to the frame. Two round convex parts with concentric circles mark the chest and the rump of the central animal, a massive, stylized horse. The line of a tight mane follows along a short curved neck. The head is more naturalistically depicted than the body, with an eye marked by a simple hole, a leaf-shaped ear and an open mouth. The legs, with flaring hooves, are short and bent, and rest on the inner edge of the frame; the tail is absorbed into the inner row of the frame decoration. The bridle and reins are depicted with thin relief lines.

To the upper left, standing, as it were, on the horse's rump, is a bull; to the right, placed vertically along the horse's chest, is a dog, and below the horse's belly is a bird, the legs and highly stylized wings of which are identical with the strands of the netweave. The head of the bull is accentuated – it is stylized, triangular in shape, with enormously proportioned horns that protrude up into the frame and, as the head does, pushes away from the work towards the viewer. The dog has a mouth that opens upward toward the horse's downward-facing head, and an eye indicated by a circular indentation. Its erect ears stick out to the sides. Both dog and bull have spirally wound tails. The bird's small head echoes that of the bull in shape and in pushing out to the viewer, with eyes represented by round knobs. Such buckles are uniquely and characteristically Georgian (some 200 are still in existence), and have been found in the provinces of Imereti (Racha region) and Kartli (Trialeti region). Stylistically and semantically they are linked to other work such as axeheads and other buckles that were produced at this time in Colchian and central Caucasian workshops. (See also 92.) LP

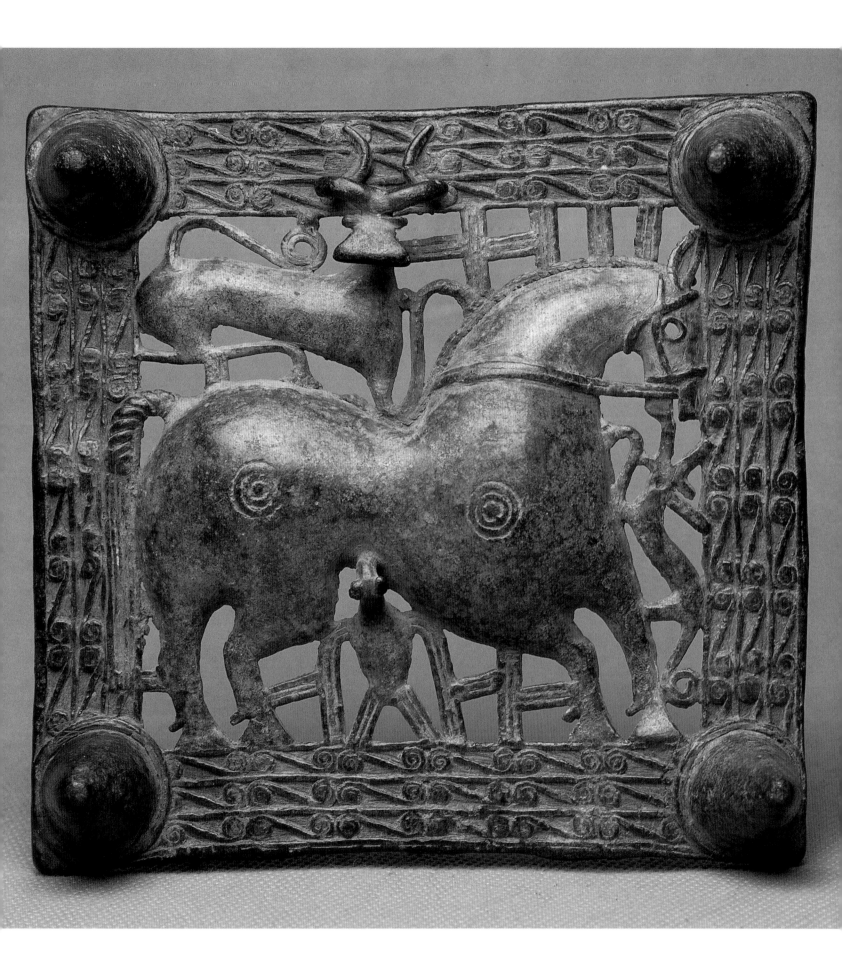

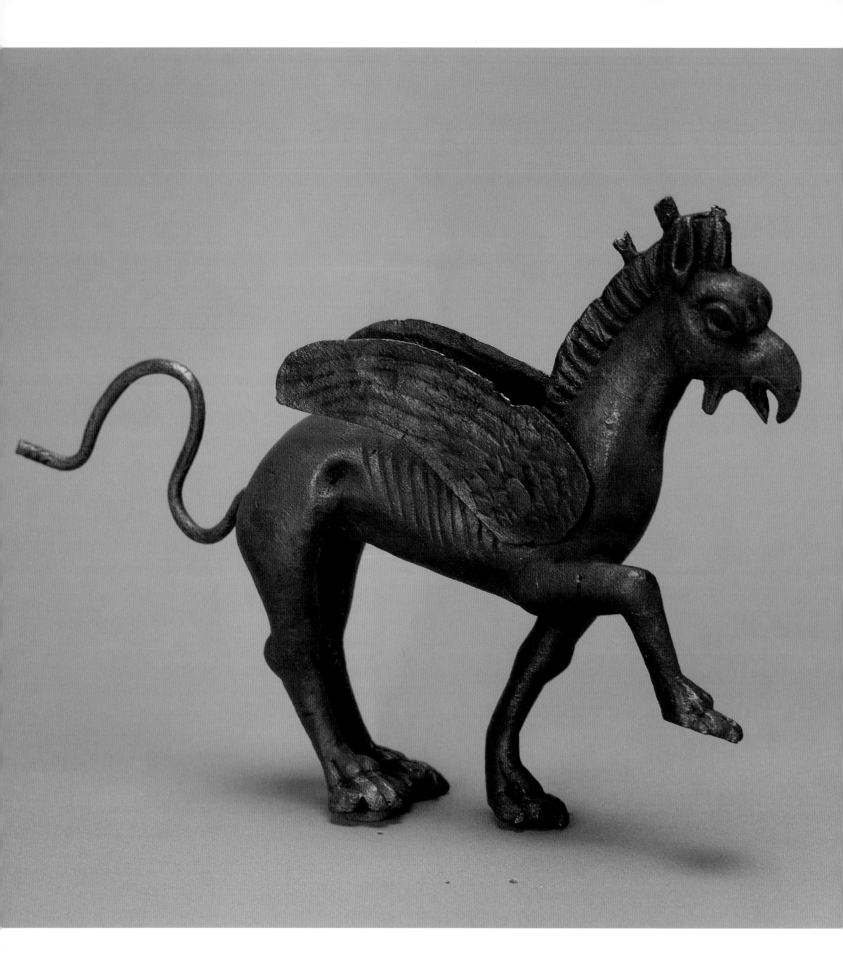

93 Griffin [92]

3rd–4th century AD
Bronze
9 x 6⅛ x 1½ in
Zguderi (Shida Kartli), late ancient cemetery, a plundered grave
GSM 190:65/264

The griffin has the body and paws of a lion, the beak of a bird of prey, pointed ears, the beard of a goat, and a short mane. This one was decorated with so-called divine rays (by inlays that are now gone). Because of its raised right front paw it does not stand on its own; thus it is probable that it was part of some other object (either furniture or a vessel). Its thin sheet-like forged wings are riveted to the body. A wire tail and two rays of a mane (three are missing) are attached to special holes; the mane, wings, and sides of the body are grooved. There is no known exact analogue for the piece. Somewhat similar images of horses incised on the bottoms of silver bowls have been discovered in kurgans of the ruling aristocracy of Kartli of the 3rd and 4th centuries at Armaziskhevi, Bori, Zguderi, and Zhinvali. GN

94 Torso of Pan [91]

1st century AD
Bronze
7 x 4⅜ in
Mtskheta (Shida Kartli)
GSM 28-51:27

This piece was a decorative affix for the upper part of a table leg. It represents a young, beardless Pan with thick wavy hair and large goat ears. His mouth is open and his hands are held as if he were playing the pipes. His fingers are extremely long and delicate, and overall this is very carefully wrought Roman work. KJ

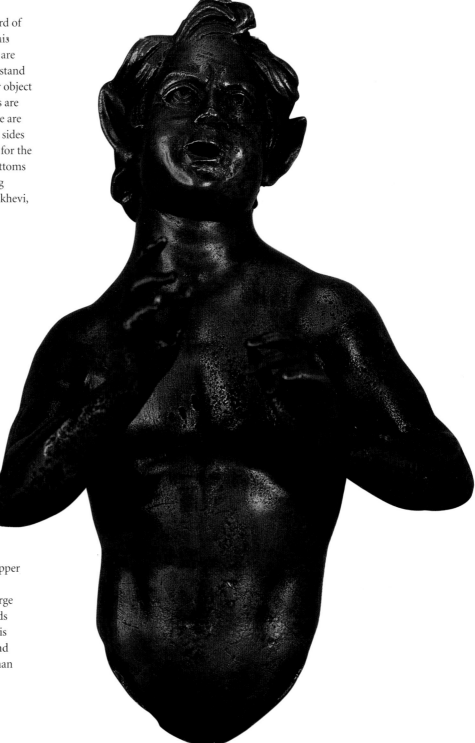

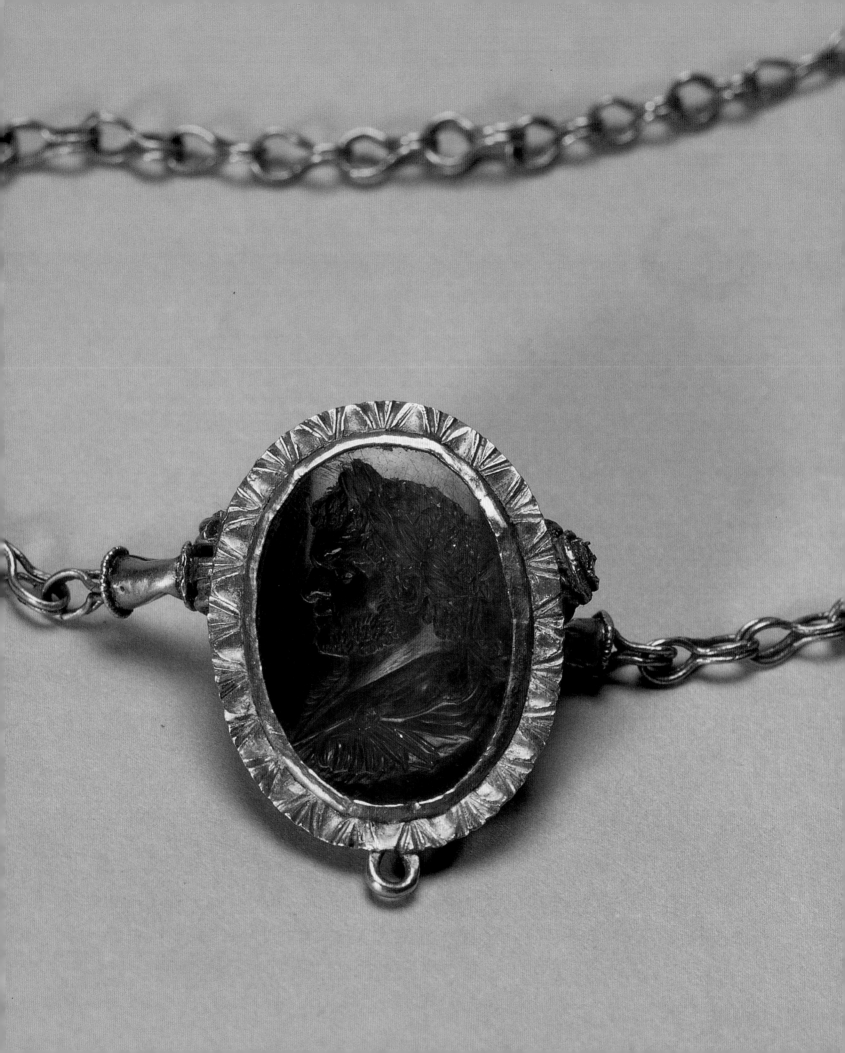

95 Pendant [94]

3rd century AD
Gold, amethyst
1 x ½ x 9½ in
Urbnisi (Shida Kartli) cemetery
GSM Glyptic 1104

A large oval, dark, carved amethyst medallion embedded
in a thin gold plate setting hangs from a chain of interlaced
'figure-eight' links, made of thin gold double wire. The
narrow edges of the setting bend toward the surface of the
stone and are in turn bound by a second, wider frame, also
of gold plate but shaped as a leafy ornament and soldered
to the gold holding the gem. Two loops are soldered to the
edges of the wider frame, on opposite sides, which attach
to the chains.

At both ends of the chain are small cylinders made of
thin gold plate. The ends of the cylinders are encircled by
very thin wire, and each is attached to the chain from one
end and has a flat loop on the other, which can be placed
between the two loops on the medallion and fastened by
means of tiny pins.

The intaglio embedded in the medallion has a slightly
convex form. The Roman emperor of the Severan dynasty
known as Caracalla (r. AD 209–17) is portrayed in profile
looking to his right. He is crowned with a laurel-wreath
and wears a chlamys round his shoulders fastened by a
large clasp, his armor visible beneath it. This is an
individualized representation of a well-known historical
figure and a superb example of Roman art, with analogues
in the collections of both the Hermitage and the British
Museum (the latter also containing analogues of the
medallion and chain). KJ

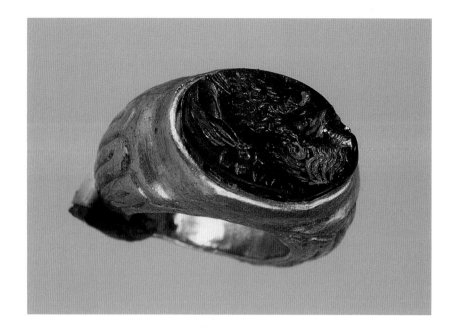

96 Double portrait seal-ring [93]

3rd century AD
Gold, carnelian
⅝ x ½ x ⅞ in
Zguderi Burial Ground (Kartli), wooden sarcophagus 1
GSM Glyptic 1187

This large massive-looking ring must be cored; the band is flat on the inner side
and embossed on the outer side. There is a ridge along the entire length of the
band, which widens toward the upper part, forming narrow horizontal shoulders
onto which an oval bezel is soldered.

The gem embedded in the bezel is a carnelian with an embossed surface
depicting a young woman on the right and a bearded young man on the left,
facing each other in profile. The woman's hair is separated, with part of it hanging
along the edge of the forehead, covering her ear and fastened tightly at its end,
and part combed from the forehead to the back and fastened at the nape like a
braid. She wears a small hat made of net-like cloth and the visible upper part of
her garment is fastened at the right shoulder by an oval clasp. The man's slightly
wavy hair is partly combed forward, covering most of his forehead, and in part
has been allowed to curl down toward his neck. He wears no visible garment. The
hairstyles closely resemble the Roman fashion of the 3rd century AD.

Though generalized, these portraits bear individualized features. Their spiritual
sensibility is very evident: their glances are directed towards each other, with faint
smiles and an overall sense of calm. These features give a particular charm to the
portraits. The names of the couple are inscribed in Greek letters (in reverse, for
the purposes of seal-imprint); the woman is designated matrona and the man
kabrias. [Since matrona means 'mother' in Latin, it is conceivable that this is not
actually the woman's name, but rather an honorific title that her husband has
placed here along with the immortalizing image of his wife, the mother of his
children – ed.] The letters are well-formed, large and clear-cut. This is first-rate
Roman work. KJ,GN

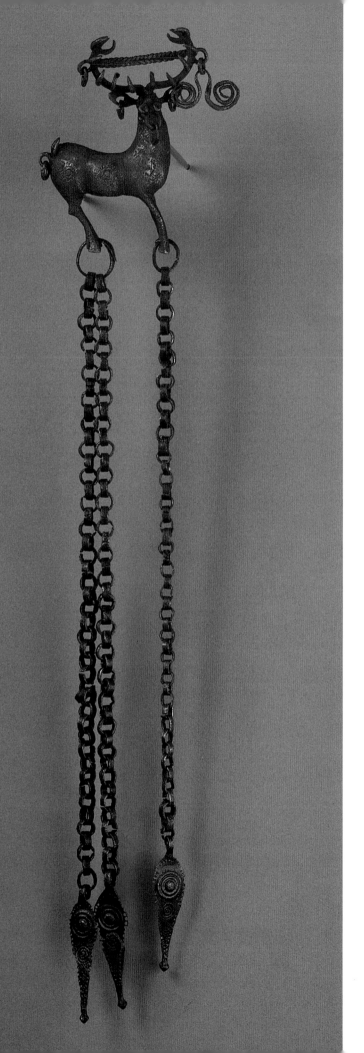

97 Clasp in the form of a stag [99]

Late 3rd–early 4th century AD
Bronze
2⅞ x 2½ x 9¾ in
Nedzihi (Pshavi), grave 199
GSM 09-XI:86-757

A relief-sculpted stag, its body decorated with incised solar
symbols, is depicted in right profile, head turned toward
the viewer, legs slightly forward. A horizontal pin clasp
made of iron, now partially missing, goes across the back
of the stag's body. The representation is quite naturalistic,
especially the head with its impressive eyes and dynamic
hollow nostrils. A ring is fixed on the oblong lower lip with
a thin small medallion. The ears, pricked up as if listening,
have oval pin-holes in their middles, with small rings
through them. Seven-point antlers rise between the ears;
the antlers are connected at their widest point of
separation by a twisted post which terminates on the outer
sides of the antlers in a pair of rings; one more ring pierces
the turned-up tail. The front and hind legs are joined at
the hooves by two short posts, from which hang three
bronze chains, one from the front and two from the back
legs, each 12–13 inches long; at the ends of the chains are
thin, curved, leaf-shaped plaques. The body is decorated
with a symbolic representation of the sun.

Parallels for this kind of clasp are found only in the
mountain regions of eastern Georgia. RR

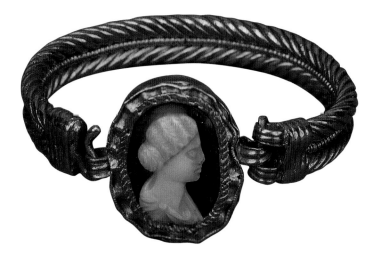

99 Bracelet [95]

3rd century AD
Gold, sardonyx
2⅛ x 1 x ⅝ in
Mtskheta (Shida Kartli), Bagineti, sarcophagus 1
GSM Glyptic 853

The Roman bracelet consists of a flat open ring and a medallion mounted with a cameo. The ring is made from three soldered wires – the two outer ones are thick and twisted in a diagonal pattern; the one in the middle is thin and incised. One end of the ring is decorated with a thin crimped border, and terminates in two grooved rings; the other ends in a thick wire hook. On either side of the medallion is a small attached loop, one of which attaches to the bracelet ring by fitting between its two grooved end-rings, held by a short pin; the other connects to the bracelet end-hook which enables the bracelet to open and close.

The medallion frame is an oval cell made of sheet gold shaped as a narrow crimped plate, encircled along the outside by a thin wire border, and along the inside by a thin wire frame enhanced by decorative notches. The sardonyx is double-layered; the background is dark blue. The very light blue – almost white – top layer is carved as a high-relief bust of a young woman in profile. She wears a chiton with a chlamys round her shoulders. Her hair is done in a fashion typical of Rome in the 3rd century, with wide waves laid on her nape, ending in a large bun. There are analogues of the bracelet in the collections of the British Museum, and analogues of the image in the Berlin Museum and the Bibliothèque Nationale, Paris. KJ

98 Bowl [96]

4th century AD
Silver, gilded silver
1½ x 4¾ in
Mukuzani (Kakheti)
GSM 11-994:1

A cast bowl with decoration carved after the casting. The upper edge has a lip covered with small bosses ending in a wavy ornamentation – vertical lines executed with a puncheon. The bowl rests on a double medallion bearing the head of a wild boar, facing to the right, in low relief. The remainder of the outer surface of the bowl is covered with low-relief emanations from the medallion: a type of 'tree of life' extending in opposite directions. Various flowers are set in the branches in both directions. Small animals, birds, and even humans fill the spaces between the branches. The most prominent image is that of grapes being gathered by two men, one with a basket and the other with a knife.

A gilded cross with equal arms occupies the center of the inner surface of the bowl where the boar's head rests on the exterior. The bowl is a fine example of Sassanian-style metalwork. It exhibits the attributes of Zoroastrian cult objects, though it is designed in accordance with early Christian symbolism, which is further accentuated by the contrasted gilding, the vine motif symbolizing humanity. This combination of Zoroastrian and Christian elements suggests a 4th-century dating. LC

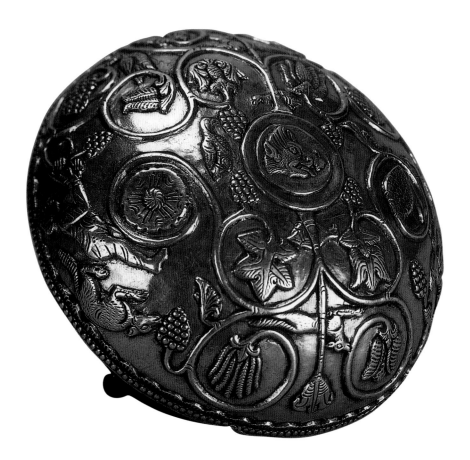

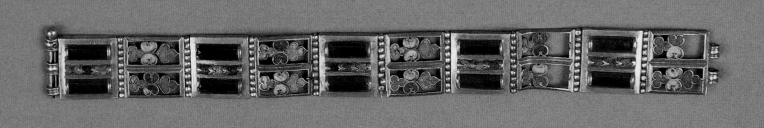

100 Bracelet [101]
4th century AD
Gold, lazurite, malachite, almandin
8⅛ x ¾ in
Necropolis of Armaziskhevi (Shida Kartli), grave 40
GSM 4-981:1

The jewel setting of this bracelet is flat, consisting of ten equal
square sections, framed in gold and connected by articulating gold
joints. The sections are of two open-work types which alternate.
The first is adorned with almandin and oblong colored stones, as
well as small rows of semi-cylindrical malachite, placed at the
edges, and in the center, a lazurite line. The second is divided by a
gold band into two equal partitions, filled with malachite trefoils
and bean-shaped pieces of lazurite. NG

101 Ring [100]
Late 3rd–early 4th century AD
Gold, garnets
1 x 1 in
Djinvali, Aragvispiri (Shida Kartli), necropolis
Zandukliani Navenakhari, grave 9
GSM 5-975:6

The band and bezel for this ring are made of
a thin gold plate. The frame is wide and flat,
widening still further to the shoulders where a
large round garnet bezel is encompassed. The
bezel does not extend out beyond the surface
of the ring. The ring has partitions; the surface
of its frame is separated by one long and four
wide partitions. The lower part, around a long
partition, is divided into three large-sized partitions. The
large round bezel is divided into five rounded radially
directed segments. Flat-surfaced garnets of corresponding
forms, 21 pieces in all, decorate the band and bezel – of
these, several are lost. KJ

102 Bracelet [97]
3rd century AD
Jet, gold, pyrope
3 x 1¼ in
Mtskheta (Shida Kartli)
GSM Glyptic 853

This massive bracelet of jet consists of two major sides and
ribs. It is decorated with five sheets of gold with square gold
bezels on all sides. Bezels of a similar form, decorated with
42 flat pyrope stones, are set into the jet loop on both sides.
Each part of the bracelet has gold clasps and hinges.

The bracelet was found in a sarcophagus that belonged to
a young noble lady. Typically, a sarcophagus, with two
sloped roofs, contained rich women's burial items and this
one is no exception. Created with great taste and unique
among similar jewelry found within the territory of Georgia,
it was found together with other sumptuous burial items,
among which was a gold coin of Ardashir I (r.224–40), the
first Sassanian king, providing an approximate date. GN

104 **Buckle** [102]

3rd century AD
Gold, wine-colored glass
1¾ x 3 in
Kldeeti (Imereti) cemetery
GSM 11-57:51

Roman work, this disk is cut from a single gold plate. The lower part is virtually square; the upper part consists of two triangles surmounted by hieratic birds with their beaks touching. Three gold disks hang by separate chains from the lower edge of the square, which is framed, with the triangles, by simple narrow threefold convex borders. The square also has five cells set with stones soldered on, a large oval one in the middle and four small round ones in the corners. These cells hold dark wine-colored glass; the corner jewels are convex and the central one is flat. Both triangles also have cells for inserts, currently missing. So, too, on the birds concave surface plates have been soldered: round cells for the birds' eyes and almond-shaped cells for the wings, all currently empty. Additional granulated decoration has been soldered onto the square, the triangles, and the birds. On the square, two small granulated triangles are soldered along each side and fifteen small groups of granulated rhombs and shapeless pieces are soldered around the center. At the center of each triangle, granulation encircles the central cell and follows along the frame. The edges of the birds, their wing cells, and parts of their bodies are also decorated with a layer of granulation. KJ

103 **Brooch** [103]

3rd century AD
Gold, garnet, sardonyx, glass
1⅝ x 2¼ in
Ureki (Guria)
GSM 12-57:6

A well-cut and polished agate with a blank surface is set in an oval, open-work gold frame, from the lower edge of which hang sixteen knitted gold wire chains. In the middle of each chain a blue paste white-eyed bead is set, and each chain terminates in a small garnet. A pin and hook are fastened to the smooth back of the medallion. Such a brooch would have been used to fasten a ceremonial cloak at the shoulder, and was a widespread feature of late Roman and Byzantine clothing. LC

105 Bowl [104]

Second half of 3rd century AD
Silver
1⅜ x 7⅜ in
Mtskheta, Armaziskhevi (Shida Kartli), sarcophagus 2
GSM AR-12-57:6

This is a fine example of Sassanian metalwork, high with a widened upper part and a low heel. The upper edge is thickened (c.⅖ in) and gilded. A medallion, depicting a man facing to the right, occupies the interior center of the bowl and is framed with concentric flutes. The style of his headgear, hair, facial type, and clothing are those of a Persian nobleman. A pear-like earring hangs from his ear and he wears a necklace consisting of large round beads. In his right hand he holds a stylized lily which he raises to his face. He himself is placed rising out of an elaborate and large, stylized vegetal pattern, like a flower rising from its plant base. The entire space between the central medallion and the bowl edge is occupied by four rows of round bosses. On the reverse of the medallion (the central exterior of the bowl) is a Pehlevi inscription, executed with large incised dots. The inscription is damaged, but it is still possible to read the following: 'pitiakhsh [the ruler] of divine Ardashir, divine Papaki…' It seems that the owner of the bowl was the governor of one of the provinces of Kartli (i.e. Iberia or eastern Georgia). LC

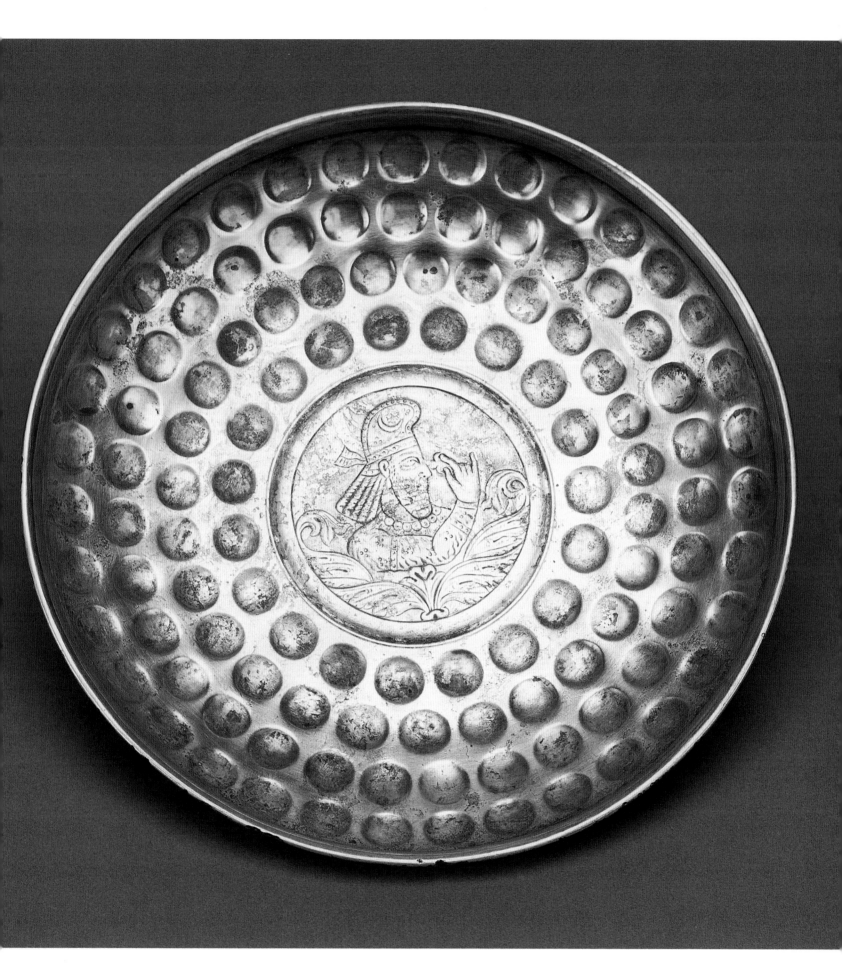

106 Panel from an altarscreen [105]

End of 7th–beginning of 8th century AD
Limestone
34¼ x 32¾ x 4⅜ in
Tsebelda, Gulripshi
GSAM 126

This work is part of an altarscreen from the Tsebelda church in the Gulripshi district, Abkhazia, in the northwest corner of Georgia. By its style and compositional as well as iconographic details, the altarscreen belongs to East Christian art and is an outstanding example of Georgian stone-carving.

The central rectangular portion of the plaque is framed by floral ornamentation and divided into two sections. The top section is a five-figured presentation of the Crucifixion – Christ clad in a colobium in the center; the Virgin Mary on the right; a Roman soldier thrusting a pole topped by a vinegar-doused sponge towards Christ on the left; and the two thieves to the extreme left and right. The bottom section represents the Resurrection. To the right an angel with wings sits on the empty tomb; before him two saint mothers stand, holding containers of anointing oil. To the left hand, above and below, are sleeping Roman soldiers and a sarcophagus.

The upper part of the stone's left-hand side presents two scenes from the life of St Peter. On the uppermost register, the Lamentation of St Peter is depicted with his hands raised to his face, weeping; to his right is an enormous cock, seated on the branch of an olive tree. This recalls Christ's prophecy to Peter that he would deny his Master three times before the cock crowed and Peter's realization of having fulfilled that prediction. Below this scene the martyrdom of St Peter is depicted: he is shown being crucified upside-down (for he had asked to be so executed, not being worthy of crucifixion in the same manner as Christ), as two bearded men tie his legs to the cross.

On the right-hand side of the stone, on the upper register, there appear to be the remains of a depiction of Abraham's Sacrifice. Owing to severe damage to the stone, only parts of two elements are still visible, the figure of a servant and the saddled ass. Below this the Baptism of Christ is depicted. The Savior stands, naked, as St John the Baptist, to the right, douses him. Above them two angels flank the Dove of the Holy Spirit descending from Heaven.

The left-hand side of the plaque's lower part portrays the Miracle of St Eustace Placida, in which St Eustace, while out hunting, saw a vision of Christ between the antlers of a stag, which caused his conversion to Christianity. Attired in the garb of a Sassanian king, the saint is shown on horseback, a sword extending from his belt, a cloth wrapped around his head, and its ends flowing out behind him. His horse is richly caparisoned, its tail tied in the Persian style. St Eustace holds a bow and arrow in his left hand. In the left corner of the composition a fleeing stag turns its head back toward the saint, with Christ's face carved between its antlers. Between the stag and the rider, a dog, a hunting falcon and a handful of abstract elements fill out the composition [suggesting a strong *horror* vacui common to medieval Christian art – ed.]. A tree, growing at an angle to frame the rear part of this scene, separates it from that of the lower right-hand portion of the stone, where the figures of a man and a youth are shown with upraised arms. Above the man's head is a cross; the youth holds what would appear to be torches in his hands. These two figures no doubt represent the donors of the altarpiece. To their right, various accoutrements for communion complete the work: a laver and a tray with five pieces of Holy Bread on it. [This symbolized the five wounds in Christ's body. Other elements, such as the communion chalice, are not visible because of the damage to the right side of the stone. – ed.] GG

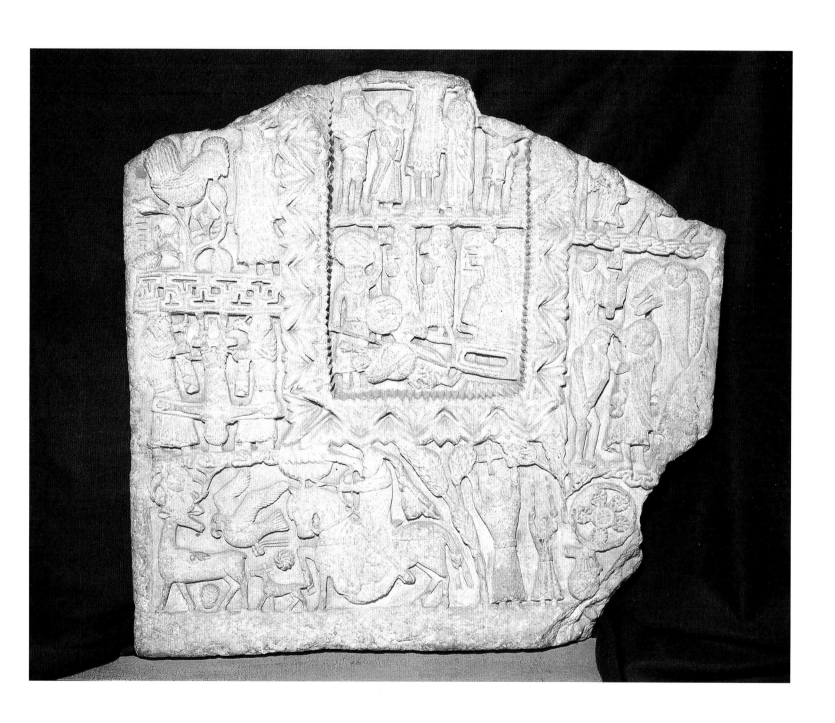

107 Panel from an altarscreen [106]

8th–9th century AD
Limestone
28 x 22⅛ x 3⅝ in
Gveldesi
GSAM 146

This panel is part of an altarscreen from the church of St John the Baptist in Gveldesi, now an abandoned village, in the Kaspi region of the province of Kartli in central eastern Georgia.

The entire central portion of the altarscreen panel's rectangular plaque is framed by a wave motif and what may be construed as button-like ornamentation. Within this frame the larger portion of the composition, to the right, is comprised by a circle with four 'corner' loops, within which there is an octagonal figure – a kind of eight-point star – the interior of which is also decorated with loops. In the center of this figure is a circle echoing the exterior circle and the outermost frame of the entire composition with its series of perforations.

To the left of this geometric composition is a stylized image of a peacock, with a long neck, a pronounced eye, and its tail outspread. GG

[A fascinating instance of Georgian stone-carving of this period, this work synthesizes Islamic style – the extensive use of geometry, and in particular the eight-pointed star – with Christian symbolism. The peacock represents, among other things, the all-seeing church (by the myriad eyes ordinarily seen on its tail) and resurrection into eternal life (there is an old Egyptian tradition that its flesh does not rot after death). In such a context the eight-pointed Islamic star occupies the symbolic place ordinarily taken in Christian art by the octagon: representing rebirth, since, according to tradition, it was on the eighth day after his arrival into Jerusalem that Christ rose from the dead – ed.].

108 Relief of Ashot Kuropalates [107]

Early 9th century AD
Sandstone
22⅛ x 26 x 3⅝ in
Opiza Monastery
GSAM 1303

This relief was located on the south façade of the main church of the monastery of St John the Baptist in Opiza in historical Klarjeti – now the village of Bajilar in the *vilayet* (province) of Artvin, Turkey.

On the left-hand side of the two-part composition, King Ashot Kuropalates is represented, attired in a garment that reaches down to his shins. In both hands he holds a building – the monastery church – domed with a triangular-fronton roof, which he presents to Christ, who is shown on the right-hand panel seated on a throne. Christ's right hand extends into the left-hand panel toward the church being presented to him, while in his left hand he holds the book of the Gospels. To the right, a man raises his hands in a gesture of prayer or adoration toward Christ. This individual's attire is similar to that of Ashot's, balancing him in compositional placement.

Each figure and even the building is marked by identifying inscriptions: 'Ashot', 'Church', 'Jesus Christ', and 'David'. Ashot Kuropalates was the founder of the Bagrationi dynasty of Tao-Klarjeti. He reigned in the years 786–826 and rebuilt the Opiza Monastery. According to the interpretation expressed in Georgian literature the David pictured here is no less than the biblical King David, believed to be the ancestor of the Georgian Bagrationis.

Recently, some scholars have suggested a less accepted idea that the plaque may commemorate later rules, Ashot (945–54) and his eldest son David (923–37), king of the Georgians. GG

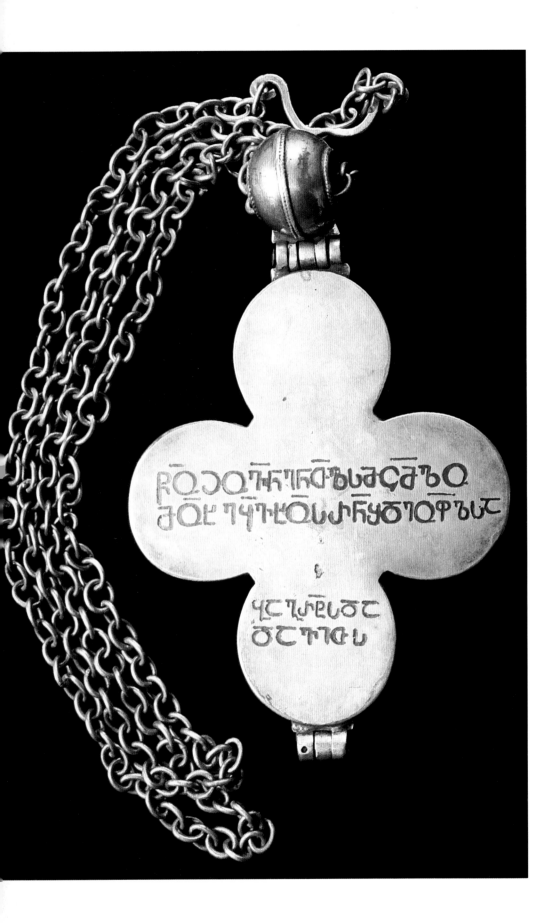

109 Reliquary cross (encolpion) [108]

9th century AD
Silver, gilded silver, niello
6 x 3¾ in
Martvili (Samegrelo)
GSAM O-41

The Crucifixion is depicted on the obverse. The composition is strongly linear, flattened, and somewhat schematic. The figure of the Savior is three times larger than the Virgin and John the Evangelist, who are placed just below the Savior's extended arms. Given the gestures of these two small figures, the iconographic vocabulary is of a Syrian type. At the base of the cross is the skull of Adam, which will be redeemed by the blood of Christ.

The standard inscription surmounts the head of the crucified Christ, in Asomtavruli script: 'Jesus of Nazareth, King of the Jews' (based on John XIX.19). This work is important with regard to the development of niello: in the early period there is a bluish quality to the black, as here, and a sense of denseness and surface sparkle. These qualities are evident throughout the niello background and interior lines of the composition, contrasting with the gilded elements – the figures, outlined parts of the cross and edge of the encolpion itself.

On the reverse is a niello inscription in Asomtavruli script, embedded directly in the silver gilt surface of the encolpion, concerning Queen Khosrovanush and her two sons, David and Bagrat. The inscription does not offer precise chronological data, but according to the historian T. Zhordania, the father of Bagrat and David would have been the ruler of the important trading city of Artanuji, the *antipatos patrikios* Sumbat I, who died in 889 leaving two young sons. Sumbat I belongs to the branch of the Bagrationi family from Tao-Klarjeti. Only the representatives of this branch of that family could use the title *mampal*, 'ruler'. The Byzantine title *antipatos patrikios* was a function of Sumbat's friendly relationship with Byzantium. HK

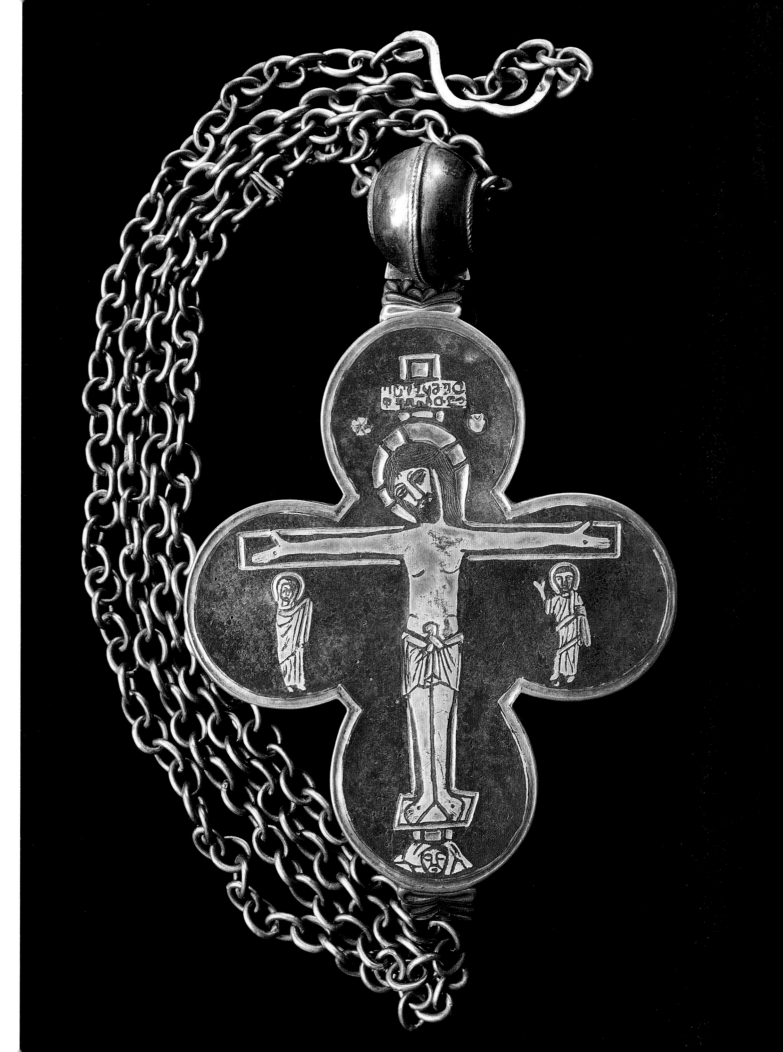

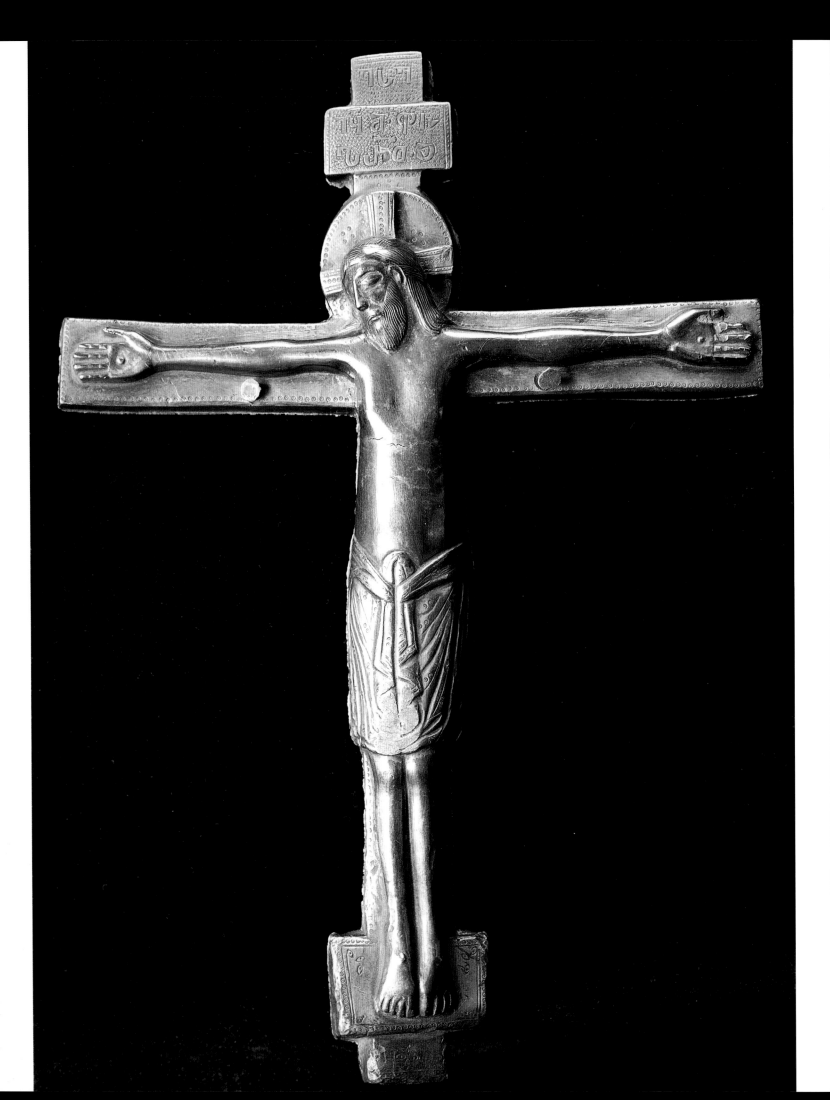

110 Processional cross fragment [115]

973 AD
Gilded silver; the body of Christ cast
8¾ x 6 in
Ishkhani (Tao-Klarjeti, southern Georgia)
GSAM L-17

This central piece of what was originally a large (20 x 14 in) processional cross, offered to the church of Ishkhani by the bishop Ilarion, remains one of the most significant examples of Georgian medieval silverwork. The crucified Christ is depicted with a straight body, a head bent slightly to the right, and a beautifully-worked loincloth which, like the minutely detailed gilded hair and beard, contrasts, in both color and intricacy, with the body of the Savior. The figure is powerful in spite of its small size; a full, generalized block is the basis for its formation and the success with which the master craftsman shaped volumetric form.

The image is surmounted by the words, written in Asomtavruli: 'Jesus of Nazareth, King of the Jews' (based on John XIX.19) and the donor's inscription in which Bishop Ilarion is referred to as the patron. According to the Georgian system of chronology – the *Kronikon* – the date of this object is 973, which is confirmed by the inscription. The piece was somewhat damaged in 1930. HK

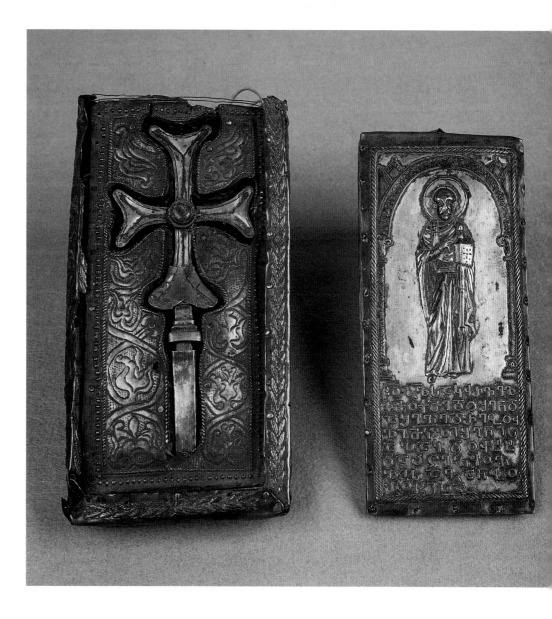

111 Icon [109]

10th century AD
Wood, silver
7½ x 4 x 1¼
Znakvari (Ambrolauri)
KSM 3089

This unusual small traveling icon functions as a diptych when opened. Embedded in the right-hand half is a small cross (2⅓ x 6⅓ in). The left-hand half, which fits into the right when closed, depicts St Grigol Neokesariel (Gregory the Neocaesarian, better known as Gregory Thaumaturgus, or Miracle-Worker), a 3rd-century saint of Neocaesaria, Pontus (modern Turkey), famous as much for his kindness as for the miracles that converted many pagans to Christianity. An inscription in Asomtavruli script says: 'May Saint Grigol Neokesariel Thaumaturgus protect Sahakdukht from evil.' The Georgian scholars Ivan Javakhishvili and S. Janashia have concluded that Sahakdukht was the mother of King Vakhtang Gorgasali, a supposition that supports one dating of the object to the 5th century (by P. Ingorovka and Shalva Amiranashvili), despite the 10th century dating (by Giorgi Chubinashvili) followed here. The icon was discovered in the Jvarisi church in 1926. NK

112 Icon [114]

10th century AD (icon); 9th–12th century AD (cloisonné enamel); 17th–18th century AD (frame)
Gold, silver, cloisonné enamel, turquoise, rubies, emeralds, pearls, wood
12⅝ x 9⅛ x ⅝ in
Martvili (Samegrelo), Chkondidi goldsmithery workshop
GSAM 0.7a

The central section of this icon, made of gold and decorated with precious stones and pearls, depicts the Virgin in the Hodigitria iconography, standing full-length with the Holy Child resting on her left arm. The figures date from the 10th century. The Virgin Mary, represented full-length in the iconographic character of Hodigitria, recalls Byzantine models of the 10th century. However, this figure differs from its Byzantine prototype by the supple treatment of her face and the free folds of her clothing, adorned with embroidery.

The gilded silver frame dates from the 17–18th centuries and offers its own complex of floral and vegetal ornamentation; it is studded with cloisonné enamel medallions. Those on the four corners show half-length figures of the Evangelists, all dating from the 12th century; the slightly smaller pair along the sides represent Sts Kviros and Paul. All of these are identified in the Greek inscriptions in the gold background of the medallions. Smaller enamels across the top, also with inscriptions in Greek, represent St Peter, St Marcian and St Basil, and along the upper corners of the central portion of the icon, the Savior and the Virgin.

Whereas the larger medallions are Georgian, the smaller ones are Byzantine in manufacture. They also vary as to their dating: the figure of St Paul dates from the 9th century; those of the Savior, the Virgin, St Marcian, St Kviros, and St Peter all date from the late 10th and early 11th centuries. The entire composition was once part of a large triptych, created in the 18th century at the instigation of the metropolitan of Chkondidi, Gabriel, son of the prince of Odishi, Bezhan Dadiani. HK

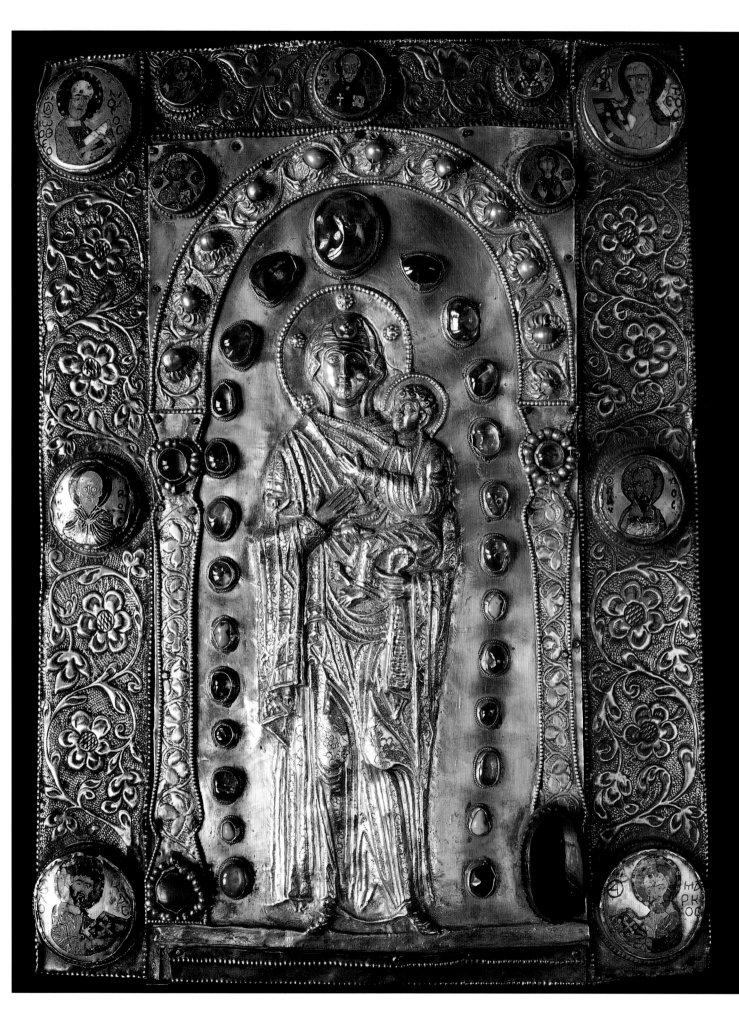

113 Upper part of a chalice (the Bedia Cup) [118]

999 AD
Gold repoussé
5½ x 5½ in
Bedia (Abkhazia, west central Georgia)
GSAM 9510A

Only the upper part of this chalice has survived, albeit intact; the base is lost. An inscription in Asomtavruli runs along the upper edge of the chalice. It gives the names of the donors – Bagrat III, king of Abkhazia (975–1014) and his mother, Queen Gurandukht – which also dates the cup to 999. In *The Life of Georgia*, the chronicler writes of the brilliance of Bagrat's reign as defined by the jewelry in the church at Bedia, from which this is the only surviving object. [Bedia was the principal foundation built by Bagrat III, and he was buried in the church after 1014. He lavished money on the church and thus, 'If anyone wishes to assess and contemplate the eminence of Bagrat's glory, first let him assess the decoration of the church of Bedei: from that he will understand that there has never been another king like him in the land of Kartli and Aphazeti.' The Bedia Cup is eloquent testimony to the chronicler's judgment. – AE]

The chalice has a spherical shape. Its twelve-part arcade encompasses twelve figures. What may be understood to be the center of the obverse is occupied by Christ seated on the throne, with St John the Evangelist and St Jacob the Greater flanking him; at the center of the reverse sits the enthroned Virgin and Child flanked by St Peter and St Paul. Sts Andrew, Luke, and Mark complete one side, and Sts Levi, Thaddeus, and Bartholomew complete the other. The heights of standing and seated figures are identical, and all, except the Mother of God, are identified by inscriptions. That of the Savior is given in the Greek initials for IC XC, an abbreviation of the words 'Jesus Christ.' The names of the ten Apostles and Evangelists are written in Georgian, using Asomtavruli script. The donors' inscription begins approximately above the image of Christ but is addressed to the Mother of God.

The chalice is a masterpiece of Georgian goldwork, most successfully exhibiting the characteristic qualities of the epoch. The master craftsman created it out of a single piece of gold, and emphasized the volumetric form of the human body. He contrived only the upper parts of the bodies in high relief and executed the lower parts in low relief. Each figure is portrayed with a sense of individuality, while the whole assumes a steady rhythmic pattern from arch to arch. The cup was kept in the Ilori monastery until 1930, when it was moved to the State Art Museum. HK

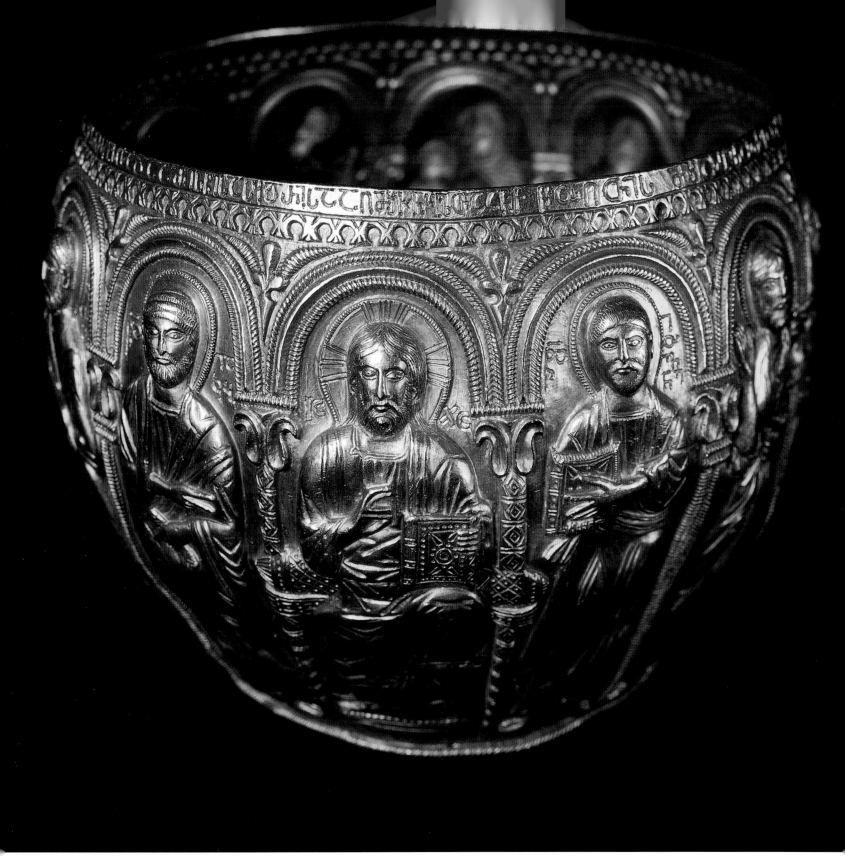

114 Pectoral cross from Martvili [110]

10th century AD
Gold, pearls, enamel, precious stones
6⅜ x 3¾ in
GSAM P289

Four figurative enamels are set against a gold background: the half-length figure of the Virgin in Prayer at the top; St Demetrios holding the cross to the left; St Nicholas with the book of the Gospels to the right; and below, a full-length figure of John Chrysostom, whose vestment is treated with long, delicate lines to indicate the folds. The predominant colors of the enamels are dark and pale blue. The Greek inscriptions are made of reddish-brown enamel. Two large patches of yellow further brighten the array of colors. The cross is also adorned at all four extremities with medallions surrounded by wide enamel borders that are either blue with gold or emerald-green with red. The sole analogous piece is the Shemokmedi quadrifolium (also in the collections of the Georgian State Art Museum). LK

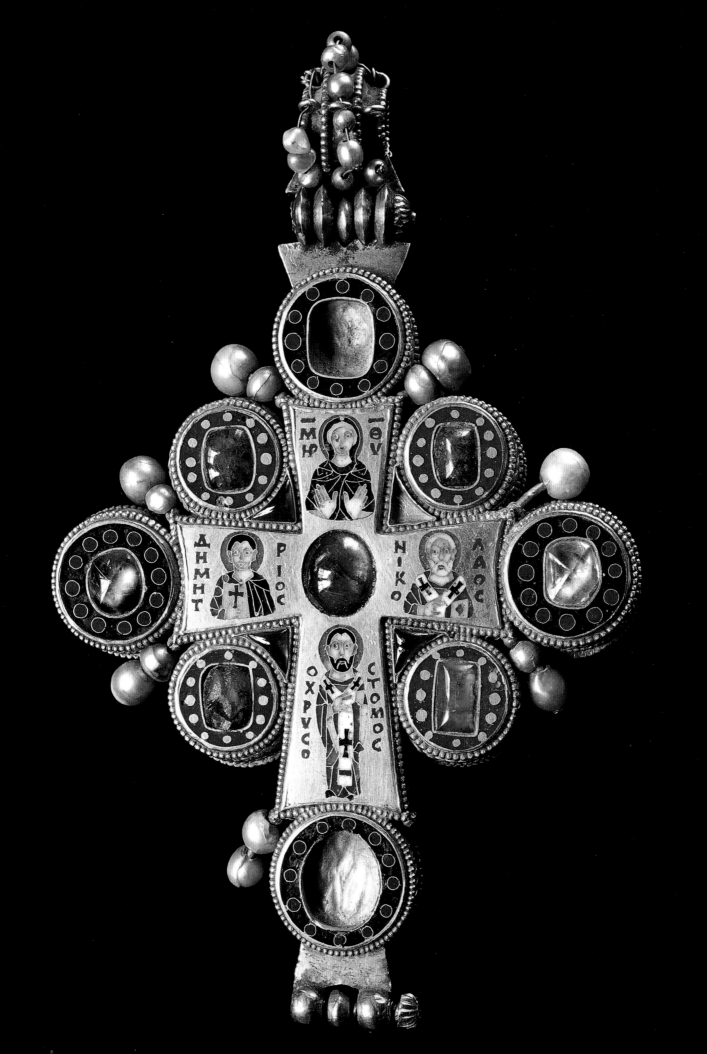

115 Iconostasis plaque [117]

Late 10th–early 11th century AD
Silver
13⅝ x 12 in
Sagolasheni (Shida Kartli), south Georgia, goldsmithery workshop
GSAM K-46

To the right, the Virgin has risen from her cushioned seat and raises her right hand in a gesture of negation. In her left hand she holds a spindle, with the end of its thread in the vessel. To the left the Angel of the Annunciation turns toward her. He gestures with his right hand in benediction; in his left hand he holds a staff. The iconography of this Annunciation is Byzantine in type.

Framing the two figures is a pair of columns connected by a curtain rod; a curtain separates the two figures and is surmounted by a dome. The dome is in turn flanked by two background volumetric buildings. A threefold decorative frame, consisting of palmettes and knobs, completes the work.

[The paired columns and dome are long-standing abbreviated references to the Temple in Jerusalem – paired columns following the allusion in I Kings 21 to the two columns, named Yachin and Boaz, that were part of the First Temple; the dome because Abdul Malik's Dome of the Rock has dominated the Jerusalem landscape for so long (since AD 691) that already by the ninth century it had come to be associated with the architecture of the Temple, in Christian and Jewish as well as Muslim art. Thus this scene is placed, for symbolic purposes, in a most august setting. – ed.]

The image exhibits features characteristic of Georgian metal relief sculpting of the end of the 10th and beginning of the 11th centuries: the figures, executed in sharp relief, are block-like in configuration and their heads are hemispheres. The bodies are lost in the myriad elegant folds of the clothing. HK

116 Iconostasis plaque [116]

Late 10th–early 11th century AD
Silver
13⅝ x 11⅞ in
Sagolasheni (Shida Kartli), south Georgia, goldsmithery workshop
GSAM K-46

This scene of the Visitation – the meeting between The Virgin and Elizabeth, one pregnant with the Christ Child, the other with John the Baptist – takes place in a setting framed by unequal arches. To the left, Mary and Elizabeth embrace in greeting under a wide arch which extends beyond the frame; they are flanked by explanatory inscriptions in Asomtavruli script. To the right, under a smaller arch, is the upper part of a smaller figure, facing front: a servant woman who witnesses this moment. She raises her hands, palms out, in the *orans* (praying and receiving the Grace of God) position.

As with the companion Annunciation scene (115), the entire work, including its decorative framing, has been chased on one sheet of silver. The movement of the figures here is freer in composition than in the Annunciation plaque, without the floral elements so prominent in that scene, and the framing is heavier.

Overall, five of the Sagolasheni plaques have survived (the three not on exhibition here show the Presentation in the Temple, the Baptism, and the Ascension, and are on permanent display at the Georgian State Art Museum in Tbilisi). They are all thought to be either iconostasis or altarpiece plaques, or decorative plaques from a cathedral. HK

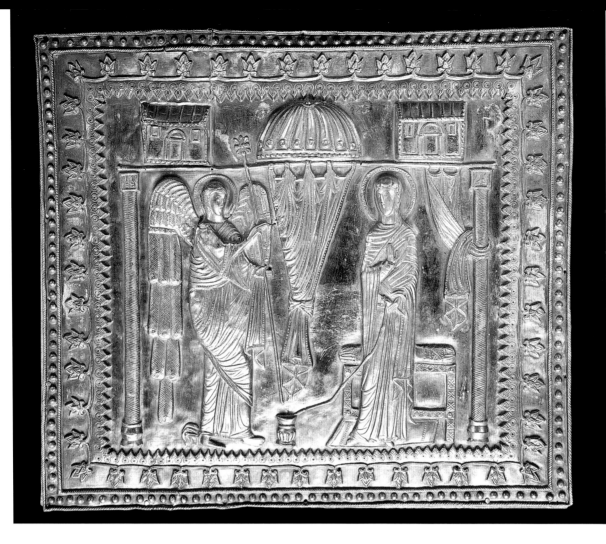

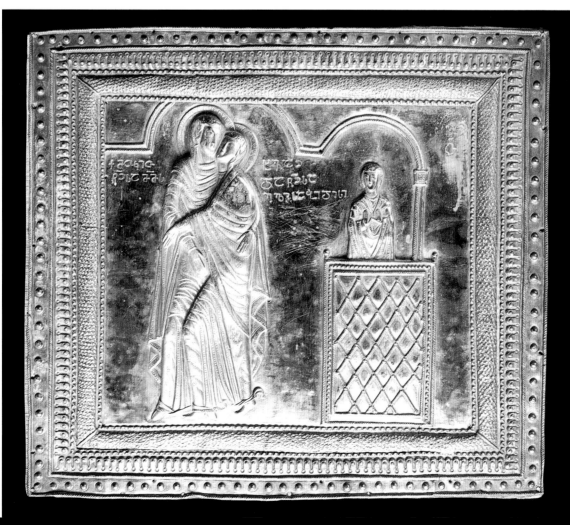

117 Icon of St George [113]

10th–11th century AD
Silver
11½ x 9½ in
Tsvirmi-Tchobeni (upper Svaneti)
GSAM 10134

Dominating the center of the icon, and identified by an inscription in Asomtavruli, a mounted St George spears the pagan Roman emperor Diocletian. This variation on the general theme of St George was first used in Georgia and is unique. [Diocletian, the last pagan Roman emperor, and most severe persecutor of Christians, is said by tradition to have martyred St George, hence his position as the symbol of evil ordinarily occupied by the dragon. As the theme continues through Georgian art, Diocletian most often appears in the garb of a Roman or Byzantine emperor, but sometimes, as here, he is depicted in the dress of the contemporary Islamic enemies of the Georgians. According to one tradition, St George triumphs over his adversary while looking out at us rather than at his victim, since he should not look at evil, but his outward gaze is also intended to provide direction connection with the viewer. – ed.]

The frame of the icon bears plain, diamond-shaped ornamentation. Two archangels are depicted in the upper corners; in the lower corners there are two further representations of St George, identified by their inscriptions. The icon is a typical example of the local folk-art-influenced goldsmithery found in upper Svaneti at the end of the 10th and early 11th century. HK

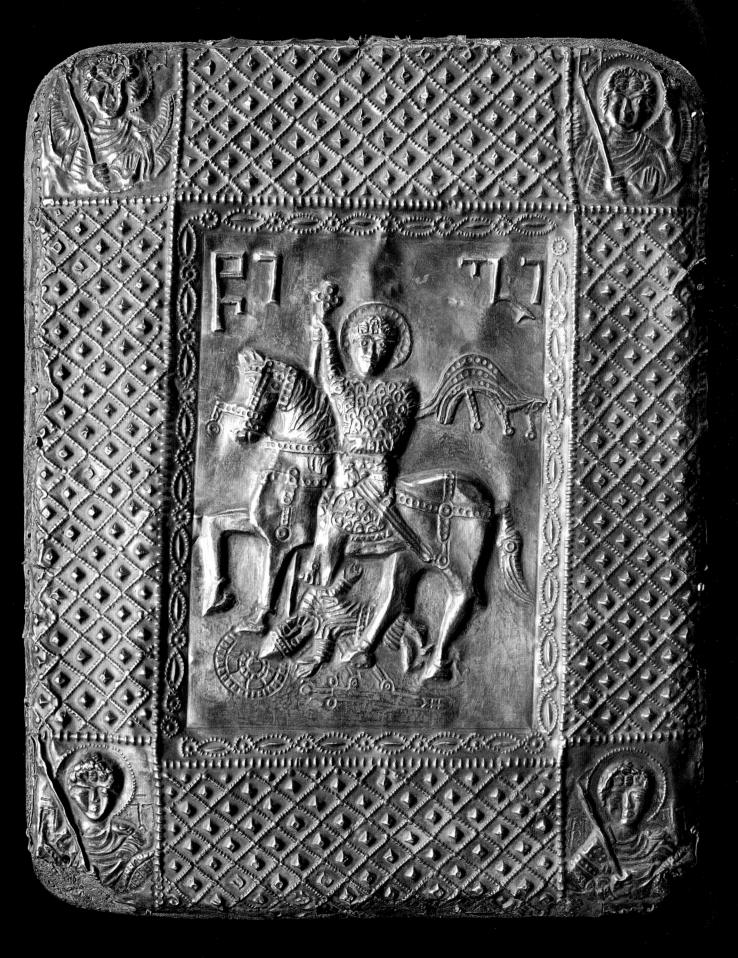

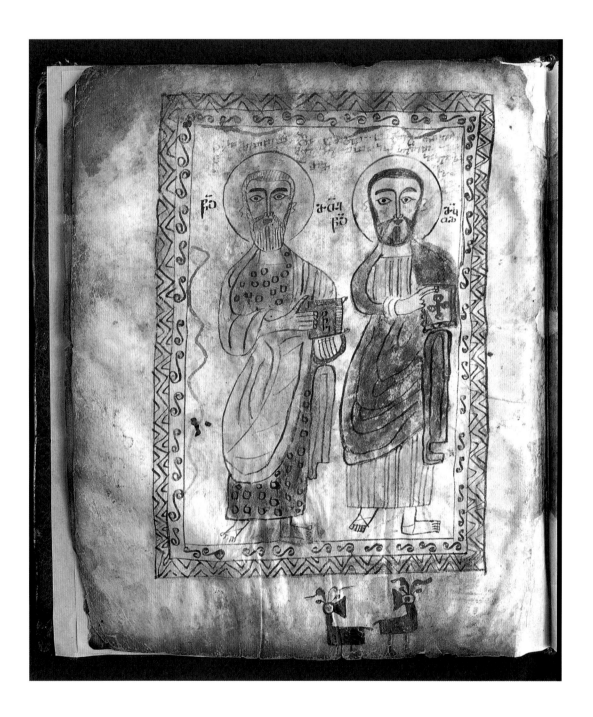

118 Illustrations from the Tskarostavi Gospels [111]
10th century AD
Gold leaf, ink, paint on parchment, leather binding
216 folios
9 x 8¼ x 3¾ in
IM A-98

This manuscript is composed in Asomtavruli script in two columns. The cover has been restored by using the leather from an old cover. The manuscript was executed in southern Georgia by Gabriel Patarai, who is also considered to be the illuminator. The illustrations represent eight canons, with the Evangelists at the beginning of the text. They are represented in pairs on two pages, standing with their respective gospels in their hands. The illustration is done in ink, brightened with yellow, red, and grayish-green paints. The title of each gospel is written in red ink. A colophon (f.4v) executed in 1070 says that the text was further decorated at that time by Iovane.

The figures are depicted in a very bold, stylized manner. There is no attempt to represent the human body, which is lost behind an abstract swirl of drapery. The manner in which the folds of the robes are depicted can be compared with that seen in the Opiza donation panel (108). HM

119 Tondo from Gelati [119]

11th century AD
Silver, gilded silver
7 7/8 in (diameter)
Gelati (Imereti)
GSAM 1198

This masterpiece of 11th-century Georgian metalwork depicts St Mamas astride a lion, together with an identifying inscription in Asomtavruli script. The saint holds a cross in his right hand. His left hand is held out in a gesture of entreaty. This iconographic type is a characteristic feature unique to Georgia, appearing only once in Georgian art in the 12th-century manuscript of the Homilies of St Gregory Nazianzeni (the Theologian) (122) and in the wall paintings in the 11th-century churches of Ishkhani and Manglisi. No image of St Mamas astride a lion is found in Byzantine or East Christian art. According to the accounts in the works of Basil the Great and Gregory Nazianzeni, St Mamas Caesarian was tortured to death on September 2, 275 for having accepted Christianity, which was illegal at that time in the pagan Roman world.

The workmanship is exquisite. The entire image is carefully executed in high relief. Particular attention has been devoted to the molding of the head of the saint, but the plastic forms throughout are modeled with great sensitivity, the proportions being held in careful balance. So, too, the use of silver and gold adds a dynamic series of contrasts to the work. HK

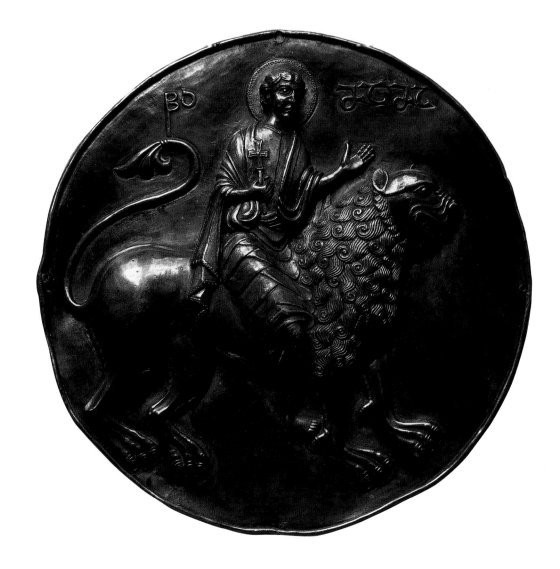

120 **Icon reliquary** [120]
11th century AD
Gilded silver, pearls, precious stones, wood
15⅜ x 13 x 1 in
Zestafoni region
KSM 3025

Gilded and decorated with 106 pearls and precious stones of various sizes, this icon portrays a complex double scene. On the lower half, the Crucifixion includes the two thieves; two Roman centurions on the right side balance the Virgin and St John on the left. Inscriptions in Asomtavruli identify all of the figures, offering on the upper part of the cross the words 'Jesus of Nazareth, King of the Jews,' and also encircle the schematized Golgotha from which the cross rises. On the upper part of the icon the risen Christ, flanked by two angels, is shown in majesty, surrounded by inset pearls which also encompass his halo and the entire upper frame of the icon. There are several small attached box-like protrusions which contain unidentified relics along the lower part of the icon. The reverse of the icon, which also depicts the Crucifixion, dates from the 16th and 17th centuries. NK

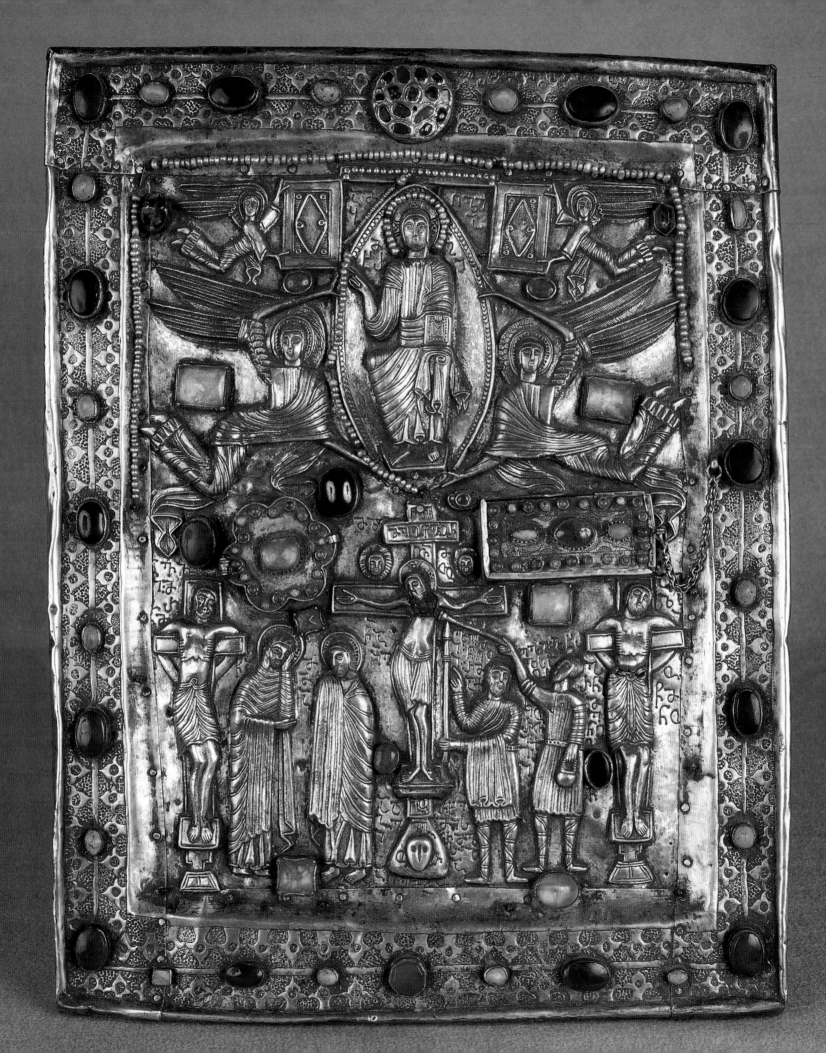

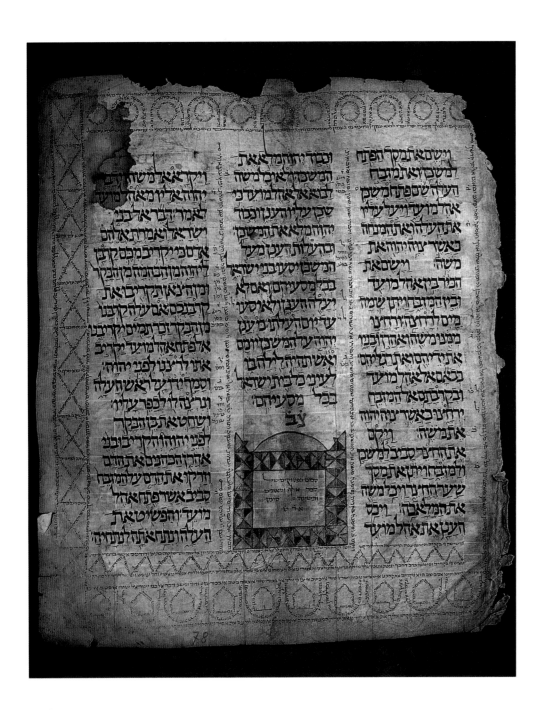

121 Pentateuch from Lailashi (Lechkhumi) [112]

10th century AD
Ink, paint, gold leaf on parchment
169 folios, 338 pages
17¼ x 14½ in
IM Hebr-3

The manuscript utilizes handwritten square Hebrew script in three columns with additional marginalia. Several folios are missing, as is the cover and most of the binding.

The manuscript is decorated at the end of each book (the last folios of Genesis and Deuteronomy are missing), with abstract illuminations in red and black. The text is beautifully written in square script; there is also geometrically configured micrographic commentary in the margins of many pages, adding a beautiful decorative element.

The manuscript was found at the end of the last century in Lailashi, northwestern Georgia; six folios of it surfaced in the mid-1980s in the possession of a family in Racha, a mountainous region also in northwestern Georgia. It is one of the most important such manuscripts in the world for the evidence it offers regarding the history of Hebrew script, and shares prominence with only four other similar texts, found in libraries in St Petersburg; Aleppo; Ann Arbor, Michigan (University Library); and Oxford (the Bodleian). This bible was brought to Lailashi from Svaneti. HM

122 The Homilies of Gregory Nazianzeni (the Theologian) [123]

12th century AD
Ink, paint, gold leaf on paper,
leather binding
262 folios
17¾ x 13¾ x 3¼ in
IM A-109

The homilies are written in Nuskhuri script in two columns. The cover has been restored using the leather of an old cover.

Thirteen miniatures illustrate events in the life of St Gregory Nazianzeni (the Theologian) as well as of other saints and parts of the life of Jesus. One of the miniatures represents 'Renewal,' a rarely painted scene which includes the image of St Mamas. The images are represented without a frame against an unpainted background of paper. Each miniature is placed at the beginning of the words pronounced by Gregory. The composition is distinguished by simplicity of line and a monumental handling of the figures. Brown predominates, brightened with green, white, and black. HM

123 **Processional cross** [124]
12th century AD
Gilded silver, ruby, sardonyx, iron
13 x 7⅜ in
Gelati (Imereti)
GSAM P289

On the obverse of the cross, the Crucifixion is offered in high relief repoussé; above the head of the Christus Patiens the traditional inscription 'Jesus Christ, King of the Jews' (based on John XIX.19) is written in Asomtavruli script. Relief medallions encompass the half-length figures of the Virgin Mary and John the Evangelist beyond Christ's outstretched hands; their gestures of grief (with the hand raised to the face) reflect Byzantine iconographic sensibility. A third medallion on the uppermost arm of the cross is occupied by the half-length figure of the Archangel Michael. All three are also identified in Asomtavruli inscriptions. At the bottom of the lower vertical cross arm is a sardonyx intaglio with a dynamic representation of St Eustace's hunting scene.

The reverse of the cross is entirely covered with a low-relief foliated scroll centered on a cross. A donor inscription covers the ball on which the cross rests. This mentions a certain Arsen, who is mentioned nowhere else in Georgian records. The figurative reliefs are all evenly done, with a certain mannerism, so that although Christ is depicted with his legs bent and his head listing to the side in death, his body does not slump down earthwards. HK

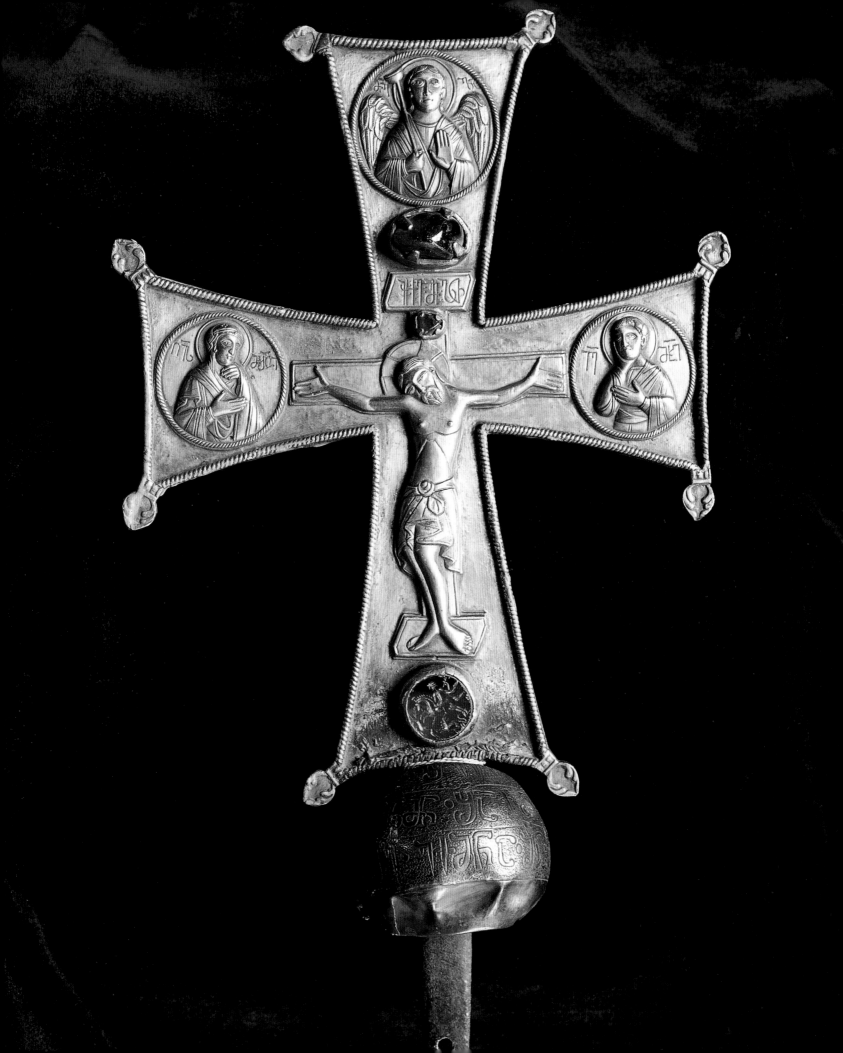

124 Medallion [121]

First half of 12th century AD
Gold, cloisonné enamel
3⅜ in (diameter)
Jumati
GSAM 3221

The half-length figure of St Luke is shown in a frontal position holding the book of his gospel in his left hand, which is covered with a cloak, and raising his right hand to his breast. The saint wears a light blue tunic with a thin yellow stripe and a deep blue cloak. The folds of his garments are presented in a schematic parallel arrangement. The outline dark green, semi-translucent halo, ringed in red, is uneven, resembling the haloes of the Georgian enamels on the Jumati icon of the Archangel Michael. The face is exquisitely drawn, the enamel completely honeycombed. The pupils of the eyes are somewhat dilated. The precise origin of this medallion is unknown, but it was probably produced in a Georgian workshop under the strong influence of similar Byzantine pieces.

 The medallion (together with 125) was returned to Georgia in 1923 from the former Botkin Collection. LK

 [There has been a strong debate, in the last decades, regarding the dating of this work, as well as 125. – ed.]

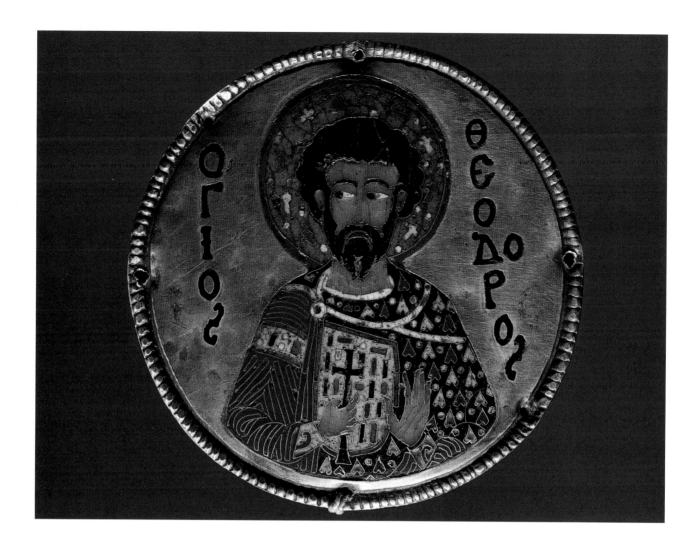

125 Medallion [122]
First half of 12th century AD
Gold, cloisonné enamel
3⅜ in (diameter)
Jumati
GSAM 3228

The medallion of St Theodore once adorned the Jumati icon of the Archangel Gabriel. Together with the medallions of St George now in the Metropolitan Museum of Art in New York City and that of St Demetrius in the Cluny Museum in Paris, it was part of the tier of Warrior Saints on the bottom register of the frame. The other eight medallions from the icon are also in the Metropolitan Museum collection.

The figure is shown in a frontal position against a gold background, holding a cross in his right hand and raising his left hand, with the palm out, to his breast. He wears a red tunic with yellow cuffs and a yellow stripe adorned with precious stones. Over the tunic he wears a blue cloak with white dots and red and yellow stylized ivy leaves. The gold-embroidered *tablion* is studded with precious stones. The turquoise halo of the saint, rimmed with red, is decorated with white dots and red and yellow crosses; the face is brownish-yellow in color. The Greek inscription is made of blue enamel.

Graceful gestures, refined features, clean-cut lines and exquisite decorative details, together with an intense expression reflecting inner strength, characterize the image. It belongs to the proto-Byzantine school of Georgian enamel-manufacture of the 12th century. Similar medallions dating from the same period are found in the Museo Lazaro Galdiano, Madrid; the Museum of Historic Treasures, Kiev; and the Museum of the Orthodox Church, Kuopio, Finland. LK

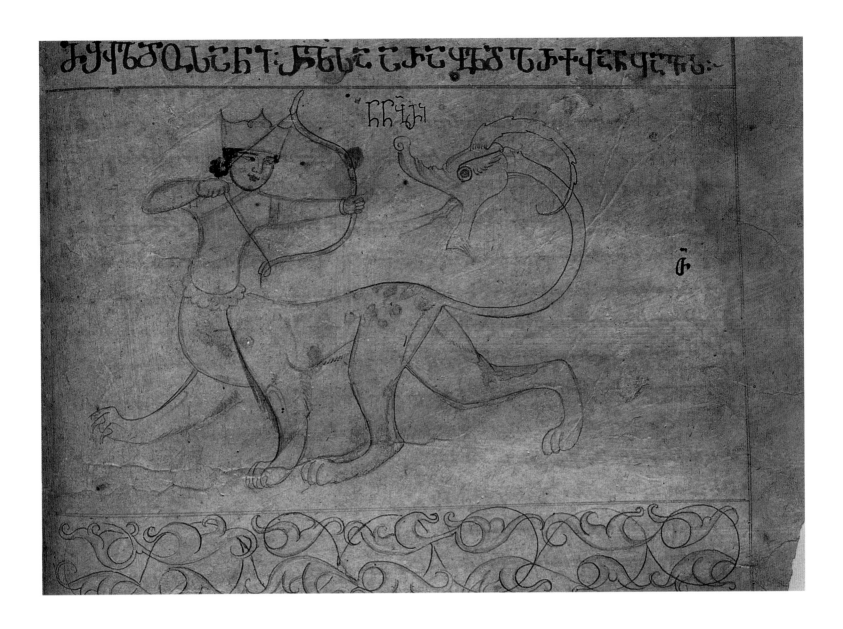

126 Astrological treatise [126]

1188–1210 AD
Ink, paint, gold leaf on paper with leather binding
213 folios
12¹¹⁄₁₆ x 10 x 2⁷⁄₈ in
IM A-65

Written in Nuskhuri script in one column, this illustrated treatise includes several pages (181r–192) rewritten by Isaya.

The illustrations include the title-page, where the phases of the moon are represented. The twelve signs of the Zodiac are attached to the text. Each image occupies half a page, separated from the text by an ornamental line and decorated with floral as well as animal motifs. The images have explanatory inscriptions in Arabic writing with Georgian transcriptions in Asomtavruli script, in red ink with brown contour highlights. The plasticity and linear quality of the forms are to be noted. These very delicate line drawings are among the finest works of Georgian draftsmanship, and show the influence of Persian art – in the broad faces and narrow eyes of human representations, for example. HM

127 Tskarostavi (Tao Klarjeti) Gospels [127]

1195 AD
Binding of gilded silver, silver, leather,
stones, ink on parchment
276 folios
9⅞ x 7½ x 3¹⁵⁄₁₆ in
IM Q907

This manuscript was executed, in
Nuskhuri script in two columns,
in southern Georgia by Ioane
Pukaralisdze and Giorgi Sanaisdze
at the behest of the bishop of Tbeti
(Tao Klarjeti), for a church in
Tskarostavi. It is decorated with
images of the Evangelists. Each of
them is depicted on the page before
his gospel. A multi-layered painting
technique on a gold background is
used.

The manuscript is housed in a
chased and gilded cover, made by
the goldsmith Beka Opizari. [Opizari
is one of the finest Georgian artists of
the 12th century, known from several
works including the miraculous icon
of Christ from Anchi (Tao Klarjeti)
now in the Georgian State Art
Museum. – AE] The Crucifixion is
represented on the front cover, the
Deesis (see IV.4) on the back cover.
Both are framed by wide lines of
stylized floral and vegetal motives,
which dominate the four corners of
the cover surfaces. The front cover is
also ornamented with inscriptions in
Asomtavruli script and with semi-
precious stones (four on the front
cover, placed as the end points of a
cross; two on the back cover, at top
and bottom). The flat chasing of the
inscriptions and the plasticity of the
ornamentation and the figures all
reflect a high professional level of
craftsmanship. HM

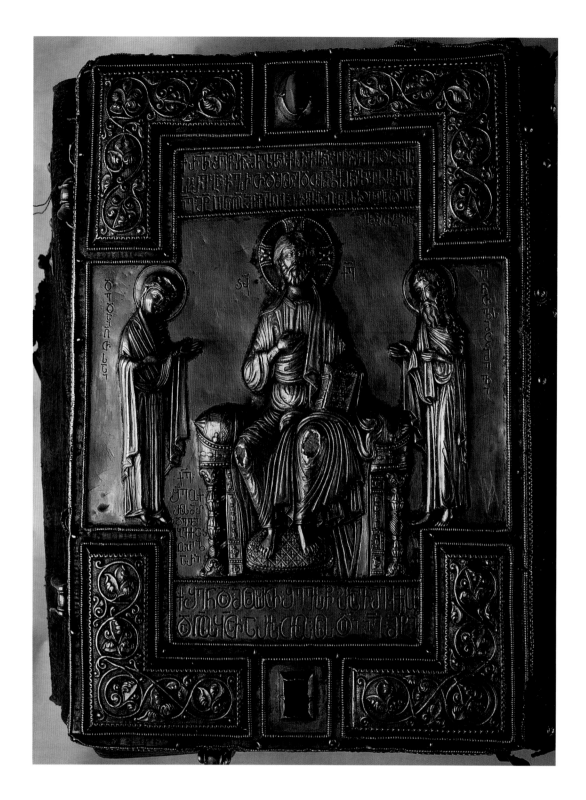

128 Coin of King Giorgi III [125] (above)
1174 AD
Copper
⅞ to 1 in (diameter)
GSM FH 1802

OBVERSE: King Giorgi III (r.1156–84) is seated cross-legged, facing the viewer. On his head is a crown with hanging tassels, surmounted by a cross. He is bearded and attired in a close-fitting tunic, loose trousers, and boots; his left hand rests on his thigh, and on his upraised right hand sits a falcon. To the right of his head the name 'Giorgi' is inscribed in Georgian Mkhedruli script. The date is given as 394 (=1174 AD in the Georgian *Kronikon*).
REVERSE: Three-lined inscription in Arabic letters: 'King of Kings/Giorgi, son of Demetri/Sword of the Messiah' and a border of dots.

Georgian coinage under Giorgi III was based on copper; silver coins went out of usage. The overall appearance and particularly the shape of coins sustained considerable changes; they were struck in varied weights, sizes, and shapes. MSh

129 Coin of Queen Tamar [128] (below)
1200 AD
Copper
1⅛ in (diameter)
Vejini (Gurjaani region, eastern Georgia)
GSM FH 1231

OBVERSE: In the center appears the royal emblem of the ruling Bagratid dynasty (which reigned from the 9th century to 1801). Around it run Georgian letters spelling out the names of Queen Tamar (1184–1212) and her second husband David Soslan. In the corners the date 420 (=1200 AD in the Georgian *Kronikon*) is spelled out.
REVERSE: Four-lined inscription in Arabic letters: 'The Queen of Queens/Glory of the World and Faith/Tamar Daughter of Giorgi/Champion of the Messiah.'

The name of Queen Tamar resonates with legendary splendor. The military might and cultural presence of the Georgian Kingdom during her reign was felt east into Iran and west into eastern Anatolia. Copper fractional currency provides the only physical evidence of the monetary series of her reign. MSh

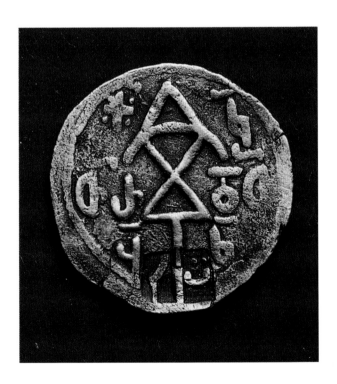

130 Irregular coin of King Giorgi Lasha [131]

1210 AD
Copper
2⅝ x ⅝ in
Kvemo Kartli (eastern Georgia)
GSM FH 25748

This coin is shaped like a shoe-print; each side bears two stamps, one in the 'sole' and one in the 'heel'.

OBVERSE: The 'sole' bears the inscription: 'GI DZE Tamarisi,' an abbreviation for 'Giorgi, son of Tamar.' Around the incised circle the inscription reads: 'In the name of God this copper piece was struck in [the year] 430' (=1210 in the Georgian *Kronikon*). The second stamp, in the 'heel', offers a four-line inscription in Arabic letters: 'King of Kings/Glory of the World and Faith/Giorgi Son of Tamar/Champion of the Messiah.' A border of linked dots adds the inscription: 'In the name of God, struck in [the year] 430' (=1210).

REVERSE: The same as the obverse, but without a mark.

It is interesting that this coin was struck before the death of Queen Tamar in 1213, but mentions only Giorgi Lasha (r.1213–23) as ruler. Giorgi Lasha struck only copper coins, of both regular and irregular types. MSh

131 Dirhem (Drahma) of Queen Rusudan [132]

1230 AD
Silver
1 in (diameter)
GSM FG 270

OBVERSE: Frontal bust of a bearded Christ, draped in a mantle and backed by a cruciform halo. His right hand is raised in a benedictory gesture. The Greek abbreviations for the words 'Jesus' and 'Christ' flank his right and left shoulders respectively. The inscription further reads, in Georgian, 'In the name of God, struck in [the year] 450' (=1230 in the Georgian *Kronikon*). The entirety is surrounded by a border of dots.

REVERSE: In the center Rusudan's name is abbreviated in Georgian letters: 'RSN'. A round linear border contains an ornamental pattern of stars and crescents. The inscription in Arabic letters around the periphery reads: 'Queen of Queens/Glory of the World and Faith/Rusudan, daughter of Tamar/Champion of Messiah.'

For a period of 150 years no silver coins were issued in Georgia, only copper ones. It was during the reign of Rusudan (r.1223–45) that silver coinage again appeared, with her monetary reforms of

1230. Silver coins also began to be struck again at the same time in neighboring Near Eastern countries. MSh

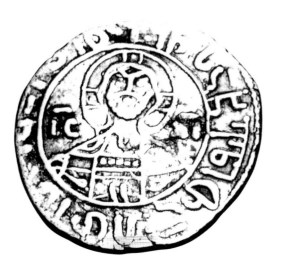

132 Psalter [130]

13th century AD (miniatures),
15th century AD (text)
Ink, paint, gold leaf on paper with
leather binding
144 folios
10⅛ x 8½ x 2⅝ in
IM H-75

The text is written in Nuskhuri script
in one column. The cover has recently
been restored, using the leather of an
old cover.

The 55 13th-century miniatures
appear to have been cut out of a
contemporary manuscript. They are
followed by the written text to which
they were added as illustrations in the
15th century by Germanoz, the head
of a church.

Some miniatures occupy the whole
page, others are included within the
body of the text. The manner of
painting is pictorial. Red serves as the
background color. A multi-layered
painting technique is used. The
miniatures illustrate the Old Testament
text with scenes from the history of the
Israelites, as well as scenes from the life
of Jesus Christ. HM

133 Psalter [129]

13th century AD (miniatures),
15th century AD (text)
Ink, paint, gold leaf on paper with
leather binding
236 folios
10½ x 8½ x 2⅞ in
IM H-1665

Written in Nuskhuri script in one
column, the text was placed in an old
leather cover. In the 15th century,
when the text was ordered by Prince
Zilikhania, the miniatures from an
earlier manuscript were attached to
the end of the new text.

The manuscript is thus illustrated
with 132 miniatures, each occupying
an entire page, on the front and on
the back. The Israelite King David is
depicted on the title-page. The other
illustrations offer various biblical
scenes from both the Old and New
Testaments, including portraits of the
Prophets and battle scenes from the
Old Testament.

Each composition is framed by a
narrow, colored line or an arch over
two columns. Thick brown, dark
green, light green and dark red
pigment are used, but bright red is
particularly conspicuous, often
serving as a background color.
Explanatory inscriptions outline
the frames of the miniatures. HM

[There is some debate about the
date of the miniatures, which certain
scholars have dated to the same
period as the text. – ed.]

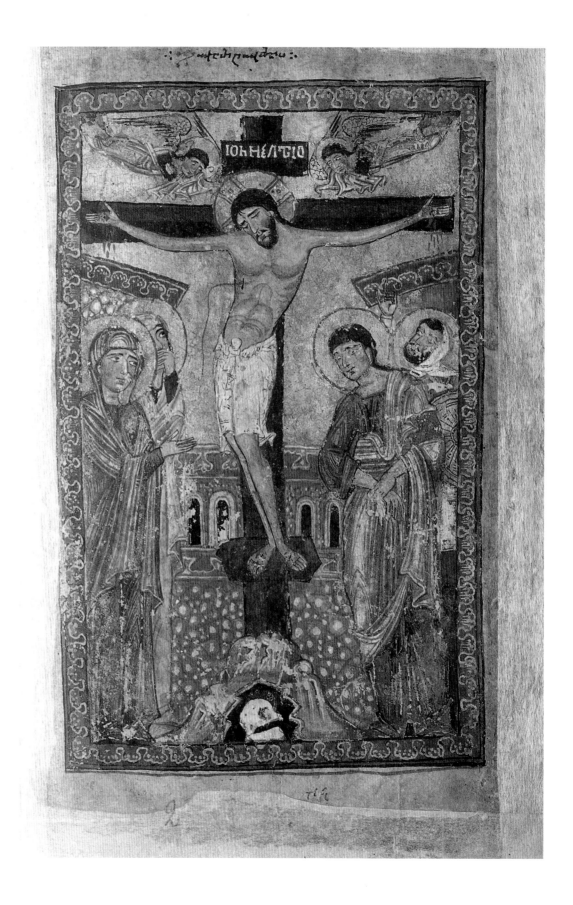

134 Pocket-size psalter [135]
1495 AD
Ink, paint on parchment, green vellum binding
168 folios
4⅛ x 3½ x 1¼ in
IM A-351

Written in Nuskhuri script in one column, this manuscript has been placed in a wooden cover layered with ornamented and imprinted green paper. The fastening is made of silver.

The text was written by Ambrosi (signed on f.165r). A certain Mzechabuki is referred to as the owner. The image of the Israelite King David is depicted on the title page (f.2v); he is seated on a throne and playing the lyre. There are architectural structures on both sides of the throne; throne and buildings are drawn in perspective. David is shown looking up toward the benedictory right hand of God at the top middle part of the image. The paint has been applied in thick multiple layers. David wears a blue cloak and bright red is used for the curtain, the cushion and David's shoes. The background is gold leaf. At the beginning of the text itself is a decorative illumination (f.3v) with floral ornamentation in blue paints on a gold background. HM

135 Stole [133] (left)

1358 AD
Silk, twisted gold and silver on silk threads
157½ x 9⅞ in
Ancha, Tao-Klarjeti
GSAM 1362

An enthroned Christ, flanked by the Virgin and John, gestures benedictorially with his right hand, displaying the book of the Gospels with his left. Stylized lilies grow at his feet. At right angles to this scene is a series of arches under each of which a different apostle, saint or ecclesiastic is portrayed. Each figure has its own identifying Georgian inscription.

On the lower part of the omophorion stole is an original inscription which refers to 'dedopalt-dedopali' ('queen of queens') Natela. She was the daughter of Kvarkvarc I Atabagi; in 1358 she married the king of Imereti, Bagrat I, at which time she crafted this magnificently embroidered work. The second inscription, in the central part of the omophorion, notes that the garment was saved from the Tatars by Tsaishi Bishop David Solia and was restored in 1653 by his sister, Tamar Jolia Tsaishi, who reworked some of the figures and decorated it with pearls. Unfortunately, no pearls remain today. OZS

136 Icon of the Savior [140]

c.1525–50 AD
Gold, tempera on wood, garnets, rubies, turquoise, amethyst, pearls, bone, mastic, resin
23 x 16¾ x 1⅛ in
Akhali Shuamta
GSAM K-178

This icon is a half-length figure of Christ as Pantocrator, with his right hand raised in benediction against his chest and a closed text of the Gospels in his left hand, executed in medium relief.

The face of the image is executed in reddish-brown tempera. A relief halo and the background of the icon are ornamented with a low-relief, carpet-like floral pattern, familiar as an influence from Safavid Persian decoration. The same pattern continues onto the frame, where it is developed into higher relief. Pearls, turquoise, and amethyst are set into the halo and background. The Gospel in the Savior's hand is also decorated in low relief. There is carpet-like decoration in the corner medallions and on the edge of the relief on the Gospel.

On the reverse of the icon a donor inscription in Asomtavruli script informs us that Levan, king of Kakheti (1520–74), and his wife, Queen Tinatin (1532–48), commissioned the work. HK

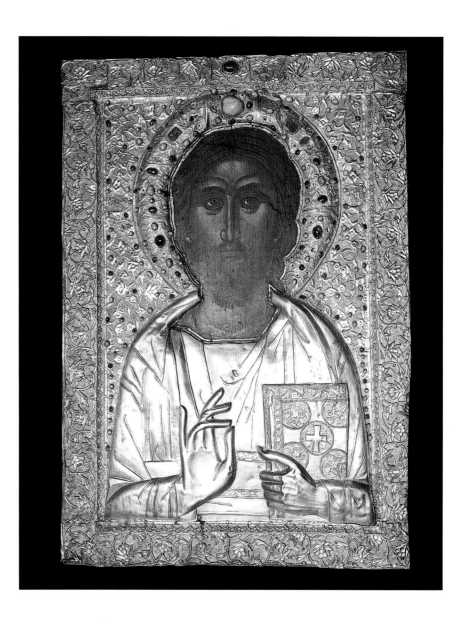

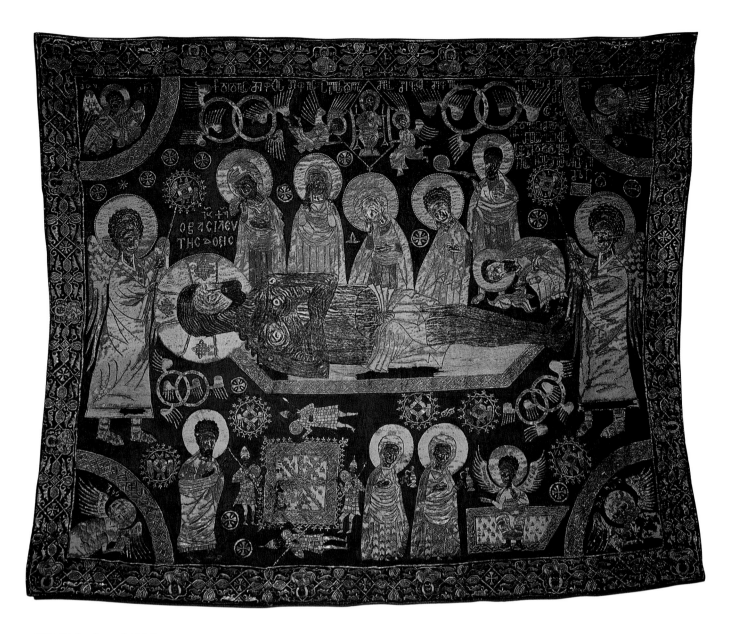

137 Holy shroud [134]

1446–66 AD

Twisted silver and gold on silk threads, silk

73 x 62 in

GSAM 1354

On a blue background the central composition is encircled with an ornamental frame containing pictures of saints. At the center of the shroud the dead Jesus is depicted. Behind the body is a group of weeping women: the Mother of God holds a handkerchief to her cheek; Mary Magdalene pulls at her hair; and a third woman repeats the gesture of the Mother of God. John lays his head on his hands. Behind him is an old man with a stick, on top of which is a sponge; in the other hand he holds a vessel of vinegar. [This is presumably St Joseph of Arimathea or Nicodemus, displaying the instruments of Christ's martyrdom. – ed.] At the head and feet of Jesus are archangels with liturgical fans in their hands. All the figures are haloed.

Beneath the main composition, on the right and near the tomb, a curly-headed Peter is surrounded by guards. Nearby are two women with vessels of perfume and ointment; an angel sits on the tombstone. Over the composition in a rhombus-shaped mandorla is the Ascension of Christ, flanked by two angels. Over the whole background are circles, cherubs, seraphim, and small crosses. At each corner is a symbolic representation of an Evangelist. Near the head of Christ is an explanatory donor inscription which refers to Giorgi VIII, son of King Alexander I. MK

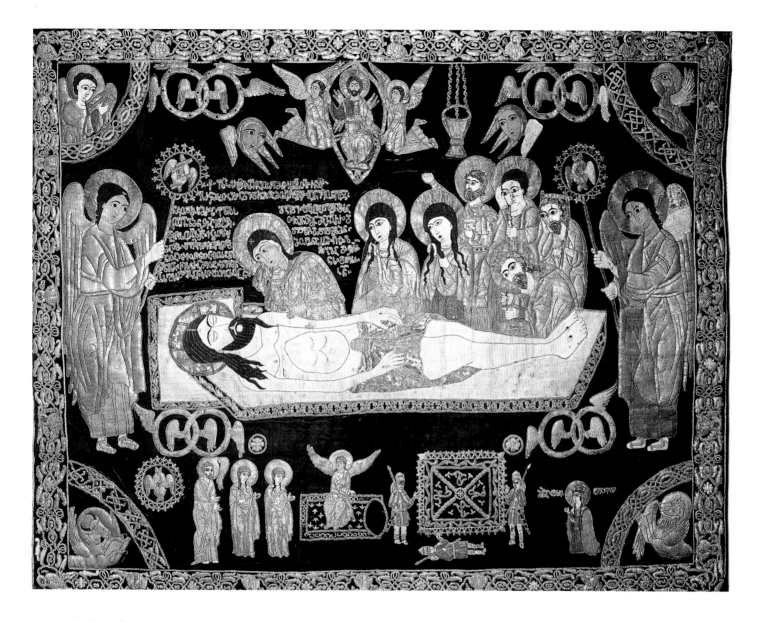

138 Holy Shroud [147]

1632–82 AD
Silk, twisted gold and silk on silk threads, silver threads on velvet
43¾ x 54¼ in
Mtskheta (Kartli), Svetitskhoveli Patriarchal Cathedral
GSAM 1357

In the center of a dark green velvet background, Christ lies on a funerary bier, the Mother of God peering down at him, handkerchief to cheek, with two archangels – one at his head and one at his feet – leaning forward with seraphim-decorated rhipids (fans). A crowd of other mourners, including St John the Evangelist, Martha, Mary Magdalene, Nicodemus, and St Joseph of Arimathea lean in toward the outstretched figure.

Around this central scene circle other figures and motifs. The Ascension is shown above, with a hanging lamp (symbol of God's eternal presence) nearby, together with winged representations of the sun and the moon and seraphim in double roundels. Below are depicted three witnesses of the empty tomb from which the Lord ascended: an angel seated on and gesturing at the tomb, sleeping Roman guards, and another pair of double-roundel-framed seraphim. At the lower right the donor, Queen Mariam, wife of King Rostom (1632–59), is identified by the inscriptions flanking her head and encircling the figure of the Virgin. The borders are embroidered with complex ornamentation featuring the half-figures of saints, and in the four corners the symbols of the four Evangelists: the angel of Matthew, the ox/bull of Luke, the lion of Mark, and the eagle of John. MK

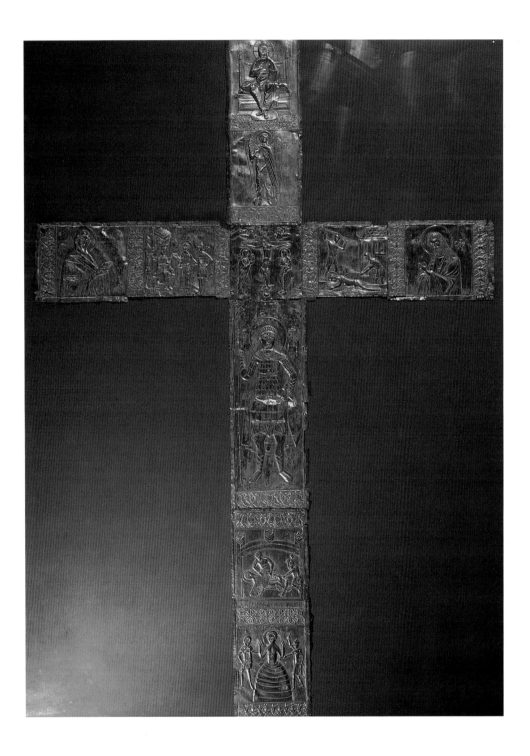

139 Processional cross [139]
16th century AD
Silver, gilded silver
63 x 42½ in
KSM 3248

This large processional cross, dedicated to St George, is made from three large and four small sheets of silver, the largest being 18½ x 7⅛ in. On the cross are depicted an enthroned Christ and directly below him the figure of the Archangel Michael and other figures and small scenes. The Virgin and John the Baptist occupy the outer corners of the arms of the cross, with the Crucifixion at the intersection of its horizontal and vertical axes; St George (depicted at twice the size of the others) is shown just below that point, and again before the Roman emperor Diocletian (echoing the idea of Christ before Pontius Pilate) and in scenes of his torture at the emperor's behest, the most famous of these, the wracking on the wheel, being depicted at the base of the cross. NK

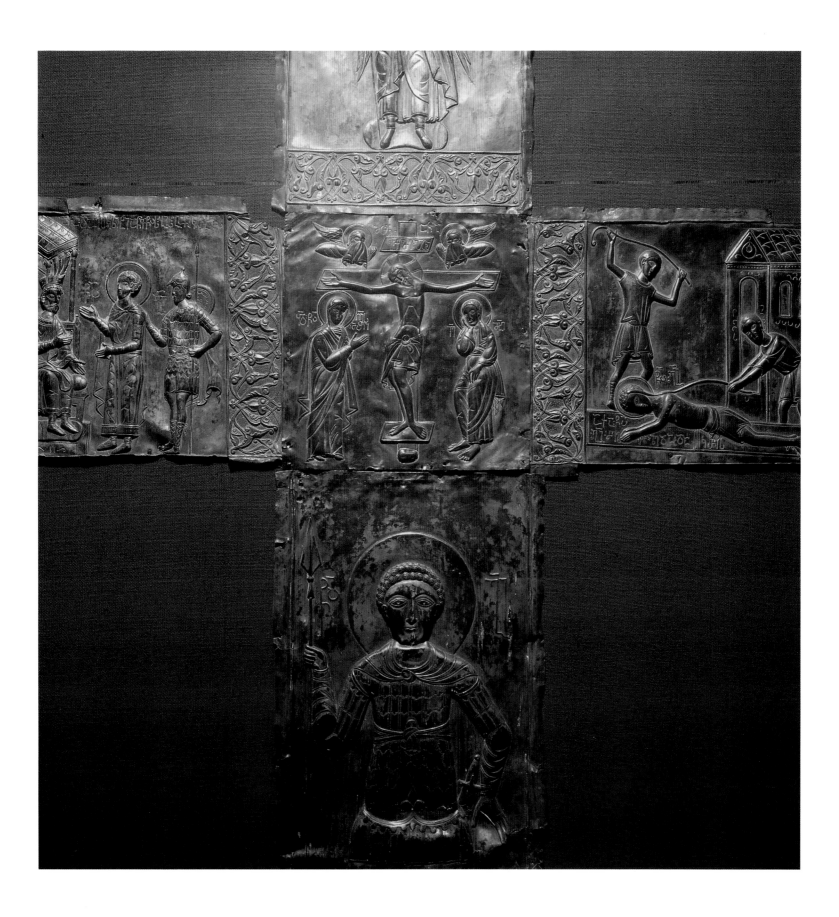

140 **Triptych** [136]

16th century AD
Gilded silver, silver, turquoise, amethyst, greenstone, wood
23¾ x 27½ x 2 in
Alaverdi (Kakheti)
GSAM K-179

A standing Mother of God occupies the center, in accentuated and emphatically-sized relief. The enthroned Savior and two angels turned and bending towards him are represented on the tympanum. On the upper register of the inner faces of the side wings is an Annunciation, with the twelve Apostles depicted in two double rows below, all facing toward the center.

The triptych is a major example of 16th-century Georgian chasing. In producing volumetric figures, the master who made it continued the earlier traditions of Georgian repoussé. At the same time, the carpet-like floral decoration that completely overruns the background, and the use of precious stones of varied colors, reflect the influence of Safavid Persian art.

Along the bottom of the central panel is an inscription in Asomtavruli which states that a leader in the royal court, the Prior Phillip, donated this triptych to the Church of the Holy Virgin, built by Phillip himself, in the village of Kvareltbolo (Kakheti). According to the inscription on the back of the icon, the triptych was presented by the king of Imereti, Alexander III (r.1639–59), to Alexander Mikhaylovich in Moscow. In 1685 the bishop of Samtavne, Nicholas Amilakhvari, was able to reclaim it for Georgia and placed it in Samtavisi (Kartli, or eastern Georgia). HK

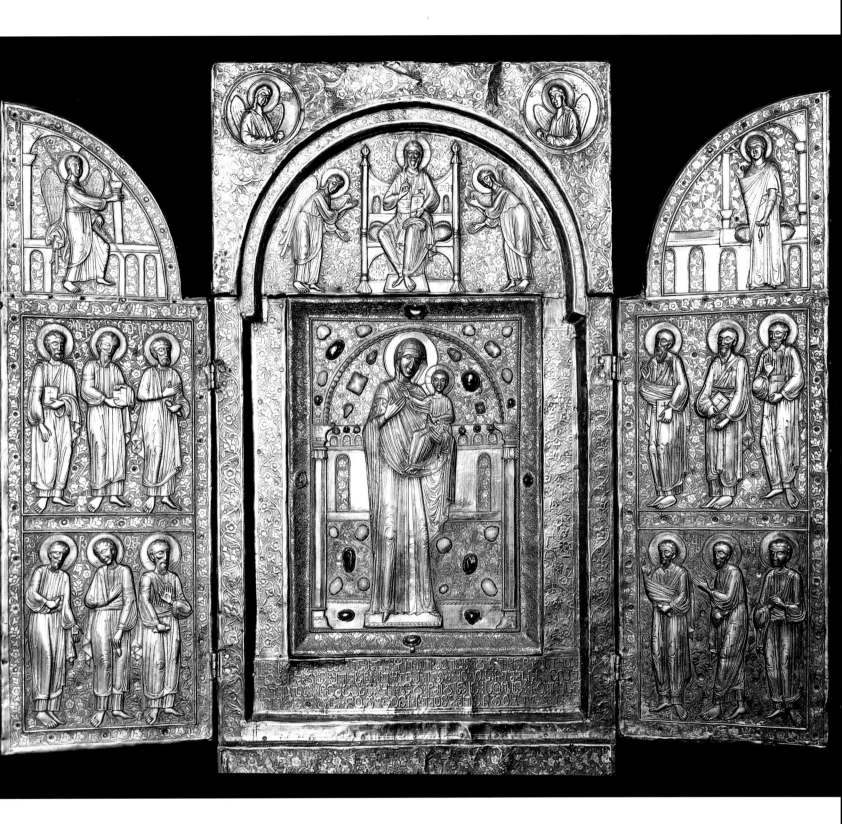

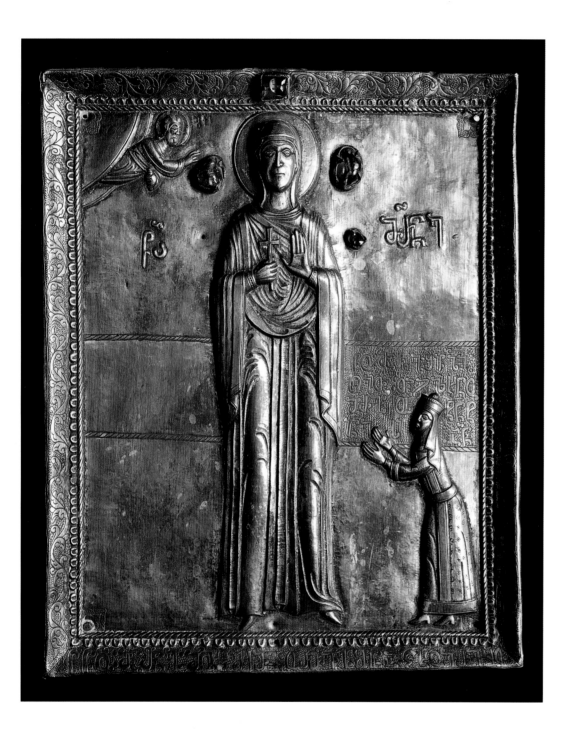

141 **Icon of St Marina** [137]

16th century AD
Gilded silver, rubies, amethyst, wood
8½ x 6⅞ x 1⅛ in
Imereti
GSAM I-190

The full-length, frontal figure of St Marina dominates this small icon. She holds both hands up at breast level; in her right hand she holds a cross and raises her left hand, palm outward, in a gesture of prayer and receiving the Holy Spirit. A repoussé inscription at shoulder level, in Asomtavruli script, identifies her.

The figure of Christ, his right hand upraised in a gesture of benediction, appears to the upper left, from the sky above the saint. The small figure of a donor rising from the lower right at ground level counterbalances the figure of the Saviour; she is attired in the garments of a queen. In a band filling the background at the level of her head, the donors' inscription in Asomtravuli informs us that Constantine (d.1587), fourth son of Bagrat III, king of Imereti (1510–65), and Constantine's wife Helen (d.1605), commissioned the icon. It is Helen who is depicted with her hands raised in supplication.

The icon continues earlier traditions of Georgian metalwork. HK

142 Icon of St Nicholas [138]

16th century AD
Gold, silver, pearls, rubies, turquoise,
wood, bone, mastic, unidentified resin
11⅜ x 7⅞ x 1¼ in
Alaverdi (Kakheti)
GSAM K-217

St Nicholas, identified by an inscription
on the upper bevel of the icon frame,
and attired in his bishop's garb, sits on
a throne, his right hand held up in a
gesture of benediction. In his left hand
he holds up the book of the Gospels.
A relief image of the bishop is executed
according to the traditions of the
Middle Ages [albeit with a somewhat
diminished interest in detail compared
with earlier works – ed.].

The rich, low-relief, semi-abstract
floral carpet decoration which overruns
the background and the frame, as well as
the abundant use of contrasting stones,
on the other hand, reflect the influence
of Safavid Persian artistic traditions.
On the back of the icon the donor
inscription informs us that Alexander II,
king of Kakheti (r.1574–1604), and his
wife Queen Tinatin donated this icon to
the church of St Nicholas in the Toga
fortress. Later it was transferred to the
cathedral of Alaverdi. HK

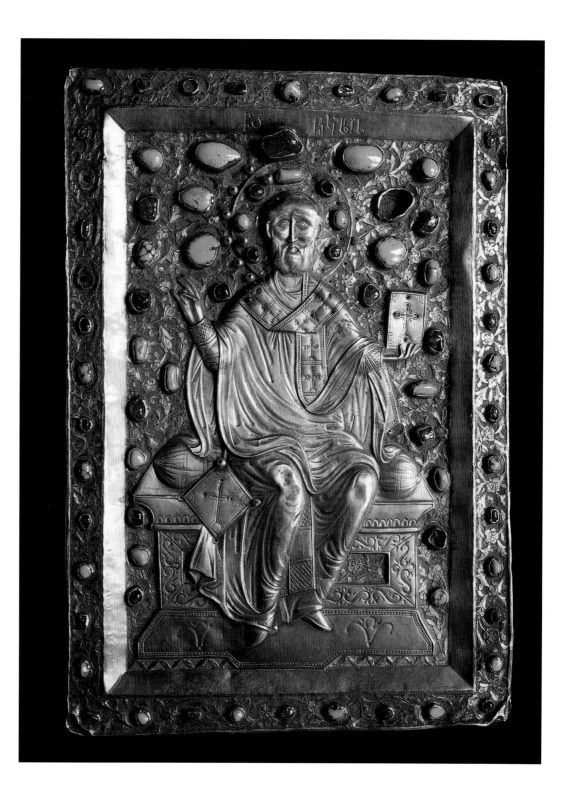

143 Two donor plaques [148]

1640 AD
Gilded silver
13¼ x 8⅞ in
Kortsekheli (Samegrelo), goldsmithery workshop
of Levan Dadiani
GSAM O211 (A,B)

Levan II Dadiani (1611–58) and his wife Nestan-Darejan
(d.1640), who ruled Samegrelo, one of the historical
principalities of Georgia, are depicted on a double plaque as
supplicants. Originally, the plaques made up part of a large
icon which used to be in the church of the village of Kortskheli.
The donor figures were placed on the lower part of the icon, to
either side of a lengthy inscription, each figure being identified
by a label in Asomtavruli script. Below the band, the entire
background is overrun with a carpet-like vegetal and floral
design. Both the ground ornamentation and the headgear and
clothing of the two figures reflect a Safavid Persian influence.
The work gives us a sense of the general stylistic characteristics
of objects being produced in the goldsmithery workshop of
Levan II Dadiani. HK

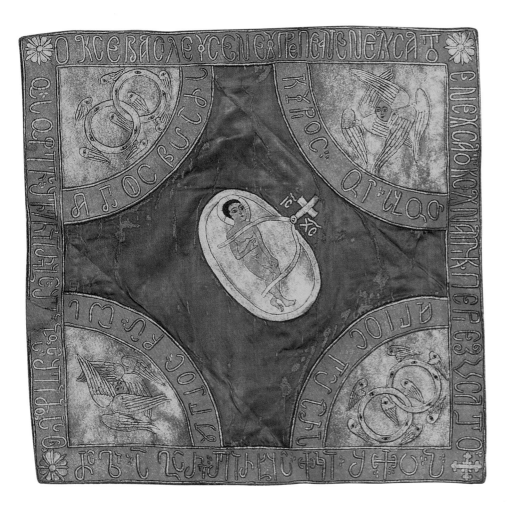

144 Purificator for chalice [151] (left)

1667 AD
Silk, satin, gold and silver on silk threads
23 x 22½ in
Nikortsminda (Racha, western Georgia)
GSAM 3846

In the center of a blue satin field, an embroidered Christ Child (identified by Georgian and Greek inscriptions) is laid out as a sacrificial offering – the Agnus Dei – on a plate that would call to the viewer's mind the plate with the bread of the Eucharist. His right hand is raised in benediction. In the corners to either side of the Christ Child Seraphim are set off, by frames with Georgian and Greek inscriptions, as faces embedded among six wings. [In the other two corners Ophanim (wheels of eyes) are intertwined with their wings – ed.] The entire cloth is framed with a light-brown-colored bullion border covered with identical inscriptions in Georgian and Greek.

The figures and inscriptions are worked in gold wire, and the central and corner backgrounds are worked in silver. The body of the Christ Child is in pink bullion. His hair, eyes, eye-brows, and lips are worked in colored silks. GB

146 Chalice cover [144] (right)

Late 17th century AD
15 in square
Silk, twisted gold and silver on silk,
gold and silver thread, gold, turquoise,
rubies, pearls, sequins
GSAM 60

In the center of a cruciform wine-red sequin-studded silk field, the Christ Child is depicted rising from a golden chalice, his hands raised in benediction and his golden halo highlighted with turquoise and rubies and ringed with pearls. The Georgian inscription flanking his halo identifies him, in abbreviated form, as Jesus Christ, and that flanking the chalice identifies the Nun Irina, no doubt as the creator of this magnificent work. In each of the four arms of the cloth is a seraph; four times the inscription repeats: 'Holy, holy, holy, holy' [as the seraphim are described as intoning (three times) in Isaiah 6 – ed.]. The entire work is edged with a gold and silver floral frame. GB

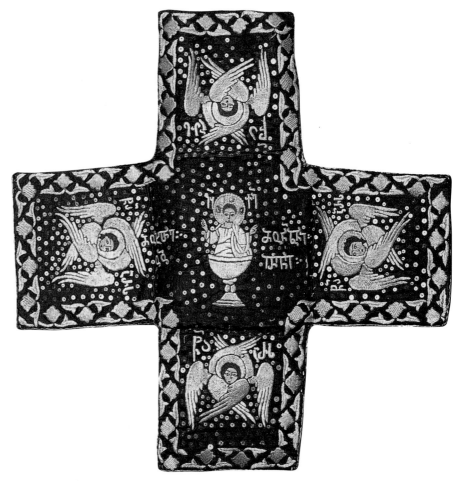

145 Chalice cloth [152] (right)

1667 AD

Satin, gold and silver wire on silk thread

22 x 22¼ in

Nikortsminda (Racha, western Georgia)

GSAM 3844

This flamboyant cloth embroiders the image of the Christ Child rising from the Eucharistic cup [which also offers a visual pun in symbolizing the bitter cup of his martyrdom, accepted in the Garden of Gethsemane – ed.], his hands raised in benediction, in the center of a light-brown silk field. In each of the four corners the full-length figures of angels, bearing long crosses, are placed against identifying Georgian inscriptions. The embroidered frame, in blue bullion with rosettes in the corners, offers a double inscription in Georgian and Greek. GB

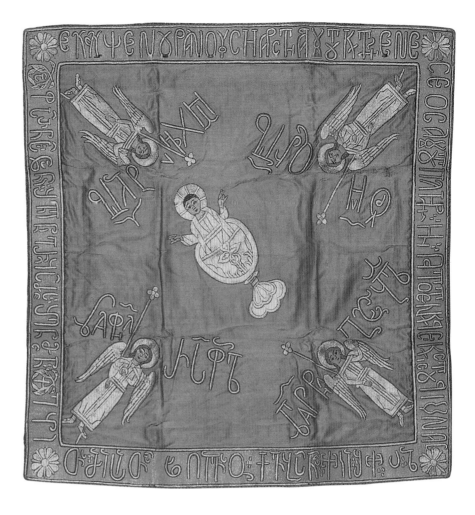

147 Chalice cloth [153] (left)

1678–80 AD

Satin, twisted gold and silver on silk threads, colored silk thread

18⅜ in square

Svetitskhoveli, Mtskheta (eastern Georgia)

GSAM 3690

The half-length image of the Savior as a child is placed in a round medallion in the center of the cruciform cloth. Both of his hands are raised in benediction. The rays emanating from the medallion – hence the title 'I am the Light', inscribed in Georgian along the edge-frame – become pointed arches in each of which a medallion is placed. In each medallion a half-figure angel is depicted, with a sphere (the *orbis mundi*) and a sword (the sword of Judgment) in his hands. The inscription connects the subject to the donor, Levan Batonishvili, king of Kartli (eastern Georgia), and his wife Tuta. (See also 149.) GB

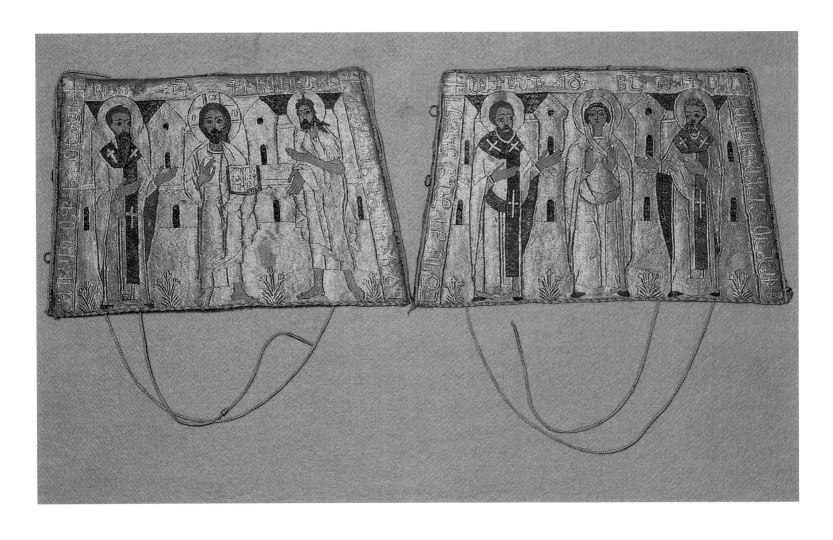

148 Pair of armlets [149]

1648 AD
Silk, linen, twisted gold and silver on silk thread
11¼ x 7 in
Kartli (eastern Georgia)
GSAM 3794 (A, B)

On both armlets or 'liturgical cuffs' saints are represented at full length on
architectural backgrounds. On the left-hand armlet Christ is represented
in the center, dressed in a silver and gold vestment. He is flanked by St John
and St Nicholas who gesture in supplication. Each figure is depicted at three-
quarter length, dressed in a silver phelonion and brown omophorion. The
Virgin is represented in the *orans* position. Faces and hands are worked in
pink bullion with hair and beards in brown silk thread.

Jesus Christ is also represented at the center of the right-hand armlet.
He makes a benedictory gesture with his right hand, and in his left he holds
a gospel. He is dressed in a pink vestment. On his left, St Basil is dressed in
a phelonion and omophorion, and gestures as a suppliant, turned toward
Christ. On the right, St John the Baptist, dressed in a short silver vestment
which resembles a camel's skin, appears on the border. IM

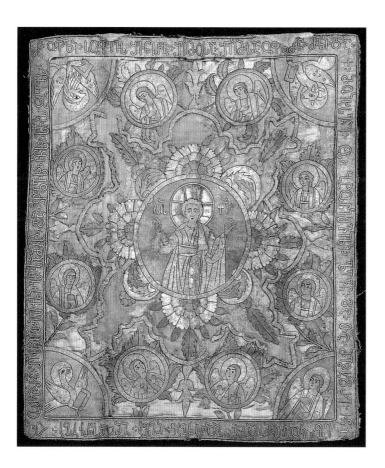

149 Cloth for Communion tray [154] (left)
1678–80 AD
Satin, twisted gold and silver thread, colored silk thread
21⅞ x 28⅜ in
Svetitskhoveli, Mtskheta (eastern Georgia)
GSAM 3769

In the center of a beige-colored satin field is a round mandorla/medallion which contains a two-thirds-embroidered figure of the Christ Child, with his hands raised in benediction. Stylized rays, in the form of flowers and leaves, emanate from the medallion and yield ultimately to eight smaller medallions bearing the half-length images of angels. Part of the pattern surrounding the central mandorla assumes the shape of a diagonally placed quadrifoil cross, its arrow-like, stylized rays directed to the corners of the cloth with symbols of the four Evangelists. An inscription on the encompassing frame refers to Levan Batonishvili, king of Kartli (eastern Georgia), and his wife Tuta. See also 147 which together with this piece forms a set. GB

150 Eucharist cloth [150] (right)
1667 AD
Satin, gold and silver wire, colored silk
24½ x 17 in
Nikortsminda (Racha, western Georgia)
GSAM 3845

Centered within a field of olive-green silk, a figure in a round mandorla contains the image of Christ, gesturing in benediction with both hands. He is depicted as an angel, identified by his wings and the fact that he is beardless, as well as by the inscription in Georgian above the mandorla. The fact that this 'Angel of Great Intentions' is actually Christ is suggested by the placement of two flanking archangels with sacramental fans (ripids) held over the mandorla. The archangels are identified by their inscriptions as Michael and Gabriel, just as the four figures in the corners, the symbols of the four Evangelists, are also identified by their inscribed names. This most unusual cloth is framed by an inscription with identical phrases in Greek and Georgian. GB

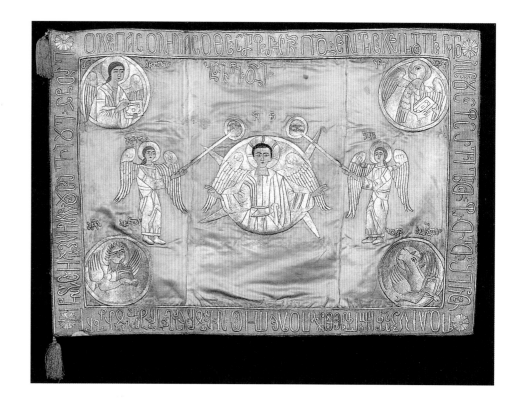

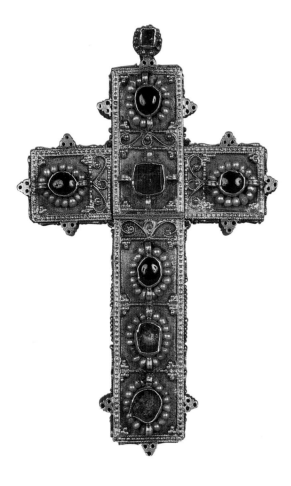

152 Mitre [142]

17th century AD
Gold and silver twisted thread, pearls, gold,
silver, rubies, emeralds, turquoise
7¾ x 6⅝ in
Gelati Monastery, Imereti (western Georgia)
GSAM 3839

Originally made at and for the church at the Gelati
Monastery near Kutaisi in western Georgia, this mitre
comprises two parts: a cylindrical, flat-topped hat of
couchwork in gold threads, and a lower portion in
couchwork in silver threads rising on both sides to a pair
of points. Both components are richly decorated with
precious stones (pearls, rubies, emeralds, and turquoise).
Along the top of the mitre are small winged embroidered
circles representing cherubim. Various embroidered scenes
appear along the upper register, outlined in pearls, such as
'The Last Supper,' 'The Virgin and Child,' 'Washing the
Lord's Feet,' 'The Eucharist,' and portraits of the Four
Evangelists, as well as of John the Baptist, Basil the Great,
and St John Chrysostom. An inscription explains who the
donors were.

 This mitre has had an interesting odyssey. In 1921, after
the struggle for independence, the Georgian Mensheviks
left Georgia and took with them thirty-nine cases packed
with many artifacts from different museums. They took
these treasures to Marseille and placed them in the vault
of the Marseille Bank, from which they were subsequently
moved to the vault of the Paris Bank. In 1935 the keeper
of the Museum Treasury in Tbilisi, Ekvtime Takaishvili,
appealed to the French government to restore these
treasures to Georgia. Ten years later, at the end of World
War II, the artifacts were finally returned. The manuscripts
were restored to the Kekelidze National Institute of
Manuscripts; the archaeological collection was returned to
the State Museum, and the medieval metalwork and
textiles, including this mitre, were passed back to the State
Art Museum. MK

151 Pectoral cross [141]

17th century AD
Gilded silver with pearls and precious stones
3⅝ x 2½ x ⅝ in
KSM 3310

Eleven colored stones and pearls, framed in separate
sections, of which four stones are missing, decorate
this cross. The seven sections are surmounted by an
eighth stone symbolizing the Resurrection (it was
on the eighth day after his entry into Jerusalem that
Christ rose from the grave). This pectoral cross was
moved from the Kutaisi Catholic Church to the
Kutaisi Museum in 1939. NK

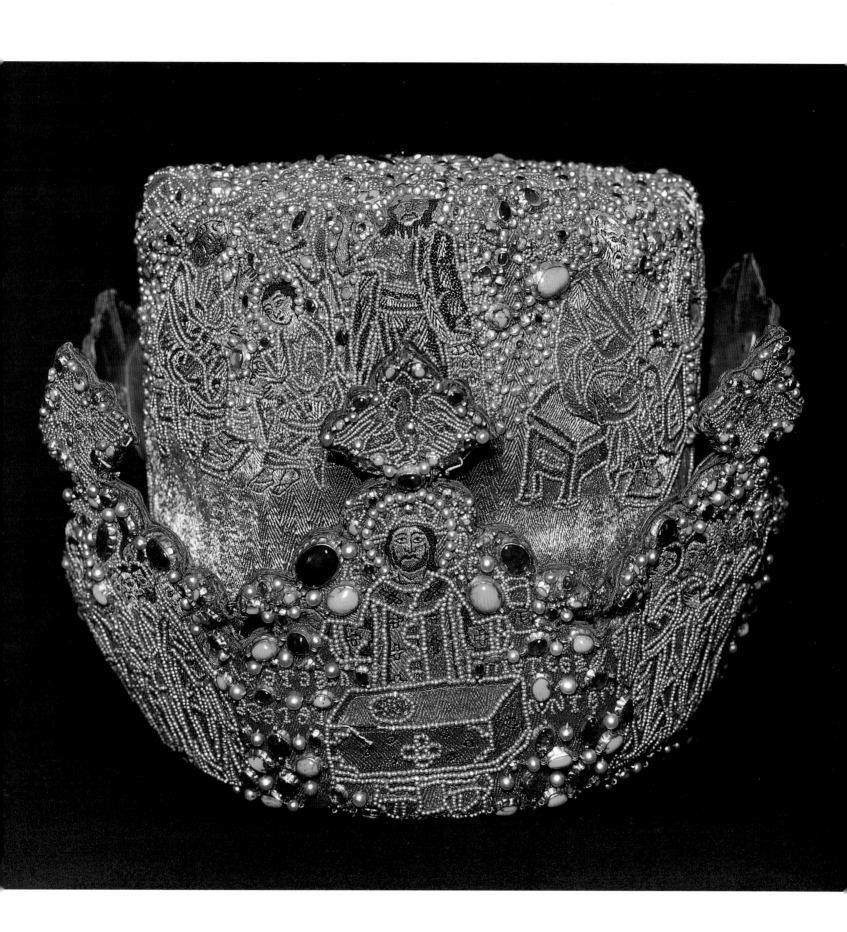

153 Ecclesiastical belt [143]

17th century AD
Silver wire, string, silk and canvas cloth, twisted gold
and silver threads, glass beads, pearls
35½ x 3⅜ in
Svetitskhoveli Mtskheta
GSAM 3730

On a golden background, embroidered in silver gilt wire, are
eleven medallions outlined with brown silk. Apostles, kings,
judges and archbishops are represented in the medallions, each
identified in Georgian. The faces are worked in flesh-colored
bullion, the beards and moustaches in brown silk, the outlines
of haloes and garments in green bullion, partially highlighted
by pearls. At each end of the belt is a large circle with a stylized
six-petaled flower, couchworked with silver thread. In the spaces
between the blossoms are small blue and yellow trefoils, worked
in bullion; among the medallions are stylized green leaves
attached to a continuous double brown vine, running in a
sinuous parallel to the silver-thread couchworked upper and
lower edging of the belt.

The belt is held closed by a gilded and incised-decorated
buckle, in the center of which is a lion, symbol of the Evangelist
Mark. Four seraphim, a representation of the Virgin, and floral
ornamentation frame the buckle. NN

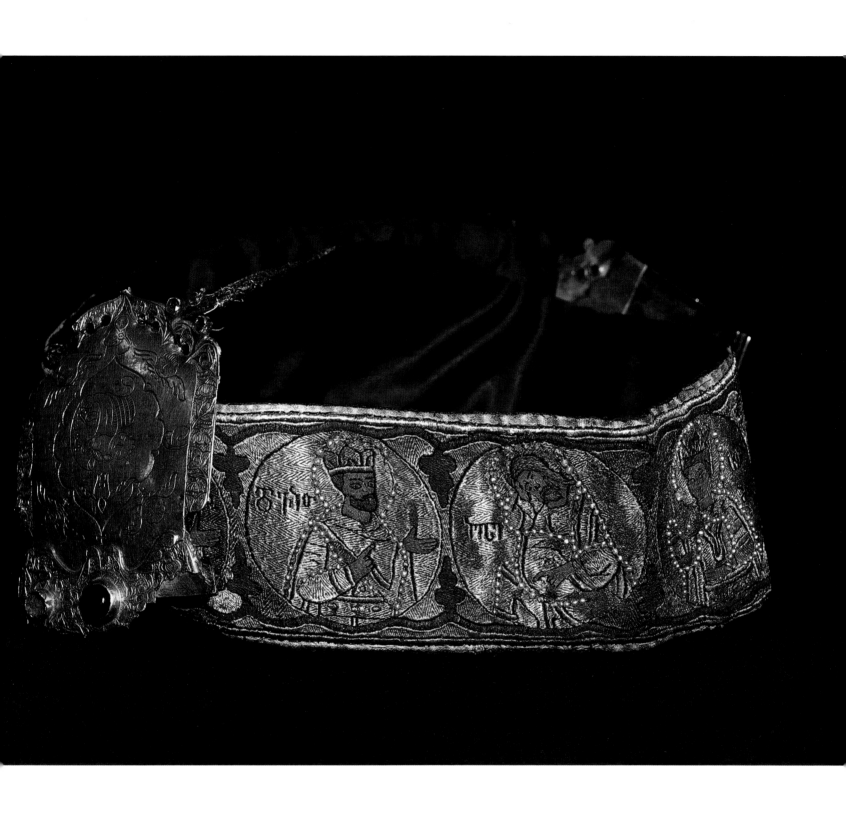

154 *The Knight in the Panther's Skin* [145]
1680 AD
Paper leaves with gilt inlays, ink, gold paint on paper and leather binding
262 folios
$17^{15}/_{16}$ x $13^{1}/_{4}$ x 2 in
IM H-54

This manuscript was written in Mkhedruli script in one column. The cover is newly restored, using the leather of an old cover.

The manuscript was written out by Begtabegi, secretary of King Giorgi XI, and is a wonderful example of the calligraphic art. The colophon states that no king had ever decorated a manuscript so well and that the king who ordered it paid a good deal of money for it. The text is placed inside a wide decorative border filled with stylized floral ornamentation, interspersed with images of birds and animals. The illumination is executed using *Okromelani* – gold ink, sometimes comparatively thinly applied, which creates an impression of great lightness. The ornamental design is different on each page. The difference between this manuscript and other manuscripts framed by decorative borders is that here both parts are integral to each other; the text and border illuminations were created together on each page – as opposed to the borders being created separately and the text subsequently inserted within them. HM

პატრონ წინა ჭირთა და მრავალთავდა მქონ ნდა სსვ

ენაპირ ბდი თქვნ იყვს მიეონტდელი რქდოს სჭ

ხოლ ედ ვგდა და ვდავდა ბამი დდენი მოონსოთ

ზსჩათა ემჩუდა ენიდორ ბდი ქრთა თქვ რქთა ჭე

დარიდოს ათელი სსსხოლსა ცრელთათ დასმგბ

თქ ნსჯსჯვ ოლორსსა ესევნ სსჯუშიოენი მდ ჭე

ოჯსო ე ძძანი როდ ძძმ ბჭნ ანჯ როდ დანი მდჯდ

ე აჯჭყ გჯსჯფნტ ლოესა ძსი ოდიდტნ ცჯსზლონი მდჯდ

ასა ძზდ რატტდნ მჯიხჯ ცდჯლი ცჯცსლი მიბ

რქთა ჭჯრთა მიქრთელტიად მსხი მჯრდელი მიბ

მოჯდით მჯუულტსს ცჯცსლი ცდჯლი მჭდდლ ჭელირ ჯს

ჯ დჭჭდ ამცdდროდ ათ მჯფჯცდჯრჭჯ ჭჯრსნ ასრჯჯდ

ომისს ჯცჯთა სსჯცჯსდოლო სჯჭ ნჯდ ო დჯს ედფჭდ

რჭფ სჯცდილი ოსხანდ ძჯჯცჯს ძჯრჭჭმჭდსა რდ ბჯლოდ

ძრთი ძჭჯლჯს წძმსსტდdდ ჯრნი ცჯდდტდ ამდოლდ

ძდით ჭითთი მჭცbტრთჯბи სჭჯლრ ბიი სრჯ ძჭოსსოდ

155 *The Knight in the Panther's Skin* [155]
17th–18th century AD
Ink, paint, gold leaf on paper with gold-tooled leather binding
289 folios
13⁹⁄₁₆ x 10¼ x 2¹⁵⁄₁₆ in
IM S-5006

This manuscript was written in Mkhedruli script in one column. The cover was restored using the leather of an old cover.

The manuscript, which belonged to Tsereteli [the patriotic poet, Akaki Tsereteli (1840–1915), one of the 'fathers' of modern Georgian literature and of modern Georgian nationalism – ed.], contains 87 miniatures. Each occupies an entire page. Two different groups can be discerned. Those belonging to the first are painted under the influence of Safavid Persian art, and exhibit a highly professional level of skill. The Persian influence is recognizable in the manner of execution, choice of colors, handling of the figures, and their compositional distribution. A delicate but distinct line outlines the figures and separates the colors, which are strong in contrasts and dynamic in abstract pattern. The colors have been applied thickly. The decorative impression is intensified by the lavish use of gold leaf throughout the image to treat various parts of clothing and objects. The second group of miniatures, while exhibiting the influence of Persian art, also clearly exhibits local features. In one example Avtandil writes a letter from left to right rather than right to left as a purely Persian form would have shown. HM

156 Eucharist serviette [146]

1680–1723 AD
12⅝ x 12 in
Linen, satin, twisted silver and gold, silk threads,
pearls, rubies, turquoise
GSAM 3677

On a dark violet background, Christ sits on his heavenly throne flanked by two smaller figures, each gesturing in supplication. Above the Savior's head are a pair of winged medallions with abbreviations for the words 'Jesus Christ' in Greek. Symbolic images of four evangelists appear in medallions in each corner. The serviette is decorated with pearls and other precious stones. The entire design is framed by a Georgian inscription identifying the donors as George Eristavi and his wife, Darejas. ES

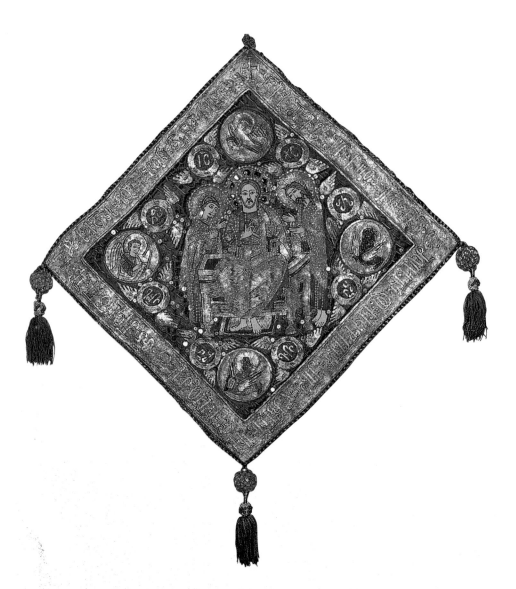

157 Door curtain [158]

1773 AD
58½ x 59½ in
Satin, gold thread, twisted gold and silk,
silver and silk, colored silk threads
Tbilisi, Sioni Cathedral
GSAM 5054

The imaginative composition that dominates the red satin field of this door curtain is a Tree of Jesse, as a stylized gold and silver grape vine growing from or behind the patriarch's body with monarchs emerging from its flowers, in medieval royal attire. In the center of the Tree is the image of the Virgin and Child, flanked on both sides by three full-length figures of haloed saints, set off by a floral design. The entire scene is triple-framed in a rich blue dominated by an Ottoman-style garden motif, and centered, below and above, by inscriptions which indicate that the work was donated by Ketevan, mother of prince of Ksani-David. Tamar and Akaki Papava bought this curtain from a German and in 1939 it was placed in the Hamburg Bank for safety as World War II broke out. In 1943 the bank burned down, but the curtain was rescued, and in 1987, following the dictates of the wills of Tamar and Akaki Pagava, it was donated to the Georgian State Art Museum by their grandchildren. MK

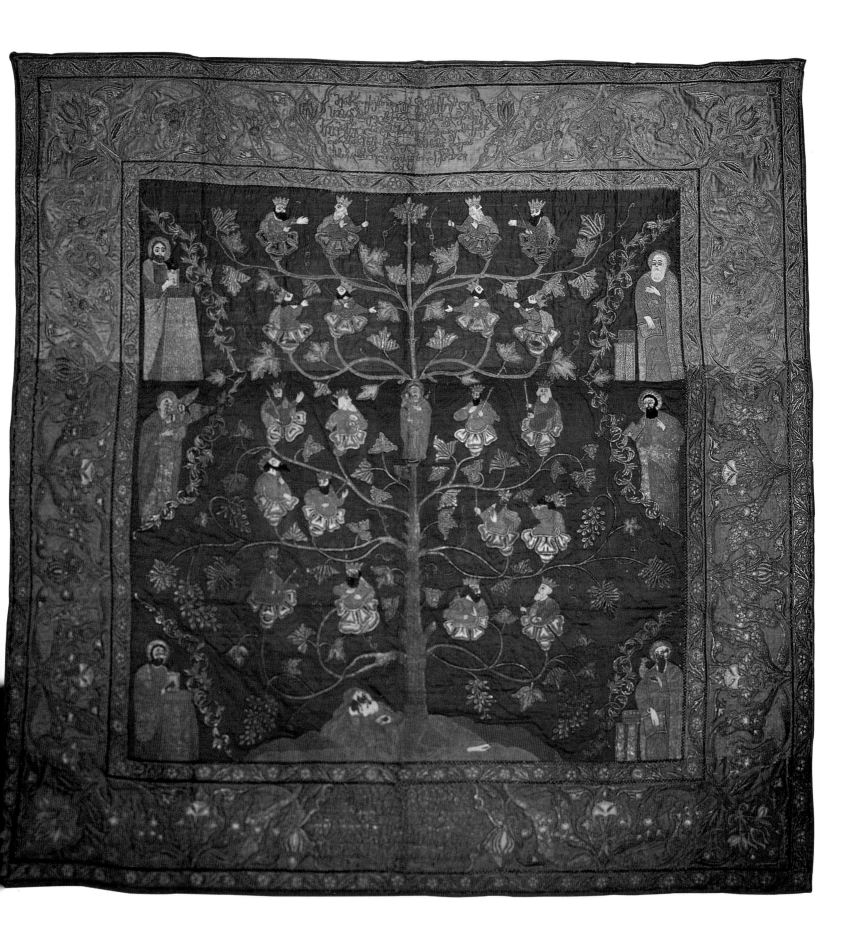

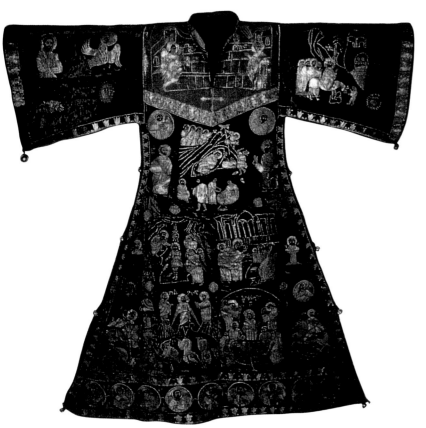

158 Phelonion [157] (left)

Early 18th century AD
Silk, brocade, gold and silver thread, colored silk, sequins
52 x 23 in
Eastern Georgia
GSAM 3799

This phelonion (ecclesiastical cape) is sewn with gold fabric, encompassed by an embroidered 5¼-inch-wide edge with floral ornamentation.

On the back-piece of the garment, the Tree of Jesse is depicted with non-traditional iconography in gold, against a black background; in its branches are prophets and Apostles with haloes, and at the top a king and queen with crowns and haloes. The composition is surmounted by a Virgin *orans* with the Christ Child. The colors are scintillating, combining very bright gold, red, greenish, and bluish bullion. GB

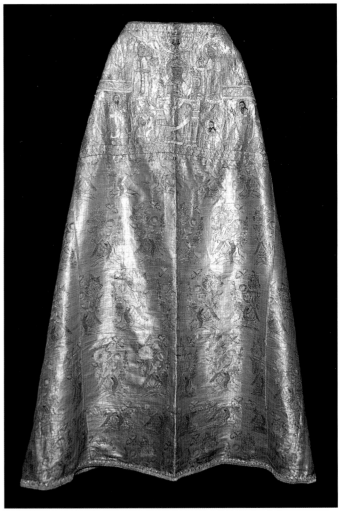

159 Phelonion [156] (right)

Early 18th century AD
Colored silk, gold fabric, pearls, turquoise,
gold and silver thread
53 x 75 in
Sioni Cathedral (Tbilisi)
GSAM 1373

This garment is sewn with gold fabric that has been lavishly decorated with birds, animals, and flowers. The silver and gold shoulder piece centers around the image of the Savior on his throne of glory. Asomtavruli inscriptions identify the figures who flank him: archangels above, John the Baptist and the prophet Elijah immediately below. Beyond these figures extend images of the twelve Apostles, embroidered in two rows. Each of the figures has a halo decorated with small pearls. The inscription between the two rows of Apostles records the generosity of the donor, Ktitor. IM

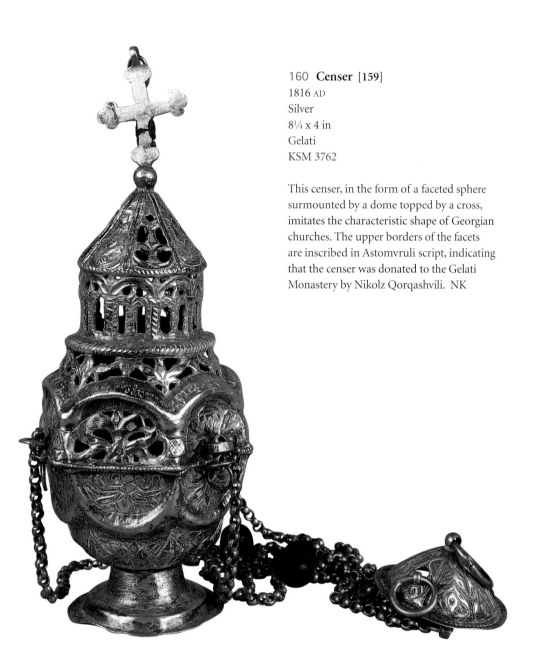

160 Censer [159]
1816 AD
Silver
8¼ x 4 in
Gelati
KSM 3762

This censer, in the form of a faceted sphere surmounted by a dome topped by a cross, imitates the characteristic shape of Georgian churches. The upper borders of the facets are inscribed in Astomvruli script, indicating that the censer was donated to the Gelati Monastery by Nikolz Qorqashvili. NK

reverse

161 Georgian double Abazi *tetri* [160]
1831 AD
Silver
1 in (diameter)
Tbilisi
GSM FH 18833

OBVERSE: Above the word 'Tbilisi' a mural crown is shown; below, criss-crossed palm and olive branches.
REVERSE: The words 'Georgian silver' – *Kartuli tetri* – are stamped. Below the inscription is the European date, indicated in Georgian numerals *CHKLA* (= 1831). Below the date are the initials of the Russian mintmaster VK.

Such a Georgian *tetri* (silver coin) would have been struck after the East Georgian Kingdom was proclaimed as part of the Russian Empire. The coins were issued in Tbilisi for the local population and used throughout the entire Caucasus region during the years 1800–34. MSh

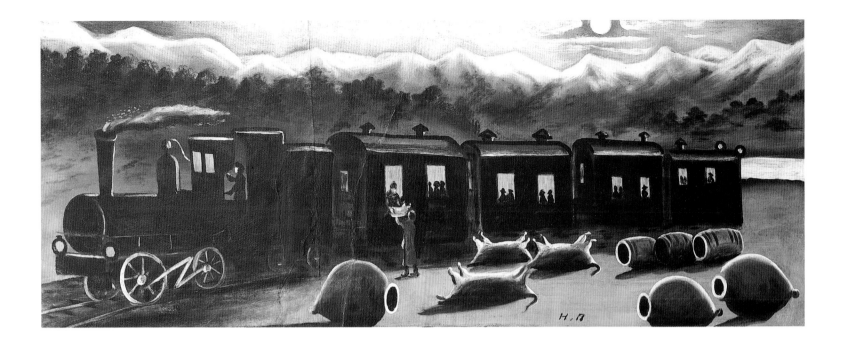

162 *The Kakheti Train*
by Niko Pirosmanashvili
(Pirosmani) [161]
1913 AD
Oil on cardboard
28 x 42½ in
Initialed at bottom right: 'N.P.'
GSAM 234

Purchased from Gamrekeli by the
People's Committee for the Georgian
State Art Museum on December 16,
1933 for 1000 rubles.

163 *Three Deer at a Spring*
by Niko Pirosmanashvili
(Pirosmani) [162]
1913 AD
Oil on cardboard
41 x 32 in
Signed at bottom right: 'N. Pirosmana'
GSAM 1343

Purchased by the Georgian State
Museum of Fine Arts from Archil
Archvadze on December 21, 1954.

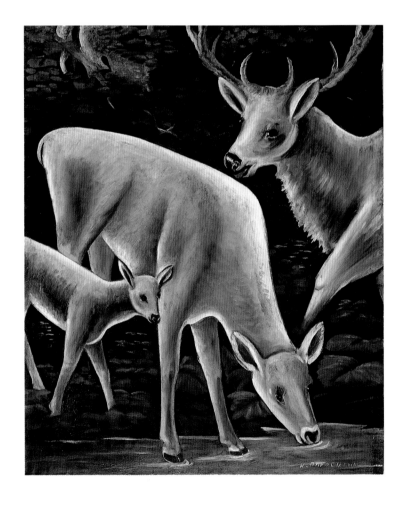

164 *The Doctor on a Donkey*
**by Niko Pirosmanishvili
(Pirosmani)** [163]
1914–15 AD
Oil on cardboard
32 x 40 in
Initialed at bottom right: 'N.P'
GSAM 198

Purchased in Moscow from Cyril
Zdanevitch by Dimitri Shevardnadze
for the State Art Museum in 1930.

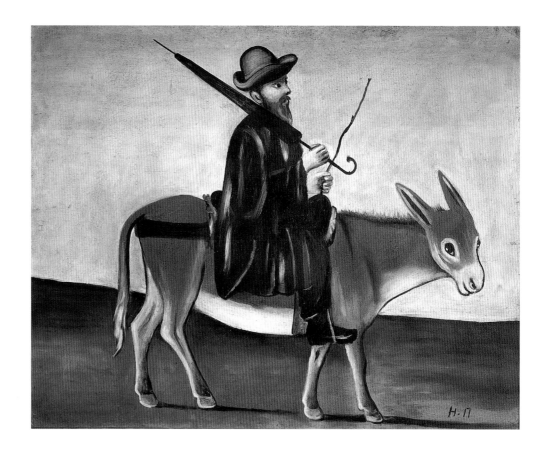

165 *Kalooba* (**On the Threshing-
floor**) **by Niko Pirosmanashvili
(Pirosmani)** [164]
1916 AD
Oil on cardboard
29 x 40 in
Signed at bottom left: 'Niko Pirosmanash'
GSAM 1335

Removed from the alehouse 'Shavi Vano'
in Tbilisi by Dimitri Shevardnadze in
1919 and given by him to the Georgian
State Museum of Fine Arts on October 1,
1930.

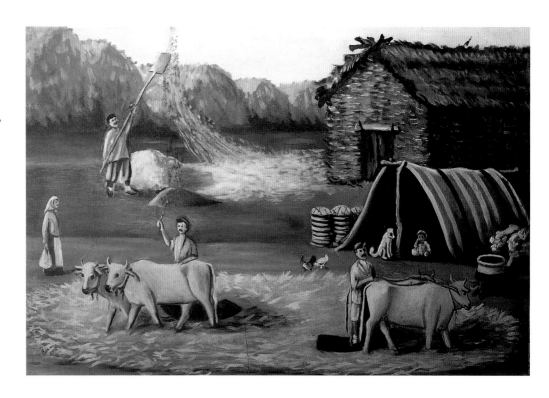

List of Exhibits

Exhibits are listed by catalogue number first and exhibition number in parentheses.

1 Female figure [1]
6th millennium BC
Clay, unfired
1⅝ x ⅞ in
Khramis Didi-Gora, Shulaveri culture
(Kvemo Kartli)
GSM 110-973:226
LITERATURE: L. Glonti, A. Javakhishvili,
T. Kiguradze, *Anthropomorphic Figurines
from Khramis didi-Gora, Dzeglis Megobari*,
33, Tbilisi, 1973, p.6 fig.5 (in Georgian);
T. Kiguradze, *Neolithische Siedlungen von
Kvemo Kartli, Georgien*, München, 1986,
abb. 83:7; *Unterwegs zum Goldenen Vlies*,
Saarbrucken, 1995, #3.

2 Ceramic shard [2]
6th millennium BC
Ceramic
6¾ x 6½ in
Khramis Didi-Gora, Shulaveri culture
(Kvemo Kartli)
GSM SH-XXI-63
LITERATURE: *Unterwegs zum Goldenen Vlies*, #4.

3 Sickle [3]
6th millennium BC
Horn and flint
13 x 2½ in
Khramis Didi-Gora, Shulaveri culture
(Kvemo Kartli)
GSM 110-973:353,5,113,134
LITERATURE: T. Kiguradze, *Agmosavlet
Amierkavkasiis Adresamitsatmokmedo
Kulturis periodizatsia*, Tbilisi, 1976, p. 78
pl 60; T. Kiguradze, *Neolitische Siedlungen
von Kvemo Kartli, Georgien*, München,
1986, abb 76:6; *Unterwegs zum Goldenen
Vlies*, #9.

4 A, B Blades [4 A, B]
6th millennium BC
Obsidian
A: 5⅝ x 1⅛ in; B: 3¾ x ⅞ in
A: Imiris-Gora; B: Khramis Didi-Gora,
Shulaveri culture (Kvemo Kartli)
GSM A: 66-969:305; B: 110-973:272
LITERATURE: T. Kiguradze, *Agmosavlet Amier-
kavkasiis Adresamitsatmokmedo Kulturis
Periodizatsia*, Tbilisi, 1976, p. 78, pl 58–60;
Unterwegs zum Goldenen Vlies, #10.

5 Nucleus (core) [4C]
6th millennium BC
Obsidian
6¼ x 5½ x 5 in
Imiris-Gora, Shulaveri culture
(Kvemo Kartli)
GSM 66-969:2332
LITERATURE: *Unterwegs zum Goldenen Vlies*, #8.

6 A, B Arrowheads [5 A, B]
5th–4th millennium BC
Flint
A: 3¼ x 1⅛ in; B: 2¾ x 1 in
Chalcolithic period; Samele Klde
GSM A: 1-60:1853; B: 1-60:1864
LITERATURE: G. Javakhishvili, *K Voprosu
Rannezemledecheskoi Kulturi Zapadnogo
Zakavkazia*, Tbilisi, 1971, p. 12; *Unterwegs
zum Goldenen Vlies*, #21.

7 Fibula [7]
Early 3rd millennium BC
Bronze
7⅜ x 2½ in
Urbnisi, grave 44 (Shida Kartli),
Kura-Araxean culture
GSM 1-62:3625
LITERATURE: *Abesadze, Litonis Tsarmoeba
Amierkavkasiashi dz. tseltagritskvis III
atastsleulshi*, Tbilisi, 1969; L. Chilashvili,
Naqalaqari Urbnisi, Tbilisi 1964; *Unterwegs
zum Goldenen Vlies*, #47.

8 Dagger [8]
First half of 3rd millennium BC
Copper
11⅞ x 2 in
Tsartsis-Gora, Satchkhere (Imereti),
Kura-Araxean culture
GSM 10-16:11
LITERATURE: B. Kurtin; *Arkheologichecheskaia
marshrutnaia ekspedicia*, 1949, p 30;
O. Japaridze, *Saqartvelos arqeologia*, p. 126;
Unterwegs zum Goldenen Vlies, #39, fig. 38.

9 Tripod bowl [12]
2500–2000 BC
Wood
14¼ x 6½ in
Bedeni (Kvemo Kartli), kurgan 5,
Bedeni culture
GSM B15
LITERATURE: G. Gobejishvili, *Bedeni korganta
kultura*, Tbilisi, 1980, p. 48, plates XXV, 6
and XXX, 23; *Unterwegs zum Goldenen Vlies*,
#88, fig. 58

10 Jar [6]
3200–3000 BC
Ceramic
7 x 6¾ in
Kura-Araxean culture; Tsikhia-Gora

(Shida Kartli)
GSM 16-86:432
LITERATURE: *Unterwegs zum Goldenen Vlies*,
Kat #32.

11 Pot [9]
Second half of 3rd millennium BC
Ceramic
7¼ x 9¼ x 7¼ in
Bedeni culture; Martkopi, kurgan 5
GSM 6-979:183
LITERATURE: G.Avalishvili, N.Aptziauri,
T. Kekelidze, M. Kobaladze, M.Chechelashvili,
A.Tsereteli, *Tbilisis Sakhelmtsipo universitetis
arkeologiuri ekspeditsiis 1989–1990 tslebis
mushaobis angarishi*, pl. XIII–183.
Arkeologiuri Krebuli I, Tbilisi, 1994.
Unterwegs zum Goldenen Vlies, #82
Arkeologiuri Krebuli I, Tbilisi, 1994, pl.XIII–
183; *Unterwegs zum Goldenen Vlies*, #82.

12 A, B Two spiral rings [11 A, B]
2500–2300 BC
A: gold; B: gold over copper core
A: ½ x ½ in; B: ⅝ x ½ in
Martkopi (Kakheti), kurgan 3,
Bedeni culture
GSM A: 6-979:45; B: 6-979/70
LITERATURE: *Unterwegs zum Goldenen Vlies*,
#64; O.Japaridze, *Saqartvelos arqeologia*,
Tbilisi 1991, fig. XXIV.

13 Necklace [10]
2500–2300 BC
Gold
9½ x 9½ in (pectoral)
Ananauri (Kakheti), kurgan 2,
Martkopi culture
GSM 1-995:1-3
LITERATURE: *Unterwegs zum Goldenen Vlies*,
#60, fig. 50.

14 Necklace [16]
2000–1800 BC
Gold, agate, carnelian
3⅜ x 1⅛ in (pectoral)
Trialeti (southeast Georgia), kurgan 8
GSM 9-63:622, 623, 624, 625, 626, 627, 628
LITERATURE: B.A.Kuftin, *Arkheologicheskie
raskopki v Trialeti*, I, Tbilisi 1941, p. 92;
Jorjikashvili, Gogadze, *Pamiatniki trialeti
epokhi rannei I srednei bronzi*, Catalog II,
Tbilisi, 1974, p.81; E. Gogadze, *Trialetis
korganuli kulturis periodizacia da genezisi*,
Tbilisi, 1974.

15 Bear figurine [15]
Late 3rd–early 2nd millennium BC
Bronze
1⅛ x ⅝ in
Azanta (Abkhazia), dolmen 2,

Dolmen culture
GSM 23-61:15
16 **Fibula** [14]
Late 3rd–early 2nd millennium BC
Gold
3⅛ x 2 in
Bedeni (Kvemo Kartli), kurgan 5,
Bedeni culture
GSM 134-975:1
LITERATURE: G. Gobeɟıshvılı, *Bedeni korganta kultura*, Tbilisi, 1980, plate XXXVIII; Sh. Dedabrishvili, *Korgani alazanskoi dolini*, 1979, plates XIV, LXVI; E. Gogadze, *Trialetis korganuli kulturis periodizacia da genezisi*, 1972, plate IX, 9; *Unterwegs zum Goldenen Vlies*, #85, fig. 8.

17 **Lion figurine** [13]
2300–2000 BC
Gold
1 x 2⅛ in
Tsnori (Kakheti), Alazani Valley, kurgan 12
GSM 140-975:1
LITERATURE: Sh. Dedabrishvili, *The Barrows of the Alazani Valley*, Tbilisi, 1979, p. 41 #11–12, plate LXVII; *Unterwegs zum Goldenen Vlies*, #88, fig. 32, fig. 51, and #86.

18 **Goblet** [18]
18th–17th century BC
Gold, carnelian, lapis lazuli, amber, jet
2¾ x 3⅛ in
Trialeti (southeast Georgia), kurgan 17,
Trialeti culture
GSM 9-63:981
LITERATURE: B.A.Kuftin, *Arkheologicheskie raskopki b Trialeti*, I, Tbilisi, 1941, p. 92; Jorikhashvili, Gogadze, *Pamiatniki trialeti epokhi rannei I srednei bronzi*, Catalog II, Tbilisi, 1974, p.81; E. Gogadze, *Trialetis korganuli kulturis periodizacia da genezisi*, Tbilisi, 1974.

19 **The Trialeti Goblet** [17]
18th–17th century BC
Silver
4⅛ x 3⅛ in
Trialeti (southeast Georgia), kurgan 5,
Trialeti culture
GSM 9-63:348
LITERATURE: B.A.Kuftin, *Arkheologicheskie raskopki b Trialeti*, I, Tbilisi, 1941, p. 92; Jorjikashvili, Gogadze, *Pamiatniki trialeti epokhi rannei I srednei bronzi*, Catalog II, Tbilisi, 1974, p.81; E. Gogadze, *Trialetis korganuli kulturis periodizacia da genezisi*, Tbilisi, 1974.

20 **Feline figurine** [21]
Late 2nd–early 1st millennium BC

Bronze
4½ x 1½ x 1 in
Martazi, Mtskheta (Shida Kartli)
GSM 15-51:5
21 **Pendant** [19]
18th–16th century BC
Bronze
1¼ x 4 x ⅝ in
Racha, Brili cemetery, grave 12
GSM 221-39
LITERATURE: *Unterwegs zum Goldenen Vlies*, #110, fig. 57.

22 **Dagger** [22]
Second half of 15th–14th century BC
Bronze
10⅛ x 2⅞ x ¼ in
Orkhevi (Kakheti), kurgan 5
GSM 14-997:1
23 **Standard with stag figure** [23]
15th century BC
Bronze
11½ x 5⅛ in
Berikldeebi (Shida Kartli), kurgan 4
GSM 87-986:107
LITERATURE: *Unterwegs zum Goldenen Vlies*, #3.

24 **Pectoral** [25]
14th–13th century BC
Bronze
6¼ x 3¾ in (9 in total length)
Melaani (kakheti), Pevrebi cemetery, grave 85
GSM 7258
LITERATURE: *Unterwegs zum Goldenen Vlies*, #122.

25 **Stag figurine** [24]
15th–14th century BC
Bronze
6 x 4⅜ x 1¾ in
Tsitelgorebi (province of Kakheti), kurgan 1
GSM 95-61:98
LITERATURE: M. Khidasheli, 'Gviai brinjaos da adre rkinis khanis irmis qandakebebi agmosavlet saqartvelodan', Matsne #2, 1974. *Unterwegs zum Goldenen Vlies*, #3

26 **Frog figurine** [26]
14th–13th century BC
Bronze
¾ x ⅜ in
Melaani (kakheti), Pevrebi cemetery, grave 85
GSM 7262
LITERATURE: *Unterwegs zum Goldenen Vlies*, #127

27 **Pendant** [20]
18th–16th century BC

Bronze
5¼ x 2⅞ in
Brili (Racha), grave 12
GSM 87
28 **Bracelet** [28]
14th–12th century BC
Bronze
3⅜ x 3⅜ x 1⅛ in
Orkhevi (Kakheti), kurgan 12
GSM 14-997:7
29 **Axehead** [27]
14th–13th century BC
Bronze
7¼ x 5 x 1⅝ in
Kvemo Sasireti hoard (Shida Kartli)
GSM 17-30:6
LITERATURE: G. Nioradze, *Der Verwahrfund von Kvemo-Sasireti Georgien (Raion Kaspi)*, ESAZ, Helsinki, 1992; P. Koridze, *Tbilisis arqeologiuri dzeglebi*, v. I, Tbilisi, 1955.

30 **Axe mold** [30]
End of 2nd–beginning of 1st millennium BC
Stone
7½ x 6¼ in
Natsargora settlement (Shida Kartli)
GSM A-5
LITERATURE: *Unterwegs zum Goldenen Vlies*, #166

31 **Decorated spearhead** [29]
13th–12th century BC
Bronze
12⅞ x 2 in
Shilada sanctuary (Kakheti)
GSM 19:982/1425
LITERATURE: B. Maisuradze, L. Pantskhava, *Shilada Sanctuary*, #2437; K.Pizchelauri. *Jungbronzezeitliche bis altereiyenzeitliche Neiligtümer in Ostgeorgien, Materialen zur allgemeinen und vergleichenden Archäologie 12; Unterwegs zum Goldenen Vlies*, #133.

32 A–C **Three swords** [31 A-C]
12th–9th century BC
Bronze
A: 23½ x 3⅛ in; B: 25¾ x 3⅛ in; C: 25¾ x 3⅛ in
Melaani (Kakheti), shrine, complex I
GSM A: I-58:2; B: I-58:3; C: I-58:12
LITERATURE: *Unterwegs zum Goldenen Vlies*, #204

33 A–C **Arrowheads** [33 A-C]
8th century BC
Bronze
A: 3⅛ x 1⅛ in; B: 3½ x 1 in; C: 2⅞ x 1 in
Melaani (Kakheti), shrine, complex 1
GSM A: I-58:82; B: I-58:93, C: II-58:76
LITERATURE: *Unterwegs zum Goldenen Vlies*, #206.

34 **Male figure** [35]
8th–7th century BC
Bronze
7⅜ x 2⅞ in
Melaani sanctuary (Kakheti)
GSM TSU175
LITERATURE: G. Javakhishvili.
*Anthropomorphic Sculpture in pre-Christian
Georgia*, Tbilisi, 1984, fig. XIV; *Unterwegs
zum Goldenen Vlies*, #201.

35 **Stag pendant** [32]
10th–9th century BC
Bronze
2⅞ x 1⅞ x 2 in
Mtskheta (Shida Kartli),
Samtavro cemetery, grave 96b
GSM 12-54:2155
LITERATURE: A.Kalandadze, *Archeological
Sites of the Pre-Clasical Period from
Samtavro, Mtskheta*, v. VI, Tbilisi, 1982.

36 **Miniature war chariot** [34]
9th–8th century BC
Bronze
2 x 7⅞ x 2⅝ in
Mta Gokhebi, near Tsiteltskaro (Kakheti)
GSM A-7
LITERATURE: K. Pitskelauri, *East Georgia at
the End of the Bronze Age*, Tbilisi, 1979,
p. 58, table XIII (in Russian).

37 **Zoomorphic vessel** [36]
8th–7th century BC
Ceramic
7⅛ in (diameter)
Treli (Shida Kartli), grave 16
GSM 11-1:70-39
LITERATURE: *Unterwegs zum Goldenen Vlies*,
#381.

38 **Chain with stag pendants** [38]
8th–7th century BC
Bronze
3½ x 3⅛ in (each stag);
23 in (chain length overall)
Chabarukhiskhevi hoard (Shida Kartli)
GSM 27-61:65,66,67,68
LITERATURE: A. Kalandadze, *Hoards of
Chabarukiskhevi and Pasanauri*, Tbilisi
1965; M. Khidasheli, 'Bronze Sculptures
of Deer from East Georgia', in *Matsne*,
1974, #2.

39 **Belt/Girdle fragment** [37]
8th–7th century BC
Bronze
8 x 16⅝ in
Mtskheta (Shida Kartli), Samtavro cemetery,
northern plot, grave 276
GSM 12-54:7399

LITERATURE: M. Khidasheli, 1982, plate I;
N. Urushadze, 1984, p.48, picture 22.

40 **Situla (Pitcher)** [39]
8th–7th century BC
Bronze
5½ x 5 in
Okureshi (Lechkhumi), Lajobispiri hoard
GSM 1-36:179

41 **Colchian didrachm, second type** [43]
6th century BC
Silver
⅞ in (diameter)
Western Georgia
GSM FH22466
LITERATURE: D. Kapanadze, *Georgian
Numismatics*, Tbilisi, 1971 (in Georgian)

42 **Axehead** [40]
Late 7th–early 6th century BC
Bronze
6⅜ x 2⅛ in
Tskhinvali hoard (Shida Kartli)
GSM 8-09:1
LITERATURE: O. Japaridze, *The Tskhinvali
Hoard*, XVI-B, 1950; *Unterwegs zum
Goldenen Vlies*, fig. 92. L. Pantskhava,
Kolkhuri mkhatvruli khelosnobis dzeglebi,
Tbilisi 1988, fig. XIX.

43 **Axehead** [42]
Early 6th century BC
Bronze
6⅞ x 2¾ in
Ozhora cemetery (Shida Kartli), grave 5
GSM 7-59:47
LITERATURE: L. Pantskhava, *Kolkhuri kulturis
mkhatvruli khelosnobis dzeglebi*, Tbilisi, 1988;
Japaridze, *Arqeologiuri gatkhrebi sofel
ojorashi*, Tbilisi State University works # 65,
Tbilisi, 1975.

44 **Standard with aurochs and human
figure** [44]
6th–5th century BC
Bronze
4⅝ x 2 x 1½ in
Kazbegi hoard
GSM 2-021 1/177
LITERATURE: L. Tsitlanadze, *Khevis arkeologiuri
dzeglebi*, Tbilisi, 1976.

45 **Bowl** [46]
5th century BC
Silver
7⅜ x 7¼ x 1 in
Pitchvnari (Atchara), Greek necropolis,
grave 110
ASM 19836
LITERATURE: *Unterwegs zum Goldenen Vlies*

46 **Hermaphroditic figurine** [41]

7th century BC
Bronze
12½ x 4 in
Fersati (Imereti)
KSM 5668

47 **Red-figure skyphos** [52]
480–475 BC
Ceramic
3¼ x 6⅛ x 3⅞ in
Pichvnari (Atchara), Greek necropolis,
grave 118
SAM 124/1986
LITERATURE: T. Sikharulidze, 'Atikuri mohatuli
keramikis akhali nimushebi Pichvnaris
berdznuli samarovnidan', in *Samkhret-
dasavlet saqartvelos dzeglebi*, 17, Tbilisi, 1988
(in Georgian, with Georgian and Russian
summary), pp. 67–70, pl. 39; *Unterwegs zum
Goldenen Vlies*, #264.

48 **Aryballos** [53]
Second quarter of 5th century BC
Glass
3¾ x 2¼ in
Pitchvnari (Atchara), Greek necropolis,
grave 137
SAM 150/1986
LITERATURE: *Unterwegs zum Goldenen Vlies*,
#269.

49 **Amphoriskos** [57]
Mid-5th century BC
Glass
2¾ x 1¾ in
Pitchvnari (Atchara), Greek necropolis,
grave 48
SAM 2/1979
LITERATURE: L. Chkhaidze, 'Adreantikuri
khanis importuli minis churcheli Pichvnaris
naqalaqaris berdzen moakhalshenta
samarovnidan', in Samkhret-dasavlet
Sakartvelos dzeglebi, Tbilisi, 1974, pp. 34–41;
Unterwegs zum Goldenen Vlies, #268.

50 **Alabastron** [54]
480–450 BC
Glass
4⅛ x 1⅛ in
Pitchvnari (Atchara), Greek necropolis,
grave 120
SAM: 129/1986
LITERATURE: *Unterwegs zum Goldenen Vlies*,
#270.

51 **Alabastron** [55]
480–450 BC
Glass
3⅞ x 1¼ in
Pitchvnari (Atchara), Greek necropolis,
grave 120

SAM: 155/1986
LITERATURE: *Unterwegs zum Goldenen Vlies*,
#270

52 **Diadem [50]**
First half of 4th century BC
Gold
9¾ in (diameter)
Vani (Imereti), grave 6
GSM 11-974:1
LITERATURE: O. Lordkipanidze, *Vanis
naqalaqari, Vani I*, 1972, pp. 12–13;
A. Chkonia, *Dz. Ts. V–IV ss. Pirveli nakhevris
oqros samkaulebi*, Tbilisi, 1981, pp. 14–15,
101; *Unterwegs zum Goldenen Vlies*, #272

53 **Beads [45]**
Second half of 1st millennium BC
Glass
1 x 1¼ in and 1¼ x 1½ in (range of
diameters)
Brili (Ratcha), grave 27
GSM 5-993:623,624

54 **Colchian hemidrachm (triobolos),
second type [49]**
5th–4th century BC
Silver
¾ in (diameter)
Potskho, Martvili (Samegrelo)
GSM FH 25632

55 **Plaque in the shape of an eagle [51]**
5th century BC
Gold
1¾ x 1⅞ in
Vani (Imereti), grave 11
GSM 10-975:71
LITERATURE: O. Lordkipanidze, et al., *Archae-
ological Excavations in Vani in 1969, Vani I*,
1972, p.226. A. Chkonia, *Gold Jewelry from
the Site of Vani: Vani VI*, 1981, pp. 51–52, 111.

56 **Necklace [47]**
5th century BC
Gold
10 in (diameter), each turtle ¼–⅜ in
Vani (Imereti), grave 1
GSM 10-975:56
LITERATURE: O. Lordkipanidze and others,
Arqeologiuri gatkhrebi Vanshi 1969. Vani I,
1972, pp. 219–221; Chkonia, *Oqros
samkaulebi Vanis naqalaqaridan, Vani VI*,
Tbilisi, 1981, p.104.

57 A, B **Pair of earrings [58 A, B]**
Third quarter of 5th century BC
Gold
2½ x ⅝ in
Pitchvnari (Atchara), Greek necropolis,
grave 104
ASM 22415/3

LITERATURE: *Unterwegs zum Goldenen Vlies*,
#254, abb. 140

58 A, B **Pair of earrings [59 A, B]**
450–425 BC
Gold
1⅝ x ⅜ in
Pitchvnari (Atchara), Greek necropolis,
grave 15
ASM 19708/7
LITERATURE: *Unterwegs zum Goldenen Vlies*,
#255, abb. 140

59 **Red-figured crater [56]**
460–450 BC
Ceramic
19½ x 17¼ x 19¾ in
Pitchvnari (Atchara), Greek necropolis,
grave 1
ASM 19930
LITERATURE: A. Kakhidze, *Agmosavlet
Shavizgvispiretis antikuri dzeglebi
(Pichvnaris berznuli samarovani)*, Batumi,
1975, pp. 34–58; T. Sikharulidze, *Atikuri
mokhatuli vazebi fichvnaris samarovanidan,
samkhret-dasavlet saqartvelos dzeglebi, XVI*,
1987, pp. 60, 66, pl. 39; *Unterwegs zum
Goldenen Vlies,* #267.

60 **Finial from a standard [48]**
Mid-5th century BC
Bronze
6 x 3 in
Kanchaeti (Shida Kartli), kurgan
GSM 16-980:10
LITERATURE: I. Gagoshidze, 1964, pp. 43, 47

61 **Pitcher [67]**
4th century BC
Ceramic
6 x 4½ in
Takhtidziri (Shida Kartli), Tsitelbegebi
cemetery, grave 36
GSM 97:36-1

62 **Earring [61]**
First half of 4th century BC
Gold
3¼ x 1⅜ in
Vani (Imereti), grave 6
GSM 11-974:2
LITERATURE: R. Puturidze, et al., *Archaeological
Excavation in Vani in 1969: Vani I*, 1972,
p. 114; A. *Chkonia, Gold Jewelry from the Site
of Vani: Vani VI*, 1981, pp. 27–32, 104;
Unterwegs zum Goldenen Vlies, cat #273.

63 **Earring [62]**
5th century BC
Gold
2¼ x 1⅛ in
Vani (Imereti), grave 11

GSM 10-975:54
LITERATURE: O. Lordkipanidze, et al.,
*Archaeological Excavations in Vani in 1969:
Vani I*, 1972 pp.217–218; A. Chkonia, *Gold
Jewelry from the Site of Vani: Vani VI*, 1981,
pp. 18, 101–102.

64 **Seal-ring [68]**
4th century BC
Gold
⅞ x ¾ x ⅝ in
Vani (Imereti), grave 9
GSM Glyptic N 1237
LITERATURE: O. Lordkipanidze, *Kolkhetis
dzveli tseltagritsqvis V–III ss.
Sabechdavibechdebi*, Tbilisi, 1975, pp. 80–93,
fig. 23.

65 A, B **Beads [70A, B]**
4th–3rd centuries BC
Glass, paste
1 x 1 in
Kazbegi
GSM 337
LITERATURE: S. Uvarova, *Mogilniki severnogo
kavkaza*, 1902, p. 155, pl. LXXIII5; Kuftin B,
Materiali arkheologii kolkhidi, 1950, p.9;
Krupnov, *Drevnaia istoria severnogo kavkaza*,
1960, pl. LXIX35; L. Tsitlanadze, *Shua
kavkasionis mtis mosaxleobis kultura VI–I
ss-shi*, 1966, pp.83,237; V. Tolordava, *mdidruli
samarkhi dabalgoridan*, 1976, p.70, fig. 862;
E. Alekseeva, *Antichnie busi severnogo
pricher- nomoia*, 1982, p.41, pl. 47; E.
Gigolashvili, *Mdzivsamkauli*, 1983, pp. 110,
103.

66 **Arm rings [63]**
First half of 4th century BC
Gold
3⅞ in (diameter)
Vani (Imereti), grave 6
GSM 11-974:14
LITERATURE: O. Lordkipanidze, *The Site of
Vani: Vani I*, p. 18, Fig 49; R. Puturidze, et al.,
*The Results of Archaeological Excavations in
the Northwest Part of the Site of Vani,
1961–63*, Tbilisi, 1972, p. 115; A. Chkonia,
Gold Jewelry from the Site of Vani: Vani VI,
1981, pp. 47, 110; *Unterwegs zum Goldenen
Vlies*, cat #276.

67 **Arm ring [64]**
First half of 4th century BC
Gold
3⅞ in (diameter)
Vani (Imereti), grave 6
GSM 11-974:15
LITERATURE: R. Puturidze, et al, *The Results of
Archaeological Excavations in the Northwest*

Part of the Site of Vani, 1961–63, p. 115, fig 50; A. Chkonia, *Gold Jewelry from the Site of Vani: Vani VI*, 1981, p, 48, fig 28; *Unterwegs zum Goldenen Vlies*, cat #277.

68 Temple pendant [69]
4th century BC
Gold
5⅛ in
Hoard of Akhalgori, Sadzeguri (Shida Kartli)
GSM SM-26
LITERATURE: J. I. Smirnow, *Der Schatz von Achalgori*, Tiflis, 1934, pp. 23–29, #26, plate III; J. Gagoshidze, *Materialen zur Geschichte der Goldschmiede kunst im alten Georgien*; Boreas, *Munstersche Beitrage zur Archaologia*, Band 20, Munster, 1997, pp.134–135, plates 23–25.

69 Pectoral [60]
First half of 4th century BC
Gold, inlaid with carnelian and turquoise
9¼ in
Vani (Imereti), grave 6
GSM 11-974:13
LITERATURE: R. Puturidze et al., *Vanis nakalakaris chrdilo-agmosavlet natsilshi 1961–1963 chatarebuli arkeologiuri tkhris shedegebi*. Vani I, Tbilisi, 1972, p. 115, pl. 48; A. Chkonia, *Okros samkaulebi Vanis nakalakaridan*, Vani VI, Tbilisi, 1981, pp. 40– 46, pl. 24; *Unterwegs zum Goldenen Vlies*, #279.

70 Bowl [65]
First half of 4th century BC
Gold
5¼ x 2⅝ in
Vani (Imereti), grave 6
GSM 11-974:39
LITERATURE: R. Puturidze et al, *Vanis nakalakaris Chrdilo-agmosavlet natsilhi 1961–1963 tslebshi chatarebuli arkeologiuri tkhris shedegebi*, Vani I, Tbilisi, 1972, p. 116. pl. 55; O. Lordkipanidze, *Gorod-Khram Kolhidi*, Moscow, 1984, p. 13.

71 Pitcher [66]
4th century BC
Ceramic
5 x 5½ in
Takhtidziri (Shida Kartli), Tsitelbegebi cemetery, grave 6
GSM 96-65:1732

72, 73 Fragments of a *kvevri* [71, 72]
3rd century BC
Ceramic
16¼ x 14 in; 13 x 17½ in; thickness of both fragments ⅝ in
Samadlo (Shida Kartli)

GSM 72-68:233 (both fragments)
LITERATURE: I. Gagoshidze, *Archaeological Excavations at Samadlo*, Tbilisi, 1979, p. 93, plates I, II; Yu. Gagoshidze, Samadlo: *Catalogue of the Archaeological Material*, Tbilisi, 1981, p.20, plates XVI, XVII (in Russian).

74 Male figure [75]
3rd century BC
Iron and gold
11¾ in
Vani (Imereti), grave 1
GSM 10-975:20
LITERATURE: N. Khoshtaria, *The History of Vani Archaeological Study I*, Tbilisi, 1972, p.88, plate #2

75 Head of Pan [77]
2nd century BC
Bronze
5⅛ x 3¾ in x 2¼ in
Vani (Imereti)
GSM 10-975:186
LITERATURE: O. Lordkipanidze 'Vanis Naqalaqari', *Vani I*, 1972, pp.31–32.

76 Stater of Alexander the Great [73]
336–323 BC
Gold
¾ in (diameter)
Chuberi (Svaneti)
GSM FH 10213
LITERATURE: G. Dundua, *The Numismatics of Ancient Georgia*, Tbilisi, 1987 (in Russian).

77 Stater of Lysimachus [74]
306–282 BC
Gold
⅞ in (diameter)
Svaneti
GSM FH 2229
LITERATURE: G. Dundua, *The Numismatics of Ancient Georgia*, Tbilisi, 1987 (in Russian)

78 Georgian imitation of the staters of Lysimachus [76]
3rd century BC–1st century AD
Gold
⅞ in (diameter)
Tbilisi, Mari Street
GSM FH 5253
LITERATURE: G. Dundua, *The Numismatics of Ancient Georgia*, Tbilisi, 1987 (in Russian).

79 Georgian imitation of the staters of Alexander the Great [78]
2nd century BC–1st century AD
Gold
¾ in (diameter)
Magraneti (Tianeti), grave 13
GSM FH 12170

LITERATURE: G. Dundua, *The Numismatics of Ancient Georgia*, Tbilisi, 1987 (in Russian).

80 Nike [79]
Second half of 2nd century BC
Bronze
8½ x 7¼ x 2 in
Vani (Imereti)
GSM 10-975:186
LITERATURE: O. Lordkipanidze, *The Site of Vani: Vani I*, Tbilisi 1972, pp.31–32, plate 143; *Unterwegs zum Goldenen Vlies*, p. 155, cat #289.

81 Pitcher [86]
2nd century AD
Glass
10¼ x 3½ in
Mtskheta-Samtavro (Shida Kartli), tile grave 159
GSM 12-54:10699
LITERATURE: N. Ugrelidze, *Glass in Ancient Georgia*, 1961, plate 8; O. Lordkipanidze, *The Ancient World and the Georgian Kingdom*, 1968, p. 75, plate II–1; M. Saginashvili, *Matsne: Glassware from Tbilisi*, 1974, #4, p. 167, plate II −1.

82 Leopard figurine [81]
1st century BC
Bronze
3⅛ x 4⅛ x 1in
Mtskheta, Samtavro cemetery, 'cultural' layer
GSM 12-54:7165

83 Gazelle figurine [80]
1st century BC
Bronze
4 x 5¾ x 1½ in
Mtskheta, Samtavro cemetery, 'cultural' layer
GSM 12-54:7166

84 Figurine of a young male [82]
1st–2nd century AD
Gold
2⅞ x 1⅛ in
Gonio (Atchara), hoard
ASM 20110/10
LITERATURE: O. Lordkipanidze, M. Miqeladze, D. Khakhutaishvili, *Gonios gandzi*, Tbilisi 1980, pp. 11, 58; *Unterwegs zum Goldenen Vlies*, p. 155, cat #290.

85 Dagger sheath [90]
170–80 AD
Gold, glass
9⅛ x 3 in
Armaziskhevi, Pitiakhshes cemetery, Mtskheta, cist 1
GSM 18-55:22
LITERATURE: Mtskheta I, pp 32–33, plate I bis, 1

86 **Dagger** [98]
AD 250–300
Iron (blade), gold with inset almandin,
turquoise (handle)
4¹⁄₈ x 8¹⁄₄ x 1⁵⁄₈ in
Mtskheta, Armaziskhevi (Shida Kartli),
grave 3
GSM 18-55:56
LITERATURE: A. Apakidze, G. Gobejishvili,
A.Kalandadze, G.Lomtatidze, Mtskheta, I,
*The Archaeological monuments of
Armaziskhevi*, I, Tbilisi, 1955, p.48, plate III.
87 **Buckle** [84]
3rd century AD
Gold
2⅜ in (diameter)
Vani (Imereti)
GSM 24-29:1
LITERATURE: B.A. Kuftin, *Materials from the
Archaeology of Colchida, Vol II*, Tbilisi, 1950,
pp. 4–6, plate I; N. Khoshtaria, *The History
of Archaeological Research in Vani: Vani I*,
1972, p. 87. A. Chkonia, *Oqros samkaulebi
Vanis naqalaqaridan*, 1981, pp. 81–82.
88 **Buckle** [83]
1st–2nd century AD
Gold and lapis lazuli or turquoise jewels
5⅜ x 5½ in
Gonio (Atchara), hoard
ASM 20110/2
LITERATURE: O. Lortkipanidze, M. Miqeladze,
D. Khakhutaishvili, *Gonios gandzi*, Tbilisi
1980, pp. 11, 58; *Unterwegs zum Goldenen
Vlies*, p. 155, cat #292.
89 **Bowl** [89]
c. AD 170
Silver, gold
2¾ x 8¹⁄₈ in
Mtskheta (Shida Kartli), Bagineti necropolis,
sarcophagus 1
GSM 13-57:7
LITERATURE: K. Machabeli, *Pozdneantichnaia
torevtiki Gruzii*, Tbilisi, 1976; A. Javakhishvili,
G. Abramishvili, *Jewelry and Metalwork in
the Museums of Georgia*, Leningrad, 1986,
pl. 62; *Unterwegs zum Goldenen Vlies*, #325
90 **Necklace with pendant and
hanging flagon** [88]
AD 150–200
Gold, amethyst, garnets, turquoise
13 x 1⅞ in
Armaziskhevi, Pitiakhshes cemetery,
Mtskheta, grave 7
GSM 18-55:148
LITERATURE: *Mtskheta I*, pp. 97–102, #148,
plate IX.

91 **Buckle** [87]
2nd–3rd century AD
Bronze
5¹⁄₈ x 5⅜ in
Gebi (Racha)
GSM 6-02:108/1021
LITERATURE: P. Uvarova, *Burials of the
Northern Caucasus*, Moscow, 1900, p. 351,
fig. 277;
M. Khidasheli, Tbilisi, 1972, p.110, #139.
92 **Buckle** [85]
1st–3rd century AD
Bronze
5¾ x 5⅝ in
Zekota (Shida Kartli)
GSM 8-52:1
LITERATURE: M. Khidasheli, *Brinjaos
mkhatvruli damushavebis istoriisatvis antikur
saqartveloshi*, Tbilisi, 1972, pp. 110
93 **Griffin** [92]
3rd–4th century AD
Bronze
9 x 6¹⁄₈ x 1½ in
Zguderi (Shida Kartli), late ancient cemetery,
a plundered grave
GSM 190:65/264
LITERATURE: G. Nemsadze, *The Results of the
Zgudery Archaeological Expedition of 1964–
1966 Archaeological Expeditions of the
Georgian State Museum*, I, 1969; G. Nemsadze,
Burials of Iberian Aristocracy from Zguderi,
1977, pp.108–114, picture 8; *Unterweigs zum
Goldenen Vlies*, #160.
94 **Torso of Pan** [91]
1st century AD
Bronze
7 x 4⅜ in
Mtskheta (Shida Kartli)
GSM 28-51:27
LITERATURE: G. Lomtatidze, I. Tsitsishvili. 'A
Newly Found Tomb in Mtskheta', in *Moambe*,
1951, # 10, pp. 641–648; G. Lomtatidze, *The
Life and Culture of the People of Georgia in the
First–Thirteenth Centuries*, Tbilisi, 1977, p.29.
95 **Pendant** [94]
3rd century AD
Gold, amethyst
1 x ½ x 9½ in
Urbnisi (Shida Kartli) cemetery 25
GSM Glyptic 1104
LITERATURE: Q. Javakhishvili, *Urbnisis
Naqalaqaris gliptikuri dzeglebi*, Catalogue,
Tbilisi, 1972. Q. Javakhishvili, *Karakals
portreti*, Khelovneba 1968, #11.
96 **Double portrait seal-ring** [93]
3rd century AD

Gold, carnelian
⅝ x ½ x ⅞ in
Zguderi Burial Ground (Kartli), wooden
sarcophagus 1
GSM Glyptic 1187
LITERATURE: Q. Javakhishvili, G. Nemsadze,
Zgudis gliptikuri dzeglebi, Tbilisi 1982,
pp. 139–144, fig. IX.
97 **Clasp in the form of a stag** [99]
Late 3rd–early 4th century AD
Bronze
2⅞ x 2½ x 9¾ in
Nedzihi (Pshavi), grave 199
GSM 09-XI:86-757
LITERATURE: R. Ramishvili,
'Archaeologitcheskie issledocania v ushelie
Aragvi', in *Polevie arkeologicheskie
issledovania v 1986 godu*. Tbilisi, 1991, plate
238; *Unterwegs zum Goldenen Vlies*, #332.
98 **Bowl** [96]
4th century AD
Silver, gilded silver
1½ x 4¾ in
Mukuzani (Kakheti)
GSM 11-994:1
99 **Bracelet** [95]
3rd century AD
Gold, sardonyx
2¹⁄₈ x 1 x ⅝ in
Mtskheta (Shida Kartli), Bagineti,
sarcophagus 1
GSM Glyptic 853
LITERATURE: M. Apakidze, *Baginetis kldekaris
sarkopagi, 'Dzeglis megobari'*, Tbilisi 1973;
M. Lortkipanidze, *Saqartvelos sakhelmtsipo
muzeumis gemebi*, II, Tbilisi, 1958, #8. Fig. 19.
100 **Bracelet** [101]
4th century AD
Gold, lazurite, malachite, almandin
8¹⁄₈ x ¾ in
Necropolis of Armaziskhevi (Shida Kartli),
grave 40
GSM 4-981:1
LITERATURE: *Mtskheta, I Tbilisi*, 1953,
pp. 129–130, plate C,12; A. Djavakhishvili,
G. Abramishvili; *Orfèvrerie et Toreutique
des Musées de la République de Georgia*,
Leningrad, 1986, #54.
101 **Ring** [100]
Late 3rd–early 4th century AD
Gold, garnets
1 x 1 in
Djinvali, Aragvispiri (Shida Kartli),
necropolis *Zandukliani Navenakhari*, grave 9
GSM 5-975:6
LITERATURE: R. Ramishvili, *Akchali*

arkeologiuri agmochenebi Aragvis kheobashi, 'Dzeglis megobari', Tbilisi, 1975, pp. 7–15, #39

102 Bracelet [97]
3rd century AD
Jet, gold, pyrope
3 x 1¼ in
Mtskheta (Shida Kartli), kurgan 25
GSM Glyptic 853
LITERATURE: A. Apakidze, V. Nikolaishvili, A. Sikharulize, T. Bibiluri, G. Giunashvili, Sh. Iremashvili, G. Mandjgaladze, V. Sadradze, L. Khezuriani, 'Didi Mtskheta, 1981, Savelearkeologiuri kvleva-dziebis shedegebi', *Mtskheta*, v. IX, Tbilisi, 1989, pp. 40–76, plate 188, 189, 190.

103 Brooch [103]
3rd century AD
Gold, garnet, sardonyx, glass
1⅝ x 2¼ in
Ureki (Guria)
GSM 12-57:6
LITERATURE: A. Apakidze: 'Late Antique Archaeological Monuments from Urekii', in *The Georgian State Museum Review*, XIV–b, pp. 89–125.

104 Buckle [102]
3rd century AD
Gold, wine-colored glass
1¾ x 3 in
Kldeeti (Imereti) cemetery
GSM 11-57:51
LITERATURE: G. Lomtatidze, *Kldeetis samarovani*, Tbilisi 1957, fig. XIV.1.

105 Bowl [104]
Second half of 3rd century AD
Silver
1⅜ x 7⅜ in
Mtskheta, Armaziskhevi (Shida Kartli), grave 2
GSM AR-12-57:6
LITERATURE: A. Apakidze, G. Gobejishvili, A. Kalandadze, G. Lomtatitdze, Tskheta I, *The Archaeological Monuments of Armaziskhevi*, Tbilisi, 1955, pp.45, 46. plates XLVII, XLVIII, XLIX.

106 Panel from an altarscreen [105]
End of 7th–beginning of 8th century
Limestone
34¼ x 32¾ x 4⅜ in
Tsebelda, Gulripshi
GSAM 126

107 Panel from an altarscreen [106]
8th–9th century
Limestone
28 x 22⅛ x 3⅝ in

Gveldesi
GSAM 146

108 Relief of Ashot Kuropalates [107]
Early 9th century
Sandstone
22⅛ x 26 x 3⅝ in
Opiza Monastery
GSAM 1303

109 Reliquary cross (encolpion) [108]
9th century
Silver, gilded silver, niello
6 x 3¾ in
Martvili (Samegrelo)
GSAM O-41

110 Processional cross fragment [115]
973 AD
Gilded silver; the body of Christ cast
8¾ x 6 in
Ishkhani (Tao-Klarjeti, southern Georgia)
GSAM L-17

111 Icon [109]
10th century
Wood, silver
7½ x 4 x 1¼
Znakvari (Ambrolauri region)
KSM 3089

112 Icon [114]
10th century (icon); 9th–12th century (cloisonné enamel); 17th–18th century (frame)
Gold, silver, cloisonné enamel, turquoise, rubies, emeralds, pearls, wood
12⅝ x 9⅛ x ⅝ in
Martvili (Samegrelo), Chkondidi goldsmithery workshop
GSAM 0.7a

113 Upper part of a chalice (the Bedia Cup) [118]
999 AD
Gold repoussé
5½ x 5½ in
Bedia (Abkhazia, west central Georgia)
GSAM 9510A

114 Pectoral cross from Martvili [110]
10th century
Gold, pearls, enamel, precious stones
6⅜ x 3¾ in
GSAM P289

115 Iconostasis plaque [117]
Late 10th–early 11th century
Silver
13⅝ x 12 in
Sagolasheni (Shida Kartli), south Georgia, goldsmithery workshop
GSAM K-46

116 Iconostasis plaque [116]

Late 10th–early 11th century
Silver
13⅝ x 11⅞ in
Sagolasheni (Shida Kartli), south Georgia, goldsmithery workshop
GSAM K-46

117 Icon of St George [113]
10th–11th century
Silver
11½ x 9½ in
Tsvirmi-Tchobeni (upper Svaneti)
GSAM 10134

118 Illustrations from the Tskarostavi Gospels [111]
10th century
Gold leaf, ink, paint on parchment, leather binding
216 folios
9 x 8¼ x 3¾ in
IM A-98

119 Tondo from Gelati [119]
11th century
Silver, gilded silver
7⅞ in (diameter)
Gelati (Imereti)
GSAM 1198

120 Icon reliquary [120]
11th century
Gilded silver, pearls, precious stones, wood
15⅜ x 13 x 1 in
Zestafoni region
KSM 3025

121 Pentateuch from Lailashi (Lechkhume) [112]
10th century
Ink, paint, gold leaf on parchment
169 folios, 338 pages
17¼ x 14½ in
IM Hebr-3

122 The Homilies of Gregory Nazianzeni (the Theologian) [123]
12th century
Ink, paint, gold leaf on paper, leather binding
262 folios
17¾ x 13¾ x 3¼ in
IM A-109

123 Processional cross [124]
12th century
Gilded silver, ruby, sardonyx, iron
13 x 7⅜ in
Gelati (Imereti)
GSAM P289

124 Medallion [121]
First half of 12th century

Gold, cloisonné enamel
3⅜ in (diameter)
Jumati
GSAM 3221

125 Medallion [122]
First half of 12th century
Gold, cloisonné enamel
3⅜ in (diameter)
Jumati
GSAM 3228

126 Astrological treatise [126]
1188–1210
Ink, paint, gold leaf on paper with
leather binding
213 folios
12¹¹⁄₁₆ x 10 x 2⅞ in
IM A-65

**127 Tskarostavi (Tao Klarjeti)
Gospels [127]**
1195
Binding of gilded silver, silver, leather,
stones, ink on parchment
276 folios
9⅞ x 7½ x 3¹⁵⁄₁₆ in
IM Q907

128 Coin of King Giorgi III [125]
1174
Copper
⅞ to 1 in (diameter)
GSM FH 1802

129 Coin of Queen Tamar [128]
1200
Copper
1⅛ in (diameter)
Vejini (Gurjaani region, eastern
Georgia)
GSM FH 1231
LITERATURE: D. Kapanadze, *Georgian
Numismatics*, Tbilisi, 1969 (in Georgian)

**130 Irregular coin of King Giorgi
Lasha [131]**
1210
Copper
2⅝ x ⅝ in
Kvemo Kartli (eastern Georgia)
GSM FH 25748

**131 Dirhem (Drahma) of Queen
Rusudan [132]**
1230
Silver
1 in (diameter)
GSM FG 270

132 Psalter [130]
13th century (miniatures),
15th century (text)
Ink, paint, gold leaf on paper with

leather binding
144 folios
10⅛ x 8½ x 2⅝ in
IM H-75

133 Psalter [129]
13th century (miniatures),
15th century (text)
Ink, paint, gold leaf on paper with
leather binding
236 folios
10½ x 8½ x 2⅞ in
IM H-1665

134 Pocket-size psalter [135]
1495
Ink, paint on parchment, green vellum
binding
168 folios
4⅛ x 3½ x 1¼ in
IM A-351

135 Stole [133]
1358
Silk, twisted gold and silver on silk threads
157½ x 9⅞ in
Ancha, Tao-Klarjeti
GSAM 1362

136 Icon of the Savior [140]
c.1525–50
Gold, tempera on wood, garnets, rubies,
turquoise, amethyst, pearls, bone, mastic,
resin
23 x 16¾ x 1⅛ in
Akhali Shuamta
GSAM K-178

137 Holy shroud [134]
1446–66
Twisted silver and gold on silk threads, silk
73 x 62 in
GSAM 1354

138 Holy Shroud [147]
1632–82
Silk, twisted gold and silk on silk threads,
silver threads on velvet
43¾ x 54¼ in
Mtskheta (Kartli), Svetitskhoveli Patriarchal
Cathedral
GSAM 1357

139 Processional cross [139]
16th century
Silver, gilded silver
63 x 42½ in
KSM 3248

140 Triptych [136]
16th century
Gilded silver, silver, turquoise, amethyst,
greenstone, wood
23¾ x 27½ x 2 in

Alaverdi (Kakheti)
GSAM K-179

141 Icon of St Marina [137]
16th century
Gilded silver, rubies, amethyst, wood
8½ x 6⅞ x 1⅛ in
Imereti
GSAM I-190

142 Icon of St Nicholas [138]
16th century
Gold, silver, pearls, rubies, turquoise,
wood, bone, mastic, unidentified resin
11⅜ x 7⅞ x 1¼ in
Alaverdi (Kakheti)
GSAM K-217

143 Two donor plaques [148]
1640
Gilded silver
13¼ x 8⅞ in
Kortsekheli (Samegrelo), goldsmithery
workshop of Levan Dadiani
GSAM O211 (A,B)

144 Purificator for chalice [151]
1667
Silk, satin, gold and silver on silk threads
23 x 22½ in
Nikortsminda (Racha, western Georgia)
GSAM 3846

145 Chalice cloth [152]
1667
Satin, gold and silver wire on silk thread
22 x 22¼ in
Nikortsminda (Racha, western Georgia)
GSAM 3844

146 Chalice cover [144]
Late 17th century
15 in square
Silk, twisted gold and silver on silk, gold
and silver thread, gold, turquoise, rubies,
pearls, sequins
GSAM 60

147 Chalice cloth [153]
1678–80
Satin, twisted gold and silver on silk
threads, colored silk thread
18⅜ in square
Svetitskhoveli, Mtskheta (eastern Georgia)
GSAM 3690

148 Pair of armlets [149]
1648
Silk, linen, twisted gold and silver on silk thread
11¼ x 7 in
Kartli (eastern Georgia)
GSAM 3794 (A, B)

149 Cloth for Communion tray [154]
1678–80

Satin, twisted gold and silver thread,
colored silk thread
21⅞ x 28⅜ in
Svetitskhoveli, Mtskheta (eastern Georgia)
GSAM 3769

150 **Eucharist cloth** [150]
1667
Satin, gold and silver wire, colored silk
24½ x 17 in
Nikortsminda (Racha, western Georgia)
GSAM 3845

151 **Pectoral cross** [141]
17th century
Gilded silver with pearls and precious stones
3⅝ x 2½ x ⅝ in
KSM 3310

152 **Mitre** [142]
17th century
Gold and silver twisted thread, pearls, gold,
silver, rubies, emeralds, turquoise
7¾ x 6⅝ in
Gelati Monastery, Imereti (western Georgia)
GSAM 3839

153 **Ecclesiastical belt** [143]
17th century
Silver wire, string, silk and canvas cloth,
twisted gold and silver threads, glass beads,
pearls
35½ x 3⅜ in
Svetitskhoveli Mtskheta
GSAM 3730

154 *The Knight in the Panther's Skin* [145]
1680
Paper leaves with gilt inlays, ink, gold
paint on paper and leather binding
262 folios
17¹⁵⁄₁₆ x 13¼ x 2 in
IM H-54

155 *The Knight in the Panther's Skin* [155]
17th–18th century
Ink, paint, gold leaf on paper with
gold-tooled leather binding
289 folios
13⁹⁄₁₆ x 10¼ x 2¹⁵⁄₁₆ in
IM S-5006

156 **Eucharist serviette** [146]
1680–1723
12⅝ x 12 in
Linen, satin, twisted silver and gold,
silk threads, pearls, rubies, turquoise
GSAM 3677

157 **Door curtain** [158]
1773
58½ x 59½ in
Satin, gold thread, twisted gold and
silk, silver and silk, colored silk threads

Tbilisi, Sioni Cathedral
GSAM 5054

158 **Phelonion** [157]
Early 18th century
Silk, brocade, gold and silver thread,
colored silk, sequins
52 x 23 in
Eastern Georgia
GSAM 3799

159 **Phelonion** [156]
Early 18th century
Colored silk, gold fabric, pearls,
turquoise, gold and silver thread
53 x 75 in
Sioni Cathedral (Tbilisi)
GSAM 1373

160 **Censer** [159]
1816
Silver
8¼ x 4 in
Gelati
KSM 3762

161 **Georgian double Abazi *tetri*** [160]
1831
Silver
1 in (diameter)
Tbilisi
GSM FH 18833

162 *The Kakheti Train* by Niko
Pirosmanashvili (Pirosmani) [161]
1913
Oil on cardboard
28 x 42½ in
Initialed at bottom right: 'N.P.'
GSAM 234

163 *Three Deer at a Spring* by Niko
Pirosmanashvili (Pirosmani) [162]
1913
Oil on cardboard
41 x 32 in
Signed at bottom right: 'N. Pirosmana'
GSAM 1343

164 *The Doctor on a Donkey* by Niko
Pirosmanashvili (Pirosmani) [163]
1914–15
Oil on cardboard
32 x 40 in
Initialed at bottom right: 'N.P'
GSAM 198

165 *Kalooba* (**On the Threshing-floor**) by
Niko Pirosmanashvili (Pirosmani) [164]
1916
Oil on cardboard
29 x 40 in
Signed at bottom left: 'Niko Pirosmanash'
GSAM 1335

Bibliography

GENERAL WORKS

Allen, W.E.D., *A History of the Georgian People*, London, 1932

Alpago-Novello, A. et al., *Art and Architecture in Medieval Georgia*, New Louvain, 1980

Amiranashvili, Shota, *Istoriya gruzinskovo isskusstva* [A *History of Georgian Art*]; in Russian, 1963

Asatiani, Notar and Bendianachvili, Alexandre, *Histoire de la Géorgie*, Paris, 1997

Beridze, V., Alibegashvili and G.V., Vol'skaia, A., and Khuskivadze, L., *The Treasures of Georgia*, London, 1984

Brosset, M.F., *Histoire de la Géorgie depuis l'antiquité jusqu'en 1469 de J.-C*, St Petersburg, 1849

Charachidzé, G., *Le système religieux de la Géorgie païenne*, Paris, 1968

Eastmond, Anthony, 'Royal Renewal in Georgia: The Case of Queen Tamar', in P. Magdalino (ed.), *New Constantines: the Rhythm of Imperial Renewal in Byzantium, 4th–13th Centuries*, Aldershot, 1994, pp. 283–93

————, 'Gender and Orientalism in Georgia in the Age of Queen Tamar', in L. James (ed.), *Women, Men and Eunuchs. Gender in Byzantium*, London, 1997, pp. 100–118

————, *Royal Imagery in Medieval Georgia*, University Park, PA, 1998

Gaprindashvili, G., *Ancient Monuments of Georgia: Vardzia. Architecture, Wall Painting, Applied Arts*, Leningrad, 1975

Gvaharia, V., 'La musique en Géorgie au temps de la grande reine Tamar', *Bedi Kartlisa* 25 (1977), 204–35

Lang, D.M., *The Georgians*, Bristol, 1966

Lordkipanidze, M., *Georgia in the XI–XII Centuries*, Tbilisi, 1987

Manvelichvili, A., *Histoire de la Géorgie*, Paris, 1951

Mepisashvili, R. and Tsintsadse, W., *Die Kunst des alten Georgien*, Leipzig, 1977; in English as *The Arts of Ancient Georgia*, London, 1979

————, **and Virsaladze, T.**, *Gelati: Architecture, Mosaic, Fresco*, Tbilisi, 1982

Mgaloblishvili, T., *Ancient Christianity in the Caucasus* (*Iberica Caucasica*: 1),

London, 1998

Pätsch, G., *Das Leben Kartlis. Eine Chronik aus Georgien 300–1200*, Leipzig, 1985

Q'aukhchishvili, S., *Kartlis tskhovreba*, Tbilisi, 1955–59; reprinted with an introduction by Rapp S. by Caravan Books, Delmar, NY, 1998

Rapp, S.H., *Imagining History at the Crossroads: Persia, Byzantium, and the Architects of the Written Georgian Past* [unpublished Ph.D thesis], University of Michigan, 1997

Salia, K., *History of the Georgian Nation*, Paris, 1980

Soltes, Ori Z., (ed.), *Beyond the Golden Fleece: The Jews of Georgia*, Forthcoming, 1999

Suny, Ronald Grigor, *The Making of the Georgian Nation*, Bloomington and Annapolis, 1994

Thomson, R.W., *Rewriting Caucasian History. The Medieval Armenian Adaptation of the Georgian Chronicles.* [The original Georgian texts and Armenian adaptation], Oxford, 1996

Toumanoff, C., *Studies in Christian Caucasian History*, Georgetown, 1963

Vivian, K., *The Georgian Chronicle. The Period of Giorgi Lasha*, Amsterdam, 1991

ANTIQUITY

Braund, David, *Georgia in Antiquity, 500 BC–550 AD*, Oxford, 1994

Brosset, M.F., *Rapports sur un voyage archéologique dans la Géorgie et dans l'Arménie exécuté en 1847–48*, St Petersburg, 1849–50

Burney, C. A. and Lang, D. M., *The Peoples of the Hills: Ancient Ararat and Caucasus*, London, 1971

Edens, C., 'Transcaucasia at the End of the Early Bronze Age', *Bulletin of the American School of Oriental Research*, 1995 no. 299/300: 53–64

Japaridze, O., *Arkheologicheskiye Raskopi v Trialeti* [*The archaeological excavations at Trialeti*]; in Russian, Tbilisi, 1969

Kohl, P. A., 'Central Asia and the Caucasus in the Bronze Age', in Sasson J., Baines J., Beckman G., Rubinson K.S. (eds.), *Civilizations of the Ancient Near East*, New York, 1995, pp. 1051–65

Kuftin, B. A., *Arkheologicheskiye Raskopki v Trialeti*, (in Russian), Tbilisi, 1941

Kushnareva, K. Kh., *The Southern Caucasus in Prehistory: Stages of Cultural and Socioeconomic Development from the Eighth to Second Millennium BC*, Philadelphia, 1997

Rubinson, K. S., 'The Chronology of the Middle Bronze Age Kurgans at Trialeti', in Levine L. D. and Young T. C. (eds.), *Mountains and Lowlands: Essays in the Archaeology of Greater Mesopotamia*, Malibu, 1997, pp. 235–49

Sagona, A. G., *The Caucasian Region in the Early Bronze Age* (*British Archaeological Reports, International Series* 214), Oxford 1984

'Uber die Ethnokulturelle Situation in Georgien gegen Ende des 3. Jahrtausends v. Chr.' **in Frangipane M., Hauptmann H., Liverani M., Matthiae P. and Mellink M.** (eds.), *Between the Rivers and Over the Mountains*, Rome, 1993, pp. 475–91

Zhorzhikashvili, L. G. and Gogadze, E. M., *Pamyatniki Trialeti epokhi Ranneyi i Srednei Bronzy II: Katalog* [*Monuments of the Early and Middle Bronze Age at Trialeti; II. Catalogue*]; in Russian, Tbilisi, 1974

THE ART OF PRE-CHRISTIAN GEORGIA

Au pays de la toison d'or. Art ancien de la Géorgie soviétique (Catalogue of exhibition of ancient Georgian art, with introductory notes by Gaberit-Chopin D., et al.), Paris, 1982

Djavakhishvili, A., *Stroitelnoye delo i arkhitektura poseleni yuzhnovo Kavkaza, V–III tys. do n.e.* [*Building and architecture in the settlements of the southern Caucasus during the fifth to third Millennia BC*], Tbilisi, 1973

Kuftin, B.A., *Arkheologitsesky raskopki v Trialeti, Pervi opyt periodizatsii pamyatnikov* [*The archaeological excavations at Trialeti – a first attempt at classifying the Monuments by Period*, in Russian, with summaries in Georgian and English], Tbilisi 1941

Lordkipanidze, O., *Drevnyaya Kolkhida* [*Ancient Colchis*], Tbilisi, 1979

Smirnov, J., *Akhalgorisky Klad* [*The Treasure of Akhalgori*], Tbilisi, 1934

ARCHITECTURE

Beridze, V., *The Architecture of Samtskhe in the Thirteenth to Sixteenth Centuries*, [in Georgian with summaries in Russian and German], Tbilisi, 1955

————, *Architecture de Tao-Klardjétie*, Tbilisi, 1981

———— **and Neubauer, E.**, *Die Baukunst des Mittelalters in Georgien vom 4. bis zum 18. Jahrhundert*, Vienna and Munich, 1981

Chubinashvili, G.N., *Pamyatniki tipa Dzhvari* [*Monuments of the type of Jvari*], Tbilisi, 1948

Djobadze, W., *Early Medieval Georgian Monasteries in Historic Tao, Klarjeti and Savseti*, Stuttgart, 1992

Gruzinskaya arkhitektura rannekhristianskovo vremeni, IV–VII vv [*Georgian architecture of the early Christian period, fourth to seventh centuries*, in Russian], Tbilisi, 1974; French edition published as *Architecture géorgienne paléo-chrétienne, IVe–VIIe siècle*, Faenza, 1973

Shmerling, R. O., *Malye formy v arkhitekture srednevekovoyi Gruzii* [*Small forms in the architecture of medieval Georgia*], (in Russian), Tbilisi, 1962

SCULPTURE

Aladashvili, N., *Monumental'naya skulptura Gruzii* [*Monumental sculpture in Georgia*; in Russian with summary in English], Moscow, 1977

Djobadze, W., 'The Sculptures on the Eastern Façade of the Holy Cross of Mtzkheta', *Oriens Christianus* 44 (1960), 112–35 and 45 (1961), pp. 70–77

MURAL PAINTINGS

Abramishvili, G., *The Cycle of David Garejeli in Georgian Monumental Painting*, [in Georgian with summaries in Russian and English], Tbilisi, 1972

Aladashvili, N., Alibegashvili, G. and Vokskaja, A., *Rospisi khudozhnika Tevdore v Verkhni Svanetii* [*The frescoes of the painter Theodore in Upper Svaneti*; in Russian, with summary in English], Tbilisi, 1966

————, *Zhivopisnajya shkola Svanetii* [*The pictorial school of Svaneti*, with summary in French], Tbilisi, 1983

Amiranashvili, S., *Istoriya gruzinskoi monumentalnoi zhivopisi* [*History of Georgian monumental painting*], Tbilisi, 1957

————, *Beka Opizari* [*Beka of Opiza*; in Georgian], Tbilisi, 1964

Chubinashvili, G.N., *Peshchernye monastyri David-Garedzhi* [*The rock-cut monasteries of David Gareja*], Tbilisi, 1948

Lordkipanidze, I., *The Frescoes of Nabakhtevi*; [in Georgian, with summaries in Russian and French], Tbilisi, 1973

Shervashidze, L., *Srednevekovaiya monumental'naiya zhivopis' v Abkhazi*

[*Medieval monumental painting in Abkhazeti*; in Russian with summary in French], Tbilisi, 1980

Sheviakova, T.S., *Monumentalnaia zhivopis rannevo srednevekov'y Gruzii* [*Monumental painting in early medieval Georgia*, in Russian], Tbilisi, 1983

Skhirt'ladze, Z., 'Early Medieval Georgian Monumental Painting: Establishment of the System of Church Decoration', *Oriens Christianus* 81, 1997, pp. 169–206

Thierry, Jean-M and Thierry, N., 'Peintures du dixième siècle en Géorgie médiévale et leurs raports avec la peinture Byzantine d'Asie Mineure', *Cahiers Archéologiques*, XXIV, 73–113, Paris, 1975

Thierry, N., 'La peinture medievale géorgienne', *Corsi di cultura sull'arte ravennate e bizantina*, 1973

————, 'Peintures géorgiennes en Turquie', *Bedi Kartlisa* 42, 1984, pp. 131–67

Velmans, T., *La peinture murale byzantine à la fin du Moyen Age 1* (*Bibliothèque des Cahiers Archéologiques* 11), Paris, 1977

————, 'L'image de la Deésis dans les églises de Géorgie et dans celles d'autres régions du monde byzantin", *Cahiers Archéologiques* 29, 1980–81, pp. 47–102

Virsaladze, T., *Rospisi atenskovo Siona* [*The Paintings of the Sioni Church at Ateni*], Tbilisi, 1984

Volskaya, A., *Rospisi srednevekovykh trapeznykh Gruzii* [*The frescoes in medieval Georgian refectories*; in Russian with summary in French], Tbilisi, 1974

PAINTED ICONS
Alibegashvili, G. and Volskaya, A., 'Georgian Icons', in Weitzmann K., et al., *Icons*. London, 1982

SAINTS' LIVES
Abuladze, I., *Dzveli kartuli agiograpiuli lit'erat'uris dzeglebi* [*Monuments of ancient Georgian hagiographical literature*; in Georgian], 2 vols, Tbilisi, 1963, 1967

Lang, D.M., *Lives and Legends of the Georgian Saints*, London, 1956

Peeters, P., 'Histoires monastiques géorgiennes', *Analecta Bollandiana* 36, 1917

Tarchnishvili, M., 'Le dieu lune Armazi', *Bedi Kartlisa* 11/12, 1961, pp. 36–40

Wardrop, M., and Wardrop J.O., 'Life of St. Nino', in *Studia Biblica et Ecclesiastica* 5, part 1, Oxford, 1900, pp. 1–88

ILLUMINATED MANUSCRIPTS
Amiranashvili, S., *Vepkhistqaosanis dasurateba. Miniat'urebi shesrulebuli XVI–XVIII saukuneebshi*, [*Miniatures from the XVI–XVIII centuries to the poem The Knight in Tiger's Skin*; in Georgian], Tbilisi, 1966

Devdariani, F., 'Illyustrirovannyye gruzinskiye bogoslujyevnyye sborniki. Gulani XVII veka. Grupa miniatyur Antsiskhatskovo Gulani' ['Illustrated collections of Georgian liturgical material. The Gulani of the seventeenth century. The group of the illuminations of the Gulani of Antsiskhati'], extract in *Second International Symposium on Georgian Art*, Tbilisi, 1977

Matsavariani, E., *Gruzinskiye rukopisi* [*Georgian manuscripts*; in Russian, Georgian and English], Tbilisi, 1970

REPOUSSE, IVORY, ENAMELS, TEXTILES, COINS AND CERAMICS
Abramishvili, G. and Javakhishvili, A., *Jewelry and Metalwork in the Museums of Georgia*, Leningrad, 1986

Amiranashvili, S., *Les Emaux de Georgie*, Paris, 1962

————, *Medieval Georgian Enamels of Russia*, New York, 1964

————, *Georgian Metalwork from Antiquity to the 18th Century*, London, New York, Sydney, Toronto, 1971

Beridze, V., *Kartuli nakargobis istoriidan* [*On the history of Georgian Embroidery: The Georgian Epitaphios*; in Georgian], Tbilisi, 1983

Chubinashvili, G.N., *Georgian Repoussé Work, 8th to 18th Centuries*, Tbilisi, 1957

Djaparidze, V., *Georgian Ceramics* [in Georgian with summary in Russian], Tbilisi, 1956

Kapanadze, D., *Gruzinskaya numizmatika* [*Georgian numismatics*], Moscow, 1955

Kenia, R., *The Triptych and Embossing of the Mother of God at Khakhuli* [in Georgian with summaries in Russian and French], Tbilisi, 1956

Ketskoveli, M., 'Medieval Georgian Ornamental Fabrics from Upper Svaneti', in *Second International Symposium on Georgian Art*, Tbilisi, 1977

Khuskivadze, L., *The Art of the Goldsmith at the Court of Levan Dadiani* [in Georgian with summaries in Russian and French], Tbilisi, 1974

———— *Gruzinskiye emali* [*Georgian enamels*; in Russian with summary in French], Tbilisi, 1981

Khuskivadze, L.Z., *Medieval Cloisonné Enamels at the Georgian State Museum of Fine Arts*, Tbilisi, 1984

Maysuradze, Z., *Art Ceramics in Georgia* [in Georgian], Tbilisi, 1953

Mitsishvili, M., *The Enameled Ceramics of Ancient Georgia (Ninth to Thirteenth Centuries)*, [in Georgian, with summaries in Russian and English], Tbilisi, 1969

Paxomov, E.A., *Monety Gruzii* [*Coins of Georgia*], Tbilisi, 1970

Rapp, S.H., 'The Coinage of Tamar, Sovereign of Georgia in Caucasia: A preliminary study in the numismatic inscriptions of twelfth- and thirteenth-century Georgian royal coinage', *Le Muséon* 106, 1993, pp. 309–30

Sakvarelidze, T. and Alibegashvili, G., *Repoussé and painted Icons in Georgia* [in Georgian], Tbilisi, 1980

Wessel, K., *Die byzantinische Emailkunst im V. bis XIII. Jahrhundert*, Recklinghausen, 1967

LITERATURE AND RUSTAVELI'S *Knight in the Panther's Skin*
Khintibidze, E.G., *Georgian-Byzantine Literary Contacts*, Amsterdam, 1996

Rayfield, D., *The Literature of Georgia. A History*, Oxford, 1994

Rustaveli, Shota, *Vepxist'q'aosani. T'ekst'i da variantebi* [in Georgian], ed., Shanidze, A. and Baramidze A., Tbilisi, 1966

Tarchnishvili, M., *Geschichte der kirchlichen georgischen Literatur*, Vatican, 1955

Toumanoff, C., 'Medieval Georgian Historical Literature (VIIth–XVth Centuries)', *Traditio* 1, 1943, 139–82

Urushadze, Venera, tr., *The Knight in the Panther's Skin*, Tbilisi, 1986

Vivian K., (tr.), *The Knight in Panther's Skin*, Amsterdam, 1995

Wardrop, M., (tr.), *Shot'ha Rust'haveli: The Man in the Panther's Skin*, Oriental Translation Fund, New Series 21, London, 1912

Notes on Contributors

Authors of articles

Abramishvili, Mikheil
Art Critic

Braund, David
Professor of Black Sea History, Exeter University

Chilashvili, Dr. Levan
Professor, Correspondent Member of the Academy of Sciences of Georgia, Director Georgian State Museum

Eastmond, Antony
Research Fellow, Department of History of Art, Warwick University

Japaridze, Dr. Otar
Professor, Academician of Academy of Sciences of Georgia

Kajaia, Dr. Lamara
Head of the Manuscripts Protection and Exposition, Institute of Manuscripts

Ketskhoveli, Mzistvala
Art Critic, Manager of the Department (GSAM)

Khuskivadze, Dr. Leila
Professor, Art Critic (GSAM)

Kiguradze, Dr. Tamaz
Deputy Director of Georgian State Museum

Kuznetsov, Erast
Art Historian, St. Petersburg, Russia

Lomouri, Dr. Nodar
Professor, Director of the State Art Museum

Lortkipanidze, Dr. Otar
Professor, Correspondent Member of the Academy of Sciences of Georgia

Machavariani, Dr. Helen
Professor

Marsagishvili, Gia
Art Critic, Deputy Director of Georgian Art Museum

McGovern, Patrick
Professor, Department of Archaeology, University of Pennsylvania

Rapp, Stephen H., Jr.
Professor, Department of History, Georgia State University

Rubinson, Karen
Fellow, Archaeological Institute of America

Sagona, Antonio
Reader in Archaeology, University of Melbourne

Sakvarelidze Taimuraz
Art Critic

Skhirtladze, Zaza
Art Critic

Soltes, Ori Z
Professorial Lecturer, Departments of Fine Arts and Theology, Georgetown University

van Esbroeck, Michel, SJ
Professor, Institute fur Semitistik, Ludwig-Maximilians Universitat, Munich

Authors of the annotations

AD **Dr. Alexander Djavakhishvili**
Professor, Correspondent Member of theAcademy of Sciences of Georgia, (GSM)

AK **Dr. Amiran Kakhidze** (GSM)

EG **Dr. Elguja Gogadze** (GSM)

HM **Dr. Helen Machavariani**
Professor (IM)

GB **Gulnazi Baratashvili**
Art Critic (GSAM)

GG **George Gagoshidze**
Art Critic, curator (GSAM)

GN **Dr. Guram Nemsadze** (GSM)

HK **Helen Kavlelashvili**
Art Critic (GSM)

IKo **Dr. Irakli Koridze** (GSM)

IK **Izolda Kurdadze**
Art Critic (GSAM)

IM **Izolda Meliqishvili**
Art Critic (GSAM)

IG **Dr. Iulon Gagoshidze** (GSM)

KJ **Dr. Ketevan Javakhishvili** (GSM)

LC **Dr. Levan Chilashvili**
Professor, Correspondent Member of the Academy of Sciences of Georgia, Director Georgian State Museum

LG **Dr. Lili Glonti** (GSM)

LK **Leila Khuskivadze**
Art Critic (GSAM)

LP **Dr. Leila Pantskhava** (GSM)

MJ **Dr. Mindia Jalabadze** (GSM)

MK **Mzistvala Ketskhoveli**
Art Critic, Manager of the Department (GSAM)

MM **Dr. Medea Menabde** (GSM)

MSh **Dr. Medea Sherozia** (GSM)

NG **Dr. Nana Gogiberidze** (GSM)

NK **Nukri Kvaratskhelia** (KSM)

OZS **Ori Z. Soltes**
Professorial Lecturer, Departments of Fine Arts and Theology, Georgetown University

RR **Dr. Ramin Ramishvili** (GSM)

TD **Dr. Tsira Davlianidze** (GSM)

TK **Dr. Tamaz Kiguradze** (GSM)

Index

Colchis, 19, 20, 22, 23, 27, 30, 31, 33, 36, 37, 57, 68, 72, 73, 74, 75, 76, 81, 82, 97, 121
Constantinople, 31, 33, 84, 91, 92, 93, 94, 95, 104, 107, 118, 119, 120
Conversion of Kartli, The, 42, 87
Copper (Chalcolithic) Age, 53-5, 56, 60
Coreseli, Michael, 118, 120
crater, **76**, **170**,170
Cross, 108-9; reliquary, **210**, 210, **211**; processional, **109**, **212**, 213, 230, **231**, **244**, 244, **245**; pectoral, 218, **219**, **256**, 256
cults and saints, 108-111

Dadiani, Levan, 118; plaques, 250, **251**
Dadiani, Vamek, 107
daggers, **64**, **138**, 138, **147**, 147, **190**, 190; sheath, **190**, 190
David 'of Tao', King, 89
David II Kuropalatos, King, 38, 100
David the Builder, King, 21, 26, 33, 38, 46, 89, 91, 92, 93, 95, 105, 107
David IV Narin, King, 107, 118
David Garejeli, St, 104, 105, 110
David Gareji monastery, 41, 202
David Jibisdze, 120
Dedoplis-Midnori, 81
Delisi, 56
Demetre I, King, 38, 95, 105
diadem, **69**, **166**, 166
Diadochus, Proclus, 46
Dialectics, 44
Diana, 79
Diaochi (Diaokhi), 30, 37
Didgori, Battle of, 26, 38
Didube, 60
Dionysus, 80-1
Dioscurias, 22, 23, 28, 31
Djinvali: ring, **202**, 202
Dmanisi, 20, 52
Dogmaticon, 44
Dolmen culture: figurine, **143**, 143
donor plaques, 250, **251**
door curtain, 264, **265**
Duin, Third Council of, 37, 87
Dzhavakhishvili, Ivan, 41
Dzhavakhishvili, Mikhail, 41
Dzlisa, 80
Dzveli (Old) Gavazi, 99
Dzveli (Old) Shuamta, 98

earrings, **169**, 169, **172**, 172
Ebla, 66
Egrisi, 20, 23, 27, 30, 31, 33, 36, 37, 65, 68, 73, 74, 81, 97
Elements of Theology, The (Diadochus), 46
embroidery, 123-6

Ephrem Mtsire, 42, 44, 45
Epiphanios of Cyprus, 42
Eptvime Mtatsmindeli, 42, 45, 94, 118, 120
Eristavi, Tornike, 45
Eucharist: cloth, **255**, 255; serviette, **264**, 264
Eugenicus, Kyr Manuel, 107
Eumelus of Corinth, 74
Euripides, 68
Evstathi Mtskheteli, St, 42

Fersati: figurine, **163**,163
fibula, **137**, 137, **143**, 143
figures/figurines, **134**, 134, **143**, 143, **144**, 144, **146**, 146, **148**, 148, **150**, 150, **151**, 151, **156**, 156, **163**, 163, **182**, 182, **188**, 188, **189**, 189
finial, standard, **171**, 171
Firdausi, 41

Gamkrelidze, Tamaz, 41
Garedzi desert, 106
Gareja, 104, 105, 110
Gebi: buckle, **79**, 194, **195**
Gelati, 34, **43**, 44, 46, **90**, 91, 93, 95, 105-6, 107, 114, 117, 118; censer, **267**, 267; Gospels, 117; mitre, **124**, 256, **257**; processional cross, 230, **231**; tondo, **225**, 225; wall paintings, **32**
George I, King, 38
George II, King, 38
George V, 'the Excellent', King, 38
George, St, 108, 109, 111,116; icon, **111**, 222, **223**
George Mtatsmindeli, 42, 45, 94
Georgian Academy of Sciences, 38
Georgian State Museum of Fine Arts, 112
Georgievsk Treaty, 27, 34, 38
Germi, 20
Giorgi III, King, 34, 44, 107; coin, **236**, 236
Giorgi IV Lasha, King, 34, 92; coin, **237**, 237
Giorgi VIII, King, 125, 126
Giorgi XII, King, 125
goblets, 144, **145**, **146**, 146
Golden Fleece myth, 22, 68, 74, 77
goldwork, classical period, 68-73
Gonio, 73; buckle, **191**, 191; figurine, **189**, 189
Great Law of Justice, The (Ikaltoeli), 46
Greeks, 19, 20, 21-2, 23, 31, 37, 68, 74, 76, 79, 80, 85, 97
Gregory Naianzeni (the Theologian), 42, 119, 120; Homilies, **119**, **229**, 229
Gregory of Nyssa, 42
Gregory Oshkeli, 42
Gremi, **86**, 101
griffin, **196**, 197

Grigol Khandzteli (Gregory of Khandzta), 87, 99-100
Grigol Pakourianisdze, 93
Gudiashvili, 41
Guria, 92
Gvaldesi: altarscreen panel, **25**, **208**, 208

Hadrian, emperor, 80
Helle, 74
Hephaestus, 75
Heracles, 75
Heraclius, emperor, 38
Heraclius II, King, 34, **35**
Hereti, 26, 33, 36, 85
Herman of Constantinople, 44
Herodotus, 19, 76
Hesiod, 37, 74
Hippolyta, 22
Hirmos, 42
Hittites, 66, 78
Holy Shrouds, **242**, 242, **243**, 243
Homer, 74
Homilies of Gregory Nazianzeni (the Theologian), **119**, **229**, 229
Homo erectus, 21, 22, 30, 37

Iberia, 19, 20, 22, 23, 26, 31, 33, 36, 37, 68, 73, 81-2
Ibn al-Azraq, 95
icon reliquary, 226, **226**
iconostasis plaques, 220, **221**
icons, 102, **110**, 114, 115, **213**, 213, 214, **215**, 222, **223**, **241**, 241, **248**, 248, **249**, 249
Ienashi, 107; Gospels, 118, 121
Ikalto, 34
Ikaltoeli, Arsen, 42, 44, 46
Imereti, 27, 34, 36, 84, 92
Imiris-Gora, 53, 97; blade, **136**, 136; nucleus, **55**, **136**, 136
Institute of Linguistics, 41
Institute of Manuscripts, 41, 42, 44, 45
Iori-Alazani culture, 64
Ioseliani, Platon, 125
Iovane Jibisdze, 120
Ipkhi, 124
Iprari, 105
Iron Age, 30, 56, 64-5
Ishkhani, 87, 104, 115; cross fragment, 14, **212**, 213
Islam, 18, 21, 26, 50, 82, 87, 96 *see also* Muslims
Iveria, 41
Ivlita (Julitta), St, 111

Jalal Ed-Din, Sultan, 38
jar, **139**,139
Jason myth, 22, 23, 30, 37, 68, 74, 77

necropolis; Jvari church; Martazi; Samtavro cemetery; Svetitskhoveli cathedral
Mukhvani Valley, 80
Mukuzani: bowl, **201**, 201
Muslims, 26, 33, 38, 49-50, 82, 91, 92, 95, 96 *see also* Islam
mythology, 19, 21-2, 74-6

Nabakhtevi, 107
Nakipari, 105
Narikala, **98**
Natsargora settlement: axe mold, **153**, 153 necklaces, **70**, **140**, 141, **142**, 143, **168**, 169, **193**, 193
Nedzihi: clasp, **200**, 200
Neolithic period, 30, 52-3, 58, 59, 77, 78, 97
Nicaea, Council of, 37, 116
Nicholas, St: icon, **249**, 249
Nike (Victory), **80**, 80, **186**, 187
Nikortsminda: cloths, **253**, 253; **255**, 255; purificator, **252**, 252
Nino, St, 21, 41, 104, 108, 109; *The Life of St Nino*, 42, 87
Ninotsminda, 96, 99
Nizibin Treaty, 37

obsidian nucleus, **55**, **136**, 136
Ochamchira, 75
Odishi culture, 53
Okureshi: situla, **160**,160
Opiza, 42, 87; relief, 209, **209**
Opizari, Beka, 116
Orjonikidze, Sergo, 35
Orkhevi: bracelet, **152**, 152; dagger, **64**, **147**, 147
Oshekeli, Gregory, 42
Oshki, 42, 45, 100, 104
Oshki Bible, 45
Otkhta Eklesia, 104
Ottoman empire, 20, 26, 27, 34, 50, 92, 96
Ozaani, 106
Ozhora: axehead, **65**, **161**, 161

Pahlavi, 82
painting, 102-7
Pakourianisdze, Grigol, 93
Paleolithic era, 22, 30, 52, 97
Palestine, 37, 45
Paluri type, 53
Pan: head, 182, **183**; torso, **197**, 197
Parkhali, 42
Parliament building, 101
Parnavaz, 24, 37, 82
Parsman VI, King, 37, 85
Parthians, 20, 23, 31
Paul I, Tsar, 34

Pazisi, 31
pectoral, **149**, 149, **177**, 177
pectoral cross, 218, **219**, **256**, 256
pendants, **71**, **72**, **147**, 147, **152**, 152, **156**, 156, **158**, 158, **176**, 176, **198**, 199
Pericles, 76
Persia, 19, 20, 23, 27, 31, 34, 37, 38, 50, 76, 78, 80, 81, 82, 84, 85, 87, 91, 92, 95, 96, 107
Petritsi, John (Ioane), 46, 93
Petritsoni, 45-6
Petritsoni Typicon, 46
Pevrebi: figurine, **151**, 151; pectoral, **149**, 149
Phasis, 75, 76, 79
Phasis (modern Rioni), River, 19, 22, 37, 75
phelonion, **266**, 266
Phokas, Bardas, 89
Phrixus, 74
Pirosmani (Pirosmanashvili), Niko, 128-30; paintings, **128**, **129**, **268**, **269**
Pitareti, 101
pitchers, **171**, 171, **180**, 180, **187**, 187
Pitchvnari: alabastron, **165**, 165; amphoriskos, **165**, 165; aryballos, **164**, 164; bowl, **162**, 163; crater, **76**, **170**, 170; earrings, **169**, 169; skyphos, **164**, 164
Pitiakhshesi: dagger sheath, **190**, 190; necklace, **193**, 193
plaques, **81**, **167**, 167; donor, 250, **251**; iconostasis, 220, **221**
Pliny the Elder, 23, 68, 120-1
Plutarch, 22
Pollux, 22
Pompey the Great, 22, 37
pot, **139**, 139
Poti, 22, 31, 38, 75
Potskho: coin, **167**, 167
processional cross, **109**, **212**, 213, 230, **231**, **244**, 244, **245**
Prometheus, 21-2, 23, 41, 75
Psalters, **120**, **238**, 238, **239**, 239, **240**, 240
Pseudo-Aristotle, 68
Pseudo-Dionysius the Areopagite, 44
Pshavela, Vazha (Lucas Razikashvili), 41
purificator, **252**, 252

Qazbegi, Alexander, 41

Racha, 64, 107
Razikashvili, Lucas (Vazha Pshavela), 41
relief, **209**, 209
reliquary: cross, **210**, 210, **211**; icon, 226, **227**
repoussé work, 115-6
rings, **141**, 141, **173**, 173, **199**, 199, **202**, 202
Romanos, Ipolitos, 42
Romans, 20, 22, 23, 31, 37, 68, 73, 74, 80, 85, 97

Ruisi-Urbnisi Church Council, 38, 105
Russia, 19, 26, 27, 28, 34, 35, 38, 92, 96, 107, 123-4
Rustaveli, Shota *see Knight in the Panther's Skin, The*
Rusudan, Queen, 92; coin, **91**, **237**, 237

Sabatsminda monastery, 45
Sabereebi, 102
Saeristao, 33
Safavid Persia, 27, 34, 50, 92, 96, 107
Sagolasheni, 115; iconostasis plaques, 220, **221**
St John the Baptist monastery, Garedzi, 106
saints, 108, 109-11 *see also* names of saints
Sairkhe, 76, 81
Sakartvelo, 36, 38, 89, 92
Samadlo: *kvevri* fragments, **59**, 180, **181**
Samegrelo, 92
Samele Klde: arrowheads, **137**, 137
Samgori, 61
Samtavisi, 101
Samtavro cemetery: belt fragment, **159**, 159; figurines, **188**, 188; pendant, **156**, 156; pitcher, **187**, 187
Samtavro culture, 64
Samtskhe, 34, 36, 42, 92, 107
Sargis of Tmogvi, 41
Sassanid Persia/Sassanian empire, 20, 23, 25, 31, 33, 37, 82, 87
Satchkhere: dagger, **138**, 138
Savlak, King, 68
Scythians, 19, 37, 64, 65, 78, 79
seal-rings, **173**, 173, **199**, 199
Seljuk empire, 20, 21, 33, 34, 38, 91
serviette, Eucharist, **264**, 264
Shah Nameh (*The Book of Kings*; Firdausi), 41
Shatberdi, 42, 87
Shavteli, Georgi Prokhore, 45
Shemokmedi, 115; Quadrifolium, 113
Shevardnadze, Eduard, 9, 11, 12, 36
Shilada sanctuary: spearhead, **154**, 154
Shio Mgvimeli, St, 104, 110
Shiomghvime, 42, 44
shrouds, **242**, 242, **243**, 243
Shukhuti, 102
Shulaveri/Shulaveri-Gora, 53, 58, 59, 97
Shulaveri culture, 53-5; blades, **136**, 136; ceramic shard, **134**, 134; figure, **134**, 134; nucleus, **55**, **136**, 136; sickle, **54**, **135**, 135
Shushanik, St, 25, 42, 85; *Martyrdom of St Shushanik*, 24, 37, 40, 82
sickle, **135**, 135
Simeon Stylites, St, 108, **110**, 110-1
Simeon the Younger, St, 110-1